MUSEUMS AND SOCIAL CHANGE

Museums and Social Change explores the ways museums can work in collaboration with marginalised groups to work for social change and, in so doing, rethink the museum.

Drawing on the first-hand experiences of museum practitioners and their partners around the world, the volume demonstrates the impact of a shared commitment to collaborative, reflective practice. Including analytical discussion from practitioners in their collegial work with women, the homeless, survivors of institutionalised child abuse and people with disabilities, the book draws attention to the significant contributions of small, specialist museums in bringing about social change. It is here, the book argues, that the new museum emerges: when museum practitioners see themselves as partners, working with others to lead social change, this is where museums can play a distinct and important role.

Emerging in response to ongoing calls for museums to be more inclusive and participate in meaningful engagement, *Museums and Social Change* will be essential reading for academics and students working in museum and gallery studies, librarianship, archives, heritage studies and arts management. It will also be of great interest to those working in history and cultural studies, as well as museum practitioners and social activists around the world.

Adele Chynoweth is currently a lecturer at the Centre for Heritage and Museum Studies at the Australian National University, where she received the 2018 Vice Chancellor's Award for Public Policy and Outreach.

Bernadette Lynch is an Honorary Research Associate, University College London. As a writer, researcher and museum professional she is known internationally for her work on public engagement and participation in museums. She has thirty years' experience in senior management in UK and Canadian museums.

Klaus Petersen is Professor of Welfare State History and director of the Danish Centre for Welfare Studies at the University of Southern Denmark.

Sarah Smed is head of the Danish Welfare Museum, and known for her activist involvement in social issues, the Danish National Apology to Care Leavers in 2019 and investigation into other institutional abuse in 2020.

MUSEUM MEANINGS

Series Editors: Richard Sandell and Christina Kreps

Museums have undergone enormous changes in recent decades; an ongoing process of renewal and transformation bringing with it changes in priority, practice and role as well as new expectations, philosophies, imperatives and tensions that continue to attract attention from those working in, and drawing upon, wide ranging disciplines.

Museum Meanings presents new research that explores diverse aspects of the shifting social, cultural and political significance of museums and their agency beyond, as well as within, the cultural sphere. Interdisciplinary, cross-cultural and international perspectives and empirical investigation are brought to bear on the exploration of museums' relationships with their various publics (and analysis of the ways in which museums shape – and are shaped by – such interactions).

Theoretical perspectives might be drawn from anthropology, cultural studies, art and art history, learning and communication, media studies, architecture and design and material culture studies amongst others. Museums are understood very broadly – to include art galleries, historic sites and other cultural heritage institutions – as are their relationships with diverse constituencies.

The focus on the relationship of the museum to its publics shifts the emphasis from objects and collections and the study of museums as text, to studies grounded in the analysis of bodies and sites; identities and communities; ethics, moralities and politics.

Also in the series:

Museums, Sexuality, and Gender Activism
Edited by Joshua G. Adair and Amy K. Levin

Museums and Social Change
Challenging the Unhelpful Museum
Edited by Adele Chynoweth, Bernadette Lynch, Klaus Petersen and Sarah Smed

Curating Under Pressure
International Perspectives on Negotiating Conflict and Upholding Integrity
Edited by Janet Marstine and Svetlana Mintcheva

https://www.routledge.com/Museum-Meanings/book-series/SE03

MUSEUMS AND SOCIAL CHANGE

Challenging the Unhelpful Museum

Edited by Adele Chynoweth, Bernadette Lynch,
Klaus Petersen and Sarah Smed

Routledge
Taylor & Francis Group

LONDON AND NEW YORK

First published 2021
by Routledge
2 Park Square, Milton Park, Abingdon, Oxon OX14 4RN

and by Routledge
52 Vanderbilt Avenue, New York, NY 10017

Routledge is an imprint of the Taylor & Francis Group, an Informa business

British Library Cataloguing-in-Publication Data
A catalogue record for this book is available from the British Library

Library of Congress Cataloging-in-Publication Data
Names: Chynoweth, Adele, editor. | Lynch, Bernadette, editor. |
Petersen, Klaus, editor. | Smed, Sarah, editor.
Title: Museums and social change: challenging the unhelpful museum /
edited by Adele Chynoweth, Bernadette Lynch, Klaus Petersen and Sarah Smed.
Description: New York: Routledge, 2020. | Series: Museum meanings |
Includes bibliographical references and index.
Identifiers: LCCN 2019057252 (print) | LCCN 2019057253 (ebook) |
ISBN 9780367228002 (hardback) | ISBN 9780367228019 (paperback) |
ISBN 9780429276903 (ebook)
Subjects: LCSH: Museums and community. | Museums–Social aspects. |
Museums–Management. | People with social disabilities–Education.
Classification: LCC AM7.M8818 2020 (print) |
LCC AM7 (ebook) | DDC 069/.068–dc23
LC record available at https://lccn.loc.gov/2019057252
LC ebook record available at https://lccn.loc.gov/2019057253

ISBN: 978-0-367-22800-2 (hbk)
ISBN: 978-0-367-22801-9 (pbk)
ISBN: 978-0-429-27690-3 (ebk)

Typeset in Bembo
by Newgen Publishing UK

To turn the struggle into common experience and
Justice into a passion.

Bertolt Brecht[1]

CONTENTS

FIGURES

CONTRIBUTORS

Adele Chynoweth was a secondary school teacher before she undertook full-time training in theatre direction. Adele also completed a PhD concerning the work of contemporary Australian women playwrights. Her extensive theatre credits include her work with a creative team commissioned to create the *Memory Museum* as part of the official programme for the Centenary of Federation celebrations in South Australia. Adele continued her curatorial work at the National Museum of Australia and the Bob Hawke Prime Ministerial Centre at the University of South Australia. Adele is currently a lecturer at the Centre for Heritage and Museum Studies at the Australian National University, where she received the 2018 Vice Chancellor's Award for Public Policy and Outreach.

Trisse Gejl is the author of nine novels, as well as poems, essays and short stories. She has an MA in Aesthetics and Culture from Aarhus University and teaches writing at the University of Southern Denmark as an associate professor. Within the context of research, Gejl has conducted writing workshops with vulnerable people.

Sioned Hughes is Keeper of History and Archaeology at Amgueddfa Cymru – National Museum Wales. Her role involves leading on the strategic direction of the department, ensuring that collections are accessible, developed, researched and used in creative and inspiring ways for the benefit of the people of Wales. Over the past five years she has led several projects that explore diverse ways of interpreting collections through public engagement, collaboration and co-production, more recently leading on the development of activist co-collecting at Amgueddfa Cymru.

Stine Grønbæk Jensen is an anthropologist and holds an award-winning PhD from the University of Southern Denmark's Department of History. It is based on the memory work of Care Leavers, and how they make sense of and cope with a difficult past in different material, social and cultural settings. Grønbæk Jensen was from 2012–2014 a part of the 'In care, in history' research project on the history of vulnerable groups in Denmark from 1945 to 1980, and from 2015 to 2018 part of the *Welfare Stories on the Edge of Society* project. She is currently a

postdoctoral student at the University of Copenhagen, Department of Media, Cognition and Communication. Her latest publications of relevance include 'At åbne skuffen' (To Open the Drawer – Transformations of the Self and the Social World through Memory-work, 2019); 'På kanten af velfærdsstaten' (2015; On the Edge of the Welfare State); the book chapter 'Anbragt i historien: Tidligere anbragte og indlagtes mundtlige fortællinger', in *Oral history i Danmark* (Placed in History: Oral History Interviews with Care Leavers, 2016).

Ying-Ying Lai is a professor at the Graduate School of Arts Management and Cultural Policy, National Taiwan University of Arts. She is also active as the Secretary General of the Chinese Museum Association, Taiwan, Director of the Research Center for Museum Studies based in National Taiwan University of Arts, and a council member of the Federation of International Human Rights Museums. She served as the Deputy Director of the Museum of Contemporary Art, Taipei and worked over 20 years as a senior curator at the Taipei Fine Arts Museum. Ms Lai received her PhD degree in art education and art administration from the National Taiwan Normal University. She has curated many exhibitions, such as *The World According to Dada*, *Gravity of the Immaterial*, *Labyrinth of Pleasure*, etc. She is also the author of *The Museum and its Social Significance, Contemporary Arts Management, A Reflexive Study of the Taipei Fine Arts Museum's Exhibition (1983–2007), Taiwanese Avant-Garde: Complex Art in the 1960s*, etc.

Bernadette Lynch is a writer, researcher and museum professional with thirty years' experience in senior management in UK and Canadian museums. Formerly Deputy Director at the Manchester Museum, University of Manchester, she has an international reputation for ethical, innovative participatory practice. Her influential research and consultancy specialises in critical public engagement and participation with diverse communities and in leading museum transformation and change. She publishes widely on participatory democracy in museums, and on 'useful museum' practice. She is an Honorary Research Associate, University College London. She continues working on museum ethics, decolonisation, power, democracy, debate, conflict, contested collections, difficult subject matter and activism in museums. Her work is freely available online: https://ucl.academia.edu/BernadetteLynch.

Kathrin Pabst is a German ethnologist who is working as the Head of the Department for Research, Collection Management and Visitor Experience at the Vest-Agder-museum in Kristiansand, Norway. She has a PhD in professional ethics, and her doctoral thesis focused on moral challenges faced by museum employees when working with sensitive topics involving external cooperation. Pabst's working experience includes both the practical and theoretical elements of working with challenging or sensitive subjects. As a project leader of several exhibitions she has worked closely with participants from local society and trained her colleagues in doing so. As an author and lecturer, she lectures extensively and presents workshops on professional ethics. She is also a member of the Norwegian board of the International Council of Museums.

Manon S. Parry is an historian of medicine, and curator of exhibitions on global health and human rights, disability in the American Civil War, and medicinal and recreational drug use. Travelling versions of these exhibitions have visited more than 300 venues in Argentina, Canada, Germany, Guam, Turkey, the United Kingdom and the United States. Her current book project on medical museums will be completed in 2021.

Adele Patrick has been developing innovative, participatory cultural projects rooted in equalities for over 25 years. A co-founder of Glasgow Women's Library (GWL), Adele has a leadership role in forging influential, change-making, organisational development within the museums sector. She is currently GWL's Creative Development Manager. Continually collaborating with artists and creatives, Adele received the Engage Scholarship for Excellence in Gallery Education in 2016. Her Clore Leadership Fellowship research in 2019 focuses on feminist leadership approaches.

Klaus Petersen is Professor of Welfare State History and director of the Danish Centre for Welfare Studies at the University of Southern Denmark. He has published widely on welfare state development and his special interests include the Nordic Model of welfare, transnational welfare studies, welfare concepts and semantics, and the links between war and social reform. His most recent book is *War and Welfare: Military Conflict and Welfare Development in the Western World* (Oxford University Press 2018), co-edited with Herbert Obinger and Peter Starke.

Jacob Knage Rasmussen is a curator at the Danish Welfare Museum. In 2010–2011, he was a part of the first Danish inquiry on child abuse and neglect in institutions or children's homes, called the Godhavn Inquiry. In 2012–2014, he was a part of the *In Care, in History* research project on the history of vulnerable groups in Denmark from 1945 to 1980. He is currently working on his PhD thesis, at the University of Southern Denmark's Department of History. It has the working title 'Who Did They Think I Was?' His latest publications of relevance are *På kanten af velfærdsstaten* (On the Edge of the welfare State, 2015); 'A Great Find: Turning the World Upside Down', in *Journal of the History of Childhood and Youth* (2015); 'Denmark: The Godhavn Inquiry', in *Apologies and the Legacy of Abuse of Children in Care* (2015); and 'Journalens potentialer', in *Temp* (Potentials of the Case Record, 2017).

Jeppe Wichmann Rasmussen is an historian and curator at the Danish Welfare Museum. He has worked in the museum since 2012 and has managed several different museum projects. Jeppe was the project manager of the project *Hidden Danish Stories* which engaged a diverse group of socially vulnerable men and women as storytellers in 12 documentaries about poverty, homelessness, exclusion and substance abuse across time. His recent publications of relevance include 'Det var ikke de bedste, der tog afsted', in *Fynske Årbøger* (The People who Left, Were Not among the Best of Us, 2017); 'Dimitteret til tysklandsarbejde', in *Handicaphistorisk Tidsskrift* (Released to Work in Germany, 2016). *Fattiggården* (The Poorhouse), the yearbook for Svendborg Museum features eight of his articles.

Sarah Smed is Head of the Danish Welfare Museum. She is a trained historian and has, since 2010, overseen both the museum's curatorial and educational programmes, creating participatory and co-produced social history projects. Sarah works across agencies and professions, between sustainable partnerships with public bodies, NGOs and educational institutions, as well as closely collaborating with both professional and alternative witnesses from the welfare system. In 2019 the Danish Prime Minister gave a national apology to Care Leavers on the ground of research carried out by the Danish Welfare Museum, and at the ceremony Sarah Smed was invited to give a public speech. In 2020 an investigation into neglect in special care institutions was launched by the Danish government – an investigation which Sarah Smed is currently heading at the museum.

Corrie Tijsseling is a researcher in the field of mental health care and social counselling for deaf and hard-of-hearing people, and in the field of special education and inclusive education for deaf and hard-of-hearing pupils and students. She advocates equal rights in, and access to, society for people with disabilities.

Paul van Trigt has published on the history of the welfare state, human rights, disability and religion. He currently works at Leiden University as a postdoctoral researcher in the project *Rethinking Disability: The Impact of the International Year of Disabled Persons (1981) in Global Perspective*. He is writing a genealogy of the United Nations Convention on the Rights of Persons with Disabilities.

Jessica and Matthew Turtle are the co-founders of the UK's first Museum of Homelessness, which is being developed by people from all walks of life, in particular those who have experienced homelessness. As well as developing the Museum of Homelessness, Jessica works on the Policy and Programmes team at the Museums Association, is Chair of Trustees for the Simon Community and also sits on Battersea Arts Centre's heritage committee. Matt currently works full-time on the Museum of Homelessness but has previously worked in programming and learning roles for the Design Museum, Open City, the Crafts Council and the Royal Academy of Arts. Jess and Matt Turtle are visiting tutors at King's College London where they teach jointly on the Education in Arts & Cultural Settings Masters course.

Nia Williams is Director of Learning and Engagement at Amgueddfa Cymru – National Museum Wales. She is responsible for leading the strategic direction for the following areas of work: public programmes to support education, skills and wellbeing; community agency and engagement; events; translation and the Welsh language; interpretation and publications. She is also responsible for Amgueddfa Cymru's compliance with the Welsh Language Standards and the Well-being of Future Generations (Wales) Act 2015. Over the past five years she has worked on developing a new strategic vision for St Fagans National Museum of History. This major redevelopment has Welsh government support and secured the largest National Lottery Heritage Fund grant ever awarded to Wales.

ACKNOWLEDGEMENTS

Our first and foremost acknowledgement must go to the inspiring collaborators who partnered with all of the museums mentioned in this book. They have helped us to be honest and brave. We must also thank the dedicated museum staff who shared their thoughts and practice here. They are, with their collaborators, pushing museum practice forward, and making it relevant to people's lives.

We started planning the book almost three years ago as part of the research project *Welfare Stories* hosted by the Danish Welfare Museum in Svendborg. Whereas the project focused on the lives and experiences of Danish Care Leavers, it proved also to be an inspiring platform for numerous collegial talks about the role of museums in the twenty-first century.

We would like to thank the Velux Foundation for its generous funding of this research project. Klaus Petersen's contribution to the book was part of his work within the Niels Bohr project *Uses of Literature*, financed by the Danish National Research Foundation (project 26223).

The editors would like to thank Heidi Lowther (Editor) and Katie Wakelin (Editorial Assistant), Museum & Heritage Studies, Routledge for helping us so well throughout to steer a direct course. Heidi and Katie don't just 'do their job'. They also put minds at ease, hearts at rest and provide steadfast professional advice whilst respecting editorial autonomy.

Heartfelt thanks to Series Editor Richard Sandell who spurred us on with enthusiasm from the outset. Social justice museology is challenging – doing it and writing about it. You afforded us the opportunity to internationally share the committed work of the museum practitioners in this volume so that their work may endure. We also extend our sincere gratitude to Christina Kreps (Series Editor) who demonstrated keen understanding and support.

We are indebted to David Fleming, not only for so generously writing the foreword but also for courageously carving out a collegial and revolutionary territory in your practice.

And to all those who offered dialogue and debate, and most of all encouragement, to the small group of international colleagues behind this book, and those who contributed throughout, we most sincerely thank you.

FOREWORD

David Fleming

One of the dangers in running a modern museum is that in our haste to reinvent and make museums relevant to all instead of to just a few, and in arguing for museums to become active in the fight to redress inequality, we end up making mistakes: these might include neglecting scholarship (though I have yet to hear of a convincing case of this) or riding roughshod over conservation requirements (ditto); it might also mean, as pointed out in this important book, patronising and actually therefore being unhelpful to people who sit outside the mainstream, who are the very 'excluded' and 'marginalised' people whom the museum is striving to reach.

This book may, therefore, come as something of a shock to museum people who have tried to make museums more 'relevant'. The book posits the notion that museums need to *involve* (or '*empower*') rather than *preach to*, 'marginalised' people; that museums, if they wish to 'break through social and institutional barriers' and to be *socially useful*, need to stop undermining these worthy aims by clinging to control of the media and the messages that they wish to deliver; thus, museums should stop treating people as passive beneficiaries and instead value them as *active agents*.

An invitation to participate is not enough, argue the authors. This is at risk of removing the passion of the voices of 'marginalised' people, and substituting for it the culturally authoritative voice of the museum itself. This is especially dangerous (and disempowering) when the voice of the museum seeks compromise rather than conflict; when the museum seeks neutrality and the depoliticisation of its messages.

I have myself struggled with these dilemmas in my work at Hull Museums, at Tyne and Wear Museums, and at National Museums Liverpool. It is true that there are real risks in changing the museum mentality from that of the nineteenth century, when patrimony was the dominant force, to something more democratic, something more relevant and purposeful, and this book flags up perhaps the main risk – that of the museum continuing to use its cultural authority, its *intellectual control*, to act as *therapist* to vulnerable people rather than appropriately involving people in a more active, genuinely participative way, thus missing the whole point of involvement, which is to ensure that voice and empowerment are both authentic and useful; that people should be enabled by a museum to help themselves, that the museum role is to promote people's freedom to choose, not to try to substitute the museum's voice for theirs.

For my own part, my viewpoint has been strongly affected by the degree to which I have believed that it is ever possible for 'marginalised' people to be able to find their voice. I have tended to try to take on the role of spokesperson (in my case, primarily for white, male working-class people). I have been driven by a belief that I could, indeed, more closely represent working-class people than others could. Perhaps, in this, in my drive to ensure that I was addressing what I saw as a gigantic void in museum interpretation, I have been wrong. Perhaps I should instead have concentrated on finding ways to involve others.

A prerequisite of creating the 'useful museum' is a profound change in attitude towards those people whom museums once categorised as 'vulnerable' or 'marginalised', to see them instead as collaborators, as experts and researchers, and as campaigners. *Interdependence* must replace the sense that the museum is dispensing kindness. This book proposes strategies for museums that wish to tread this path.

The book will cause museum practitioners to reappraise what it is they are trying to achieve and, perhaps more importantly, how they are trying to achieve it. The book is an important contribution to the ongoing debate about what museums are really for, and how they can and should aspire to a broader role in society than that which they have played traditionally.

EDITORS' PREFACE

What are the practical, everyday ethics of a museum in its relations with others? Can the museum transcend its own history of prejudice and exclusion to consciously enter a world of fellowship and solidarity, of ongoing, side-by-side struggle, as fellow changemakers in a world in trouble? Can we co-create social change? And is it possible that those existing in society's margins might have lessons to teach our cultural institutions; lessons in how we might transcend disempowering 'helpfulness', and become mutually 'useful' collaborators in a way that is transformative for all concerned? This is what is explored here, and has proven to not only change people but, as in the case of one museum in Denmark described in this book, change government policy. This is what is taking place, as will be seen throughout this book, in change-making museum practice in very different places in the world right now. The result is surprising, and takes us back to a human value in action, one that has been all-but-forgotten. It proves that it's not too late for museums to be relevant to our times. This is the time of the 'useful museum'.

Over the last decade, discussions on how museums can play a much more active role, making a real difference in society, have flourished in many countries. This has partly been triggered by new technology, new research questions and new partnerships, but it also reflects a much more radical shift in the purpose of museums and their ways of working. These days, many museums all over the globe are involved in processes in which the overall aim is to create social change and to explore how museums can facilitate processes of empowerment, social justice and active agency. There is now a focus on the museum collaborating with groups of citizens on challenging topics that were previously silenced in museums, and there is a more proactive commitment to enabling those most marginalised to tell their stories from their own perspectives. There is a strong focus on contemporary reality with what might be called a 'history of the present' approach in museums. This means focusing on issues and dilemmas of high relevance in present-day societies. In other words, the shift in museums reflects a deeply held commitment to an active democratisation of the museum for the people, by the people and about the people that turns many established modes of thinking and power relations upside-down. But it doesn't end there.

What is also happening is that some of these new collaborations are bringing about real change – not only for the people involved but also for the museum organisations and for society in general. Within these new collaborations, there has been a shift in the power dynamic, and consequently, the roles too have shifted. It is moving the museum away from simply 'doing-for', to a mode of 'doing-with' people. And it moves the role of the museum participant away from passive beneficiary, towards becoming an active agent in their own right. In certain ground-breaking museums, people living on the edge of society are now actively collaborating with museums in a much more radical way than before. Through collaboration with the museum, those previously marginalised are actively making changes in their own lives, and actively contributing to the museum across a range of activities, from educational programmes to contemporary collecting and targeted research. They are no longer simply being helped, but are helping themselves, with the museum as facilitator. They are actively helping secure the museum's contemporary relevance. This work therefore has valuable outcomes.

In this book we collect diverse international examples and experiences connected to this new way of working in museums, in which people's own agency can be seen to be facilitated in remarkable ways, while continuously moving the museum in new directions. Rethinking an established practice and way of thinking is not an easy task. It takes courage and a commitment to making museums relevant to a troubled world. It is about starting processes in which the outcomes are uncertain. It is about opening our analytical concepts ('welfare' can mean many different things). It is about taking risks. It can sometimes entail conflict. It challenges the role of museums and the authority of the people working within them. But as the examples in the book will show, it is also leading the way towards a new, fascinating and highly relevant museum for the twenty-first century.

In the book's Introduction, Bernadette Lynch establishes the rationale of the book, challenging museums to consider that their well-meaning attempts at being helpful are too often, in fact, undermining. She outlines the implications for museum policy and practice where museums are currently attempting to collaboratively engage in the fight for social justice and change: how can museums help the vulnerable and marginalised without at the same time reasserting people's vulnerability, their perceived 'helplessness', and thereby undermining their pride and self-esteem – their power? The chapter takes the reader through the theoretical and ethical considerations related to this difficult question. Lynch proposes a radically new way forward for museums, fundamentally rethinking the museum's relations to others, in order for museums to move away from a hierarchical 'helpfulness' to instead become 'useful' in terms of social justice and change. She thus proposes museums working in solidarity with groups fighting for recognition and against social exclusion, making way for them to take the lead. In order to achieve this – or begin to move museums in this direction – Lynch proposes that we need to reflectively rethink the political philosophy and everyday ethics of museum collaborative practice in action, and outlines what form this might take. She identifies a new set of values that is currently being adopted by some museums internationally; museums that are courageously laying the foundations for such a shift in museum practice.

This book provides inspirational examples of how this radical shift is being applied in collaborative practice with some of the most marginalised, taking a closer look at some of these museums and projects. The chapters offer a series of fascinating and challenging case studies in shared activism for social change from Denmark, the UK, Norway, Netherlands, Taiwan and Australia. Rather than a catalogue of success, the chapters offer first-hand insights into the possibilities and hopes, as well as the many pitfalls, dilemmas and challenges of the specific dynamic practices and projects in which the authors have recently been engaged.

The book is divided into three parts.

Part I of the book demonstrates and critically assesses the potential, as well as the risks of co-creation. What kind of dilemmas and challenges do the processes of co-creation involve? What are the preconditions for engaging with vulnerable and marginalised groups in pro-actively researching and co-creating exhibitions, collections and projects?

The Danish Welfare Museum has been a pioneer in involving marginalised groups in museum work. Sarah Smed explains in Chapter 1 how the museum uses the historical setting (an old poorhouse) as a prism to discuss contemporary issues of the Danish welfare state. Co-creational initiatives with the people who themselves have been part of institutional life ('alternative experts') in the welfare state system have been the very core of the development of the museum itself. The groundbreaking work of the Danish Welfare Museum is explained in more detailed in the subsequent Chapters 5–7.

In the UK, some museums are actively engaged in museum activism for social justice. In Chapter 2, Jessica and Matthew Turtle draw lessons from their work with the Museum of Homelessness (MoH) in London:

> The MoH was set up to shine a light on the histories of homelessness and its present-day realities. At the heart of the project was the desire to create a whole museum, from scratch, developed and run by people who have experienced homelessness. Discussing topics from 'museum neutrality' through to the minutiae of organising direct action exhibitions in Downing Street, this article covers the twists and turns involved in the early days of creating a new kind of museum, from the ground up.

In Chapter 3, Adele Patrick, a co-founder of Glasgow Women's Library (GWL), challenges the idea of 'women on the edge' and vulnerable people being brought into the museum. The origins of GWL are in collective, grassroots activism and a feminist desire to address structural inequalities and the lack of representation of women in Scottish cultural life and in mainstream institutions. Now a recognised Collection of National Significance, GWL aims to become increasingly representative of and accessible to people from the widest cultural, economic and social backgrounds. Using the example of *March of Women* (a project that looks to the past to address contemporary social challenges), the chapter discusses how at GWL the 'margins' and core have become productively blurred.

Chapter 4 moves us from Scotland to Taiwan. Based on her work with the Togo Rural Village Art Museum, Ying-Ying Lai asks how a museum that attempts to revitalise a village can actually respond to the needs of the community; how much change does art bring and is it beneficial? Togo Rural Village Art Museum created the concept of *A Museum without Walls*, based on social empowerment in the lives of villagers through a range of art-istic initiatives. The process of connecting rural art, museum and social empowerment is rarely easy, and Lai gives valuable insight into the questions raised by both locals and government.

In Part II of the book, we focus on co-researching hidden narratives. Being able to tell your own history is a key element in social recognition and working for social justice. The chapters in this sections discuss very different strategies for opening up museums and allowing for new histories about our society to be told.

In Chapter 5, Jeppe Wichmann Rasmussen discusses how museums can answer the important questions that source material about workhouses and their inhabitants does not. He

does so by recounting how the project *Hidden Danish Stories* at the Danish Welfare Museum opened up new narratives about social vulnerability in the past by engaging socially vulnerable people living in Denmark today. He underlines the mutual benefits that both the museum and the socially vulnerable derive from working together to co-create the hidden stories of the past, making them relevant today.

In Chapter 6, Stine Grønbæk Jensen draws on experiences from an exploratory project called *Memory Mondays* at the Danish Welfare Museum. She demonstrates how museums can contribute beyond merely informing the public on issues of social exclusion and injustice. Museums can be powerful spaces for the very individuals and groups who have been subjects of exclusion and injustice; a space where they can make sense of and deal with distressing memories. More specifically, she illustrates how memories, feelings, imagination and reflections were awakened at the museum and demonstrates how some participants managed to build a stronger sense of self, regain trust in their own memories and even create some images where memories were absent before.

Chapter 7 by the author Trisse Gejl argues that reading and writing fiction can significantly help mentally and physically ill people in recovery as well as traumatised people in recreating their own identity. But why and how? The author conducted writing workshops with (grown-up) orphans as part of a research project. She reflects on the potential, the challenges and the results working with this particular group. The workshops, as many participants are amateur writers, were partly based on models for conceptual writing and focused on aesthetic recognition opposed to therapeutic recognition.

In Chapter 8, Kathrin Pabst takes the reader through the working process with a documentary and exhibition project about poverty in southern Norway. She discusses the challenges museum employees can meet when working with taboo-related, sensitive issues, and how a museum can represent this to its visitors. Even if the result of the museum's work is a higher degree of awareness for the problems poverty can cause and a new role for the museum as advisor for communities who want to improve their actions towards the poor, Pabst concludes that museums still have a long way to go.

Hughes and Williams in Chapter 9 focus on Amgueddfa Cymru's active partnership with the learning disability charity Mencap Cymru on the *Hidden Now Heard* project in Wales, an oral history project that captured the untold and often painful living memories of patients, their relatives and staff from six former long-stay hospitals in Wales. The chapter explores the experiences of sharing authority, bringing together expertise and the ethical challenges faced by both organisations, and discusses how the project has become a blueprint for future active partnership working.

In Chapter 10, Manon S Parry, Corrie Tijsseling and Paul van Trigt discuss the potential of medical museums in taking up projects explicitly intended to improve health and well-being. Medical museums should be at the forefront of this work, as they hold special potential to address relevant topics, from illness, caregiving and disability, to gender, fertility and sexuality; from bodily difference to mental health. However, because their collections of historical objects and images usually represent the perspectives of medical practitioners and not the people they studied and treated, curators must work creatively to address the assumptions and silences their museums contain.

In Part III of the book, we turn attention to yet another aspect of being a useful museum: taking back history. The two chapters in this part of the book discuss practical as well as principled aspects of the rights of Care Leavers to reclaim their history and to confront

the 'official' histories in archives and museums. Even though both cases relate to Care Leavers, the critical discussions also have broader implications for the useful museum.

In Chapter 11, Jacob Knage Rasmussen opens the doors to the archives. He describes a model of supported release developed at the Danish Welfare Museum. The key element is the importance of acknowledging Care Leavers' own agency and supporting their right to challenge the professionals who wrote the case record. Using the case of the Care Leaver Peer, the chapter demonstrates how the model works on a practical level, and discusses the potential to create social change, to nuance our historical knowledge, and to minimise the negative impact of accessing case records.

In Chapter 12, Adele Chynoweth confronts the dilemmas and challenges facing museum workers in highlighting issues of social justice. She critically points out how the role of the curator and the activist might not be so easily combined. Based on her experience as a curator of a national museum exhibition concerning the institutionalisation of children in Australia, she argues that when it comes to the experiences of the marginalised and trauma survivors, simply representing narratives may not be enough. What happens when survivors who donated their narratives to the museum ask a curator for something in return? This chapter recounts and analyses how the author responded to a call for action. Chynoweth concludes that the quest for social justice, and the fight for access within our museums, may demand a re-examination of the conventional professional boundaries of the curator.

The chapters in this book do not propose any general model. They demonstrate that shared activism for social change requires an open mind-set, pragmatism, and a high degree of perseverance. It demands an ongoing process of courageous, collaborative, reflective practice; of trial and error based upon a commitment to open dialogue. It also, fundamentally, demands ongoing critical self-reflection. It does not adhere to detailed planning or work according to any single theoretical perspective, but it does ask museums to reconsider their practical ethics, and to continue to do so, openly and collaboratively, which, it proposes, is in itself at the heart of the process of social change. It will only work if museums and museum workers are willing to work collaboratively with others, to take risks together, to listen to each other, and to acknowledge mistakes. The book maintains that unblocking shared activism and social change requires a state of mind, rather than advocating for one size to fit all. One can say that this important book holds up a placard outside the museum's doors that demands change. It has written on it the simple adage: 'above all, be useful!'

INTRODUCTION

Neither helpful nor unhelpful – a clear way forward for the useful museum

Bernadette Lynch

You say you want to help me,
But you take my pride
My self-esteem
My morals and ethics
My love
My sadness.

Maybe you killed all my feelings
But I will live
heard and seen.
No longer fragmented and shared.

These words are by Richardt Aamand and this is his portrait (Figure 0.1). He had, for a long time in his early life, been in institutional care, after which he was, for many years, homeless. He was also, by all accounts, honest, smart, strong and funny. He died recently. This is dedicated to him, on behalf of all his friends at the Danish Welfare Museum.

This book discusses museums and their relationship with the marginalised – the vulnerable. It has been said that a society is best judged on how it treats its most vulnerable. In this sense, 'vulnerability', derived from the Latin word *vulnerare* (to be wounded), describes the potential to be harmed physically and/or psychologically.

While this book focuses on the dynamics of the museum's relationship with those currently deemed both socially vulnerable[1] and marginalised,[2] it holds within it lessons for museums and their relationship with people – *all* people – and how the museum can be *useful*. The notion of the 'useful museum' is therefore proposed here, as a tool for social change.

This book came out of a series of long and challenging conversations surrounding notions of 'helpful' and 'unhelpful' museum practice. Part I of this introductory chapter examines when, and under what circumstances, being 'helpful' has shown itself to be markedly 'unhelpful' in terms of the museum supporting people's self-empowerment. Part II of this chapter asks how this can be changed. The book signposts practices that we believe constitute

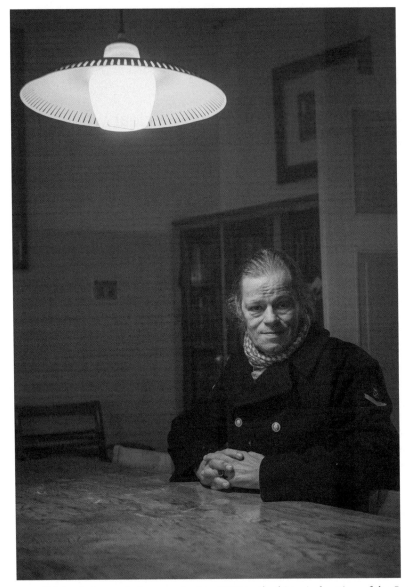

FIGURE 0.1 Richardt Aamand photographed in 2017 in the historical setting of the Svendborg poor- and workhouse.
Photo: Jon Bjarni Hjartarsson, the Danish Welfare Museum.

a socially useful museum. We have therefore looked to a re-examination of the ethics of *solidarity*, applying it in radically new and practical ways in our collaboration with marginalised people in museums.

The discussions outlined in this introductory essay, on *unhelpful* (Part I) versus *useful* (Part II) within museum practice, were further developed through the social history and justice research project *Welfare Stories on the Edge of Society*, led by the Danish Welfare Museum (Danmarks Forsorgsmuseum, no date) and the Centre for Welfare State Research at the University of

Southern Denmark, in close collaboration with public bodies, not-for-profit organisations and the socially marginalised.

While examining useful museum practice around the world, the book significantly takes inspiration from this one small museum, 'the last poorhouse in Denmark', the Danish Welfare Museum. This remarkable institution calls itself a 'socio-political museum', that rallies its energy for change by simply refusing to treat people as though they'd arrived at the door of the museum with a lack, a failing, a disability. They thus refuse to reinstate the museum's traditional hierarchical positioning, as helper or carer in relation to the marginalised.

This book is fundamentally about authenticity in human relations in museums, understanding our interdependence and putting this into practice through consciously acting in full collaboration and solidarity. This basic authenticity is the starting point and the ultimate aim for all of the contributions to this book.

The stories and museum practices described here are not only acts of recovery of self, but acts of defiance of a society and its institutions that fail to recognise – and properly listen to – others, in particular, those others perceived to be at society's edge, or margins. As we shall see, the museums in this book, through using a wide range of collaborative methodologies, including, importantly, co-produced research that is uncovering past injustices and examining them in relation to the present, show how the voices of the marginalised are gradually getting louder, demanding to be heard. And they are, at the same time, changing museum practice.

The central premise of this book is therefore that the role of the museum is not to be *helpful* – by 'doing for' or 'on behalf of', which turns out to be markedly *unhelpful*. Rather, it is to help create the circumstances by which people can help themselves, building their own 'capabilities' (Sen 2010). For welfare economist Amartya Sen, capability expresses a level of 'freedom to choose' whereby people have the freedom to reach their own conclusions, debate consequences, and make changes for themselves. Hence, the title of Sen's book *Development as Freedom* (Sen 1999).

The shift for museums advocated here is about promoting people's freedom to choose, fostering their resilience and capability – not 'aid', but self-help, self-empowerment, the empowerment of group solidarity and action towards bringing about change. This is the useful museum in action.

But exactly what type of empowerment do people need from museums? Welfare economist Martha Nussbaum notably coined the phrase that people need to be 'fitted for freedom'. She centrally noted freedom of thought and human dignity as capabilities to be developed in this regard, capabilities that this book maintains the useful museum must foster and support, in order

> to produce free citizens, citizens who are free not because of wealth or birth, but because they can call their minds their own. Male and female, slave-born and freeborn, rich and poor, they have looked into themselves and developed the ability to separate mere habit and convention from what they can defend by argument. They have ownership of their own thought and speech, and this imparts to them a dignity that is far beyond the outer dignity of class and rank.
>
> *(Nussbaum 1997: 293)*

The entire notion of 'welfare' is challenged here in terms of how our 'helpfulness' as a society, and in this case, society's cultural institutions, can be singularly unhelpful, too often serving

instead to undermine the well-being of the very people they claim to assist. The question must always be, as feminist/postcolonialist scholar Sara Ahmed puts it, does a focus on personal well-being do anything to encourage 'a heightened capacity to act' (Ahmed 2010: 246)?

The practices described in this book demand of museum institutions that they take a long hard look at notions of welfare, well-being, wellness in society and the subsequent centre/periphery positioning it implies from the world of the perceived 'well' – in other words, from that of the 'privileged' towards that of the 'marginalised' – and asks of those of us in museums, how helpful are we? Could we as institutions instead become more *useful* – and not only to those deemed most marginalised but to everyone?

We, the authors, therefore believe that the work here depicted is revolutionary for museums. It begins to establish useful museum practice. It reflects a shift in how we understand the museum's socio-ethical role. It demonstrates how we in museums might change our thinking to break through social and institutional barriers, and work in fellowship – in conscious, equitable and interdependent relations. In solidarity with people, like Richardt, to work together, to radically create social change.

The subject is human relations, the heart of museum public engagement, and its greatest challenge.

Part I: the unhelpful museum

Useful *versus* helpful *in the museum*

In its relations with people, the museum, while committed to reform, has at the same time inadvertently been in danger of undermining its social usefulness. This is primarily by confusing *helpfulness* with *usefulness*.

Richardt wrote 'You say you want to help me, / But you take my pride / My self-esteem'. One is reminded of something written by Edward Said, the great postcolonialist, who noted, while thinking about Flaubert's encounters with the Egyptian courtesan Kuchuk Hanem, that

> She never spoke of herself, she never represented her emotions, presence or history. He spoke for her and represented her …
>
> *(Said 1978: 14)*

In a museum context, Richardt's statement (and that of many others), concerning the condition of being unheard even while help is proffered, might be summarised as the museum supporting a politics of disabling kindness that undermines its recently adopted emancipatory mission (Lynch 2017a, 2017b).

Charity brings with it hierarchical positioning, and with that, the suppression of being able to speak out loud for oneself, to show emotion, to weep, and sometimes to shout, even in anger. This book is about being heard – about collaboratively conducting, as Antonio Gramsci put it, a quiet 'war of position' in resistance to cultural domination (Gramsci 1971: 168).

But too often the 'war' is over before it has really begun, with frustrated participants walking away, disillusioned with the museum. Recent debates have continued to question the effectiveness of participatory practice in museums, in particular, failure to overcome institutional power and control (Peers and Brown 2003; Crooke 2007; Lynch and Alberti 2010). Despite well-meaning intentions, participation has not always been the democratic process it purports to be; rather, it more frequently reflects the agendas of the institution where the processes,

such as the final right to edit content, are tightly controlled by the museum (Fouseki 2010; Lynch 2011a).

In spite of a genuine commitment (for many museums) to public participation, key aspects of the problematic effects of the museum's control in these relationships with participants have been identified. Following decades of government investment in public engagement in the UK's museums and galleries, this author's *Whose Cake Is It Anyway?* report found that public engagement continued to leave the public largely outside the walls of the institution. It found widespread evidence of false consensus and false promises and fundamentally, *empowerment-lite*. The main aspect of this failure has been the disabling effect of treating people as *beneficiaries* as opposed to *active agents*, thus continuing a notion of centre–periphery social improvement that permeated what was offered as democratic practice (Lynch 2011a).

Throughout its recent history therefore, much self-proclaiming museum participatory practice has inadvertently undermined the museum's relations with others. This dilemma could be summarised as an 'us and them', centre–periphery, beneficiary versus 'teacher/carer' or 'victim versus saviour' approach. These continued hierarchical relationships have often remained deeply patronising. Despite good intentions on the part of museum institutions and their committed workers, their participatory work with others has frequently been steeped in legacies of prejudice (Lynch and Alberti 2010).

What becomes clear is that simply expanding engagement in museums, even under the exemplary banner of democracy, social justice and human rights, calls for more than invitations to participate. This was made evident in the author's report (Lynch 2011a), which examined the underlying institutional values that inform the museum's public engagement and participation.

In the course of subsequent research, numerous instances could be cited that epitomise the pitfalls within genuine attempts at fostering a collaborative relationship with people in the museum, one that is ethical, democratic, participatory, reciprocal and allows for genuine challenge and debate. This research also demonstrated the damaging effects of a politics of 'kindness' in socio-cultural relations in the museum (Lynch and Alberti 2010; Lynch 2011a, 2011 b, 2011c, 2011d, 2019; Chambers *et al.* 2017). Obstacles to genuine partnerships were shown to be inadvertently created by the institution itself and were very often invisible to those very museum professionals most committed and most closely involved.

Thus, this book addresses the continuing problematic issue that the museum as institution unwittingly practises a theory of change based upon what may be called a 'therapeutic model' that places the recipient in the role of passive beneficiary. The disabling effects of tolerance and empathy have troubling undercurrents throughout this practice (Brown 2006).

Museums and their partners have found that it is not that easy to share authority and decision-making, and lessen the grip of institutional power and privilege, and participants begin to resent the position in which they are placed (Lynch 2011a, 2017a, 2017b). To borrow from the writer Reni Eddo-Lodge:

> It's clear that equality doesn't quite cut it. Asking for a sliver of disproportionate power is too polite a request. I don't want to be included. Instead, I want to question who created the standard in the first place.
>
> *(Eddo-Lodge 2017: 184)*

Yet committed museum staff continue to form partnerships, and through them, to consciously attempt to unlearn privilege (Spivak 1985; Lynch 2011b), by working critically back through

their beliefs, prejudices and assumptions, and understanding how they arose and became naturalised. And still, too often they have found themselves frustrated and disillusioned – and struggling to understand why the relationships so often break down. And so do their partners/participants (Lynch 2011a). The product (an exhibition or programme) may look good, but the relationship does not.

One recurring element of this breakdown of communication is the museum's discomfort with, and consequent avoidance of, conflict, while continuing to claim the museum as a neutral space, outside of political realities (Lynch 2017c). As writer and human rights activist Arundhati Roy writes, institutions' (in this case, museums')

> real contribution is that they defuse political anger and dole out as aid or benevolence what people ought to have by right. [They] alter the public psyche. They turn people into dependent victims and blunt political resistance … They have become the arbitrators, the interpreters, the facilitators.
>
> *(Roy 2014)*

Roy concludes:

> They are the secular missionaries of the modern world. Eventually [they] begin to dictate the agenda [and] turn confrontation into negotiation … [This] de-politicises resistance.
>
> *(Roy 2014)*

The museum can thus subtly deny people the opportunity, the right, to face up to conflict and the potential for debate, resistance and possible change. The institution does this, if we borrow from the writing of political theorist Chantal Mouffe, by ignoring 'passion and partisanship' (Mouffe 2005: 2), both of which, she points out, are central elements of democratic dialogue. As Mouffe reminds us, this is a dangerous strategy, actually at odds with democratic principles and practice.

One is repeatedly struck by how it is that museums continue to define the rules of engagement, avoiding conflict and the active agency of participants to express it, while claiming open 'negotiation' (Lynch and Alberti 2010; Lynch 2013, 2011a, 2011 b, c, d). The so-called 'shared space' of the museum remains deeply political, and yet ignores this fact, claiming for itself an illusion of neutrality and benign tolerance of all. To borrow from political theorist Wendy Brown:

> Simply cultivating tolerance as a political end implicitly constitutes a rejection of politics as a domain in which conflict can be productively articulated and addressed, a domain in which citizens can be transformed by their participation.
>
> *(Brown 2006: 89)*

While the task for museums is clearly to reclaim the political, the question remains: how to answer Richardt's individual plea, to help someone without undoing their pride and self-esteem? How might the museum do precisely the opposite? That is what this book hopes to demonstrate.

To understand the pitfalls for the museum in its relations with others, it is necessary to review how these relations developed over recent decades. What were the key influencers, and knowing what we now know, how might we best understand what we might do about it?

The rocky road to equitable relations in the museum

In terms of its relations with diverse peoples, the museum has been on a perilous path. Museums are fundamentally an exercise in ethics – in recent years, those have been the ethics of attempting to establish equitable and inclusive relations from a position of privilege with others across enormous divides of coloniality, race, class, education and economics.

From the nineteenth century, as Bennett points out, the founding philosophy of the politics of people's improvement has continued to have vestiges of what was essentially a Christian message of 'progress' and 'betterment' (Bennett 1995:192). The notion of 'progress' lay at the heart of much of the reformist zeal for the early promotion of the museum as a public learning institution.

Thus, the link between nineteenth-century Christian liberalist and later Christian socialist ideology which promoted museums as agents of social improvement has its roots deep inside the history and 'evolution' of social democratic thought.

This history has permeated the museum's relations with others to this day. Many of those who arrive at the museum's doors are still treated as though they are fundamentally 'lacking'. Ideas of social improvement and development, of an idealised society made up of idealised citizens, was continued.

Yet, in recent years many museums have courageously taken up the challenge to improve on this legacy of what amounted to social engineering, instrumentalism and prejudice that still permeated social relations in museums. Many of us, who are museum professionals, (initially inspired by educational reforms) worked with great commitment inside museum institutions and in partnership with others to make this change. We diligently attempted to overcome institutional obstructions to people's empowerment in museums, barriers we found hard-set within the bricks and mortar of our nineteenth-century institutions. This work has not been easy, nor has it always been successful.

This book is about how, through a radical shift in our relationship with others, and in particular, learning from those most marginalised, we might collectively take ownership of the museum and begin to overcome these barriers. But first we need to understand the subtleties of how, even with the best of intentions, the inequities in the museum's relations with others are inadvertently perpetuated.

Museums have been affected by major changes over the past decades, beginning in the 1970s with, as it was then called, 'the new museology'. Of particular note were two articles published in 1968 by Canadian museologist Duncan Cameron in *Curator*. Firstly, in 'Viewpoint: The museum as a communication system' (Cameron 1968), Cameron invited the reader to think of museums not as a collection of objects but as a place aiming to diffuse knowledge, thereby bringing about a shift in focus towards museum publics; secondly, in 'The museum, a temple or a forum' Cameron (1971) called for the museum to open itself to society and become a place of debate between citizens (cited by Brown and Mairesse 2018).

Some others date the new museology to British art historian Peter Vergo's ground-breaking publication of *The New Museology* (Vergo 1989), or the Smithsonian Institution's Stephen Weil's *Rethinking the Museum* (Weil 1990).

There was therefore a move away from a singular focus on collections research towards a focus on relations with people, and in particular, on the educational role of the museum (Hooper-Greenhill 1994, 2007). Museum education developed in tune with the emerging pedagogy mainly proposed for museums by the social scientist and key influencer in museum

education, George Hein. This was based on the notion that humans actively construct know-ledge and meaning from their own experiences (Hein 1998). A major influence at the time (and arguably ever since) was educator and philosopher Paulo Freire's critical pedagogy, which attempts to help students to question and challenge domination, and to undermine the beliefs and practices that dominate.

Freire argued that 'education is freedom', contending that traditional teaching styles keep the poor powerless by treating them as passive, silent recipients of knowledge. Critical peda-gogy drew upon radical democracy, anarchism, feminism and other movements that strive for social justice. Freire believed that the key democratic task was in helping people to identify and challenge the sources of their oppression. His work takes into account the social and pol-itical nature of the processes by which people learn. For their part, learners move from being passive social beings to active, critical and thinking social beings of the society in which they are involved. The learner thus becomes a co-creator of knowledge (Freire 1972).

As a development of Freire's work, the 'radical pedagogy' of cultural critic and scholar of critical pedagogy, Henry Giroux, and others, involved an analysis of the deeply politicised aspects of educational institutions, policies and practices (including museums), and went fur-ther, proposing that education can and must be oriented towards radical social change (Shor 1992; Giroux 1997, 2011; McLaren, Macrine and Hill 2010). Another profound impact on museum studies and on the museum profession, was museum anthropologist James Clifford's emphasis on the museum as 'contact zone', using museum collections to generate a dialogical bridge across ethnic and socio-cultural differences (Clifford 1997).[3]

The fight worldwide for indigenous rights had already become deeply influential in terms of rights-based museums practice (Phillips 2006; Shelton 2006). With it came increasing demands for a greater say in what happens to material in museums that was created by indi-genous people and their ancestors (Peers and Brown 2003; ICOM 2018). Besides the peda-gogical turn, the participatory turn in museums that dates from the 1970s was thus very much influenced by shared curatorship, and use of collections with indigenous stakeholders in arch-aeological and anthropological museums. There have been a large number of programmes that aimed to empower these, as they were then called, 'source' communities. Ruth Phillips, influ-ential Canadian art historian and curator, advocated for the museum, which she considered had long been a tool of colonial and imperialist ideology, to become a broker and mediator of renegotiated postcolonial relationships – the museum as sponsor of changing government attitudes towards indigenous peoples (Phillips 2011).

Anthropologist Anita Herle noted of this development:

> Museums are [no longer] simply about objects; rather, they prompt scholarship on com-plex relations among people and things. Innovative museum-based projects, exhibitions, and activities have become more inclusive and receptive, attracting increasing numbers of visitors and targeting diverse audiences. [Museums work] … to develop new collab-orative paradigms which acknowledge the special needs and interests of marginalized groups.
>
> *(Herle 2016)*

Yet, despite this significant shift towards inclusivity and 'voice', others found that there was no real, substantive shift in the museum's approach to the other. As anthropologist Robin Boast remarked, 'No matter how much museum studies have argued for a pluralistic

approach to interpretation and presentation, the intellectual control has largely remained in the hands of the museum' (Boast 2011: 58). Boast felt that the key problem was to be found in

> assumptions and practices that constitute … the new museum, the museum as contact zone [that] continue to be used instrumentally as a means of masking far more fundamental asymmetries, appropriations, and biases … Museums of the 21st century must confront this deeper neocolonial legacy … To do this, however, requires the museum to learn to let go … for the benefit and use of communities and agendas far beyond its knowledge and control.
>
> *(Boast 2011: 67)*

Boast's main area of interest was ethnographic collections, but museum education, long seen as the vanguard of progressively inclusive museology, also had trouble letting go of the hold on museum interpretation.

Reformed museum education had taken much of its inspiration from 'critical pedagogy', inspired by the progressive education theories of the 1970s, most notably Freire (1972).[4] However, when applied to museums, 'critical pedagogy' was frequently misunderstood and misapplied in terms of the entirety of its democratic, 'activist' message. What appeared to be lost to memory within critical pedagogical practice in museums is that it was never only a theory and a philosophy of education but was also a '*praxis-oriented social movement*' (emphasis added) (Shor 1992: 129).

Thus, much participatory practice with local and originating communities, often led by museum education departments, began to be criticised as essentially flawed, leaving out, as it too often has, the 'critical', and the 'political', as well as any form of collaborative activism for social justice and change (Lynch 2019). The participatory practices promoted by museum education and public programming departments too often provided an illusion of participation. In reality, consensual decisions tended to be coerced, or rushed through on the basis of the institution's control of knowledge production and its dissemination, or on the basis of the museum's institutional agenda and strategic plan, thereby manipulating a group consensus on what was inevitable, usual or expected (Lynch 2011c, 2010; Marstine 2011; Sandell 2011, 2003, 2002; Graham *et al.* 2013).

Social anthropologist Andrea Cornwall reminds us that simply having a seat at the table is a necessary but not sufficient condition for exercising one's voice (Cornwall 2008). This was precisely what Richardt memorably spoke about in his moving words quoted at the beginning of this essay.

The thrust of the new museology had been towards democratising museum public access and relations. Flawed though it may have been, this shift in museums was subsequently further undermined by the rise of neoliberal public policy. Critics such as anthropologist and geographer David Harvey (2005) see the neoliberal impact on public educational institutions (museums, libraries, universities) as the reduction or even resignation of their former roles as crucial players in the public sphere, driven by pressure to adopt a more instrumental, commercial and practical role.

The museum's public engagement policies suddenly found they were required to meet market agendas, immediately at odds with democratic practices. Wendy Brown, in her book *Undoing the Demos: Neoliberalism's Stealth Revolution* (2015), writes of the political consequences of viewing the world as an enormous marketplace. Brown notes that everything is 'economised'

with human beings becoming little else but market actors. She claims that now every field of activity is seen as a market, and every entity (whether public or private, whether person, business or state) is governed as a firm. Neoliberalism construes even non-wealth-generating areas, such as learning, in market terms, submits them to market metrics, and governs them with market techniques and practices (Brown 2003).

The museum too, in its relations with others, became swept up in marketisation, which had a profound effect upon its social impact and relations. In his influential book, *Museums in a Troubled World: Renewal, Irrelevance or Collapse*, Robert R. Janes argued that:

> the majority of museums, as social institutions, have largely eschewed, on both moral and practical grounds, a broader commitment to the world in which they operate. Instead, they have allowed themselves to be held increasingly captive by the economic imperatives of the marketplace and their own internally-driven agendas.
>
> *(Janes 2007: 13)*

Neoliberalism brought its own language to the cultural sector, placing people within its market categories and targets. As cultural critic Stephen Pritchard puts it:

> Outcomes, outputs, delivery, sustainability streams, partnerships, skills sharing, social capital, targets, wellbeing, co-production, collaboration, cultural value, citizenship, civic pride, austerity, hard-to-reach, inclusion, NEETs, BMEs, participation, on and on and on … This is the language of neoliberalism. The language of neoliberal economics. The language of capitalism. The language of money.
>
> *(Pritchard 2017)*

Competition for resources became increasingly tense between museum exhibition and education departments. The marketing of both became paramount in order to secure support, thereby further suppressing critical democratic engagement. Many glossy reports were (and continue to be) produced that demonstrate the multiculturalism of museum visitors and participants, increasingly targeting, for instance, migrant communities. As American congresswoman Rashida Tlaib usefully puts it:

> They put us in photos when they want to show [they are] diverse. However, when we ask to be at the table, or speak up about issues that impact who we are, what we fight for … we are ignored. To truly honour our diversity is to never silence us.
>
> *(Tlaib 2019)*

Meanwhile, with all these divergent pressures upon social relations in the museum already in play, then came along the 2008 economic crash. There was a swift reduction in public funding.

Retrenchment followed in many museums with closures or cuts to already marginalised museum education and public engagement departments. This lack of capital for new or continuing projects brought a sharp halt to an intense period in museum building and public programming expansion worldwide that had begun over the previous decade. This created an opportunity for some museums to get 'back to basics', to focus on their collections. Staff layoffs became endemic, particularly in the so-called 'public' areas of museum practice. As the American Alliance of Museums (2019) until recently pragmatically advised, 'Downsizing

and retrenchment can be responsible and necessary corrective actions in response to financial reductions.'

The pressure to adapt to the fast-changing economic situation has meant that museums have had a struggle on their hands to clarify what were – and remain – 'core' priorities for the museum, and with that, identifying the museum's guiding values and ethics. The last in (museum education and public engagement staff) were frequently the first out, as the cuts began to bite the institutions. This clearly demonstrated that despite the decades of commitment to public engagement, it had largely stayed on the periphery of museum 'core' activities.

Others however were unwilling to let go of the gains made in democratising museum practice.[5] The UK's Museums Association (2013) responded very strongly, in particular, with the publication of *Museums Change Lives*, and more recently, *Power to the People* (2018). In addition, in the UK, the Paul Hamlyn Foundation, following on its support of the *Whose Cake Is It Anyway?* report, and its subsequent recommendations, launched the influential five-year, large-scale *Our Museum* project in UK museums, which has very useful resources for effective public engagement on its website (Paul Hamlyn Foundation). The *Our Museum* project was designed as a means to help museums face up to their core values and overcome their institutional obstacles in relation to their public involvement (Lynch 2014c).

Meanwhile, the language of rights and social justice, particularly for the marginalised, has become a rallying-cry for progressive (anti-neoliberal) museum practice in the twenty-first century (Sandell and Nightingale 2012), and with it the emphasis on active agency – on *activism*. As Robert R. Janes and Richard Sandell (2019) emphasise in the introduction to their important book, *Museum Activism*, activist museum practice explicitly challenges the immorality of inaction. It enables museum workers to be citizens and to assume agency, as well as responsibility for the consequences of their action or inaction.

Humanitarian kindness versus people's rights in the museum

> Realism demands that one must contemplate the facts of our current global realities with a little more than a horrified humanitarianism.
>
> *(Thompson 1938, cited by Stonebridge 2017a)*

Increasingly, museums that are committed to public participation and social justice and unwilling to simply adopt the dictates of the marketplace, are explicitly adopting a moral, human rights stand. These museums are assuming an active role in leading the fight for social and climate justice (Sandell 2016). In 2009 INTERCOM (ICOM's International Committee for Museum Management) in its 'Declaration of Museum Responsibility to Promote Human Rights' adopted the following statement of purpose:

> INTERCOM believes that it is a fundamental responsibility of museums, wherever possible, to be active in promoting diversity and human rights, respect and equality for people of all origins, beliefs and background.
>
> *(INTERCOM 2009)*

A number of activist, rights-based museum network organisations have been established: Social Justice Alliance for Museums, Federation of Human Rights Museums, and the Coalition for Museums and Climate Justice.

In 2010 museologist and museum director David Fleming delivered the Stephen Weil Memorial Lecture at the INTERCOM conference in Shanghai, entitled *Museums Campaigning for Social Justice*, highlighting the ground-breaking local and international social justice work of National Museums Liverpool, where he was director (Fleming 2010).

It is without question a breakthrough to hear the museum's voice speaking out on human and environmental rights activism, the museum taking a stand and raising awareness of human rights and injustice on behalf of the marginalised, the oppressed, worldwide and locally. This in turn is generating a growing body of literature on exhibitions tackling difficult (human and environmental rights and social justice) subject matter (Mazda 2004; Sandell 2006, 2011; Bonnell and Simon 2007; Teslow 2007; Logan and Reeves 2008; Macdonald 2008; Marstine 2011).

Is this the answer to public engagement? This book still asks, what has become of the voice of the marginalised?

If we borrow from reflections on rights-based practice in an international development context, claims for a rights-based approach in museums must enable those whose lives are affected the most (by oppression or injustice) to articulate their priorities and to make change happen. It is important here to note that it is not only about the museum raising its voice about rights (important as that undoubtedly is), but the museum empowering people to know, claim and activate their own rights. On the one hand, it certainly means increasing the ability and accountability of individuals and institutions who are responsible for respecting, protecting and fulfilling rights. But it is also about clearly articulating those rights and putting them into practice, *by giving people the opportunity to exercise their rights* (emphasis added) (Nyamu-Musembi and Cornwall 2004).

The point is, where does the museum's voice raised in protest leave people's own activist voice – their voice raised in protest and resistance in the museum? Where is Richardt's voice? As this author pointed out in the *Museum Activism* publication, the museum asserting its rights to speak out on issues is not the same thing as facilitating others' voices of activist protest, and is therefore not necessarily useful in this regard:

> For the museum to simply assume the activist role on behalf of people is to potentially, inadvertently, deprive people of the chance to make change happen …The so-called 'activist museum' is not the same as a commitment to activism embedded within a rights-based practice that facilitates people's right to express themselves and act towards social change – and therefore hope.
>
> *(Lynch 2019: 123–124)*

The point here is not that the museum's role in generating awareness of social and environmental injustice and human rights abuses is not important. It is that the museum cannot, as the same time, lose sight of the critical importance of people's own active agency – something that is so easily, and inadvertently undone by the institution.

The unhelpfulness of a therapeutic model for museums

Back in 1938, the campaigning American journalist Dorothy Thompson, writing on the film *Sands of Sorrow, and the Arabs of Palestine*, noted the possibility of adopting instead a type of 'contract' with the Palestinian refugees with whom she was concerned (Thompson 1938).

Taking this up, photographer and theorist Ariella Azoulay, writing on humanitarian photography, states: 'I employ the term "contract" in order to shed terms such as 'empathy', 'shame', 'pity', or 'compassion' as organizers of this gaze (Azoulay 2008).

Both Thompson's and Azoulay's point is that is the humanitarian gaze is all too frequently one-directional, blind to the fact that it is the contracts of citizenship, legal and political recognition, that determine how we live together, as well as our feelings.

The trouble with an emphasis on humanitarian 'kindness' and the promotion of the 'well-being' and 'happiness' of others, as opposed to actually applying 'rights' in museums, is that not only are they unhelpful in terms of capability and self-determination, but they actually conceal more than they reveal. Within the glossy highlighting of injustices and atrocities, to borrow again from Sara Ahmed, they, 'conceal the ongoing realities of discrimination, non-recognition and violence' (Ahmed 2010: 9).

Rather than making these injustices more immediate, there is the very real danger that museums making a statement on injustices helps to make them further removed, while at the same time, avoiding the realities of injustices closer to home. And it is closer to home that is the problem!

Humanitarian pity is never enough – in fact it is unhelpful. The question is, are we in museums continuing to be unwittingly unhelpful – even while announcing our social justice, humanitarian and human rights commitments as museums? Are we undoing democratic practice through a continuation of the museum's therapeutic model?

Manon Parry writes critically in this publication of the fast-growing 'well-being' agenda in the cultural sector, which she says is making attempts to replace cuts in social services. In her chapter, Parry quotes Silverman (this with specific emphasis on museums and disability) on the notion of the 'therapeutic museum' and how this vision of the museum often relies heavily on the same notions of inclusion and access that have governed social scientific approaches to disability, and which critical disability studies scholars argue are inadequate to address the complex issues of discrimination, stigma, exclusion and isolation that they are designed to tackle. She argues that 'a more participatory and transformative, disability-led, methodology could address these problems'. Her contribution tunnels further down into the notion of unhelpfulness in museums that this book is challenging. In her chapter, 'Slow, uncomfortable and badly paid', she examines the instrumentalisation of some museum health and well-being projects, and appears to be suggesting that they may be 'unhelpful or even unhealthy'.

It is important to remind ourselves that museums must be ever-vigilant not to slip back into a carer–client relationship, adopting a therapeutic museum model. In contrast, as Stine Grønbæk Jensen shows in her chapter, 'the *absence* of a therapeutic frame and lingo can be exactly what makes the museum potentially healing'.

The emphasis in some museums on a consensual, empathetic approach may be in fact more to do with the museum's (and museum professionals') discomfort with people openly expressing emotion, anger and widely differing points of view. Acknowledging anger, frustration, unhappiness with complex social problems in the immediate surroundings of many museums, may mean, as Ahmed succinctly puts it, 'resisting happiness' rather than closing down debate through a subtly coerced consensuality. This, as Ahmed puts it, 'opens up other ways of being' that are not constrained by preconceived visions of happiness and the peaceful life from museums or other social agencies (Ahmed 2010: 16).

In some recent museum practice, the marginalised are encouraged to speak out about their anxieties as personal symptoms, but with an increased focus on mental health. Those most marginalised may thus be in danger of finding themselves even more unhelpfully stereotyped,

categorised and more powerless, while the museum may be reinforcing further categories of marginalisation. In his 'critique of humanitarian reason', anthropologist Didier Fassin sees this danger as potentially a process of repackaging misery – the homeless, immigrants, child poverty – as the perpetually 'vulnerable'. In the same way, museums increasingly refer to working with the 'vulnerable', as in 'targeting vulnerable communities'. Fassin sees in this the growth of a secular religion of redemption and symbolic reparation (Fassin 2010).[6]

The question remains, is it possible for museums to be effective if their efforts are merely to focus on being sorry for the poor, disaffected, marginalised? As political scientist Ayten Gundogdu and others have noted, failed efforts to address, for example, the refugee crises of the twenty-first century have been largely the result of the conspicuous rise of a 'compassionate humanitarianism centred on suffering bodies' (Gundogdu 2015: 16).

For Fassin, humanitarian kindness becomes a way of making the intolerable somewhat bearable (Fassin 2010) – but for the institution! So, who actually benefits from this approach? The museum may feel it is helping by merely acknowledging the 'vulnerable', but that is not the same as allowing them a voice – a voice that may even be raised in anger towards the museum. Kathrin Pabst in her essay within this book writes about an exhibition in Norway, for example, based on poverty and people's perceptions as social stigma: 'poverty also comprises feelings of guilt and shame while simultaneously feeling invisible. Feeling ashamed often leads to individuals retreating from others, leading to increased isolation.' We must ask if, rather than encouraging agency among those thus marginalised, we in museums are inadvertently contributing to this feeling of shame or blame through simply extricating sorrowful stories from them? The Vest-Agder Museum's exhibition *Not All Good? On Being Poor in Southern Norway* is an example of a museum on a journey, that is wrestling with these dilemmas.

In a recent interview, Lyndsey Stonebridge, scholar in humanities and human rights, while talking about humanitarianism towards, in this case, refugees, critiques humanitarian pity and says she wants to

> revive a Kantian tradition which is actually imagining the other not with empathy or with pity but with the hard work of imagining another life. That is always going to be more uncomfortable than pitying someone who is obviously not as powerful as you ... It should be uncomfortable.
>
> *(Stonebridge 2017a)*

'Victimisation' as identity need not be the inevitable conclusion of museums working with the marginalised – the museum presuming people's helpless grief as their inherent condition. Crude oversimplifications of the experience of those marginalised can lead to easy stereotyping by the museum, further denying the individual's right to self-expression and resistance.

We might more usefully, as this book is attempting to do, practise a politics of solidarity and active, collaborative change. It can reasonably be argued that we have no time for anything less, as the forces of prejudice and division rapidly gather and grow all around us in this 'troubled world', as Janes (2007) puts it, conspiring to silence and divide.

Part II: the useful museum

The categorisation of people into the 'vulnerable', the 'marginalised', which has its uses as part of a process of active socio-political agency and change, must give way, as people move

beyond their labels. As will be seen here, those who began engaging with these museums as the 'marginalised' are now collaborators, researchers, experts, co-creators, advisors, critical friends, trainers, campaigners and political change agents.

Practising a philosophy of **interdependence** *in the museum*

This book is about shifting the unhelpful and undermining relationship with others in the museum. To achieve this, we must shift how we think in museums about that relationship.

But how can we achieve this in the museum? Must it always be inevitable that a marginalised person's identity and self-respect (as Richardt's words suggest at the beginning of this essay) are dismantled by the hierarchical relationship offered by the museum, based, as it too often is, on the dispensing of kindness and charity?

Could these relationships work differently? Could they be based instead on a profound sense of *interdependence*? Is it therefore possible that truly collaborative relations in the museum might begin to dismantle the very barriers that the museum's and the state's institutional power have erected to distance and protect themselves – from people?

French philosopher Emmanuel Levinas (1991) wrote, 'I am to the other what the other is to me.' A world away, American civil rights activist Martin Luther King wrote in a letter from Birmingham Jail, Alabama:

> I am cognisant of the interrelatedness of all communities … Injustice anywhere is a threat to justice everywhere … We are caught in an inescapable network of mutuality, tied in a single garment of destiny. Whatever affects one directly, affects all indirectly.
>
> *(King 1963)*

Levinas and Martin Luther King evidently share a deep understanding of mutual dependence across socio-cultural divides, the need to work closely in proximity with an Other, and, in King's case, to help each other to become activated and to agitate, together, for change. They are neither of them speaking about *kindness* or *charity* towards an 'other', but, rather, recognising the self in an Other. This is the answer to the 'why?' of the commitment to relational dynamics in the museum.

Levinas claimed that as relational beings, humans can only successfully learn about themselves through close engagement with another. Translated into museum practice as a reciprocal process, museum staff and their collaborators (as described in this book), despite very different backgrounds and experiences, could attempt to develop understanding and respectful relationship through working together in 'proximity' (another Levinas theme). They may thus become increasingly aware that they are each ultimately dependent upon and responsible for each other (Levinas 1991).

Those of us in museums fully committed to public engagement and participation practice, whether we knew it or not, for the past few decades have been attempting to put into practice this notion of reciprocity, through proximity with an ever-expanding diversity of others. To a limited extent, it has worked – but it left out some key elements that Martin Luther King would never have ignored.

Putting the useful museum into practice

So where does this difficult ethical journey towards realising our *interdependence* with others in museums leave us today? We must have proximity and reciprocity, but not through enforced

consensus, and it must allow for free expression and conflict, and thus, agency, activism and the *political*. Are we there yet?

The following are four key strategies proposed here that form the basis for the useful museum in its relations with others:

1. Looking back/going forward: collaborative reflective practice

Too often, museums continue to be non-reflective institutions that exercise a paternalism that undermines people's self-empowerment. The only way up and out of this rabbit-hole is through a commitment to collaborative, reflective practice (Lynch 2011b).

It becomes abundantly apparent that 'reflective practice' is not some add-on or afterthought under the heading of 'evaluation' but is instead absolutely central to breaking through towards ethical and effective relations between museums and people. The central role of reflective organisational practice is through collaborative reflection with stakeholders as 'critical friends'. This is a theme running throughout the chapters in this publication. As Knage Rasmussen notes in his chapter, at the Danish Welfare Museum, 'debriefing is essential … not only for the sake of Care Leavers, but [for us] as well'.[7]

Of course, it cannot be stressed enough that this is not reflective practice by professionals on their own. All that has been learned points to the fact that people – participants, the marginalised – are central to the reflective process and institutions cannot change themselves without the input and intervention of these as 'critical friends' (Lynch 2011b, 2014c).

Sometimes, it may mean collectively asking fundamental questions such as if we, as an institution, are yet fit for purpose? Do we have the right people? As Adele Patrick of Glasgow Women's Library, for example, points out in her chapter, at the Women's Library they collectively choose and hire activists before collections professionals. She says the Library is a value-led resource where staff are specialised first and foremost in equalities.

The questions asked throughout these chapters, of one's own practice, and that of one's institution, provide excellent examples of all involved struggling with tough-minded reflective practice. Questions such as those raised by the UK's Museum of Homelessness, who, with their collaborators, challenge the subtle ways museums can overemphasise well-being and thereby cover up society's ills. They collectively ask, 'is ill-being never justified?' Surely realising one's power to resist is at the heart of democracy, for, as Davies notes, 'human ill-being is never merely an absence of pleasure … it is a basis for resistance and critique' (Davies 2011).

Truly collaborative reflective practice can avoid museums falling into old habits and old relationships, through robustly challenging notions of a therapeutic frame – the carer/cared-for – and being ever reminded of this by the museum's critical friends. For a museum to move from a focus on passive beneficiaries, objects of pity, therapeutic clients, towards supporting self-organising, active agents, requires the museum developing and maintaining a regular, mindful, reflective practice with all concerned. Such an evidently useful stance requires vigilance, reflexivity and a strong and committed mission.

This is how we shift the seemingly embedded hierarchical, patronising and disempowering relationship between people and museums. This is how we develop an acute consciousness of the complex power dynamics within these relations, and liberate all involved to develop their potential to become active agents and co-contributors.

This is a big commitment for museums. So, why should we be so committed to these relationships? Even more importantly, what is our ethical imperative for doing so? Who is the 'other' to me in the museum?

2. Agency and activism

Not only reciprocity, but the marginalised person's own agency to express his or her voice is central to the shift in relational dynamics in the museum.

In addition, as will be seen in this book, the opportunity for self-organised group support (not always including museum staff) provides an opening for self-expression to emerge. One of the most interesting and powerful elements throughout the rights-based, activist practice in museums, as demonstrated in these chapters, is just how important it is for those most marginalised to gain strength from each other – sometimes through naturally forming a support group. Glasgow Women's Museum sees this as involving all elements of 'peer education, lifelong learning and political literacy in action'. One participant at the Danish Welfare Museum, Eli, is quoted in Jeppe Wichmann Rasmussen's chapter, as saying: 'I rediscovered parts of myself and who I am that had been hidden or forgotten.'

Jensen adds, 'the conversation between the participants is highly significant… one participant commented, "how important it is that we have each other"'.

Helping support the marginalised group's self-organisation and development takes on a central role in activist museum practice. And like Glasgow Women's Library, this group, this 'community of purpose', must have decision-making powers. Both the Glasgow Women's Library and the Museum of Homelessness are committed to devolved decision-making in practice.

What follows when the group, facilitated by the museum, self-organises will be unpredictable and beyond the museum's control. It may generate anger. Jess and Matt Turtle of the Museum of Homelessness are similarly concerned with the importance of accepting that the process may involve the discomfort of sharing a degree of conflict.

It may also include the demand for change, hence people's *activism* (as distinct from the museum's activism), and this too must be supported by the museum. As Eddo-Lodge puts it:

> If you are disgusted by what you see, and if you feel the fire coursing through your veins, then it's up to you. You don't have to be the leader of a global movement or a household name. It can be as small scale as chipping away at the warped power relations in your workplace. It can be passing on knowledge and skills to those who wouldn't access them otherwise. It can be creative. It can be informal. It can be your job. It doesn't matter what it is, as long as you're doing something.
>
> *(Eddo-Lodge 2017: 223–224)*

As will be seen in this book, this is precisely what is happening in many of the examples described, where people are helping each other to *do something*. Sometimes even public policy and changes to public (social) services have been impacted by this form of people-led activism.

It is urgent, if it is not already too late, for people to find this type of agency to combat the very real threats (political, economic, environmental) that have emerged globally in recent years. Museums have little choice but to respond – but now such mobilisation in museums

must mean the museum helping marginalised people to take the lead. As political philosopher Robin Celikates puts it:

> To act as citizens, in many cases (most evidently, in the case of undocumented migrants and refugees) without being recognized as citizens by the state. In these ways they are reclaiming the political capacities of citizens that the state (or some other actor that acts in a state-like fashion) denies them or grants them only partially.
>
> *(Celikates 2016: 14).*

This book aims to promote those rights, while helping to identify the principles for an effective, ethical, collaborative, activist practice which the museum practices represented in this book are attempting to evolve. This is what makes the book exciting and very, very relevant to our turbulent times – times in which democracy itself is at serious risk, and in which museums, with their collaborators, must take a stand for democracy. As Wendy Brown argues:

> The promise of democracy depends upon concrete institutions and practices, but also on an understanding of democracy as the specifically political reach by the people to hold and direct powers that otherwise dominate us … [W]here there are only individual capitals and marketplaces, the demos, the people, do not exist.
>
> *(Brown 2015b)*

For museums to be useful they need to form the vanguard of a new and radical democratic practice, breaking free of their economic and political constraints. It is about practising radical trust *both ways*, in which we are *all* learners and *all* active agents in making change happen – within the institution and beyond. It is thus about practising *solidarity*. As Jess and Matt Turtle argue here, 'Building trust means valuing people's experience and contributions, not as participants or "vulnerable groups" but as members of a community of purpose.' For them, this means, 'bringing elements of community organising, political campaigning, theatre making and material culture to its development'.

There are models of this evolving practice in other areas of civil society, which museums might well adopt (and some already are doing so). The Skills Network in the UK, for example, emphasises the importance of acting like equals, noting that all of us are both teachers and learners. They have identified a set of key partnership skills that are usefully applicable to museums (Skills Network, no date).

The innovative, value-led, activist institutions that can be seen throughout this volume have begun to change the relationships with their collaborators by simply upturning the power relationships, the decision-making authority, the active agency. To do this, they take *interdependence* as their starting point.

3. Building capability

Jensen, in her contribution to the book, writes movingly of working in collaboration with Care Leavers at Denmark's Welfare Museum who move, as she puts it, 'from shame to anger, and from self-blame to critic'. Jess and Matt Turtle note in their chapter, 'Given the opportunity people will rewrite the script.'

The Danish Welfare Museum has established a *Panel of Experience*, made up of their collaborators, that is pushing the museum further through, as Smed calls it, 'appropriate disturbance', challenging practice and reaching for more and more social relevance.

The Museum has also established an internship programme for their collaborators which is ground-breaking in building capability for those vulnerable people involved. As Smed puts it in her chapter:

> The interns use the Museum as a platform to facilitate change and insight for both professionals and the public. As we are engaging with more interns in depth, integrating the result into the operation of the museum itself, a far fairer degree of representation is evident to Museum visitors.

The Museum sees the interns as 'eye witnesses' to contemporary welfare by:

> refusing to 'cover up' maltreatment of themselves or others by the system … The interns are bridging social capital in the context of the museum and society. Their very presence, the ways in which they solve tasks, the important questions they raise, the way that they are keeping the museum relevant and the insight they generously share have become an embedded part of what the Museum is and not just how it operates.

The interns have also recognised new possibilities for co-developing training courses for social work students. The courses use the museum (a former poorhouse) to comprehend the complexity, as Smed explains, of

> pre-welfare-state social work, to debate ethical issues in social work, address contemporary issues anchored in a historical consciousness and engage in and qualify debates about the welfare state in a 'trinity' consisting of engaged students, the interns with personal insight and curators with historical knowledge.

Thus, those previously most excluded are invited not just to tell their stories, but to help make them relevant for others. This growing movement, which in other museum settings has begun to work, for example, with refugees, is one which could easily be imagined for other museums, taking up the baton. In this way, the museum broadens and deepens its societal impact, powerfully led by the marginalised themselves who consistently develop capabilities, including (as in the Danish Welfare Museum) contributions to public debates and the training of social workers and teachers.

Much of the collaborative work with vulnerable people described in this book extends into – and overlaps with – current progressive thinking in health and social care. The Danish Welfare Museum, for example, has extended its impact very effectively into social work policy and the training of social workers. But most of the practices outlined in this book are fundamentally prescribing a self-help, unmedical model of health and social care.

This is why activism matters more than ever in the museum – not performative, but real, operational, collaborative, change-making activism, to support the building of capability and dignity among those marginalised, collectively learning from past struggles and above all, combating together for change.

4. Co-researching

There is a key element of people's activist practice in museums that links a number of chapters in this book, one that simply overturns the passive victimisation that undermines people's empowerment in museums. It centres around the question of who it is who researches and tells the story. It asks who should have the right to relay the stories of the poor and socially vulnerable men and women of the past, the men and women who lived parts of their lives, for instance, in state-run institutions? It also asks who should tell the stories of marginalised people now. It answers by opening up the possibility of marginalised people actively researching and making their own connections between social injustices of the past and the present. Knowledge is power.

 This is useful, activist museum practice in action. Wichmann Rasmussen notes in his essay here that stories of the Danish workhouse inhabitants, (the Care Leavers) were traditionally told by others:

> The people in charge of the workhouse, people in power, had produced every single bit of source material, and the views of the clients are almost non-existent. [But] the material [from the past] does not tell us much about how it felt. What was it like to live in such a place, to lose your freedom and your fundamental rights? How did it feel to live on the street, to be an alcoholic or abuse drugs? How did it feel to sell your body to strangers, to be deserted by your parents, how did it feel to be the parent who had to desert your children?

To change who tells the story, Wichmann Rasmussen maintains that it must be through

> engaging socially vulnerable people living in Denmark today as authentic experts and storytellers, people who, from own experience, know how it feels to be homeless, neglected and stigmatised.

The Welfare Museum emphasis on those marginalised, like Richardt, as 'authentic experts' means that:

> the authentic experts [quickly became] aware of the fact that their personal problems were quite valuable because other people would be able to benefit from learning about them, and our shared history would be gaining a completely new dimension.

As Wichmann Rasmussen adds, these authentic experts

> engage in a cultural job [that allows] them to experience that they can contribute, and that their personal stories are acknowledged and appreciated as an essential part of something that will create insight, debate and new thoughts on poverty, homelessness and socially vulnerable people across time.

Here, people themselves become the active researchers, and agitate for change in public (and professional) perception, and sometimes even the law.

The museum anthropologist and First Nations rights activist, Amy Lonetree, notes the importance of museums helping others to uncover the truth and address sometimes very difficult subject matter (Lonetree 2006). The stories told – and most importantly, researched – by the marginalised in the cases described in this book, are similarly acts of resistance to represent themselves and bring about personal and social change.

But this is an important exercise in people using the museum to gain personal power, not a museum practising therapy. Commenting on the motivation for Care Leavers to research their past histories, Jensen adds that at the Danish Welfare Museum

> the Care Leavers … do not seek therapy – at least not at the Museum – instead, they search history. They make contact with the Museum in order to find background information and a mirror for their own personal story, and in order to contribute to the history with their personal version of it.

She notes in her chapter that, at the museum, the Care Leavers

> are not clients or receivers of help … The experiences from the Danish Welfare Museum strongly indicate that a focus on history, rather than healing, and an approach towards the participants as active contributors rather than passive receivers of help can be empowering.

Thus, as the book demonstrates, there are mutual benefits that both the museum and the socially vulnerable achieve from working closely together in solidarity to uncover the hidden stories of the past, and in this way, make them relevant to the present. Richardt had commented on this different approach: 'I felt at home at the museum because the people there were serious about listening to me and learning from my story.' By asking collaborators, with their history of marginalisation, to be experts in poverty and social vulnerability across time, this work aims to convey what it was like, and is like, to be in a situation where you lose either the ability or the right to control basic aspects of your life.

People's open access to research methodologies is what the Danish Welfare museum, and others, such as the Glasgow Women's Library and the UK's Museum of Homelessness, are attempting to establish, in a way that is not only liberating through informing and inspiring activism, but also of course changing the museum itself. As will be seen in their contributions to this book, *research* is a critically important emancipatory tool when put into people's hands. It quickly becomes action for change. Another term for this is, as Smed calls it, 'collective inquiry'. This activism is led by people themselves, using this tool – *research*, that the museum has traditionally monopolised.

Arjun Appadurai argued that the ability to conduct research on one's social surround should be considered a basic human right (cited by Cammarota and Fine 2010: V11). Co-produced research is a continuous theme running throughout the examples in this book. Knage Rasmussen here calls the Care Leavers 'insider researchers', experts of their own lives. In her chapter, Smed adds that

> inviting the so-called 'socially vulnerable' to be co-creators using the collections, source material and historical setting as resources [is] a means to create social

change – co-creational and participatory initiatives which continuously and respectfully challenge all partners.

She states:

> In our work, citizens with experiences from orphanages, life on the streets, substances abuse, mental and physical illnesses are engaged as valuable 'insider researchers'. They work with us in producing new knowledge, new projects and methods.

Smed describes this very different approach to their work, for example, with extremely vulnerable Care Leavers:

> We ask questions such as: Why has placement in care often been tantamount to exclusion from society and erasure from the historical records? What happens when we invite the people, with untold stories, to co-create both their personal but also an established social welfare history?

As one Care Leaver states, 'This is MY story.'

Conclusion: solidarity as a radical act of love

Finally, where do we meet Richardt where his powerful words challenge us to meet him? How do we learn to see him, hear him, learn from him?

Reviewing the shifts in relations in museums that this book so clearly reflects, one quickly realises that what is being described here is all about *solidarity*. It involves the conscious fostering of transformative relationships based on interdependence, as a radical act of resistance and struggle, leading to personal and social emancipation.

Solidarity here rejects the notions of kindness, empathy, 'charity' towards the 'other' that implicate the shutting down of dignity, of resistance, the shutting down of legitimate anger towards prejudice. Humanitarian 'charity' remains deeply problematic in museums. As writer Eduardo Galeano so eloquently put it:

> I don't believe in charity. I believe in solidarity. Charity is vertical, so it's humiliating. It goes from the top to the bottom. Solidarity is horizontal. It respects the other person and learns from the other person. I have a lot to learn from other people.
>
> *(Cited in Barsamian 2004)*

Solidarity in action here is an act of collaborative dialogue and struggle that links people together. When looking for a name to give the glue that binds together the work described here, that binds the people together, one might go so far as to say that this solidarity is *love*. And, as in all close and radically transformative 'loving' relations, we frequently argue, and we frequently get it wrong. Authentic relations require being unafraid to get it wrong.

One is struck by how closely the people involved in the museum practice described here are attuned to each other. It is no coincidence then that sociologist Thomas Scheff defined solidarity in terms of social 'attunement'. In his words, attunement is 'mutual understanding; joint attention to thoughts, feelings, intentions, and motives between individuals but also

between groups' (Scheff 1990: 201). Scheff is especially concerned with how emotion is used to maintain social interactions and connections. By definition, a social bond exists between people to the degree that there is mental and emotional attunement between them, and 'the same kind of attunement between groups is referred to as solidarity' (Scheff 1990: 201).

This is similar to the philosopher and political activist Simone Weil's earlier notion of *attention* as love, 'for just as attention acknowledges the existence of another, love requires the recognition of a reality outside of the self' (Weil 2009: 130). For Weil, this loving solidarity was central to social justice.

Weil placed this notion of *attentiveness* at the centre of authentic friendship. This loving friendship is built on careful attention to the words, silences and needs of the other person. She describes a kind of vigilance in her definition of attention. She says we need to apprentice ourselves to learn this, letting go of our ego (or the institution's goals) in order to receive the world – and others – without the interference of our limited perspective.

Weil was critical of any form of humanitarian kindness as a form of moral duty. She strongly emphasised that attention is not motivated by a duty or measured by its consequences. It is not about realising one's own 'virtuous' projects – in fact, it is a letting go of one's projects, to give up 'being the centre of the world'. She wrote, 'The face of this love, which is turned toward thinking persons, is the love of our neighbour' (Weil 2009: 100).

Social justice and the love of one's neighbour are not distinct for Weil. She conflated justice and love, claiming that they make possible compassion and gratitude on the one hand, and on the other, respect for the dignity of the marginalised – a respect felt by the person themself, and by others (Weil 2009: 85).

Attuned, attentive and committed to social justice summarises most of the relations outlined in this book. What is proposed here is that museums consciously upskill themselves in this way to develop loving solidarity with others – and, as in all practice described here, its basis is dialogue.

Paulo Freire wrote about the importance of real dialogue which, he claimed, cannot exist in the absence of love, profound love, for the world and for people. For him, dialogic engagement is an act of love. According to Freire, 'love is at the same time the foundation of dialogue and dialogue itself' (Freire 2000: 89).

Freire believed that authentic love opens up the self to the other. With this opening up of the self comes solidarity and the struggle for freedom and liberation. He proposed that:

> as individuals or as peoples, by fighting for the restoration of the humanity they will be attempting the restoration of true generosity … And this fight, because of the purpose given it by the oppressed, will actually constitute an act of love opposing the lovelessness which lies at the heart of the oppressors' violence.
>
> *(Freire 2000: 45)*

Critical pedagogy theorist Peter McLaren also mentions the political and active nature of Freire's vision of love. He argues that 'a love for humankind that remains disconnected from a liberatory politics does a profound disservice to its object' (McLaren 2000: 171). Love is connected to that which is political and that which is active. In opposition to love and dialogue, lies oppression.

The concept of radical loving solidarity is therefore the central shift involving mutual attention and attunement with an Other in the museum that this book is proposing. This

emotional solidarity is as a 'transformative relation' with others (Featherstone 2012). There is therefore a clear and important difference here between this form of radical solidarity, and the depoliticised concept of humanitarianism that underpins the work of modern international aid and development in nongovernmental organizations (NGOs). One sometimes fears that this depoliticised humanitarianism may be latched onto by museums, one that can be read as an example of the phenomenon now critiqued as 'NGOisation' (Choudry and Kapoor 2013).

Solidarity is therefore the key to counteract this. It is the glue that ties together all the work shared by people, museum staff and others throughout the risk-taking museum practice described here. In an Australian example, Chynoweth writes in her chapter of an exhibition she co-curated, *Inside: Life in Children's Homes and Institutions*, at the National Museum of Australia. She was, she says, faced with questions from survivors of institutionalised child abuse with whom she had collaborated. She reports that they asked

> 'But what now? Are we supposed to just go home now? Is that it?' And then came the big question. One of the women turned to me and asked, 'Are you going to help us get justice?'

This was a demand for active solidarity – for help in demanding recognition and reparation. It is a demand for a deeper level of partnership, a deeper level of commitment for change. It is asking of museum colleagues, exactly whose fight is it? Are we in this together?

Without hesitation, this book replies, 'yes we are'.

The shift towards authentic museum relations is plainly about museums collaborating with those labelled as 'marginalised' as fellow humans trying to make sense of the troubled world in which we all live – and helping each other to do so. As Gejl notes in her contribution, in agreeing to participate in what she calls 'the vulnerable space', there can be no silent observers, no note-taking. It is about finding a way to reach authenticity for all involved. We are all implicated, all involved.

Thus, a politicised 'community of interest' is established, based on a contract of loving compassion. I believe that this is what we can witness at work in many of the chapters in this book. Hannah Arendt wrote about the notion of compassion as part of love. In *On Revolution* (1963), she claimed that compassion does not generalise the suffering of other people but is direct and singular. Although 'politically speaking', compassion is 'irrelevant and without consequence', Arendt thought that when guided by political reason, compassion could help forge the solidarity necessary to establish 'a community of interest with ['with', note, not 'in'] the oppressed and exploited' (Arendt 1963: 79).

Pity, by contrast, was for Arendt a perversion of compassion, a sentiment that, once permitted to drive politics, is capable of inspiring the cruellest manifestations of virtue. It is too easy, she felt, to be enchanted by one's own capacity for pity. It is far harder to forge a reasoned politics of communal compassion.

Arendt's primary concern was in a mutual conferring of rights. In contrast, she called pity a 'fancy word' capable of as much harm as good, a sort of cheap empathy with no rights-exchange on offer. Pity, she also noted, prefers to chat about its achievements rather than measure them in historical and political terms (Arendt 1963: 79).

Writer and activist bell hooks took the importance of loving solidarity even further, claiming 'love as the practice of freedom', in her book *Outlaw Culture: Resisting Representations* (hooks 1994). Similar to Freire, she speaks of the need for collaboration to be based within an

ethic of love, and she maintains that in order to achieve this, we need to begin to truly understand how systems of oppression work. And to do that, we need to operate as each other's 'critical friends'. Developing this self-awareness, she claims, is at the heart of love as the practice of freedom.

The ethical stance therefore required of museums is in making discursive room for the 'other' to fully exist. In other words, as Gayatri Spivak explains, ethics are not just a problem of knowledge but a call to a relationship. The ideal relationship is individual and intimate.

> We all know that when we engage profoundly with one person, the responses come from both sides: this is responsibility and accountability … The object of ethical action is not an object of benevolence, for here responses flow from both sides.
>
> *(cited by Landry and MacLean 1996: 269–270)*

The ideal relation to the 'other', then, according to Gayatri Spivak, is an 'embrace, an act of love' (Spivak cited by Landry and MacLean 1996: 269–270). Such an embrace may be unrequited, as the differences and distances may be too great, but if we are ever to get beyond the vicious cycle of prejudice, it is essential to remain open-hearted, as can be seen demonstrated by those describing their work in this book. hooks put it this way:

> The moment we choose to love we begin to move against domination, against oppression. The moment we choose to love we begin to move towards freedom, to act in ways that liberate ourselves and others. That action is the testimony of love as the practice of freedom.
>
> *(hooks 1994: 298)*

Museums may then perhaps have a very important role to play in generating the kind of critical awareness and freedom that these writers describe as supporting a mutual, loving friendship, one in which people like Richardt might speak and be heard. Social activism demands friendship and solidarity. This book displays this in action.

Those involved are, this author believes, attempting to learn about the other, not as saving someone, but as all of us, in solidarity, saving each other. Creating a world that, as Freire imagined, might be one that is 'more round, less ugly, and more just' (Freire, as cited by Macedo 2000: 26).

Not all examples outlined in this book have it perfect – likely none do – but all are asking questions of themselves, and each other, critically reflecting on their ongoing practice with the help of their partners as 'critical friends', as they progress along the perilous path of friendship and collaboration in museums. In this way, they are inspiring.

The perilous path for museums in relation to others, in the end, may not be so very complicated. The radical shift in museum practice that can be found here promotes a form of personal and collective resistance, and, in this case, led by those most vulnerable in society. For museums it means practising a type of conscious solidarity that supports individual and collective capability development, freedom and activism.

It is difficult to overestimate the transformations involved in these practices. Those formally understood under the collective noun, 'the marginalised', are, as this book demonstrates, transcending their label and inhabiting their own active agency in a multitude of ways. Much of that transformation is also within the museums themselves. We in museums, to borrow

again from Simone Weil, need to apprentice ourselves to learn this solidarity, this letting go of our ego (or the institution's goals) in order to help people in this important way, as Nussbaum put it, to be 'fitted for freedom'. That is precisely what these museums are attempting to do. And it has an ever-widening impact on society.

In this way, those most marginalised, like Richardt, are showing us the way towards establishing a useful museum. We salute him.

Acknowledgements

I would like to dedicate this paper to a dear friend and former co-collaborator, Jaya Graves, who sadly passed away a couple of years ago. She had been the director and one of the founders of Manchester's 'Southern Voices', a network of people committed to bringing the knowledge and understanding of Southern and Black people to the global issues that are central to education and to living in the world today. A core principle for the group since its inception has been a commitment to making 'southern voices' heard more loudly, clearly and often, and on their own terms. Jaya taught me (often over cooking lessons in her kitchen, while she also taught me how to make delicious Indian food) how to critique my own assumptions as a museum professional; about recognizing the subtleties of institutional power and prejudice, and about how to support particularly marginalised people's active agency 'on their own terms'. (Southern Voices can be found at www.southernvoices.org.)

Notes

1 Blaikie et al. (1994: 9) defines vulnerability as the 'set of characteristics of a group or individual in terms of their capacity to anticipate, cope with, resist and recover from the impact of hazard. It involves a combination of factors that determine the degree to which someone's life and livelihood is at risk by a discrete and identifiable event in society.'

2 The term 'marginalisation', or as it is often described, 'social exclusion', is used in the social sciences to refer to social disadvantage and relegation to the fringes of society. It describes the process by which individuals are blocked from (or denied full access to) various rights, opportunities and resources that are normally available to those more privileged. See also Silver (2007: 15) who defines social exclusion as 'a multidimensional process of progressive social rupture, detaching groups and individuals from social relations and institutions and preventing them from full participation in the normal, normatively prescribed activities of the society in which they live.

3 In a keynote address to the Modern Languages Association titled 'Arts of the Contact Zone', Mary Louise Pratt (1991) introduced the concept of 'the contact zone'. She articulated, 'I use this term to refer to social spaces where cultures meet, clash and grapple with each other, often in contexts of highly asymmetrical relations of power, such as colonialism, slavery, or their aftermaths as they are lived out in many parts of the world today.' Pratt described a site for linguistic and cultural encounters, wherein power is negotiated and struggle occurs.

4 Later taken up by educational theorists such as Henry Giroux (1988, 2002, 2009, 2011, 2012; Giroux and Witkowski 2011) and museum education theorists, most notably Eilean Hooper-Greenhill (1994).

5 In the UK, notably Glasgow Museums Service, National Museums Liverpool and Tyne and Wear Museums have maintained their public engagement and later, social justice commitment.

6 In his 2010 inaugural lecture at Princeton University's Institute of Advanced Study, Fassin analyses the revealing shifts in terminology, in which 'injustice' becomes 'suffering', 'violence' becomes 'trauma', and 'resistance' becomes 'resilience'. As Fassin (2010) points out, 'combatants' are increasingly transformed into victims.

7 'Care Leaver' broadly means an adult who spent time in care as a child, that is, under 18. Such care could be in foster care, residential care – mainly children's homes – or other arrangements outside the immediate or extended family.

Bibliography

Ahmed, S. (2010), *The Promise of Happiness*, Durham, NC: Duke University Press.

American Alliance of Museums (2019), 'Retrenchment or Downsizing', viewed 1 April 2019, www.aam-us.org/programs/ethics-standards-and-professional-practices/professional-practice-retrenchment-or-downsizing.

Arendt, H. (1963), *On Revolution*, Harmondsworth: Penguin.

Azoulay, A. (2008), *The Civil Contract of Photography*, New York: Zone Books.

Barsamian, D. (2004), *Louder Than Bombs: Interviews from The Progressive Magazine*, Boston: South End Press.

Bennett, T. (1995), *The Birth of the Museum: History, Theory, Politics*, London and New York: Routledge.

Blaikie, P., Cannon, T., Davis, I. and Wisner, B. (1994), *At Risk: Natural Hazards, People's Vulnerability and Disasters*, London and New York: Routledge.

Boast, R. B. (2011), 'Neocolonial Collaboration: Museum as Contact Zone Revisited', *Museum Anthropology*, 34 (1): 56–70.

Bonnell, J. and Simon, R. I. (2007), '"Difficult" Exhibitions and Intimate Encounters', *Museum and Society*, 5 (2): 65–85.

Brown, K. and Mairesse, F. (2018), 'The Definition of the Museum through its Social Role', *Curator*, 61 (4): 525–539, viewed 11 May 2019, https://onlinelibrary.wiley.com/doi/full/10.1111/cura.12276.

Brown, W. (2015a), *Undoing the Demos: Neoliberalism's Stealth Revolution*, New York: Zone Books.

Brown, W. (2015b), 'What Exactly is Neoliberalism?', interview with Timothy Shenk, Dissent, 2 April, viewed 12 March 2019, www.dissentmagazine.org/blog/booked-3-what-exactly-is-neoliberalism-wendy-brown-undoing-the-demos.

Brown, W. (2006), 'Tolerance as a Discourse of Depoliticisation', in *Regulating Aversion: Tolerance in the Age of Identity and Empire*, Princeton: Princeton University Press.

Brown, W. (2003), 'Neo-liberalism and the End of Liberal Democracy', *Theory & Event*, 7 (1): 15–18.

Cameron, D. (1971), 'The Museum, a Temple or a Forum', *Curator*, 14: 11–24.

Cameron, D. (1968), 'A Viewpoint: The Museum as a Communication System and Implications for Museum Education', *Curator*, 11: 33–40.

Cammarota, J. and Fine, M. (eds) (2010), *Revolutionizing Education: Youth Participatory Action Research in Motion*, London and New York: Routledge.

Celikates, R. (2016), 'Rethinking Civil Disobedience as a Practice of Contestation', February 2019, www.academia.edu/23493406/Rethinking_Civil_Disobedience_as_a_Practice_of_Contestation_-_Beyond_the_Liberal_Paradigm_Constellations_published_version.

Chambers, I., De Angelis, I., Orabona, M. and Quadraro, M. (eds) (2017), *The Postcolonial Museum: The Arts of Memory and the Pressures of History*, London and New York: Routledge.

Choudry, A., and Kapoor, D. (eds) (2013), *NGOization: Complicity, Contradictions and Prospects*, London: Zed Books.

Clifford, J. (ed.) (1997), 'Museums as Contact Zones', in *Routes: Travel and Translation in the Late Twentieth Century*, Cambridge, MA: Harvard University Press, 188–219.

Coalition of Museums for Climate Justice (no date), Website, viewed 2 May 2019, https://coalitionofm useumsforclimatejustice.wordpress.com.

Cornwall, A. (2008), *Democratising Engagement: What the UK Can Learn from International Experience*, London: Demos.

Crooke, E. M. (2007), *Museums and Community: Ideas, Issues and Challenges*, London and New York: Routledge.

Danish Centre for Welfare Studies, Website, viewed 1 May 2019, www.sdu.dk/en/forskning/forskningsenheder/samf/daws

Danmarks Forsorgsmuseum (no date), Website, viewed 1 May 2019, www.svendborgmuseum.dk/forsorgsmuseet.

Davies, W. (2011), 'The Political Economy of Unhappiness', *New Left Review*, 71, September–October, viewed 24 February 2019, https://newleftreview.org/issues/II71/articles/william-davies-the-political-economy-of-unhappiness.

Eddo-Lodge, R. (2017), *Why I'm No Longer Talking to White People about Race*, London: Bloomsbury Publishing.

Fassin, D. (2010), 'Critique of Humanitarian Reason', Lecture at Institute for Advanced Study, Princeton, 27 January 2010, viewed 16 January 2019, https://www.youtube.com/watch?v=jDT2mYg6mgo.

Featherstone, D. (2012), *Solidarity: Hidden Histories and Geographies of Internationalism*, London: Zed Books.

Federation of International Human Rights Museums (no date), Website, viewed 24 April 2019, www.fihrm.org.

Fleming, D. (2010), 'Museums Campaigning for Social Justice – 5th Stephen E. Weil Memorial Lecture', INTERCOM Shanghai, 8 November 2010, viewed 24 April 2019, https://drive.google.com/drive/folders/1sCMcDUoL85m6zsMcfLKPHpVkT0K3CL6_?ths=true.

Fouseki, K. (2010), 'Community Voices, Curatorial Choices: Community Consultation for the1807 Exhibitions', *Museum and Society*, 8 (3), 180–192.

Freire, P. (2000), *Pedagogy of the Oppressed*, trans. Myra Bergam Ramos, 30th Anniversary edn, New York: Continuum (1st edn 1970).

Freire, P. (1972), *Pedagogy of the Oppressed*, Harmondsworth: Penguin.

Giroux, H. (2012), *Disposable Youth, Racialized Memories, and the Culture of Cruelty*, London and New York: Routledge.

Giroux, H. (2009), *Youth in a Suspect Society: Democracy or Disposability?* London: Palgrave Macmillan.

Giroux, H. (2002), *Public Spaces/Private Lives: Democracy beyond 9/11*, Lanham, MD: Rowman & Littlefield.

Giroux, H. (1997), *Pedagogy and the Politics of Hope: Theory, Culture, and Schooling: A Critical Reader*, Boulder, CO: Westview Press.

Giroux, H. (1988), *Schooling and the Struggle for Public Life*, Minneapolis: University of Minnesota Press.

Giroux, H., and Witkowski, L. (2011), *Education and the Public Sphere: Ideas of Radical Pedagogy*, Cracow: Impuls.

Graham, H., Mason, R. and Nayling, N. (2013), 'The Personal is Still Political: Museums, Participation and Copyright', *Museum and Society*, 11 (2), 105–121, viewed 10 January 2019, https://core.ac.uk/download/pdf/18492997.pdf.

Gramsci, A. (1971), *Selections from the Prison Notebooks*, London: Lawrence & Wishart.

Gundogdu, A. (2015), *Rightlessness in an Age of Rights: Hannah Arendt and the Contemporary Struggles of Migrants*, Oxford: Oxford University Press.

Harvey, D. (2005), *A Brief History of Neoliberalism*, Oxford: Oxford University Press.

Hein, G. (1998), *Learning in the Museum*, Museum Meanings series, London and New York: Routledge.

Herle, A. (2016), 'Anthropology Museums and Museum Anthropology', in F. Stein *et al.* (eds), *The Cambridge Encyclopaedia of Anthropology*, viewed 17 April 2019, http://www.anthroencyclopedia.com/entry/anthropology-museums-and-museum-anthropology.

hooks, b. (1994), *Outlaw Culture: Resisting Representations*, London and New York: Routledge.

Hooper-Greenhill, E. (2007), *Museums and Education: Purpose, Pedagogy, Performance*, London and New York: Routledge.

Hooper-Greenhill, E. (ed.) (1994), *The Educational Role of the Museum*, London and New York: Routledge.

ICOM (2018), 'Trends and Influences on Museum Anthropology and the Study of Indigenous Peoples', viewed 19 April 2019, https://icom.museum/en/news/trends-and-influences-on-museum-anthropology-and-the-study-of-indigenous-peoples.

INTERCOM (2009), 'Declaration of Museum Responsibility to Promote Human Rights', viewed 19 April 2019, https://icom.museum/en/museum/intercom-icom-international-committee-for-museum-management.

Janes, R. R. (2007), *Museums in a Troubled World: Renewal, Irrelevance or Collapse*, London and New York: Routledge.

Janes, R. R. and Sandell, R. (eds) (2019), *Museum Activism*, London and New York: Routledge.

King, M. L. (1963), 'Letter from a Birmingham Jail', 16 April, *African Studies Center – University of Pennsylvania*, viewed 19 April 2019, www.africa.upenn.edu/Articles_Gen/Letter_Birmingham.html.

Landry, D. and MacLean, G. (eds) (1996), *The Spivak Reader: Selected Works*, London and New York: Routledge.

Levinas, E. (1991), *Alterity and Transcendence*, London: Columbia University Press.

Logan, W. and Reeves, K. (eds) (2008), *Places of Pain and Shame: Dealing with 'Difficult Heritage'*, London and New York: Routledge.

Lonetree, A. (2006), 'Missed Opportunities: Reflections on the NMAI', *American Indian Quarterly*, 30 (3–4): 632–645.

Lynch, B. (2019), 'I'm gonna do something': Moving beyond Talk in the Museum', in R. R. Janes and R. Sandell (eds.), *Museum Activism*, London and New York: Routledge, 115–126.

Lynch, B. (2017a), 'Migrants, Museums and Tackling the Legacies of Prejudice', in C. Johnson and P. Bevlander (eds), *Museums in a Time of Migration: Rethinking Museums' Roles, Representations, Collections, and Collaborations,* Lund: Nordic Academic Press, 225–242.

Lynch, B. (2017b), 'The Gate in the Wall: Beyond Happiness-making in Museums', in B. Onciul, M. L. Stefano, and S. Hawke (eds), *Engaging Heritage, Engaging Communities*, Suffolk: Boydell Press, 11–29.

Lynch, B. (2017c), 'Disturbing the Peace: Museums, Democracy and Conflict Avoidance', in D. Walters, D. Leven, and P. Davis (eds), *Heritage and Peacebuilding*, Suffolk: Boydell Press, 109–126.

Lynch, B. (2014a), '"Whose cake is it anyway?": Museums, Civil Society and the Changing Reality of Public Engagement', in L. Gouriévidis (ed.), *Museums and Migration: History, Memory and Politics*, London and New York: Routledge, 67–80.

Lynch, B. (2014b), 'Challenging Ourselves: Uncomfortable Histories and Current Museum Practices' in J. Kidd, S. Cairns, A. Drago, A. Ryall, and M. Stearn, (eds), *Challenging History in the Museum: International Perspectives*, London: Ashgate, 87–99.

Lynch, B. (2014c), 'Our Museum: A Five-Year Perspective from a Critical Friend', viewed 20 April 2019, Paul Hamlyn Foundation, http://ourmuseum.org.uk/wp-content/uploads/A-five-year-perspective-from-a-critical-friend.pdf.

Lynch, B. (2011a), *Whose Cake Is It Anyway? A Collaborative Investigation into Engagement and Participation in Twelve Museums and Galleries in the UK*, London: Paul Hamlyn Foundation, viewed 20 April 2019, www.phf.org.uk/publications/whose-cake-anyway.

Lynch, B. (2011b), 'Custom-made Reflective Practice: Can Museums Realise their Capabilities in Helping Others Realise Theirs?', in *Museum Management and Curatorship*, 26 (5), 441–458.

Lynch, B. (2011c), 'Collaboration, Contestation, and Creative Conflict: On the Efficacy of Museum/Community Partnerships', in J. Marstine (ed.), *Redefining Museum Ethics*, London: Routledge.

Lynch, B. (2011d), 'Custom-made: A New Culture for Museums and Galleries in Civil Society', *Arken Bulletin*, 5: *Utopic Curating*.

Lynch, B. T., and Alberti, S. J. M. M. (2010), 'Legacies of Prejudice: Racism, Co-production and Radical Trust in the Museum', *Museum Management and Curatorship*, 25 (1), 13–35.

Macdonald, S. J. (2008), 'Unsettling Memories: Intervention and Controversy over Difficult Public Heritage', in M. Anico and E. Peralta (eds), *Heritage and Identity: Engagement and Demission in the Contemporary World*, London and New York: Routledge, 93–104.

Macedo, D. (2000), 'Introduction', in P. Freire, *Pedagogy of the Oppressed*, trans. Myra Bergam Ramos, 30th Anniversary edn, New York: Continuum (1st edn 1970).

Marstine, Janet (ed.) (2011), *The Routledge Companion to Museum Ethics: Redefining Ethics for the Twenty-first Century*, London and New York: Routledge.

Mazda, X. (2004), 'Dangerous Ground? Public Engagement with Scientific Controversy', in D. Chittenden (ed.), *Creating Connections: Museums and the Public Understanding of Current Research*, Lanham MD: Rowman & Littlefield.

McLaren, P. (2000), *Che Guevara, Paulo Freire, and the Pedagogy of Revolution*, Lanham MD: Rowman & Littlefield.

McLaren, P. (1999), 'A Pedagogy of Possibility: Reflection upon Paulo Freire's Politics of Education', *Educational Research*, 28: 49–56.

McLaren, P. (1995), *Critical Pedagogy and Predatory Culture*, London and New York: Routledge.

McLaren, P., Macrine, S., and Hill, D. (eds) (2010), *Revolutionizing Pedagogy: Educating for Social Justice within and beyond Global Neo-liberalism*, London: Palgrave Macmillan.

Mouffe, C. (2005), *On the Political*, London and New York: Routledge.

Museums Association (2018), 'Power to the People', viewed 6 April 2019, https://www.museumsassociation.org/download?id=1254507.

Museums Association (2013), 'Museums Change Lives', viewed 5 April 2019, www.museumsassociation.org/download?id=1001738.

Nussbaum, Martha C. (1997), *Cultivating Humanity: A Classical Defence of Reform in Liberal Education*, Cambridge, MA: Harvard University Press.

Nyamu-Musembi, C., and Cornwall, A. (2004), 'What Is the "Rights-based Approach" All About? Perspectives from International Development Agencies', IDS Working Paper 234, viewed 4 February 2019, www.ids.ac.uk/files/dmfile/Wp234.pdf.

Our Museum (no date), Website, viewed January 2019, http://ourmuseum.org.uk/?welcome=1.

Peers, L., and Brown A. (2003), *Museums and Communities*, London and New York: Routledge.

Phillips, R. (2011), *Museum Pieces: Toward the Indigenization of Canadian Museums*, Montreal and Kingston: McGill-Queen's University Press.

Phillips, R. (2006), in Edwards, E., Gosden C. and Were, G. (eds), *Sensible Objects: Colonialism, Museums and Material Culture*, Oxford and New York: Berg.

Pratt, M. (1991), 'Arts of the Contact Zone', *Profession*, 91, 33–40.

Pritchard, S. (2017), viewed 2 April 2019, https://colouringinculture.org/blog/neoliberalismlanguageengagement?rq=Outcomes%2C%20outputs%2C%20.

Roy, A. (2014), 'The NGO-ization of resistance', *Massalijn*, 4 September, viewed 4 March 2019, http://massalijn.nl/new/the-ngo-ization-of-resistance.

Said, E. (1978), *Orientalism*, New York: Pantheon Books.

Sandell, R. (2016), *Museums, Moralities and Human Rights*, London and New York: Routledge.

Sandell, R. (2011), 'Ethics and Activism', in J. Marstine (ed.), *The Routledge Companion to Museum Ethics: Redefining Ethics for the Twenty-first Century Museum*, London and New York: Routledge.

Sandell, R. (2006), *Museums, Prejudice and the Reframing of Difference*, London and New York: Routledge.

Sandell, R. (2003), 'Social Inclusion, the Museum and the Dynamics of Sectoral Change', *Museum & Society*, 191, 45–62.

Sandell, R. (2002), 'Museums and the Combating of Social Inequality: Roles, Responsibilities, Resistance', in R. Sandell (ed.), *Museums, Society, Inequality* London and New York: Routledge, 3–23.

Sandell, R. and Nightingale, E. (2012), *Museums, Equality and Social Justice*, London and New York: Routledge.

Scheff, T. (1990), *Microsociology: Discourse, Emotion, and Social Structure*, Chicago: University of Chicago Press.

Sen, A. (2010), *The Idea of Justice*, London: Penguin.

Sen, A. (1999), *Development as Freedom*, Oxford: Oxford University Press.

Shelton, A. A. (2006), 'Museums and Anthropologies: Practices and Narratives', in S. Macdonld (ed.), *A companion to Museum Studies*, London: Blackwell, 64–80

Shor, I. (1992), *Empowering Education: Critical Teaching for Social Change*, Chicago: University of Chicago Press.

Silver, H. (2007), 'Social Exclusion: Comparative Analysis of Europe and Middle East Youth', Middle East Youth Initiative Working Paper, viewed 19 April 2019, www.meyi.org/uploads/3/2/0/1/32012989/silver_-_social_exclusion-comparative_analysis_of_europe_and_middle_east_youth.pdf.

Skills Network (no date), 'Our Key Ideas', viewed 3 March 2019, www.skillsnetwork.org.uk/aims-ideas/our-key-ideas.html.

Social Justice Alliance for Museums (no date), Website, viewed 12 January 2019, http://sjam.org.

Spivak, G. C. (1985), *In Other Worlds: Essays in Cultural Politics*, London and New York: Routledge.

Stonebridge, L. (2017a), 'Writing, Rights, Refugees', in *Critical Life*, viewed 20 March 2019, https://criticallife.org/2017/07/03/lyndsey-stonebridge-interview.

Stonebridge, L. (2017b), 'Humanitarianism Was Never Enough: Dorothy Thompson, Sands of Sorrow, and the Arabs of Palestine', *Humanity: An International Journal of Human Rights*, 8 (3), 441–465, viewed 22 April 2019, www.academia.edu/37201846/Humanitarianism_Was_Never_Enough_Dorothy_Thompson_Sands_of_Sorrow_and_the_Arabs_of_Palestine_Humanity_An_International_Journal_of_Human_Rights_vol_8_3._Winter_2017_pp._441-465.

Teslow, T. L. (2007), 'A Troubled Legacy: Making and Unmaking Race in the Museum', *Museums and Social Issues*, 2: 11–44.

Thompson, D. (1938), 'Refugees: A World Problem', Foreign Affairs, April, viewed 20 March 2019, www.foreignaffairs.com/articles/69803/dorothy-thompson/refugees-a-world-problem.

Tlaib, R. (2019), Twitter comment @RashidaTlaib, 7:04 pm, 13 April, 2019.

Vergo, P. (1989), *The New Museology*, London: Reaktion Books.

Weil, S. (2009), *Waiting for God*, trans. Emma Craufurd, New York: HarperCollins (*Attente de Dieu*, Paris: Éditions Fayard, 1966).

Weil, S. E. (1990), *Rethinking the Museum*, Washington, DC: Smithsonian Institution Press.

PART I

Museums and co-creation

1

BEHIND BARBED WIRE

Co-producing the Danish Welfare Museum

Sarah Smed

Everybody needs to feel valued and heard. That's why it's important to also include the people with stories of vulnerability. Everybody can contribute. And everybody can make a difference.

Mette Løjmann Hansen (2017), intern at the Danish Welfare Museum

On 16 April 2018 something astonishing and revealing happened at the Danish Welfare Museum. It would affect our way of co-producing welfare history. On this, the International World Voice Day, Mette, an intern at the museum, had arranged an event, where the often quiet or silenced voices of the welfare system could and would speak out. As an appreciated and brave liaison officer for the museum, Mette had invited six of her friends to share their stories and voices at a public event at the museum. Stories were shared which stemmed from difficult and powerful memories from children's Homes, from homelessness, from substance abuse, from physical and mental illnesses and from mistrust and exclusion. Mette, herself formerly homeless and a drug abuser, not only planned the event in full detail. She also hosted it and created a powerful atmosphere of respect, inclusion and thought-provoking debates. Had it not been for Mette, the event would never have taken place. Had it not been for the unique historical setting of the Museum, the event might not have had a space for this respectful public forum. Had it not been for the participants sharing honest and moving insights, there would have been no debates. Through the combination of all these participants' willingness and mutual interest and curiosity, something very valuable and unique took place in the historical setting of the preserved poor- and workhouse in Denmark.

Despite its small size, Denmark is quite well known worldwide, and we often see ourselves placed high in international rankings on, for example equality, reduction of poverty, happiness, digitalisation, social and economic security and the eradication of corruption. Our society is formed by the renowned Nordic welfare state model, and it has been an integral part of both Danish society and self-perception for many decades – a solid system of universal rights that secures freedom and excellent welfare for all Danish citizens, a system with strong and powerful roots in Danish history, and a system which has shaped Danish society

in numerous ways. For many outsiders, Denmark must seem to be quite the El Dorado of nations, safe and idyllic for everyone. Yet, just a scratch on the surface of this picture postcard of Denmark reveals a much more complex Danish welfare history consisting of paradoxes, dilemmas and taboos. The Danish welfare history is complicated and filled with contrasts, and the experiences within the welfare system have been, and sometimes still are, anything but safe or idyllic. I work at the Danish Welfare Museum and we ask questions such as: Why has placement in care often been tantamount to exclusion from society and erasure from the historical records? What happens when we invite the people with untold stories to co-create both their personal but also an established social welfare history?

The Danish Welfare Museum preserves and works collaboratively to secure the heritage and memories of the institutionalised, the poor and the socially vulnerable, aiming for a Danish social history which not only sheds light on the stories from the welfare system that are not told, but also works within the field of social justice and museum activism. In unconventional partnerships, interdisciplinary research and targeted and relevant outreach programs, we co-produce and debate welfare history in close and respectful collaboration with the people whose stories have often not been told. We make sure this is done with challenging and nuancing contemporary knowledge and in associated discussions.

There are thought-provoking and ironic paradoxes concerning both the heritage site of the Museum and the method of working. One of the most central is an inclusive museum within an historic poor- and workhouse completely preserved with segregating barbed wire and tall brick walls. Another paradox bound to raise a few readers' eyebrows is that this Museum, which deals with, and preserves, the history of one of the strongest brands of Danish national identity, was established on a local initiative almost by chance. The local Svendborg Museum took on the role of securing the heritage site. Four decades on, the Welfare Museum is still financed as part of a local city museum, without any allocated state funding even though we work nationally. The Museum has therefore led a marginalised cultural life which has consequently created space for a slow evolution to a collaborative development. From a critical standpoint, one might argue that the economic marginalisation of the Museum reflects a disturbing disregard of this history on a national level. The Museum's profile has grown from the ground up and in close collaboration with the marginalised citizens of the welfare state. This profile has not been formulated and decided in a board room by members of staff in the absence of lived experiences in children's Homes, shelters for the homeless or life on the streets but, instead, stems from different areas of collaboration with experts on alternative ways of living and with in-depth knowledge of life on the edge of society.

What happened when we invited a multifaceted community whose personal stories are also part of the Museum's subject matter: the institutional welfare system? What is the potential? What are the dilemmas? And what happens when the work of the museum becomes political at a point in Danish history when the welfare state itself is debated, and when concepts like 'deserving' and 'undeserving poor', which stem from the late nineteenth century, are once again part of public debate? What happens when a museum takes a stance?

Writing this chapter is also a record of the living history of the Museum itself. Today the Museum is prominent on both the local and the national 'museum radar' after years of obscurity. We hope that this means that the Museum will be able to continue its work with co-producing, preserving and debating Danish welfare history with a continued focus on the intersection of social-justice-based welfare and public history. Some may view this emphasis as an unhelpful museum strategy because it disrupts the national pride in the welfare state model,

but it is an approach which, I believe, is most helpful in supporting social change, in creating an insightful historical consciousness as well as in debating, remembering and sharing both the light and dark stories of the welfare state.

From poorhouse to museum

In the idyllic and historic borough of Svendborg on the island Funen, lies the best preserved and only listed poor- and workhouse in the Nordic countries, showcasing a far from beautiful side of pre- and early Danish welfare history. It was one of many, but is today the last site preserved in its entirety. Behind the closed main gate, brick walls and iron windows, men and women, old and young, well and sick, deserving and undeserving for more than a century would spend days, months or even years living and working. Some voluntarily. Most involuntarily. Some with the hope and desire to leave. Others without any hope at all. In 1974 the institution was shut down after being run as a shelter with fewer restrictions from 1961, and from one day to the next it was turned into a museum. It was not local pride and cooperation with the city council that prompted the Museum to save the buildings from demolition. There was no political strategy to debate welfare history from a local perspective. Instead, practical considerations prevailed. The local city museum needed extra space for new exhibitions, stores for museum objects and offices for staff.

From 1974 to the millennium, the Museum lived a rather quiet existence nationally, but locally 'the Poorhouse', as it was unofficially named by locals, became a central part of the city's cultural life. For many local citizens born and raised in Svendborg, the institution, while functioning, had been part of their past – but almost always from a distance. With the Museum taking over 'the Poorhouse', the site featured various exhibitions about the history of Svendborg and partly about the history of the institution itself. However, during the last two decades, the perspective has indeed changed for this small Museum in Svendborg making an activist turn in its strategic work. A radical way of doing museum work has evolved where we are collecting, creating and debating 'the outskirts of Danish social history': the often forgotten or hidden histories of institutionalised lives from cradle to grave.

Today the Danish Welfare Museum, placed in the authentic setting of the 'the Poorhouse', exists to explore the tensions within our welfare history, taking on the national task of securing and debating this part of Danish welfare history as the only specialist museum of its kind in Denmark. On one hand, the historical setting of the institution depicts the very harsh conditions and stigmatising elements of pre- and early welfare assistance where recipients would lose their personal freedom and civil rights to live behind barred windows. On the other hand, the Museum has developed a safe and supporting framework, inviting the so-called 'socially vulnerable' to be co-creators, using the collections, source material and historical setting as a means to create social change – co-creational and participatory initiatives which continuously and respectfully challenge all partners.

The Panel of Experience

In 2016 I took part in and presented at the Federation of International Human Rights Museums (FIHRM) conference in Milan. Listening to the opening talk from the ever-inspirational President of FIHRM, Dr David Fleming, I especially took note when he stated that we should always keep in mind that museums are part of real time and real life. This simple

FIGURE 1.1 Thought-provoking view from the inside of the historical setting of the workhouse. Photo: Jon Bjarni Hjartarsson, Danish Welfare Museum.

but also enormously important statement resonated in my head and I silently added to myself 'and we have to make a real difference to real people'. The statement emphasised to me the importance of having real relevance for the communities that we wish to co-produce contemporary welfare history with. If we are not relevant to them, why would they even want to cooperate with us?

Since 2015 we have actively sought a new kind of partnership. Initially, the aim was to broaden the Museum's area of work, to create visibility, to network and to secure our relevance. That is why we co-produced an exhibition with the Danish street paper *Hus Forbi* collecting objects and testimonies with the homeless street paper vendors (Danmarks Forsorgsmuseum 2016). This is why we, with social workers, created the award-winning exhibition *Poverty across Time* to provide insight and inspire debate about the strengths and weaknesses in the welfare system past and present. This is why we developed the international EU-funded summer camp *Beat Poverty*, hosted at the Museum with almost 50 teenage Europeans, of whom many came from marginalised backgrounds, and the most fun, absorbing and exhausting museum work that I have ever done.

These new kinds of partnerships and collaborations marked an intensified focus on the fact that we wanted to extend our relevance as a museum even further, and that such initiatives and ambitions are highly dependent on time, flexibility and support from both staff and collaborators. New questions were raised, both big and small. Can the homeless vendor bring his dog (his treasured friend and companion) to the museum for the opening of the exhibition? (And yes – of course, he can!) Should we facilitate debates on political issues when the

tone of a debate unexpectedly becomes provocative or even contains personal attacks? (Yes, we should!) Or how do we ethically engage vulnerable citizens in sharing personal stories? (By continuously debating the very reasons for doing it *with* the citizens.) Questions, processes and issues which have demanded huge amounts of on-the-spot flexibility and which, thankfully, are achievable in a relatively small museum like ours. But which have also made the path clear in how we continuously should and must strive to become an increasingly more and more useful museum for these alternative partnerships and collaborations. What has also become gradually more evident over the last five years, in pursuing both value and usefulness, is that the museum initiatives that are useful for the citizens we collaborate with, are also the initiatives which create public attention. In other words: The more useful the museum strives to be, the more visible our work also seems to become. Usefulness is many things at the Museum as there are many citizens and partnerships that we collaborate with. The important, but not always easy, issue is to listen and pay attention to what being useful means in the specific collaboration. Once a museum begins to not only focus on teaching, explaining and talking but begins to also listen and learn, then a reflective and valuable space for creating useful initiatives and real social change will appear.

As a response to the questions above and many other questions even more ethically challenging, we decided to establish a 'Panel of Experience', not an Advisory Board, but instead a panel put together by people with special personal knowledge of the welfare system. The first panel, established in May 2017, consists of people who have spent part, or all, of their childhood in institutions. The reasons for participation in the panel are very varied. Steff said, 'I represent my 24 friends from my children's Home and we have a message about also remembering the more positive stories from children's Homes. The museum forgot about these stories to begin with'. Vibeke stated:

> I had a terrible childhood full of neglect and abuse, and as an adult I have always wanted to make a difference. Shout it out if something was or is done wrongly. Therefore, I want to be part of the panel.

In the written invitation, we wrote:

> The Danish Welfare Museum believes it is important that the lived stories from citizens in the welfare system are collected and documented. To do this ethically, respectfully and with nuance, we need your experiences and support … We want to create a joint panel, which will work from a wish to debate how the museum can produce research, exhibitions and educational initiatives in welfare history in the best possible way.

In practice, the Panel of Experience works to generate new ideas, it contributes to setting the course and areas of focus for our work, and it generates feedback on new ideas, projects and actions. The panel rarely agrees at first, but through debates and discussions with representatives from the Museum a situational code of conduct is formulated connected to the specific issue at hand. The process of inviting members from marginalised communities, for example, or citizens whose personal stories are intertwined with that of the welfare state, has, in many ways, also given rise to the need for the Museum to work in a useful way. A concrete example of this work is that the Panel of Experience has not only assisted, but actually guided the Museum professionals in the planning of new exhibitions and events, where the questions,

FIGURE 1.2 Vibeke, herself a Care Leaver and member of the museum's Panel of Experience in front of her own poster in the exhibition *After the Orphanage,* which she and the panellists co-created with the museum.
Photo: Jon Bjarni Hjartarsson, Danish Welfare Museum.

comments and ideas from the Panel have demonstrated more bravery and creativity than usually witnessed in the Museum offices. Establishing these close and respectful collaborations has proven to be useful for both the Museum and the community members themselves.

Additionally, when the Panel meets with Museum staff, an unexpected but most welcomed reflective institutional change occurs. It is a slow change, which is often not visible at first. It takes time, mutual respect and patience for this change to happen – for both the museum itself and the citizens we collaborate with. And it is my belief that this kind of change can only be created if museum management views these alternative collaborations as the very core of the management and development of the museum itself. In other words, these co-creative collaborations are not just the icing on the cake. They are the cake itself and this cake needs to be baked properly. Nobody wants to eat a badly made and unbaked cake.

The institutional change is a change created when challenging questions on relevant issues are raised in a safe and respectful environment. The long meetings, that often last for hours, are intense, and it usually takes days for all participants, both panel members and members of staff, to fully process what has been communicated and shared. In this context many museum managers reading this chapter might argue that their staff members and institutions simply do not have the resources to prioritise this work. My comment to this would be: Museums are some of the very last places in contemporary society where resources do still exist to do this work. We work in places where critical dialogue can take place in an inclusive, democratising and polyphonic space, and it is therefore both our ethical responsibility to use our resources

in striving for this change and our only way forward. Not prioritising resources for this work would be a stepping back in time, and museums are and need to be contemporary institutions striving for a better future and positive change. In management theory some theorists describe an 'appropriate disturbance' as a way to create positive change (Maturana and Varela 1987). Based on this theory, the institutional leader should, not too often, but occasionally, try to create 'appropriate disturbances' by asking tough questions, changing perspectives or by listening to the otherwise unheard. To me, the Panel of Experience continuously creates these appropriate disturbances for the sake of both the Museum itself and the panel members, thereby creating both institutional and social change that matters through 'mutual transformative relevance' (Simon 2016: 178). To use Nina Simon's illustrative description of relevance:

> When relevance goes deep, it does not look like relevance anymore. It looks like work. It looks like friendships. It looks like shared meaning. As the museum staff understood more about what mattered to their … partners, it came to matter to them too … That is the power of transformative relevance.
>
> *(Simon 2016: 20–24)*

That is the power of the Panel of Experience for the Museum.

Internships

The museum sector in Denmark comprises a varied workforce with members from many different groups of society. Many museums are embracing and inclusive workplaces with multifaceted workforces. What has also been known is that in many museums, you find a lot of staff members who work in different types of internships, for example students, volunteers, academics and, as relevant in this case, internships for unemployed and socially marginalised citizens. The rather troubling reality, as I see it, has been that these internships have been crucial parts of many economically fragile museum economies for decades, especially at smaller museums, as many interns have solved a vast number of work tasks at a low cost. For the first 20 odd years, this was the case at the Danish Welfare Museum, and some members of staff have, with a dose of sarcasm, stated that the reign of the poorhouse did not stop in 1974 but continued well into the 1990s with several interns passing through the museum to do odd jobs for short periods of time. To allay all doubt, this has stopped now, and the way we cooperate with interns is the exact opposite to that of late nineteenth-century society or the twentieth century when socially vulnerable, unemployed and poor citizens entered the poor- and workhouse (museum). According to contemporary Danish social legislation, the long-term unemployed who are categorised as 'måske jobparate' (possibly able to work), can be assigned to 'ressourceforløb' (resource training). In these courses the aim is for the unemployed to try various jobs to allow social workers to assess their employment potential. These courses and the ways in which unemployed citizens are recognised by the social welfare system in Denmark have been hugely criticised in recent years. Many citizens have noted unworthy conditions and the way in which chronically sick citizens have been forced to work, which has often worsened their health conditions in the process. Several professionals from within the sector have also been critical of the change that they have seen in the sector: focusing solely on employment and economic issues and excluding social politics, empathy and building relations. In the Danish newspaper *Politiken*, a social worker with 28 years' experience recently

drew attention to the views of the National President for the Danish municipal leaders of employment, health and social work, who said:

> I cannot rule out that we, in our dialogue with the employed citizens, can be better at keeping the focus on employment itself and ignore issues such as substance abuse, mental illnesses and social phobias. In the future, we need to distinguish between the worthy and unworthy.
>
> *(Gundlach 2018: 3)*

In this feature article, the quite disillusioned social worker further criticises contemporary debates on social policy that he sees as rooted in late nineteenth-century discourse, where the recipients of welfare should feel moral guilt. He boldly states that social politics in Denmark have dramatically changed during the last decades – a change from a beneficial incentive and obligation to support the most vulnerable citizens, to a vantage of mistrust where the recipients of welfare benefits should be constantly controlled.

The Museum has chosen to turn resource training upside down, challenging contemporary discourse. This of course is an ethical problem. Do we even want to be part of this workforce system? Our approach has been progressive in trying to offer an alternative to more conventional workforce programmes and instead focusing on empowerment and recognition. When we invite interns to develop the content of our 'resource training', we do it in close cooperation with them. The interns we collaborate with can be former drug or alcohol (ab)users, homeless, psychiatric patients or socially vulnerable and marginalised young people. In our internships we are *not* looking into whether these people have any resources or if they are 'worthy' or not. On the contrary, we know by experience that they have numerous resources that are of tremendous help for the Museum.

The content of these internships is based on the interests, experience and qualifications of the interns themselves, and the tasks assigned to the interns are embedded in the Museum's core tasks. What we see happening is both a personal and communal growth as the interns experience a transition from being viewed as vulnerable to being valuable partners with the Museum, a transition from being viewed as tacit recipients of welfare to active agents with appreciated knowledge.

The collaboration between interns and staff is creating numerous fruitful outcomes for the Museum too. The interns take part in different initiatives at the Museum, where their personal stories, knowledge and often thought-provoking comments create insight for both the public and the Museum staff about historical similarities and differences in living a marginalised life. In this way the close involvement of the interns in different museum initiatives is strengthening our practice. The interns are 'eye witnesses' to contemporary welfare, on one hand refusing to 'cover up' maltreatment of themselves or others by the system and, on the other hand, sharing the positive stories of support and respectful help. The interns use the Museum as a platform to facilitate change and insight for both professionals and the public. As we are engaging with more interns in depth, integrating the result into the operation of the Museum itself, a far fairer degree of representation is evident to Museum visitors. I suggest that this is why 22 per cent of our visitors were, in 2017, in the 'rare visitors' category, meaning people who are not regular museum-goers. The national average was only 3.6 per cent. There are bound to be numerous reasons why the Museum attracts so many 'rare visitors', but I assume that the valuable intern welcome team is a meaningful draw card. On numerous occasions, I have

witnessed interns personally inviting groups or individuals from shelters or drop-in centres for homeless, socially and/or mentally vulnerable or perhaps adults who have been in care as children. The interns are bridging social capital in the context of the museum and society. Their very presence, the ways in which they solve tasks, the important questions they raise, the way that they are keeping the museum relevant and the insight they generously share have become an embedded part of what the Museum is and not just how it operates. At its very core, this content of the collaboration with the interns is quite uncomplicated and is best seen during lunch at the Museum. Here you will find volunteers, technical staff, interns, curators, students, directors, educators and secretaries eating, drinking coffee, laughing, debating public and personal news and just sharing everyday life. The goal of the Museum is ambitious and possibly unachievable: We are working for the cohesion of Danish society, and the best place to start must be in creating cohesion in the Museum itself.

Changing social work

My final example of our line of work is the collaborative environment formed by interns, students, trained social workers and learning institutions facilitated by the Museum. Over the years, many students and teachers of social work have visited and collaborated with the Museum in different ways. In 2018, this collaboration evolved further. Why? Because our valuable interns recognised new possibilities of co-creating progressive pedagogy even before the curators did. As a result, today we are co-developing training courses for social work students. Courses, which use the poorhouse as a prism to comprehend the complexity of pre-welfare-state social work and to debate ethical issues in social work, courses, which address contemporary issues anchored in a historical consciousness and which engage in and qualify debates about the welfare state in a 'trinity' consisting of engaged students, the interns with personal insight and curators with historical knowledge. How do we achieve this?

In 2017 we opened the exhibition *Glimt af levede liv* (Glimpse of Lives) at the University College of Lillebaelt for social work. In this co-produced exhibition, life witnesses from orphanages, shelters and foster families shared glimpses of their lives (Danmarks Forsorgsmuseum 2017). At the exhibition opening, two of the life witnesses, one an intern and one a member of the Panel of Experience, shared, with the students and teachers, in-depth insight into personal experiences with social workers – good and bad. This turned out to be quite an eye-opener for all present as everyone asked thought-provoking questions. At the end of the event, the principal of the school not only acknowledged, but also sincerely thanked the participants from the Museum, stating that these types of debates were far more valuable than traditional education due to the authenticity, relevance and bravery shown by the life witnesses, and that he had witnessed a unique level of engagement that would make a difference for many of the students when they would be working as trained social workers in the near future.

Another example was the research project *Meeting the Power*. Here Gitte Berlin, a trained social worker, and graduate in welfare policies and history, made a comparative study of people who have experienced the welfare system, either past or present, and who had been in verbal or physical conflict with welfare system representatives, a highly relevant and contentious subject. For obvious reasons the voices of the past have been stilled; however, contemporary life witnesses became engaged in the project, sharing their experience of hopelessness, lack of recognition and arrogance from welfare system representatives. Gitte Berlin shared:

> The collaboration with the museum gave me an opportunity to create a setting where the socially vulnerable truly had a voice – a voice that told the story of countless encounters between authorities and clients, where the clients all too often were given the responsibility for these clashes and never allowed to actually remove the stigma that followed. Too many of them experience disempowerment and are thought of as voiceless and not able to speak their own mind.

The research resulted in a touring presentation where authorities and social workers take part in a dialogue on how to change this premise and hence, hopefully, reduce the violence by and against social workers. At the museum the project culminated in a presentation and debate which included the participation of interested members of the public, life witnesses and professionals from the field. One of the participants was a head of a regional social services organisation, and he subsequently stated that it had been important for him to take part as he and his staff needed to listen to improve their professional conduct and to create a needed change.

I believe that the polyphonic bridging taking place in the Museum, between life witnesses, students of social work and professionals and curators, is part of an important and much needed area of attention in Danish society. It is a fact for all engaged participants that insights and mistakes should be remembered, shared, debated and considered for future social work. We want to

> promote alternative voices bearing witness to society's variety and complexity. Sometimes they create a conflict with the larger story. Sometimes they lend it a degree of subtlety by adding experiences from everyday life. As museums wish to improve their social relevance, personal narratives can help bring forth aspects of contemporary and past society, which have had and still have consequences for both individuals and groups.
> *(Pabst et al. 2016: 10)*

Taking a stance

The Museum itself exists as a sociopolitical paradox. The more the welfare state system seems to be under pressure, the more it seems to become punitive and the more people are experiencing a system which challenges basic human rights and dignity, the more relevant and successful the museum becomes – and in this context it may be most important to point out: *useful*. Professionals working in other kinds of museums with no apparent connection to social history or the history of the welfare state could perhaps now think that these strategies that I have presented in this chapter are only relevant and useful for a subject-specific museum like the museum I manage. This is far from the truth. In my view, very far actually. All museums, no matter where, regardless of their collections, research, themes or size, can, and should, work strategically to become useful for the communities with whom they collaborate.

In my chapter I have done my best to exemplify how we have co-created a useful museum by not only listening but also following the advice, ideas and knowledge of alternative experts; by creating relevant collaborations with other sectors than the museum sector; and by continuously inviting in contemporary political debates. These are three easily transferable strategies which can be applied to all museums – that is, if the management will prioritise the resources.

The Museum is a sociopolitical museum at its core. In our work, citizens with experiences from orphanages, life on the streets, substance abuse and mental and physical illnesses are engaged as valuable 'insider researchers'. They work with us in producing new knowledge, new projects and methods. For us, this has proven to be both a respected and meaningful part of the Museum's profile. In addition, it has the huge benefit of providing us with new insight, and it challenges the otherwise established knowledge. In society, these citizens are often perceived as 'extras on the set of the welfare state'. At the Museum, they take a leading role. In partnership with them, we have a joint mission to secure the historical conscious-ness of the social welfare system, to contribute to the cohesion of society and to Create a social politics of the future in the historical setting of the museum with an engaged com-munity. Museum professionals working at perhaps more mainstream museums could easily choose to take the same path at their museums. 'Insider researchers' can always be identified and collaborated with no matter the museum's subject matter, and the involvement of these citizens will, I believe, always create the possibility of gaining new knowledge, of asking new questions, of increasing the relevance of the museum and strengthening and democratising the joint mission in securing a broader historical consciousness.

Working in this direction has provoked mostly support and some critique from the Danish museum sector. People disagreeing with this mode of operation have criticised the Museum for being political, taking a position and not being value-neutral. In Norway, a national survey conducted by ICOM Norway in 2015 showed that approximately 20 per cent of people

FIGURE 1.3 A group of alternative experts in front of the museum: Camilla, Henriette, Mette and Steven with the author (from left).
Photo: Jon Bjarni Hjartarsson.

working in the sector emphasise that museums must retain their value-neutral status, not advancing a position or putting forward opinions of their own, beyond the representation of different viewpoints and voices from their community (Pabst *et al.* 2016: 19). It is hard to know whether this number mirrors the situation throughout the Danish museum sector. But based on recent years' conference debates on this subject, if ICOM Denmark conducted the same survey, I estimate that the number would be the same. The Museum will continue to share accounts of past and present injustice targeting vulnerable citizens. All museums must 'as far as is practically possible, be prepared to take sides and speak out unequivocally against attempts to justify unequal treatment of people', as Professor Richard Sandell describes it (2017: 7). And interestingly enough this has not happened at the cost of more traditional museum tasks at the Museum. We now have a growing number of visitors, we are continuously developing new educational initiatives, our national and international visibility is increasing, and we have built up research as the initiator of several externally funded projects and through close cooperation with the University of Southern Denmark. And what museum board or museum management would not approve and support results like this?

The never-ending paradox of the Museum is that the more troubled and polarised Danish society seems to become, the more the Museum experiences political and public attention and the more people share their thoughts on why we, as a society, should learn to listen to stories from the alternative experts of the welfare state, because as the Australian comedian and writer Hannah Gadsby (2018) eloquently put it when describing the potential of taking a stance, 'You learn from the part of the story you focus on'. But there are important lessons to be learned, valuable stories to focus on and new alternative knowledge and insight to be sought after at *all* museums, and it is crucial both now and in the future for both society and citizens that we stay on track in our efforts to become increasingly more and more useful as museums. For citizens, society and history. The alternative is, in my view, simply unbearable to think of.

Acknowledgements

My sincere thanks go to the many wise and engaged people who have bravely shared their stories, energy and motivation with the Museum and myself. Looking back over the last decade I have lost count of the times I've been humbled by experiencing unique strength and wisdom in the most unexpected people and places. I would also like to thank my great colleagues and collaborators who were part of the *Welfare Stories* project, who all took part in setting the course for both the project and the museum – finding new ways to explore. A sincere thank you goes also to my family who not only support me but also understand why this work is so important for us all.

Bibliography

Danmarks Forsorgsmuseum (2017), 'Museet åbner udstilling på UCL', 6 December, viewed 4 August 2019, www.svendborgmuseum.dk/visforsorgnyhedermtemplate/558-museet-abner-udstilling-pa-ucl.
Danmarks Forsorgsmuseum (2016), 'Hus Forbi FORDI!', 11 May, viewed 17 September 2019, www.svendborgmuseum.dk/udstillinger/hus-forbi-fordi.
Gadsby, H. (2018), *Nanette* (television broadcast), directed by John Olb and Madeleine Parry, produced by Frank Bruzzese.
Gundlach, J. (2018), 'Kommunen overser sociale problemer. Fokus er udelukkende rettet mod at få flere i arbejde', in *Politiken (Debat)*, 21 July.

Maturana, H. and Varela, F. (1987), Kundskabens Træ, Aarhus: Ask.

Pabst, Kathrin, Johansen, E.D. and Ipsen, M. (eds) (2016), *Towards New Relations between the Museum and Society*, Oslo: ICOM Norway.

Rasmussen, J.K. and Smed, S. (eds) (2017), *Fattiggården (The Poorhouse)*, Ringe: Svendborg Museum.

Sandell, R. (2017), *Museums, Moralities and Human Rights*, London and New York: Routledge.

Simon, N. (2016), *The Art of Relevance*, Santa Cruz: Museum 2.0.

2

REWRITING THE SCRIPT

Power and change through a Museum of Homelessness

Jessica and Matthew Turtle

The Museum of Homelessness (MoH) is a social justice museum that is responsive to the day-to-day realities of homelessness. The museum has been created by people with direct experience of homelessness to collect and share the art, history and culture of homelessness and housing in order to make a difference to society today.

MoH is run by people at the sharp end of inequality with support from a broad network of arts, academic, policy and medical professionals. Our work draws on our archive of historical material and present-day experiences from the streets, hostels and temporary accommodation across the UK. We do not have a building but over the last four years our work has taken place in different places throughout the country.

Our volunteer, artist support, training and bursary programmes help individuals who have been homeless to change their lives. Our collection and archive help policy-makers, academics and charities to learn from the past and find new solutions. And our events and exhibitions form new connections and change public perceptions. Together, we fight for a better society and find hope in the midst of complex, divided times.

In 2014 the Museum of Homelessness was set up to shine a light on the histories of homelessness and its present-day realities. At the heart of the project was the desire to create a whole museum, from scratch, with direct experience of homelessness at its core. The outcomes would be twofold – a museum that would play a practical role in working with people but also heightening public awareness around homelessness at a time when it has been rising exponentially in the UK. But the idea was also to go much further than being 'informed' by, or 'deferential' to, people's lived experience, or worse, facilitating a kind of tokenistic involvement. This would be about a museum literally being created as a community, from top to bottom.

This chapter charts the complex picture that has emerged through this work and the way that the MoH community has shaped the organisation, bringing elements of community organising, political campaigning, theatre-making and material culture to its development.

We will set this development in a context of the present moment for UK museums as they sit within a wider landscape of social justice activity. The chapter will also explore the subtly pervasive, psychosocial barriers that society throws up which impact on museums, the public and those affected by homelessness.

We will then describe the various ways that, in the last few years, MoH has manifested as cultural spaces where all kinds of people can authentically take up membership to attempt to overcome the barriers already mentioned. We will discuss how there is no one-size-fits-all approach to access and participation, detailing how MoH creates different ways for people to get involved, holding a space for people to connect in a way that works for them.

Most importantly, we will challenge the notion of what a vulnerable group is, and look at how power operates in organisations and how seemingly 'vulnerable' people are actually essential members of the twenty-first-century museum.

Death on the streets

On 3 March 2018 in snowy central London, members of team MoH, together with a handful of people from the direct action group Streets Kitchen, created an exhibition in the space of one hour. Dreamt up the day before on the back of a bus, this 'placard exhibition' would soon be visible on national news and play a part in bringing central London to a standstill. Adding colour and texture to the *No More Deaths on Our Streets* demonstration, the placard exhibition was taken to Downing Street where it was installed, before being carried through Westminster in the hands of protestors.

The statistics that fuelled this direct action are all too visible in the UK. Homelessness has risen 169 per cent since 2010 (Butler 2018) against a backdrop of glaring inequality where 27 per cent of Londoners live in poverty (Tinson *et al.* 2017) and real wages have been stagnant since the 2008 financial crisis (Romei 2017). Snow was on the ground that particular week and MoH was one of countless groups across the UK concerned about the impact of the weather on society's most marginalised people.

The week before the protest, Streets Kitchen had decided to take over an empty commercial building, Sofia House, in order to house people beyond the reach of the authorities. The occupation was legal under section 144 of the Legal Aid, Sentencing and Punishment of Offenders Act 2012. Nevertheless, it was an act of defiance and frustration, fuelled by compassion for the street homeless population, whom the system was desperately failing. Within a few days of occupation the numbers of rough sleepers in the central London building (which had previously lain empty for more than five years) were more than one hundred. These were people who were too scared to engage with official offers of help in case they were deported; people who had been turned away from other shelters; LGBTQI people who were frightened of hostel environments; couples who would be split up if they went inside and would rather brave the freezing temperatures in a tent.

At the Sofia Solidarity Centre, all were welcomed. People could come in from the snow, no questions asked. Public response was phenomenal. People from the MoH community helped out with the night watch in the early days. In the middle of the night, a woman brought in a vat of soup she had made for the residents of Sofia. A couple drove over from Ilford with some bread and butter pudding, fresh from the oven. Donations flooded in as the residents thawed. This was the space where our first placard exhibition was made.

What was on the placards? Press clippings, reports and other archival records showing a history that has repeated itself. The placards were themed to highlight how government policy has tended to cause homelessness rather than 'fix' it. They shared news reports of the tragic deaths of homeless people through the decades. These kinds of stories, all too often

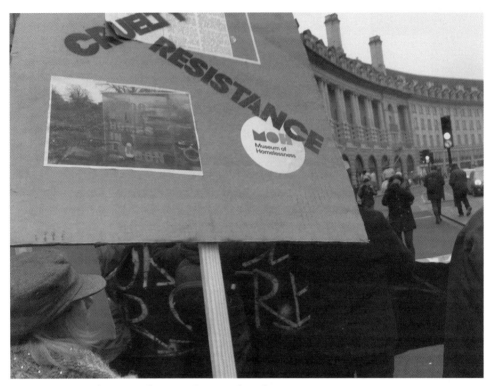

FIGURE 2.1 *No More Deaths on our Streets* – placards.
Photo: Museum of Homelessness.

forgotten, were the main catalyst for the protest. Just two weeks earlier, an Italian waiter who had been homeless was found dead outside the Houses of Parliament.

In campaigning terms, this piece of direct action would be called a stunt – an example of action that gets people's attention. In museum terms it might be called a 'pop-up'. In human terms, you simply cannot be in this field and stand by when people are dying. Using MoH's archive and collection within the protest highlighted all too sharply the successive failures in our society. The placards pin-pointed crystallising moments in UK housing and homelessness policy that have fuelled the levels of inequality we see today. The implementation of the 'Right to Buy' legislation in 1980 is one such moment. It led to the decimation of social housing stock in the UK, but this is rarely acknowledged in policy terms. The need for more council housing is the elephant in a room crowded with property developers.

As museum professionals we can offer lessons from history. Politicians and activists alike are busy with the day-to-day, but we are in a position to remind people about what has gone before to help influence decisions made tomorrow. The change we want to see is change for individuals, for institutions and for society. We have set MoH the overarching goal of using the art, culture and history of homelessness to tackle systemic prejudice and social stigma. We want better opportunities and access for people, we want more informed policy and we want better understandings of homelessness from the general public. Our community has created a *Theory of Change* which sets out our goals and everything we do is underpinned by this. The *Theory of Change* manifests in a variety of ways. For example an upcoming partnership with

the National Health Service will help us reach people with decision-making power regarding the way in which people are dealt with in hospital settings. This project, *Objectified*, will take about a year to develop. But sometimes, like that snowy week with deaths on the street, swift and creative action is needed.

The idea of creating an exhibition in one hour out of cardboard, stencils, photocopies and stickers that bear your logo would be anathema to many museum curators. There is a whole barrage of reasons not to do it: What about the quality? What about historical authenticity? What about balanced representation? What about reputational risk? These questions tell us something about why museums have not often been involved directly in this type of activity. Museums are much more likely to collect placards after the event than create them. Museums are unlikely to 'pop up' in squatted buildings, but MoH exists wherever it is needed.

Museums tend to reflect society as opposed to try and change something about it. However, because MoH is made up of people who have been there, merely reflecting homelessness is not an option. The myth of museum neutrality is one which is increasingly being challenged. The year 2017 saw the launch of the #museumsarenotneutral campaign on Instagram and Twitter which states that:

> Museums are cultural products that originate from colonial enterprise, they are about power. They are political constructs.

However, as the campaigners LaTanya S. Autry and Mike Murawski know, this myth still holds true as a foundational belief for many institutions (Autry and Murawski 2018). We at MoH also know that the acts of collecting, preserving, selecting and interpreting are inherently political. All involve a choice; none of these acts can ever be considered neutral. The people involved in MoH recognise the power that comes with developing and running a museum. We know that museums are not neutral and that is exactly why we have set one up.

Power and museums

In order to understand why a Museum of Homelessness is a useful endeavour we need to talk about power. From the outset MoH was concerned with power and how to channel it to those who rarely benefit. More widely, museums are wrestling with fundamental questions about their purpose. In the last ten years, policy and practice has focused on ideas around co-production (Simon 2010; Lynch 2011; Museums Association 2013), which is a process concerned with power and a step in the right direction, but is hard to get right. Funding cycles, institutional processes and historical conceptions of expertise can all hamper effective co-production. There has been talk more recently about museums themselves becoming activists in an era of seismic political change (Garrard 2016; Richardson 2017). There is anxiety within the field behind many of these debates. There are questions about ethics and representation and concerns about relevance in an era of funding cuts. However, the questions that should be asked are not really being asked: What power structures are operating here and how can they be changed? Who benefits from privilege and who doesn't? And if some people have more privilege than others, what are they doing with it?

In the UK, museums are in an interesting moment and discussions about power are starting to happen. Whilst there are brilliant, committed people in museums and pockets of very interesting work, we have yet to see systemic change. Successive attempts to 'diversify'

museums have failed (Davies *et al.* 2015; Turtle 2016), with conference sessions and policy papers providing the backdrop to many years of conversation on the matter. The data has gaps in it (Arts Council England 2019), but what does exist tells us that the diversity agenda is not serving those perceived as or identifying as 'diverse'.[1] This turgid status quo has led to movements like Museum Detox – a networking group for BAME professionals in museums and heritage – that are speaking truth to power and have recently emerged to disrupt the sector from within.[2] Change is starting to happen, but is slow and requires emotional labour on the part of the change agents who are often acting from a place of lived experience. We hope that we will reach a stage where more people with more privilege act as better allies.

However, the current movement is important and we believe it is fair to view it as part of a wider set of movements for change which includes the Me Too campaign and Black Lives Matter. It is particularly important that museums are being included in what can be viewed as a widespread reassessment of oppressive power structures. This is because the very thing that is problematic about museums (in the UK linked unquestionably to their historic role in the celebration of empire) is in fact the reason they are the ideal space for change. They were – and still are – powerhouses, literally and metaphorically. For centuries, they have played a significant role in educating people, establishing dominant norms and forming public perceptions. All too often they have shared a very narrow set of histories and present-day realities, through the lens of (relative to the population) a handful of curators and academics. No wonder then, that in 2018 they are highly contested sites. To change museums is to do no less than to rewrite the shared social script. People who have been excluded and subject to stigmatisation and oppression know this. Our people know this. That is, perhaps, why we are seeing new types of museum and activities around museums emerge.

It is probably fair to say that the people involved in the Museum of Homelessness community have something in common with other agents of change operating in the field today. It is likely that we all see the potential of museums as influential and change-making vehicles. However, the process of making social change is complicated, ethically tricky and often painful for those instigating it. It takes tenacity and thoughtfulness. To borrow from the campaigning world, it also needs a range of tactics, both insider (such as policy change and influencing those 'inside the walls') and outsider (such as direct actions and activities 'outside the walls').

For this reason MoH is not simply hoping to run a community workshop with existing museums or be brought in to programme for established galleries so that they can better welcome people experiencing homelessness, although we do that work happily. In addition to working with the sector, we are making a museum of our own; rewriting the script as we go. In this way, we are deploying our take on the mix of insider and outsider tactics that is needed to create real, substantive change. But if we are to challenge power structures in society, we must remain focused on them in our own organisation too. In all of our work, attention to power is at the core of our practice.

Changing the message

When we explore how power is working we inevitably arrive at an assessment of inequality. Inequalities of opportunity for homeless people include social exclusion, higher risk of mental and physical health problems and economic inequalities. Many of these difficulties are well known and throw up barriers for people at many stages of their life.

Our work responds to this by placing an emphasis on shifting wider social attitudes. Social stigma in relation to homelessness is centuries old and continues to play a negative role in public life. There is evidence that about a third of people believe that most homeless people have 'probably made bad choices in life that have got them into their situation' (Dahlgreen 2013). Similar numbers believe that alcohol or drug dependency is the single biggest contributor to homelessness (Salvation Army and Ipsos Mori 2015). In reality, the biggest single contributor to homelessness today is the end of assured short-hold tenancies. This is homelessness caused through evictions directly related to government policy changes and the predominance of the private rental market (Wilson Craw 2017).

The media and homelessness charities have not always helped people understand these systemic causes of homelessness. They often deliver highly individualised messages around homelessness that reinforce stereotypes. Charity fundraising almost always focuses on rough sleeping. Whilst sleeping rough is a devastatingly traumatic experience and a highly visible aspect of homelessness, there are many types and forms of homelessness existing in society. Forced reallocation for single mothers to cities miles away from their support networks, detention centres, young people 'sofa surfing', temporary accommodation that is unfit for human habitation, are but a few other examples. All of these examples have systemic inequalities as their driving factor.

Putting the individual rough sleeper under the magnifying glass might sell papers and keep the coffers full but it does nothing to shift societal attitudes. This has finally been acknowledged in a major piece of work, published in late 2017, by the homelessness charity Crisis and the Frameworks Institute. The report highlights the pervasive individualism that tends to shape people's perspectives of homelessness, often divorcing them from related and vitally important systemic issues such as poverty, inequality and the lack of available social housing. In it, the very justification for a Museum of Homelessness which reveals systemic issues is put forward:

> Homelessness is a story about individual people and their trials and tribulations; the public has very little access to robust discussions of its social roots, social costs and the social solutions required to address it.
>
> *(O'Neil et al. 2017: 4)*

Making a Museum of Homelessness

To make a Museum of Homelessness which addresses these biases whilst trying out different ways of operating museums, we knew we needed to start with the people. Not start by (as the reader may have guessed by now) telling the stories of homeless individuals but by inviting people with lived experience of homelessness to actually make MoH a reality. If we got that right, everything else would follow. This approach is inspired by what has gone before. In the UK there is a wonderful history of change-making in homelessness at a grassroots level. Since the 1950s, there has been a tradition of women and men, some of them homeless, rising up to make change.

One of MoH's co-founders, Jess, was born into a grassroots community for homeless people set up by her parents Fred Josef and Jane Josef (née Rothery) in 1978, after Freddie had spent many years rough sleeping. The community Jess grew up in was named after Anton Wallich-Clifford, a radical probation officer who founded the Simon Community in London after making friends with Freddie, one of his case load in the 1960s. These communities

offered a completely different way of being than existed in society at the time. Street homeless people and volunteers lived and worked side by side. The results were transformative for everyone involved.

Jess grew up as part of a large family of people whom society had rejected, working together to make something new and different. In this space people were accepted just as they were and this acceptance often meant people were able to emerge as their best self. There were only three rules: no drink, no drugs and no violence. In the community, disagreements were discussed with the whole community at a meeting, rather than being allowed to fester. In the community, everyone contributed what they could; cooking breakfast for 50, digging the garden or looking after some of the newer residents as they slowly unfurled from the trauma of the streets. The community was porous, some people came in and out and the door was always open. This community was not about the individual, but rather about the things that could be achieved together. Perhaps inevitably, this culture has strongly informed the setting up of MoH and its approach to people.

Right from the start, we knew that if we could kindle something of this 1960s and 1970s approach to working with people within a heritage and artistic setting then the results would be phenomenal. It has manifested practically in a number of ways, which we explore in the following sections. At the core of it all is the idea that direct experience of homelessness is at the centre, making decisions and driving things forward, but that the focus is not on the individual story.

The core group

The core group is a small group of people who meet monthly at MoH's offices to discuss the major creative activities of the museum and its strategy. It is a group of people, many of whom have direct experience of homelessness, who come together to shape the future of the organisation. In those meetings we talk about what MoH is doing and make decisions. It is not a formal setting; the discussions are practical and informed. What is common to all is a passion for the issues. The core group has written its own terms of reference and reflects MoH's commitment to devolved decision-making. All core group members are empowered with decision-making for major developments facing the charity. Over the last year the core group has decided which funding partners to approach and has worked with the trustees to write a three-year strategic plan for MoH. The core group is the lifeblood of MoH, a work in progress, and is a mechanism for making sure MoH is paying close attention to its own power structures.

Object storytelling

The dynamic of the core group affects MoH's work intimately; our flagship launch campaign *State of the Nation* was both coined and driven by the late Jimmy Carlson OBE. Jimmy was one of our first core group members and came through our partnership with Groundswell, a homelessness charity which Jimmy had been part of for two decades. Jimmy spent nearly a quarter of a century living on the streets and in hostels and then spent the next 20 years dedicating his life to tackling homelessness. He was awarded an OBE for his services to homelessness. Jimmy was a rare kind of person and we sadly lost him unexpectedly in January 2017.

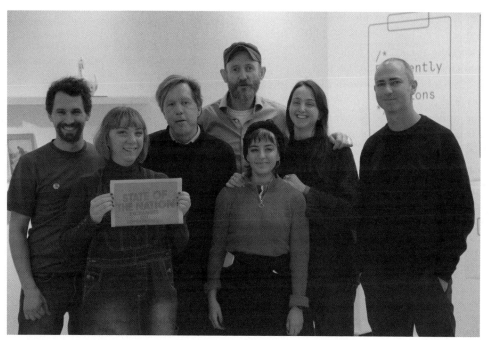

FIGURE 2.2 State of the Nation team at Tate Liverpool, January 2018.
Photo: Museum of Homelessness.

In 2016 when we were offered the opportunity to host a weekend of activities as part of the Tate Exchange programme at Tate Modern, Jimmy immediately recognised its significance and coined the phrase *State of the Nation* to set the tone for what we would share with Tate's visitors.

This was an important moment for MoH. It was the first time it had creatively developed a major public presentation. Jimmy led a discussion where the core group decided we could not support the idea of displaying inanimate objects in gallery spaces with fixed descriptions. Jimmy argued passionately that this way of doing things simply would not do justice to the complexities. A 150-word caption written by someone on behalf of someone else was particularly galling to the core group. In our view, this model of display and interpretation was too cumbersome and not fit for purpose. Instead, we worked up an idea of 'exchanges', an alternative model to an exhibition with the purpose of devolving as much power as possible. We decided that people could offer objects of their choosing and give a recorded testimony about the importance of that object. Donors would be anonymised and could withdraw their testimonies and objects at any time – the power of veto. The testimonies would be shared with the public verbatim.

The result was our first 'exchange' held at Tate Modern in April 2017. The show resembled something of an exhibition, but was actually quite different. Part installation, part storytelling space, the display of objects and stories from across the UK offered a snapshot of what is happening on the streets, in hostels and in alternative communities. Through these testimonies, we revealed the structural issues – the *State of the Nation*. Objects were donated from a wide mix of sources, including homelessness workers and volunteers, activists and people

experiencing various forms of homelessness. We worked with actors who themselves have experienced homelessness to tell the stories verbatim. What defined the process was that it paid close attention to ethics, from the power of veto for donors through to fair pay for our actors. The artistic result was moving, profound and real.

The relationship between the core group and the representational practices of the MoH is intimate and manifests in fascinating ways. This commitment to devolving power means that the realities of homelessness are not sugar-coated. MoH events can be intense experiences. We aim for a mix of people: policy-makers, the public and people with direct experience discussing the issues at our events. Issues-based creative work is emotionally charged, but feed-back from current participants and visitors tells us that it is rewarding and enriching.

A space to be 'un-well'

The honest, unassuming, creative culture of the core group has taught the organisation so much. We also have core group members to thank for MoH's approach to the well-being agenda that is increasingly predominating within museum practice. Within well-being discourses, cultural activity is seen as a positive and healthy act. Indeed, there is great power in the arts to be a positive force in people's lives but there is a danger of instrumentalising people. It is easy to assume a 'helper' and 'helped' dynamic, but the richest and most productive creative work at MoH has manifested when there is a two-way relationship.

There is also a real danger of harnessing perceived 'vulnerability' for a particular aim – a temporary community project, or to improve wellness to meet funding criteria. This is ethic-ally complicated at best. Often there is a (perhaps unconscious) assumption that the museum has more to offer the 'beneficiary/participant' than vice versa. Our experience is that, with the right setting and relationships in place, it is much more likely to be the other way round.

Our work has taught us to strike a note of caution when thinking through or acting upon observations about the well-being of those involved in our organisation. We want to urge other museums to enter the well-being arena with thoughtfulness, discernment and respect for those they might seek to make 'well'. Our core group members have stressed the importance of being accepted as they are and being able to be 'un-well' and still participate in the life of MoH on terms that work for them. The idea of going as far as measuring people's well-being is very problematic for people in our organisation and even if we were to do so, the results would not necessarily show an upward trajectory. We are operating in a field where people have been through terrible experiences, where stigma is the norm, where death comes easily and people pass unremembered.

There is no doubt that heritage and creative projects are indeed hugely positive for people. There is an important place in society for projects and organisations that allow people to lose themselves in creativity – Streetwise Opera, for example, offer a very precious space where people can leave their issues at the door. However, as MoH has developed, it has increasingly been shaped into a social justice organisation by its people. This means that, for our organisa-tion, creative participation alone is not sufficient to address what is happening in society today. The MoH community also wants to reveal the wider systemic violence that people are subject to, both in historical terms and today.

We are inspired by the thinking of Christopher Scanlon and John Adlam on this. We have been lucky to have Scanlon as an advisor to MoH since the early days. They write persua-sively that (in the frame of the welfare state) a well-being programme which targets individuals

whilst ignoring the structural issues that might cause someone to have a mental health crisis or chronic depression is 'an unrealisable utopian social-inclusion model without a realistic socio-political model for understanding the phenomena being treated' (Scanlon and Adlam 2010: 109).

Our work on the ground has taught us that a Museum of Homelessness attempting to 'fix' individual well-being without trying to improve the bigger picture – what we would call societal well-being – is indeed a limiting endeavour. Offering a person the opportunity to bolster their well-being through a Museum of Homelessness creative programme without simultaneously calling out the systemic inequalities – evident in our archive and collection – that have caused them to be in that position in the first place is, at best, misguided, and at worst, disrespectful. It is no surprise then that everyone who has been involved in the life of MoH so far has been hugely passionate about revealing structural inequalities. We find that everyone's well-being is most enhanced when we are all working together to make wider change happen.

Revealing the structural stuff – nationally

Within the last two years, the core group has worked hard to position MoH as a national organisation because homelessness is a national set of stories. At the time of writing, MoH is a loose band of people who give their time and creative energies. We occupy two desks in the basement of a social enterprise hub. We have a small storage unit that holds our collection and archive and more creative ideas than we can deliver.

But our size and scale have not stopped us from working nationally. To this end, we have created projects that reflect the national picture. *State of the Nation* involved collecting objects from donors from Glasgow and Leeds, and it travelled to Tate Liverpool in January 2018. One of the highlights for our week's residency in Liverpool was to present the project *Frequently Asked Questions*. *Frequently Asked Questions* is an installation of facts, diagrams, maps and statistics that lifts the lid on the twists, turns and bureaucratic dead ends faced by Britain's most vulnerable people when attempting to contact local councils for support for their most basic needs.

This landmark artwork by Anthony Luvera and Gerald Mclaverty aggregated responses from 61 local authorities across Northern Ireland, England, Scotland and Wales, highlighting how they responded when asked questions such as 'Where can I get something to eat?' Informed by Mclaverty's experience of homelessness, the questions illustrate rough sleepers' struggle to meet their most basic needs.

Councils were given new powers and responsibilities last year by the Homelessness Reduction Act. This timely artwork offers a state-of-the-nation snapshot on a pressing issue. Only 5 of the 61 councils responded to Gerald's email. The brilliantly original concept behind this work, to simply email councils and turn the results into an artwork, reflects how lived experience must lead our programme. The duties imposed by the act come into force in April 2018 and the results of Luvera and Mclaverty's project show that much work needs to be done.

Artists involved in the MoH community are incredibly important to achieving the change we want to see. Another long-term collaborator and core group member is the social artist David Tovey. MoH has been honoured to bring David's work to wider audiences. David works in a variety of media and his work reveals the effects that inequality and social stigma have. Visitors often cry when encountering David's installations. In January 2018, David was made a commissioner for Shelter's Big Conversation on Social Housing which will present

recommendations to government on the future of social housing in the UK. David's passion and abilities to use his direct experience to make change are inspiring and exactly in line with MoH's aim to achieve institutional and social change through art, culture and heritage.

Conclusion

This has been quite the beginning and one which has been accelerated by our peers and colleagues in the sector. The wonderful response to MoH has demonstrated that museums want to do this work well and that they are staffed by people who care about society. MoH owes a huge amount to other museums opening their doors and wanting to make partnerships with us. We hope there are some takeaways in this chapter for colleagues and peers who want to do socially engaged work but are not sure where to start.

At the centre of it all is attention to power and attention to relationships. Building trust through long-term relationships is essential for a twenty-first-century museum, even when funding cycles make this difficult. Building trust means valuing people's experience and contributions, not as participants or 'vulnerable groups' but as members of a community of purpose.

Our journey has taught us that a conventional approach to museum practice does not work for people who have been marginalised and excluded. Given the opportunity, people will rewrite the script. We have had the joy and challenge of turning everything on its head; from throwing out the idea of the museum label to completely rethinking what makes an object valuable. In fact, as our most recent 'placard exhibition' demonstrates, the script is constantly being rewritten, responding to what is most useful for people and for society.

There have been twists and turns. We have had collective moments of insight, of triumph and also of deep sadness. What has emerged through all of this is something incorporating community organising, political campaigning, theatre-making and material culture. Somewhere inside it is a museum – and a collection – coming to life where it is needed.

Acknowledgements

We are so grateful for the creativity, insights and guidance of MoH's community in the early days; David Tovey, Lainie, Damien, Phoebe Barnicoat, Zoe Louizos, Peter Nutley, Andy Palfreyman, Gary, Tony McBride, Ben Smithies, Sherrie Cameron-Akoto, Elle Payne, Kerry Norridge, Rhymestein, Anthony Luvera, Gerald Mclaverty and the late Jimmy Carlson OBE.

Love and solidarity to our friends at Streets Kitchen, Focus E-15 and elsewhere fighting tirelessly for a better world.

And finally our respect and heartfelt gratitude to all our object donors, who shall remain anonymous, whilst their stories shall be amplified.

Notes

1 A significant number of organisations funded by Arts Council England are not able to report on diversity targets for the workforce. In the 'Creative Case' report, Arts Council England states that responding organisations often indicate that in relation to categories of ethnicity, disability and sexuality, high levels of staff members, contractors and volunteers report on this data as 'unknown'. Arts Council England believes that the level of unknown respondents ranges between 34 per cent up to 62 per cent depending on the category.
2 BAME is a term long used in the UK to refer to black, Asian and minority ethnic people.

Bibliography

Arts Council England (2019), 'Equality, Diversity and the Creative Case: A Data Report, 2017–2018', viewed 24 February 2019, www.artscouncil.org.uk/sites/default/files/download-file/Diversity_report_1718.pdf.

Autry, LaTanya S., and Murawski, M. (2018), 'Museums Are Not Neutral' *Artstuffmatters*, viewed 12 January 2019, https://artstuffmatters.wordpress.com/museums-are-not-neutral.

Butler, P. (2018), 'Rough Sleeper Numbers Rise in England for the Seventh Year Running', The Guardian, 25 January, viewed 8 March 2018, www.theguardian.com/society/2018/jan/25/rough-sleeper-numbers-in-england-rise-for-seventh-year-running.

Dahlgreen, W. (2013), 'Public Conflicted about Homelessness', Yougov, viewed 11 March 2018, https://yougov.co.uk/topics/politics/articles-reports/2013/10/22/public-conflicted-homeless.

Davies, M., Griffiths, C. and Wilkinson, K. (2015) 'Diversity in the Workforce and Governance of Arts Council England's Major Partner Museums: Research Project', Arts Council England, viewed 26 February 2019, www.artscouncil.org.uk/sites/default/files/download-file/Diversity_in_the_work-force_and_governance_of_Arts_Council_Englands_Major_partner_museums_Research_project.pdf.

Garrard, C. (2016), 'Museum Activism Is Becoming a Rich Field of Diverse Tactics for Change', Museums Association, viewed 24 November 2018, www.museumsassociation.org/comment/07122016-tools-of-the-museum-activist.

Lynch, B. (2011), 'Whose Cake Is It Anyway: A Collaborative Investigation into Engagement and Participation in 12 museums and galleries in the UK', Museums Association, Paul Hamlyn Foundation, viewed 23 February 2019, http://ourmuseum.org.uk/wp-content/uploads/Whose-cake-is-it-anyway-report.pdf.

Museums Association (2013), 'Museums Change Lives', viewed on 16 January 2019, www.museumsassociation.org/download?id=1001738.

O'Neil, M., Gerstein Pineau, M., Kendall-Taylor, N., Volmert, D. and Stevens, A. (2017), 'Reframing Homelesness in the United Kingdom', viewed 6 March 2018, Crisis, www.crisis.org.uk/ending-homelessness/homelessness-knowledge-hub/services-and-interventions/reframing-homelessness-in-the-united-kingdom-a-frameworks-messagememo-2018.

Richardson, J. (2017), 'Should Museums Be Activists?', *MuseumNext*, 24 April, viewed 13 January 2019, www.museumnext.com/2017/04/should-museums-be-activists.

Romei, V. (2017), 'How Wages Fell in the UK while the Economy Grew', The Financial Times, viewed 2 March 2018, www.ft.com/content/83e7e87e-fe64-11e6-96f8-3700c5664d30.

Salvation Army and Ipsos Mori (2015), 'Perceptions of Homelessness', Ipsos Mori, viewed 21 February 2018, www.ipsos.com/ipsos-mori/en-uk/perceptions-homelessness.

Scanlon, C. and Adlam, J. (2010), 'The Recovery or the Modelling of a Cover-up? On the Creeping Privatisation and Individualisation of Dis-ease and Being Un-well-ness', *GroupWork*, 20 (3), 100–114.

Simon, N. (2010), *The Participatory Museum*, Santa Cruz, CA: Museum 2.0.

Tinson, A., Ayrton, C., Barker, K., Born, T. and Long, O. (2017), 'London's Poverty Profile', Trust for London, viewed 27 February 2018, www.trustforlondon.org.uk/publications/londons-poverty-profile-2017.

Turtle, J. (2016), 'Valuing Diversity: The Case for Inclusive Museums', Museums Association, viewed 26 January 2019, www.museumsassociation.org/download?id=1194934.

Wilson Craw, D. (2017), 'Landlords are Turfing People Out of Their Homes Without Reason – and It's Completely Legal', The Guardian, viewed 27 February 2018, www.theguardian.com/housing-network/2017/jul/25/no-fault-evictions-landlords-tenants.

3

MARCH OF WOMEN

Equality and usefulness in action at Glasgow Women's Library

Adele Patrick

This book posits 'unhelpful' versus 'useful', promoting a notion of the 'useful museum' as opposed to charitable and ultimately disempowering notions of being 'helpful'. This chapter demonstrates how this is working in action at a dynamic, inclusive, multifaceted useful institution in Scotland, run for and by women. In others words, an institution that aims to be used by, and useful for, women.

At its basis, Glasgow Women's Library was an aspiration to challenge the representation of Glasgow's culture as embodied by white men. Inspired by and connected with international feminist art and archive projects from the 1970s on, the Glasgow Women's Library (GWL) launched in Garnethill, Glasgow in 1991. Throughout our history and with the focus fixed firmly on equality, diversity and inclusion (EDI), the Library has worked across two key terrains: a commitment to uncover and foreground lost and hidden histories of women and to nurture contemporary women's cultural and creative endeavours. GWL projects typically foreground and combine *active citizenship* (highlighting equalities activism in the past with links to contemporary campaigns) and *living histories* (how we might ensure that women making contributions to culture today are supported and recorded). Both themes are evident across hundreds of events, programmes and projects: from the development of groundbreaking women's heritage walks led by volunteers since 2008, to countless projects that focus on the recovery and restoration of women into history or that support women to make their voice count.

Almost thirty years on, GWL still has as its primary focus women actively uncovering the hidden histories of women. However, the context has changed: although still the sole resource of its kind in the UK, three decades on, there has been a sea change in the library, museum and archives sectors of which GWL is a part. In 1991, when GWL was launched, the cultural, social and political climate on equalities was 'unhelpful' to say the least. GWL was forged to address a widespread, normative lack of representation, a structural deficit in equalities thinking in the collections field. Today, GWL is finding itself in much more productive dialogue with many mainstream institutions who, coincident with the development of GWL, have been to a greater or lesser extent grappling with the sometimes unhelpful notion of 'inclusion', and shifting, with some difficulty, towards 'active agency'. Indubitably,

the museum sector is in protracted throes of change. Thirty years into a digital revolution, three generations on from the germination of equalities campaigns in Britain, with seismic political and financial churn nationally and globally, the sector has been forced into a prolonged period of often reactive introspection, debate and action confronting challenges along the fault lines of representation, reinvention and relevance.

Robert R. Janes is one of the growing number of theorists advocating museum activism. In his call to action, from incremental to seismic progress, from timidity to dynamism on equalities, he has written:

> The here and now for museums is paradoxical – replete with opportunity and constraints; freedoms and danger; clarity and chaos – contradictions born of external issues that push, pull and batter. These paradoxes are, in turn, accompanied by a host of internal museum issues that hinder organisational courage, foresight and empathy.
>
> *(Janes and Sandell 2018: 1)*

In this context, while models of museums that have already charted a course based upon the values of equality remain few in number, GWL offers two useful contributions. First, we will reflect on the ways in which equality is a powerful dynamic in the workings of GWL. Secondly, we will provide an illustration in action, by focusing on GWL's project *March of Women*. We will demonstrate how this method of working has given rise to agency within the Library's locale and with wider communities of interest and specifically for those so often excluded from the museum offer. The aim here is to share the ways that working with equality, diversity and inclusion (EDI) as core values can be of wide relevance, common interest and social impact in the *useful* museum.

Context and origins

In its first two decades GWL grew from a grassroots project run entirely by volunteers into an Accredited Museum and a Recognised Collection of National Significance. Now staffed by a team of 25 specialists working in the fields of Archives, Libraries, Lifelong Learning and Equalities, and with a volunteer cohort of over 100, GWL has amassed and makes available through exhibitions, residencies, online resources and programming a remarkable, varied collection that charts women's and equalities campaigns and conserves and makes accessible women's histories, creativity and cultures. GWL is regarded as a uniquely welcoming, accessible and inspiring museum resource: all the items in its Library, Archive and Museum collections have been donated, reflecting the breadth of its users and donors. Literacy and English as a Second Language (ESOL) classes form part of the daily offer. In recent years, as the climate on equalities has gradually improved in the collections sector, GWL has become something of an exemplar, winning awards for its environment, its events, activities and collaborations and its approach to learning. From its base in the heart of Glasgow's East End where it has become an influential anchor resource in its neighbourhood (amongst the 5 per cent most deprived areas in Scotland), GWL has developed pioneering projects and programmes frequently with partners that use the agency of the arts and an equalities focus to catalyse positive change.

The name, Glasgow Women's Library, was always something of a misnomer. In fact, GWL works across Scotland and with international partners. It is used by people of all

identifications and is the only accredited museum of women's history in the UK. Its difference is that it is firmly based upon its specific relation to communities and in/exclusion, critically, identifying the mainstream resources as 'unhelpful' in addressing deep-seated inequalities.

GWL created a locus for the safeguarding, collecting and uncovering of women's creative, cultural and political histories, to help incubate personal and collective agency in the context of Glasgow, a notoriously 'masculinised' post-industrial city where women's political voice, even by the left, was seen as secondary (to addressing class inequalities). This dynamic would grow into a new type of institution in Scotland, one founded upon the principles of collectively addressing the partiality of mainstream provision and the lack of representation of women in the civic landscape and public record.

GWL has been keen since the outset to respond to the intersections of exclusion and the historic and contemporary barriers experienced by women.[1]

Our aspirational models were never those found in the national or mainstream library, archive and museum sector, and we looked further afield for inspiration.[2] We had no collections policy or staff, no stores and no stock budget. However, the unusually high numbers of creatives in our ranks from the start ensured we charted a trajectory of dynamic and reflective purposefulness.

The Library's key strategies

1. **Creative agents and agency**

 Women creatives working as volunteers, sessional workers, 'in residence', as staff members and on the Library's board, whose practice is focused on interrogating in/equalities, have been continually active in the processes of forging what GWL is and could be. Hundreds of writers, artists and filmmakers have helped develop the physical environments, our collection and methods of working and are amongst the people who make up the communities we represent. GWL fosters creativity, and works on the principle that each person, across the wider stakeholder team of worker, volunteer and Library user, has creative insights and potential to make cultural contributions. We have found that the dynamic of equality is accelerated when creatives are involved and that artists, writers, filmmakers and designers contribute vital expertise in engendering purpose and participation.

2. **Collections professionals supporting the core work of access**

 Unusually GWL started to employ staff in recognition of the barriers to accessing its museum, archive and library resources ahead of its recruitment of collections professionals. For example, Young Lesbian Peer Support project workers were the first GWL staff to be recruited, before our first librarian. Adult Literacy development workers were working full-time for a decade at GWL before we recruited our first museum professional. The Library has also had a full-time Black and Minority Ethnic Development worker longer than we have had a professional archivist. Our work with collections professionals has been characterised by a process of collections professionals 'unlearning' those standard museum policies and procedures that tend to prioritise the centrality of objects care, conservation and compliance. Our collections staff have been mindfully shifting their perspectives from mainstream institutionalised thinking which emphasises and values things over

people, towards a commitment to public ownership, access and the removal of barriers to understanding, interpreting and handling objects.

3. **The dynamic of equality, diversity and inclusion**

 Across the mainstream museum sector in Scotland, EDI may be, at best, only one of a range of specialisms, limited to the actual or perceived responsibility or pet passion of one or a small team of staff.[3] In contrast, everyone who works or volunteers at Glasgow Women's Library shares the role of addressing the impact of privilege and structural, institutional and attitudinal barriers. This radically expands the possibilities of meaningful engagement of people with our collections and programmes. We are a values-led resource where staff aim to become increasingly specialised in equalities as a priority and where only a small number of our team (currently equivalent to one and a half full-time team members out of 25 staff) are collections professionals. In our experience of the wider sector this remains an inversion of standard practice of cultural institutions.

4. **Securing values in a locale, creating a locus for change, inspiration and support**

 Although the varied premises the Library has occupied since launching in 1991 have steadily improved, we have been most at home when we have been part of a neighbourhood: at the outset when we were embedded in the Garnethill community, and since 2014 when we became an 'anchor' cultural organisation in Bridgeton. It now feels critical as a museum for it to be able to offer a space that responds to its context, that has what Mercy McCann has dubbed 'the power to convene' (McCann 2019).

 This issue of useful and appropriate location is very important. In the case of the Library, space and locale offered us the best opportunity, after a sequence of unfit-for-purpose premises, to purposefully add value in a neighbourhood with a rich heritage and to help address a community's needs. In 2014 as GWL prepared to relocate, Bridgeton and environs was an area poorly served by arts and cultural provision, was widely perceived as fostering sectarianism within the neighbourhood and had a rapidly changing demographic with the influx of new citizens into a predominantly white local population. The wider GWL team had undertaken an options appraisal using a feminist evaluation matrix before deciding that Bridgeton would offer us an opportunity to create a permanent home for our resource whilst making a significant impact for and with women and their families in this area. Our aim was always beyond offering short-term 'lifelong learning' opportunities to siloed groups, but more to unleash the dynamic potential of our inspiring collections and assist women in playing a long-term personal and collective change-making role in a regenerating locale.

In fact, the move to Bridgeton marked the most significant period in the Library's history, coinciding with the Library's 25th anniversary. Relocation enabled the Library to work towards offering fully accessible premises for the first time; the new premises included space for screenings, exhibitions, training and events. The Library was also able to marshal its collections from dispersed storage into custom-built stores. These changes led to heightened public and press recognition, winning the Library no less than 16 awards in a two-year period for its building, staff actions and community collaboration programmes. In 2016 GWL became a Recognised Collection of National Significance and the Icon Awards Arts Venue of the Year in Scotland. We won a raft of awards for the outcomes of a 1.6 million pound sterling refurbishment programme that took place coincident with the development of the ambitious *March of Women* project.

March of Women

In the first decade GWL was run entirely by volunteers. When we did recruit our staff, they brought their own lived experiences and perspectives of exclusion and social in/justice. We all benefitted from the resource we were creating, sustaining a sense of volunteers (and later staff) being *of* rather than *for* the 'communities' of women who formed our evolving constituency. This is clearly illustrated in the project, *March of Women*.

March of Women illustrates how some of the Library's key approaches to working are driven by the dynamic of equality-focused thinking. It is a project that took place in the challenging circumstances of the Library's relocation, involved working within and with a new community with its own challenges and sought to connect women from very diverse backgrounds with complex materials, texts and ideas. It was critical for GWL that this project should not be perceived by the new community we aimed to work with as short-term with no lasting 'legacy' but would instead communicate our approach to working and encourage wide and deep 'ownership'. *March of Women* was led by an array of creatives (from within and outside GWL), involved our collections team working in imaginative ways with other colleagues to support the goal of full accessibility and the widest participation, was driven by a focus on EDI and was grounded within a specific locale.

The project was developed in partnership with an academic institution. Coincident with the move to Bridgeton, Anna Birch from the Royal Conservatoire of Scotland (RCS) had approached GWL to explore a collaboration that was to become *March of Women*. The partnership agreement with RCS underscored our twinned values and aspirations, for the project to focus on the links between the importance of past and current collective action and active citizenship by women. *March of Women* combined the skills, experience and resources of both GWL and RCS. Opportunities for participation and learning were taken up and offered to the project by many individuals and groups through a range of pathways (volunteering, workshops, meetings). Throughout, participants were encouraged to discover and meaningfully engage with some of the key resources in our collections and express their own creative responses.

We were keen that this, the Library's first major arts event in our new home (and developed whilst building works were taking place), should allow mass participation, have a public performance element, should inaugurate in a creative way GWL's occupancy of the space and involve a highly visible spilling out into the streets around the Library. *March of Women* would help us mark our presence within our new locale and enable longer-term connections with our new neighbours.

March of Women used a neglected text, *A Pageant of Great Women*, one of the most successful suffragette plays of the early twentieth century, written by Cicely Hamilton, as its focus. When first performed in London in 1909, this work had served as a catalyst for activism, raising awareness of women's historic achievements whilst being a rallying device for the suffrage campaign.[4] In discussions with RCS we could see that the involvement of participants in the production of the play might address the contemporary context of Bridgeton. Here, where women were subject to social and economic injustice, the production had the potential to ignite a sense of contemporary agency and enable deeper widespread engagement. For the GWL team and participants the project also provided an opportunity to discover what could be staged in our new home and for us to learn more about performance and the technologies of staging from specialists. We could envisage the ways that creatives working with collections

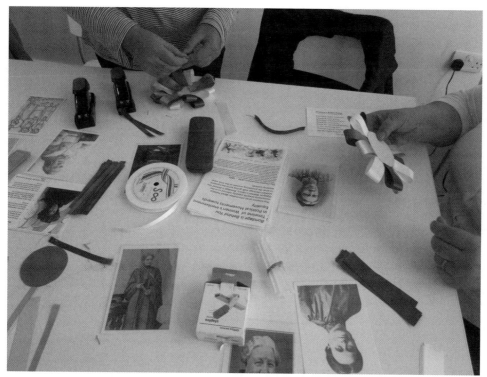

FIGURE 3.1 *March of Women* workshop participants researching suffragette histories and creating rosettes.
Photo: Adele Patrick.

staff and those specialised in equalities (for example literacy tutors and ESOL staff) could bring our collections to light in new ways for participants, and recover heroines hidden from history.

March of Women would become a project informed by GWL's collections; participants engaged with drama manuscripts, pro- and anti-suffragette memorabilia, books and archival records. The project also linked to our core aims, focusing on campaigning strategies, energies and efforts of women in the late nineteenth and early twentieth centuries, and women's fight against historical erasure and claims to have their (political) voices heard today.[5]

When *A Pageant of Great Women* was first performed, suffrage drama, processions and pageants, especially spectacles on the scale of this production (involving 100 performers, often including the most prominent women actors of the day), had proven themselves to be an effective method in the suffragettes' propaganda arsenal.[6] Our production would add more content, specifically involving women in making script and character additions based on their discovery of Scots heroines and women of colour.

The production of a relatively arcane and inaccessible early twentieth-century play in the locale of one of the most deprived areas in Europe in the early twenty-first century opened up questions of the validity of the process. Was this an anachronistic imposition, an idea that could merely involve local women as 'bit players'? Or could the play's message be pressingly relevant in the light of the febrile political context of Scotland?

In her championing of the contemporary relevance of the play, Cockin had drawn attention to the perennially relevant need to restate the political and cultural gains and contributions of women of the past. For Cockin, *A Pageant of Great Women* is an explicit recovery and limelighting within the script itself of women of the past (Cockin 2001). Indubitably, women's contributions to Glasgow's and Scotland's culture had been erased and largely forgotten. Might this be a vehicle to involve communities of women in their recovery?

Of the original *Pageant* characters, only four were women of colour and no Scots featured in the pantheon. In order for the restaging to have a chance of engaging and involving GWL's communities of staff volunteers and users, we committed to reshape and refresh the content.

In Glasgow we recognised that we would need to involve participants at the earliest stage in all aspects of the production in order to ensure people's ownership of the project, their trust and support, as well as to instil confidence for the project to be as meaningful as possible.

The restaged *Pageant* at GWL (part of a wider programme to be called *March of Women*) would have a different, more diverse range of participants. We were in a distinct community setting and we aimed to make this project relevant to women, including to our adult literacy learners, to women of colour, to young and older women and to those who were remote from cultural capital. Anna Birch (our partner from the Royal Conservatoire) envisioned the play being restaged in GWL followed by a procession led by the company out from the Library to nearby Glasgow Green, the site of historic demonstrations by suffragettes, peace campaigners and others, where a choreographed performance and tableaux would be staged.

March of Women would ultimately involve thousands of hours of complex and multifaceted work. Following the recruitment of 100 women from our networks locally and nationally, research began on suffragette history and the achievements of women in Scotland and globally (linked to contemporary issues of women's ongoing 'disenfranchisement'). The group was involved in play readings of suffrage and more contemporary feminist dramas, and supported in a process of playwriting and the generation of new scripts. Each researcher and performer would ultimately inhabit their characters in a memorable production for a packed audience at GWL. A wider community would be involved in helping to make costumes and banners, others in thinking through and shaping aesthetics and performance.

Both RCS and GWL were keen to have production professionals working collaboratively with participants to shape the impact of the staging. For example, specific colours are freighted with meaning in our neighbourhood as a result of deep-seated sectarianism.[7] The GWL team, Board, volunteers and staff worked on all elements and simultaneously enabled documentary filmmakers to record their own and participants' experiences of the process.

We established a new drop-in group, Drama Queens, and encouraged women to try their hand at play readings from the wide range of feminist plays in our collection and facilitated women who had little or no confidence in reading and writing whilst gaining knowledge from more confident women's historians. All found their personal female inspiration from history, whether in the form of 'raging dykes' or militant local community activists, and crafted a short declamatory statement that they would ultimately perform. Sessions on sash, rosette and costume making ran for weeks in increasingly unstructured sessions where training became peer-led skills exchange. Here, women who were expert seamstresses swapped skills with women who were confident researchers. Older and younger women found common ground in discovering figures from history that they gradually came to champion. All this took place as library visitors came and went. RCS colleagues worked with women on movement, stage craft, choreography and voice. Outreach sessions took place across Glasgow and our national

lifelong learning coordinator actively encouraged groups to form outside the Central Belt of Scotland.[8] Throughout, a documentary filmmaking crew interviewed women and filmed rehearsals and a soundtrack was commissioned.

In her introduction to a talk delivered as part of the GWL public learning programme ahead of the performance, Cockin wrote:

> When the campaigns for women's enfranchisement in Britain became more militant … 'Deeds not words' was the slogan of the militants and some of those deeds were highly dramatic … In the period 1905–14 many women wrote a play, a poem or a short story, for the first time.
>
> *(Cockin 2014)*

This offered an historical model as an approach to working that aligned with GWL's creative learning ethos, one that we could adopt and adapt in our work with women of the East End and those that got involved further afield as the project developed. In deciding to march from GWL out into the streets of Bridgeton adorned in sashes and carrying banners, our new community of women was embarking on a potentially provocative action.[9] The regalia of a feminist pageant boldly questioned the prerogative of the Orange and Republican marches that take place across the city and that are highly visible in the East End of the city throughout the summer. We all understood that marching was freighted with power, risk and meaning, especially since this was to be GWL's first public performance in this neighbourhood.

Throughout the project women who were seasoned campaigners spoke with others who had never exercised their right to vote; women who had little political literacy became galvanised through their own research into the suffrage cause. The Scottish Independence Referendum took place on 18 September 2014, six months before the *March of Women* event, with a record number of the population voting. *March of Women* participants held a spectrum of political positions (and none) and discussions took place each and every day at the Library as women ironed their sashes, created their scripts, ate lunch together and developed their 'characters'. The fact that the *Pageant* was a play designed to make the case of the critical right for women's full citizenship through enfranchisement was powerfully cited in conversations between women who had never exercised this right and those who were encouraging them to do so. For some women these discussions led to their first involvement in political campaigning, joining and heading up the emergent cross-party women's independence groups, canvassing and blogging. For others, GWL offered a respite in this period from the otherwise omnipresent and sometimes heated arguments being played out in the press and social media over several months. This was peer education and lifelong learning and political literacy in action. The Library, with our aims to create a space where there is safety to share a spectrum of views and ideas and for individuals to be respected for their opinions, learnt much in this process, equipping us with improved ways of holding a politically neutral but empowering space for women to be able to articulate their personal and political voice.

An excited and enthralled audience enjoyed an atmospheric performance of a new version of *A Pageant of Great Women* on an overcast March day on the eve of International Women's Day in 2015 (within our Carnegie Library built just four years before *A Pageant of Great Women* was written) at GWL in the heart of Glasgow's historic East End. The play concluded and 100 performers marched with their audience following and flanked by a steadily growing group of passers-by and supporters through the streets of Bridgeton to Glasgow's historic

FIGURE 3.2 Several of a cohort of over 100 women gathered at Glasgow Green following the procession of *March of Women* from Glasgow Women's Library.
Photo: Still from the Glasgow Women's Library film *March* by filmmaker Marissa Keating.

Green where women had vehemently protested for the vote and against war a century before. The event and the process leading up to it were powerful, unforgettable personal and collective landmarks for GWL and many who participated.

Following the event, the women who marched were in demand and 'performed' at events across Scotland. The aesthetics and content of the March have also been augmented and developed for subsequent GWL programmes, for example *Forward! Remembering Women Peace Crusaders* (2016). Our associated film *March* premiered at GWL in 2016, attracting a full house, and was distributed to all participants. *March* has subsequently been seen by audiences across Scotland and at the Palace of Westminster. Critically, a whole cohort of women, including those new to GWL when the process began, now felt a meaningful connection to historic heroines and to the collections at GWL, and understood how their own involvement in this event was represented and recorded, and now housed in the collection at GWL, and that they had made history.

After *March of Women*, some participants have been involved in GWL community curating projects, one has joined the Library's Board and some have been active in programming that marks further milestones in political change and the campaigns for equality. Fortuitously, the programme of work culminating in *March of Women* segued into a raft of work connected with the Centenary of the Representation of the People's Act in 2018, including the development by GWL of two new suffragette-themed women's heritage walks created by volunteers and an ambitious award-winning online animation project created by over 100 young animators from across Scotland that aimed to ensure that the names and histories of Scottish suffragettes became better known.[10] Participants have also made powerful work in response to the anniversary of the Race Relations Act, defying expectations that these subjects are only relevant or accessible for people who are confident in formally learnt political literacy.[11] For our academic

partner RCS this was a unique opportunity for collaboration with a voluntary sector organisation to share expertise and devise ways of working with communities of women who, in the main, had no further or higher education and/or who were remote from performance.

March of Women reflects the original intention of *A Pageant of Great Women*: 'combining the political and the aesthetic, provocatively engaging in history-making and rousing local communities to connect with it' (Cockin 2014). *March of Women* highlights how GWL's approach engenders engagement beyond the short-term, and embeds a meaningful 'legacy' with deeply felt 'outcomes' with communities that have been all too 'easy to ignore'. Working in equalities ensures that there is longitudinal impact and resilience developed both in the community of GWL and with its audiences and users. Continually checking in with values – whether (as was the case during *March of Women*) on sensitivities around sectarianism, on the representativeness or otherwise of materials and conventional histories, and an ambitious aim to include difference – enables and requires ways of working that are flexible, reflective and open to adaptation and negotiation.

March of Women typifies just one of the many risk-taking, participatory ways that Glasgow Women's Library works as a useful institution, innovative in its conception and involving exploratory partnership-working. But more significant than our individual projects are the ground-up strategies we employ as an organisation, and the ongoing reflective nature of our operations, in which all have voice, opinion and influence. The involvement of creative agents and the dynamic agency of artists, writers, filmmakers and designers drawn from the community will continue to contribute vital expertise in developing the creative agency of all, while museums across the sector could, we believe, learn from our collections staff mindfully shifting their perspectives from the valuing of objects over people, towards a commitment to public ownership and the removal of barriers to understanding. We believe we have something to teach other cultural organisations about staffing too, both in terms of broadening areas of relevant expertise in terms of recruitment, but also in staff and volunteer training, so that everyone clearly shares the role of addressing the impact of privilege and structural, institutional and attitudinal barriers. Finally, we believe that being established in one's locale – one's neighbourhood – is essential. But being firmly based too, upon values that are clearly understood by all, and that provide inspiration that unleashes the power of women to play a long-term personal and collective change-making role in society.

This, we believe, is a useful museum in operation. Meanwhile, the Library continues to generate a host of new challenges and learning for staff and volunteers, as well as our learners, users and participants, in a longitudinal, evolving programme, creating relationships that matter between people, places and collections powered by the dynamism of equality. There is no charity at work here – women are usefully working together for equality and meaningful change.

Acknowledgements

March of Women was a project involving the whole community of Glasgow Women's Library: volunteers, Board members, staff, academic interns and learners. Its success was also due to the passionate investment of time, energy and expertise of a wider cohort of partners, supporters and collaborators. It was developed with colleagues at the Royal Conservatoire of Scotland led by Artistic Director, Anna Birch. A film, *March*, was created by filmmaker Marissa Keating and her team and photo documentation was by Sarah Amy Fishlock. The Glasgow

Women's Library and Royal Conservatoire of Scotland teams were augmented by specialists in movement, voice, costume production, design, staging and related technical areas. Academics including Katherine Cockin shared their knowledge of suffragette pageants and processions in talks and workshops. Three professional actors, Patricia Panther, Lucianne McEvoy and Lesley Hart, led the performance. GWL worked in collaboration with a range of organisations whose focus is supporting women in Glasgow and around Scotland, and over 100 non-professional actors were brave enough to take to the stage. The professional and community performers led the procession from Glasgow Women's Library to Glasgow Green with support from the public. The principal funder for *March of* Women was Creative Scotland.

Notes

1 Theorist Kimberlé Crenshaw (2017) coined the term 'intersectional' to denote the overlapping systems of oppression such as race, class and gender. Our understanding of intersectional working and our critique of the 'unhelpful' stance of museums on this issue is expressed in our report (Patrick and Thain-Gray 2018).
2 We were influenced by European women's art archives and museums, principally Kunstlerinnenarchiv, Nürnberg; Bildweschel, Hamburg; the Lesbian Herstories Archives in New York; and, later, Akshara, a women's library in Mumbai, and other global women's libraries, archives and information centres.
3 As the Museum Association's *Museums Change Lives* Report (2013) highlighted, equality and social justice are not the specialisms of most museums, however much the public might expect and increasingly demand.
4 The first director of *A Pageant of Great Women*, first performed at the Scala Theatre, London in 1909 was costumier, theatre director and lesbian Edith Craig (1869–1947). Hamilton (1872–1952) was one of the most significant figures in the coterie of suffragette writers, actors and activists in the early twentieth century.
5 The feminist imperative to address hidden histories was thriving in 1909 when *A Pageant of Great Women* was first performed. This drive to recover and safeguard women's histories, activism and revolutionary gains was revived in the Second Wave, for example Rowbotham (1973), and is explicit in the ongoing work of GWL.
6 Elizabeth Robins's *Votes for Women* and Cicely Hamilton and Christopher St John's *How the Vote Was Won* are two other outstanding examples of the genre. *A Pageant of Great Women* was staged all over the UK until the First World War.
7 In the so-called 'marching season' in Glasgow, Bridgeton is the focus of many sectarian marches involving flute bands, banners, Unionist bunting crisscrossing the streets, Union Jack and other flags flying from local houses and shops and bollards and other street furniture being painted red, white and blue.
8 One very enthusiastic group was formed in Aberdeen supported by our national lifelong learning coordinator. Their triumphant arrival in Glasgow for the performance was one of many moving and memorable episodes in the *March of Women* project.
9 Shortly after our relocation GWL committed to explore the otherwise under-researched and highly political terrain of women and sectarianism in a programme of work *Mixing the Colours*. See Glasgow Women's Library, no date; and Thain-Gray 2015.
10 This project, *The Moving Story*, was an aspect of GWL's wider Vote 100 celebrations (Glasgow Women's Library, no date). In 2019 it won the UK's annual Women's Community History Prize.
11 Drama Queens continues and has become one of the Library's longest-running drop-in groups.

Bibliography

Cockin, E. (1998), *Edith Craig (1869–1947): Dramatic Lives*, London: Cassell.

Cockin, E. (2001), *Women and Theatre in the Age of Suffrage: The Pioneer Players 1911–25*, Basingstoke: Palgrave Macmillan.

Cockin, E. (2014), 'A Pageant of Great Women', Glasgow Women's Library, viewed 30 January 2019, https://womenslibrary.org.uk/event/katharine-cockin-a-pageant-of-great-women.

Crenshaw, K. (2017), *On Intersectionality: The Essential Writings of Kimberlé Crenshaw*, New York: New Press.

Glasgow Women's Library (2018), 'Research from a Grassroots Museum', viewed 19 September 2019, https://womenslibrary.org.uk/gwl_wp/wp-content/uploads/2018/06/EiP-Report-Research-from-a-Grassroots-Museum-180615.pdf.

Glasgow Women's Library (no date), 'Vote 100: The Moving Story', viewed 19 September 2019, https://womenslibrary.org.uk/discover-our-projects/vote-100-the-moving-story.

Janes, R. R., and Sandell, R. (2018), 'Posterity Has Arrived: The Necessary Emergence of Museum Activism', in R. R. Janes and R. Sandell (eds), *Museum Activism*, London and New York: Routledge.

Keating, M. (Director) (2016), *March* (film), Glasgow: Glasgow Women's Library and Royal Conservatoire of Scotland.

McCann, M. (2018), 'Activist Practice through Networks: A Case Study in Museum Connections', in R. R. Janes and R. Sandell (eds), *Museum Activism*, London and New York: Routledge.

Museums Association (2013), 'Museums Change Lives', viewed 19 September 2019, www.museumsassociation.org/download?id=1001738.

Patrick, A. (2017), 'Glasgow Women's Library', in N. Willems and S. Holla (eds), *Gender and Archiving: Past, Present and Future*, Yearbook of Women's History, Amsterdam: Atria.

Patrick, A. (ed.) (2014), *21 Revolutions: New Writing and Prints Inspired by the Collection at Glasgow Women's Library*, Glasgow: Freight and Glasgow Women's Library.

Rowbotham, S. (1973), *Hidden from History*, London and New York: Pluto Press.

Thain-Gray, R. (ed.) (2015) *Mixing the Colours: Women Speaking About Sectarianism*, Glasgow: Glasgow Women's Library.

Thain Gray, R., and Patrick, A. (eds) (2018) *Equality in Progress*, Glasgow: Glasgow Women's Library.

Whitelaw, L. (1990), *The Life and Rebellious Times of Cicely Hamilton*, London: Women's Press.

4

IN THE NAME OF THE MUSEUM

The cultural actions and values of the Togo Rural Village Art Museum, Taiwan

Ying-Ying Lai

Togo Rural Village Art Museum

The crisis of decline in rural villages is very common in Taiwan. Local farming products are no competition to imported items. A large proportion of good farming land is deserted, and the villages are left with old farmers while the young generation seek better working opportunities in cities. Located at Togo rural village in the Houbi District of Tainan, south of Taiwan, the Togo Rural Village Art Museum (TRVAM) was officially opened in 2012. The village is a museum while the museum is inside the village and this village is a canvas for art, farmers are artists, and products of the soils are artworks: these comprise the main ideas that inform the work of the TRVAM. Without a permanent building but with an entire landscape, the museum is unique in its transformation of a declining farming village into a vivid community of hope. Over the long process of community empowerment, life-oriented value and aesthetics as well as the definition of space are supported by the villagers' collective understanding and engagement. Today, the village people are proud to share their life experience, regain their dignity as farmers, enjoy cultural happenings, and also work on new possibilities for eco-farming.

Local revitalization through the Museum

Togo Rural Village Art Museum created the concept of 'a Museum without Walls', based on social empowerment of the lives of villagers through a range of artistic initiatives. Does a museum that attempts to revitalise a village actually respond to the needs of the community? How much change does art bring and is it beneficial?

Chang Chia-hui, the former village chief of the Togo rural village, is now the executive director of the Togo Rural Village Cultural Empowerment Association.

> They [the villagers] are not expecting to make money, they want to create a comfortable living environment, a comfortable living space for our next generation – one generation passing on to the next. This is the vision that they hope for and to live a happy life.
>
> *(Tsai 2016: 116)*

Togo villagers agree with the enhancement of their environment. The revitalisation of vacant space is the first benefit of art having entered the community. 'In fact, the biggest change is the environment. Now most vacant space has been transformed by green landscaping' (Tsai 2016: 139).

However, the resulting influx of tourists to the Togo Rural Village Art Museum has left villagers feeling doubtful and worried, 'We do not want too much construction. We just want the village to be clean and neat! We don't want too many people to come to visit. … [I]t's disruptive!' (Tsai 2016: 140). The youth from Togo who returned to the village to start their own businesses emphasised the importance of sustainable management and development of the features and style of the place. 'You must continue to operate in the village, which can bring people back again, that is success. If people only visit the village without understanding and experiencing life here, then the art museum would actually be useless' (Tsai 2016: 138). Facing the challenges of the transformation of a quiet rural village into an exciting art happenings site, the museum and locals shared some common concerns. Economic growth is not the only concern of the village people, but the continued improvement of villagers' livelihood and promoting local revitalization while creating a symbolic and co-prosperous development within Togo. Constant reflective change requires time and commitment.

Village as gallery

TRVAM officially opened on 16 December 2012 with the manifesto 'The village is a museum while the museum is inside the village' and 'This village is a canvas for art, farmers are artists, and products of the soils are artworks' as its themes. Breaking away from the stereotypical approach of the fine art museum, TRVAM uses the entire rural village as a gallery space. Apart from the public opening hours for the indoor space – 9 am to 5 pm daily – there are no other pre-set opening or closing times. Since being opened to the public in 2012, TRVAM organises *The Village Houses Contemporary Art Exhibition* every year during farming off-season. Artists are invited to create projects and through this process engage in artistic exchanges with local residents. The core operational members of the museum consist of team members of the Togo Rural Village Cultural Empowerment Association and art and design teams formed by graduates of the Tainan National University of the Arts (TNNUA) (Zeng 2005). In 2002, the Togo Rural Village Cultural Empowerment Association was established with the aim of reviving the energy of the village. This association was formed by a group of younger residents that believed in transforming the village from the bottom up. Soft power like community identity and cultural development were emphasised, instead of environmental decorative projects established by the traditional community association. In 2004, the TNNUA team was established with the simple goal of completing a class assignment on community empowerment. They showed their interest and willingness to participate in community projects. This museum evolved through creative community collaboration with community residents as a starting point. The recognition and mutual understanding from local residents have progressed through years of effort, from mistrust at the very beginning to current collaborative team work. As an eco-local museum, it has developed a unique programme of exhibition, collection and education, and provided a platform for sharing and gathering.

Landscape for art and people

The notion of landscape can signify a complex interaction between culture and nature with the potential to support cohesion and the spiritual life within any given community. According to the European Landscape Convention, landscape is 'one of the crucial components to form our life quality' as well as 'one of the important elements to contribute to personal and social happiness' (Lee 2009: 38). As an open museum, the landscape aesthetics based on rural village and site-specific installation art pieces have become an important component of the Museum's collection.

Since 1994, a comprehensive community development policy has been implemented by the government in an attempt to encourage public participation to improve the life of the rural villages. This idea of empowerment has a great impact on the younger generation, which supports such cultural initiatives through the Togo Rural Village Cultural Empowerment Association and the TNNUA team. At first, the TNNUA team had difficulty communicating with village residents due to their attitudes and use of academic language. The village people were very reserved and doubtful about their intention and commitment. The Togo Rural Village Cultural Empowerment Association watched the way that the students worked and eventually their work was recognised and appreciated. Students were recognised by the Togo Rural Village Cultural Empowerment Association. The Association realised the changes that could result from the students' energy and creative ideas (Hong 2012: 13). As time went on, they started to develop projects together and encouraged participation from more students, as well as farmers, carpenters, blacksmiths and other villagers. It was a long process of consensus-building that eventually resulted in identifying the benefits of art. The development of mutual trust was the turning point for the realisation of the Village Art Museum.

For instance, rose mallow is the main motif in the *Country Road* project, part of the Village Art Museum. This flower has been planted by almost all households as a form of fencing. The *Country Road* has many wall paintings and furniture featuring the rose mallow flower, evoking people's memories of the 'good old days' while hoping to project the future of a 'dignified' farming village with artistic elements. People need to collaborate in order to create highly interactive and strong territorial public art pieces that originate from village life. The village landscape now features the flower pattern painted on its walls, the fruit of long-term communication and affirmation of this symbol. Martin Heidegger said in *Art as the Happening of Truth*:

> Art is like a tree. Large flowers and rippled fruits are admired by the mortal world, but we should not forget that such beauty originated from its root. A tree requires constant watering and fertilising in order to grow and blossom.
>
> *(Lin* et al. *2007: 179)*

TRVAM is a year-long cultivation for all involved that has enriched local landscape and residential life through empowerment of the villagers.

Another example of a significant artwork is the water buffalo sculpture which has become the centrepiece of TRVAM, resulting from a series of reconstruction projects led by the Empowerment Association during the Museum's early stages. It could be regarded as the first tangible piece in the Museum collection. Once there were hundreds of buffalo in this village and now there is only one, raised by an old farmer Lai Ching-Shiu. Touched by the decline of

the village as well as of the buffalo, the Empowerment Association uses the buffalo as a familiar spiritual symbol to connect with the residents. While creating installations in 'ugly' parts of the village, they considered the stone buffalo sculpture in the open space as a public art piece that represents Togo village. The relationship between stone sculptor Hou Ja-Fu and village residents has become a leading example of public art practice (Lu 2006). After the TNNUA team joined the project in 2004, they worked together with the Empowerment Association to 'build a house' for buffalo and organised events such as the oxcart parade and the buffalo birthday celebration. The buffalo as a spiritual symbol prompts memories of past farming practices among residents.

Villagers as artists, artists being residents

Based on the notion that 'this village is a canvas for art, farmers are artists, and products of the soil are artworks', the site-specific artworks cannot be defined solely within the category of fine art. Instead, they frame current rural life as a form of public art. The establishment of the Homeland Painting Studio also encourages local residents to create art with support from the artist teacher. Some regular members at the studio, including Bao-Chen Yue-hsia (known as Grandma Bao locally), Jen Chang-Chao (known as Grandma Dao-ah), Hsu-Lu Shiu-nui (known as Grandma Squirrel) and Huang Hsin-chih (Grandma Hsin-chih), have found joy in their old age through painting. They are most supportive of the Museum's operational team, and have been photographed for the Museum's open event poster as the leading, representative artists taking pride of place (Hong 2012: 25).

Artworks by professional artists also merge with the villagers' soil lifestyle, which in turn entices them to stay. Hou Ja-Fu, who created the carved-stone buffalo, decided to move to the village after he fell for the local folk customs and camaraderie. His studio at Togo is now one of the 'must-visit' sites. On the other hand, Dignified Farmer's Studio formed by the TNNUA team transformed into several subdivisions in 2009: Dignified Farmer's Art Hub, Dignified Farmer's Fun Design and Dignified Farmer's Music Studio. They aim to recruit young talented professionals. With TRVAM as a base, they wish to promote a neo-design movement consisting of rural village, art, youth and labour, to co-execute the idea that transforms farming fields into art space, agricultural products into artworks, and farmers into artists (Chen and Huang 2013).

The empowerment process of Togo rural village

> not only turns from a subjectively descriptive approach to an interactive one, but it is also an artistic social practice with a rural village as the site. Therefore, the meaning of community participation and exhibitions is very different from the stereotype of the past. In other words, it is an innovation initiated by a rural art museum.
>
> *(Hong 2012: 29)*

Based on this rationale, we can see that art provides innovative force and energy for the rural village seeking transformation. It is a process of intersubjectivity that reveals the story, the confidence and the dignity of the local people as the core of the village, while the project also provides new opportunities for newcomers who identify with the value and dignity of the farming village.

Between the villagers and the Art Museum

The rural areas of Togo have been promoted by community empowerment through the rural art museum. They have experienced long-term development, with different management teams and implementation targets. Facing the decline of farming, population migration and aging, the villagers took action to make changes. The transformation of the local population is characterised by the influx of the younger generation. Former village chief Chang Chia-hui said in an interview:

> The impressions we had of rural areas were that they were dirty and unsanitary, so at that time we had to change the concept of the community, that is, to clean up its environment and to create a comfortable living environment space. It's as simple as this. We have also begun to make changes to the empty spaces. In this process, we have gathered a lot of teams and artists. The villagers also learn from, and participate with, each other.
> *(Hong 2012: 25)*

The participation of the Tainan University of Arts masters students has afforded them a long-term opportunity for mutual understanding, learning and communication. In this interactive process, not only has mutual trust been established, but also shared emotions and recognition. The project has also gradually resulted in a mutually beneficial partnership. Many students return to the village to start a business or continue investing in community activities, such as the Buffalo Design Tribe, Farming Arts and Crafts, and the Elegant Farmers Art Factory. These are examples of the student entrepreneurship within the community. This kind of cooperation brings new energy and creativity to the community, making the community sustainable (Wang and Chung 2014: 57–58, 70).

The Togo rural village has experienced great success in community empowerment during the past ten years such that the initial approach is no longer needed as the village has taken on the scale and professionalism of a museum. Huang Ding-Yao, the head of the Elegant Farmers Arts Factory, said:

> We are accompanying new artists to enter our space and then to create. When these special companies, these stores and these artists, are stationed in the village it does not matter whether or not there is expansion, because they are continuing to make creative works. It actually becomes one of the Museum exhibitions. And the 'empowerment project with artworks' supports the community by injecting new energy.

The transformative results of established partnerships, local industries and accompanying benefits have encouraged young people and artists to return to their hometown, and to engage in independent creative work to support the Museum's exhibitions and local life. Close partnerships encourage artists to stay after identifying with the community, not only giving back to the area, creating jobs, but also creating a local sustainable industry (Tsai 2016). Since the establishment of the Togo Rural Village Art Museum, the modes of operation have diversified, enabling further promotion of the community's work. In addition to engagement with academic institutions, there is also a potential for expanded opportunities for business partnerships in the area of regional tourism. New design companies and food stores have opened in the village over the past five years, exemplifying new business opportunities.

As for the local traditional industry of farming, the idea of environmentally friendly farming was also introduced and tried. A new brand, *Art mi*, was developed, named after art and rice, which not only encourages friendly farming but also integrates empowering art-making and the promotion of rural experience, food and agricultural education and handicrafts. The new rice brand *Art mi* is well promoted by the Museum through social media to everyday customers. A tour package has also been designed that enables Museum visitors to purchase a kit, including a pack of rice, museum map, postcard and sticker. Village natural cuisine is also promoted that is prepared by local women with fresh vegetables and rice. Ideally, rural tourism should combine with local industry and balance art with local farming in order to fulfil the goal of sustainable management. The marketing of Togo Museum is reflected in diversified programmes, art, music, performances, food, afternoon teas, an eco-friendly farming programme for schoolchildren as well as excursions for families and business companies.

Some reflections: cultural action and its sustainability

Can the Museum really serve as a means for the revitalization of the village? Is it merely a short-term blossoming cultural activity? What are the values for the Museum and villagers? And what can be done to ensure its sustainability into the future? What are the challenges?

Rural villages in Taiwan under globalization

In 1953, the Taiwanese government introduced automation to the agricultural sector. Consequently, many people moved away from rural villages, resulting in a population imbalance between urban and rural areas and a dearth of human resources in rural villages. Due to this decrease in population, many houses, and even public utilities, were discarded. It also caused a gap in youth population and discouraged the substantial development of agriculture (Zeng 2011: 34–35). Current agricultural reform in Taiwan has not resulted in any improvement in regional farming for rural villages and farmers. The food self-sufficiency ratio of 32.28 per cent in the year 2017 may be one of the lowest in the world. We need to reflect again on the implications of the assumption that agriculture is the backbone of our country.

The Togo Rural Village Cultural Empowerment Association, formed by the local young population, saw the crisis of decline in rural villages and was inspired to call villagers to reconstruct their environment. The TNNUA team then revived the vitality of the rural village through empowering art projects. They believed in 'working out how to turn hardworking farmers into "dignified" farmers based on their life experience' (Huang 2014). The buffalo, which is closely associated with rural village life, is a symbol that evokes residents' collective memories. Villagers gradually rebuild confidence and support artist teams that have settled in Togo village through their participation in the community empowerment process. With villagers' support and assistance, TRVAM and the Empowerment Association are able to organise and promote events successfully. In addition, young residents and local companies owned or run by young people reach public audiences via website platforms and blog and social networking sites to promote the idea of the 'dignified farmer'. They also host events such as experimental farming camps and rural village rock music festivals to appeal to more young people. Those innovative and fresh event ideas and friendly marketing strategies attract visitors and successfully promote the Museum.

Governmental policies: incentives and limits

During a decade of preparing and developing TRVAM, the Empowerment Association and TNNUA team started a series of art-related events which were linked to residents' daily life. Nevertheless, during the planning and implementation phases of these events, they constantly had difficulties in communicating with departments within the public sector. It suggests that the key to the success of public art might rely on respect and understanding from within the government sector (Lu 2006).

The fact that personnel from government departments question the value and outcomes of the process of art empowerment in Togo village indicates a huge gap of awareness between the public sector and those organisations that facilitate community empowerment projects. Some government departments even focus solely on industrial operation and income from tourism and do not care much about the profound spiritual benefits for local residents. The operation team of the Rural Art Museum has to raise its own funds in order to support the management of the project. Sometimes those organisations choose not to apply to governmental incentive programmes because they feel the current evaluation process is not being updated. A review of accessible and convenient methods to realise cultural policies, including equal cultural rights, community empowerment and cultural development projects, is a priority.

Village culture empowerment through the Museum

TRVAM invites local residents and young professionals to co-create empowering art projects that are innovative and authentic to the cultural history and life of the village. This makes Togo village a unique case in the community development movement in Taiwan. The Togo Rural Village Cultural Empowerment Association and TNNUA team are committed to changing the diminishment of a rural village through the force of community and adoption of an artistic approach that holistically integrates various aspects of rural village life (Lin *et al.* 2007). It is truly a significant benchmark, gaining a meaningful proximity to life, fulfilling artistic concepts and actions in a daily life that is reflected in the surroundings.

Acknowledgements

This chapter is an expansion on an article published by the journal *Muzeológia a kultúrne dedičstvo.*

Bibliography

Chen, Kuo-Ning (ed.) (2010), *The Local Cultural Museum Evaluation Manual*, Taipei: Council of Cultural Affairs.

Chen, Yu-Liang and Huang, Ding-Yao (2013), *TOGO Rural Village Art Museum*, Tainan: Togo Rural Village Cultural Empowerment Association.

Executive Yuan (Taiwan) ROC (2017), Agriculture Index, viewed 5 April 2019, http://agrstat.coa.gov.tw/sdweb/public/indicator/Indicator.aspx.

Government Tainan City Houbi District Office (2014), Tainan City: Houbi District Office, viewed 10 August 2014, http://web2.tainan.gov.tw/houbi.

Hong, Yi-Chen (2012), 'Village as Art Museum, Art Museum as Village: Narrative Analysis of Togo Rural Village Art Museum', *Tainan Journal of Taipei Fine Arts Museum*, 26: 5–36.

Huang, Ding-Yao (2014), Personal interview by Lai Ying-Ying at Togo Rural Village Art Museum.

Kester, Grant (2013), *Conversation Pieces: Community + Communication in Modern Art*, Berkeley: University of California Press.

Lee, Kuang-Chung (2009), 'Cultural Landscape and Community Development', *Science Development*, 439: 38–45.

Lin, Wen-Chia, Huang Jun-Hao and Chen Yu-Liang (2007), 'The Art Reforming Project at Togo Cluster: A Case Study of Zhuzaijiao', in Wu Mali (ed.), Art & Public Sphere: Working in Community, Taipei: Yuan-Liou.

Lu, Yao-Chung (2006), 'Get Started to Create Our Own Place: The Experience of Space Self-Reliance in Togo Village', unpublished Master's thesis, Nan-Hwa University.

Togo Rural Art Museum (2018), Website, viewed 12 March, 2018, http://togoartmuseum.blogspot.com/p/blog-page_13.html.

Tsai, Hui-Peng (2016), 'Research on the Influences of Public Art and Community Development: Take Togo Community in Tainan County as an Example', unpublished Master's thesis, Nan-Hwa University.

Wang, Kuang-Hsu and Chung, Rui-Hsun (2014), 'The Study of Young Students to Involve in Community Empowerment: The Case of "Togo" Village in Tainan', *Journal of Community Work and Community Studies*, 4 (2): 45–94.

Zeng, Xu-Zheng (2005), *Public Art in Community*, Taipei: Council of Cultural Affairs, Executive Yuan.

Zeng, Xu-Zheng (2011), 'The Methods of Rural Village Rebirth', *ACT Art Viewpoint*, 45 (Winter): 34–37.

PART II
Revealing hidden narratives

5

REVEALING HIDDEN STORIES AT THE DANISH WELFARE MUSEUM

A collaborative history

Jeppe Wichmann Rasmussen

Who should relate the stories of the poor and socially vulnerable men and women of the past, the men and women who lived parts of their lives institutionalised in Danish workhouses? The museum project *Hidden Danish Stories* sought to answer this question by engaging socially vulnerable people living in Denmark today as authentic experts and storytellers, people who, from their own experience, know how it feels to be homeless, neglected and stigmatised. The mutual benefits that both the museum and the socially vulnerable achieve from working closely together to co-create the hidden stories of the past and make them relevant today cannot be emphasised enough.

Filling in the blanks

The Danish Welfare Museum is located in Svendborg's former poor- and workhouse and has in its possession source material from 1872–1974, when the institution was in use. The original source material from Danish workhouses, 1850–1961, provides substantial insight into the daily life in these types of institutions. The material typically comprises journals describing the daily events that the warden has deemed important enough to record. This is where one gains an impression of what happened throughout a day in a workhouse. One can also find lists of who comes and goes, types of jobs, who did what and when, workhouse regulations, journals containing short descriptions of paupers breaking the rules and what punishment they were dealt and social cases containing correspondence. In some rare cases we also have letters written by the paupers themselves and often an interrogation form consisting of 36 questions that the paupers had to answer so the warden could decide whether they were deserving or undeserving poor. The interrogation forms were filled out by the warden while the paupers were questioned.

There is, however, one significant piece missing in the puzzle. As is the case with most of the available material from poor- and workhouses, the available source material very rarely gives us any insight into the minds and emotions of the paupers living there. The old, mostly handwritten pages contain stories about homelessness, alcohol abuse, physical abuse, neglect and stigmatisation, but glimpses into the emotional aspect of living in a workhouse are rare.

The material does not tell us much about how it felt. What was it like to live in such a place, to lose your freedom and your fundamental rights? How did it feel to live on the street, to be an alcoholic or abuse drugs? How did it feel to sell your body to strangers, to be deserted by your parents, how did it feel to be the parent who had to desert your children? The people who lived in the poor- and workhouse in Svendborg are long gone. Not one is alive today to share with us his or her story about life behind the barbed-wire walls. So, how do we go about telling their story?

The people in charge of the poor- and workhouse, people in power, produced every single bit of source material, and the views of the clients are almost non-existent. We find the occasional letter in individual social cases or in police reports, where written statements like 'I think I will be able to find work' or 'I would like to leave the workhouse. I have been here for eight months and I would like to try to support myself', 'My clothes are old and ragged, can you provide me with something new?' are among the most common. Certain aspects of the needs and wants of the paupers are available to us in the sources, but most times only basic needs are expressed or written down, never: 'I miss my family', 'I want to see my children' or 'I'm depressed and being locked up isn't helping'. The paupers often expressed emotion through action, though. Examples of this include attempts to escape, breaking the rules of the poor- and workhouse, drinking, smoking, sexual encounters and, in some instances, physical violence. Notes about these behaviours are always written down – by the authorities – carefully edited so only the absolute 'need to know' details are reported and almost never clarified, commented on or in other ways explained by the paupers themselves.

Through the project *Hidden Danish Stories*, the Danish Welfare Museum sought to change that by engaging people who could relate to the paupers rather than the people in power, people who could 'fill in the blanks' and help us try to understand the emotional aspects of social vulnerability across time, thereby giving a voice to the people of the poor- and workhouses through people living today.

What is *Hidden Danish Stories*?

> To what extent should the concept of social inclusion require a new approach by museums and in what ways can they begin to contribute towards inclusion policies? Fundamentally, what, if anything, can be achieved through the agency of museums?
>
> *(Sandell 2012: 562)*

Idea and motivation

Through *Hidden Danish Stories*, the Danish Welfare Museum sought to connect stories about poverty and social vulnerability across time through collaborative activity with socially vulnerable men and women living in Denmark today. The motivation behind the project was an acknowledgement of the fact that no one better understands what it means to be socially vulnerable than people who are or have been socially vulnerable themselves. None of the original paupers from Svendborg's poor- and workhouse are alive to tell their stories, but there are socially vulnerable people in Denmark who can relate and understand the problems they had and enrich our understanding of the emotions and dilemmas that these people lived through.

The overall aim of the project was threefold. First, to offer the viewers a better understanding of poverty and social exclusion across time. Second, to make the socially vulnerable people

FIGURE 5.1 The authentic experts at the first workshop.
 Photo: Instafilm.

working on the project aware of the fact that their personal struggles, especially the experiences derived from them, are extremely valuable when put into context and shared with others. Finally, we were hoping that this realisation, and the overall participation in the project, would benefit the authentic experts on a personal level.

Process

The project achieved this goal by engaging a group of socially vulnerable men and women who shared with the Museum their personal views and experiences. This group of people were positioned on-camera, the people telling the stories about the socially vulnerable people of the past as seen by them, the socially vulnerable people of today. By asking these people to be experts in poverty and social vulnerability across time, the project aimed to convey what it was like, and is like, to be in a situation where one loses either the ability or the right to control basic aspects of one's own life.

The curators, who would normally be in front of the camera, worked behind the scenes. The people who had not read books about the subject or spent hundreds of hours in archives searching for sources, but lived through homelessness, alcohol or substance abuse, physical and psychological abuse and poverty, took the centre stage.

Outcome

The outcome was 12 mini-documentaries that provide the viewer with information about poverty, homelessness and social vulnerability across time and give insight into the emotional aspects of these themes now and then. The 12 mini-documentaries were divided into three life stories and nine theme-based films. In the three short documentaries with life stories, the personal stories of two socially vulnerable people living many years apart are told by the one living today.

Expectations and preparations

The project officially began in October 2016, in cooperation with the Municipality of Svendborg (representing the local welfare state), and SAND which is an organisation of homeless people. Both partners contributed – from their different perspectives – to the realisation of the project. A couple of months before the project officially started, preparations had begun and overall expectations were written. Svendborg Social Services Department expected the participants to benefit on many different levels:

> The type of work that the participants in this project will engage in, a cultural job of sorts, will allow them to experience that they can contribute, and that their personal stories are acknowledged and appreciated as an essential part of something that will create insight, debate and new thoughts on poverty, homelessness and socially vulnerable people across time. Being a part of a project – a professional film production like *Hidden Danish Stories* – will support the recovery process of the participants and strengthen their self-esteem because they will see that their unique knowledge and experiences have value for society. The fact that the participants through this project are able to share this knowledge and thereby give other people a better understanding of the themes mentioned, is of great value.
>
> *(Müntzberg 2016: 1)*

In October and November 2016, the head of Svendborg's local care facility, Forsorgscenter Sydfyn,[1] and one of her colleagues participated in all the workshops. They did so because they knew some of the participants and had helped the Museum find people who wanted to be part of the project and share their stories. The staff at the care facility knew all but 3 of the initial 12 participants and their presence provided a feeling of safety and security for those participants who might be sceptical of why the Museum wanted to meet them. This was important, especially in the beginning of the project when everything was new – new people, new environment and a new task. Within a few weeks, however, this became less and less important and by December their participation was not needed at all. When the time came for recordings it was just me, the film crew and the authentic experts. The experts were nervous about being in front of the camera, but at this stage of the project we knew each other so well and they felt safe sharing their anxieties with us.

The participation of SAND – the organisation for homeless people in Denmark – was a little different because they have homeless – or formerly homeless – people working in the organisation in local groups whilst at the same time trying to raise awareness about homelessness. SAND also organises different kinds of activities for homeless people – trips, workshops, demonstrations and meetings, for instance. SAND primarily supported *Hidden Danish Stories* by recruiting members who wanted to be part of the project. Two of the five people (Richardt and Christina) who ended up being in the short documentaries came from SAND. Prior to the project SAND wrote:

> SAND believes that the project *Hidden Danish Stories* … will lead to an increased public awareness about cause and connection between poverty, homelessness and social vulnerability across time.
>
> *(Svejstrup 2016: 1)*

At the Museum, we had similar hopes, but we also expected that we, as a museum, would learn something new. It was important that the participants knew that they were helping us and that we wanted to learn from them. The challenge here was to show the participants that what they had experienced need not and should not be concealed but rather exposed and expressed; that they have knowledge that is extremely hard to find in archives, knowledge that is often unused in current debate about social vulnerability in present-day society. This knowledge can and should be used to educate and learn what not to do in the present and future to not cross our own path and reinvent solutions that we have already tried and stopped because they did not work. It cannot be emphasised enough how important this was.

The authentic experts were sitting on a goldmine of knowledge. They enlightened the Museum and the visitors on aspects of social vulnerability that, historically speaking, had been hidden or simply not found important enough to collect or share: the individual, personal and emotional aspects of social vulnerability. All they needed was a platform, trust and a guiding hand. Within the Museum this knowledge did not exist because the historians working there have never been homeless or abused drugs, they have not been raised in orphanages or been abused by their parents. The personal and authentic reflection on the paupers of the past gained an entirely new dimension by co-creating the hidden parts of their stories with the authentic experts.

How and why: project design

On 15 October 2016, work officially began on the project *Hidden Danish Stories*. The initial phase of the project was split into workshops, study days and days of sharing stories. The very first meeting was held at *Forsorgscenter Sydfyn*, the local care facility for homeless people in Svendborg, because it was a place where several of the participants felt at home. The manager of the care facility had gathered a group of nine people and an additional three people suggested by SAND. They all had first-hand experience with homelessness, substance abuse and social vulnerability. All of them were still very much facing the backlash of these experiences.

The group of authentic experts had little knowledge about the project before agreeing to participate in the first workshop. They knew that the aim was to make documentaries about poverty and social vulnerability, but not much more. During the project we completed:

> Three workshops, three hours per day.
> Two days of study, four hours per day.
> Three days of storytelling, four hours per day.
> Nine days of filming, seven hours per day.

On the first day of the project, I introduced the following idea to the group: they are experts who have been asked to participate in the project because we believe that they can help the museum and the public acquire new knowledge about the emotional aspects of poor people's lives in the past and present. I introduced them to the actual content of the project: What are we going to be working on? And in relation to some of the paupers who had lived in the poor- and workhouse, everybody was encouraged to comment and ask questions when they saw fit. The participants were divided into groups of four or five people. Each group consisted of people working at the museum, people working at the film production company, people

working at *Forsorgscenter Sydfyn* and people who had personal experience with being socially vulnerable. Each group was given a version of a life story of one of the paupers from the poor- and workhouse. The group members read the story and proceeded to share with the rest of the group how they could relate to the life story as well as their thoughts on the actions of the person portrayed in the story. The task was designed in the same way as the short documentaries were later in the project: how can you relate to this person on an emotional level based on your own personal experience with social vulnerability? It very quickly became clear to everyone, including the authentic experts, who had not yet fully embraced their expert roles, that they could relate in ways that luckily few other people can.

Then came a workshop where the participants worked with written memories. This workshop took place in the Danish Welfare Museum. One of the tasks was to write down a memory, good or bad, and read it to the group. Again, everyone participated, also the representatives from the film production company. Eli, one of the authentic experts, wrote about the day he was picked up by a man from social services and brought to an orphanage, and how he felt alone and abandoned. Henning wrote about a night in the winter time when he slept on his parents' porch because he was too embarrassed to knock on their door and tell them he had no place to stay.

This can seem a simple, maybe even ordinary task but it was a gentle way to start a conversation about some difficult memories and it showed the participants that the museum was a safe environment where they would not be judged but acknowledged as experts in some of the harsh aspects of life. Most of the time during the workshops, however, was spent with informal talking and sharing stories, stories that were to be used in the films but also stories that would not. We spent many hours talking about the lives of the authentic experts, and we spent hours discussing and analysing the numerous points of similarity of the lives that these experts and the paupers led, albeit many years apart.

Our approach was not only based on theory about social inclusion and museum activism, but also on common sense and intuition and treating people with equal amounts of respect and acceptance regardless of their background, be they academic scholars or formerly homeless people struggling to get ahead. We had no long talks about how to act around the participants or how to describe the project to people who are socially vulnerable. In many ways we approached the participants in the same way that we would any other co-creator who has expert knowledge that we can learn from. But we also made sure that there was enough time so that we could spend some of it just talking about stuff that was not directly related to the project, and we all spent our lunch breaks together. We also made it clear that the participants were free to quit the project if they wanted to.

With *Hidden Danish Stories* we actively decided to approach the stories of the paupers of the past in a new way. We believed that our approach would offer us new and different views on some of the stories we share at the Museum and that both we and our visitors would see the paupers from the past in a new, more authentic and emotional light. Goals that we believe we achieved. At that point, however, we were not fully aware that what we wanted to do would have a profound impact on the way we want to, and do, share stories in the museum. Bernadette Lynch has put it this way: 'Within the cultural heritage sector, it is increasingly maintained that museums can change people, but people can also change museums' (Lynch 2014: 97). This is exactly what happened.

After the first workshop some of the authentic experts had already become aware of the fact that their personal problems were quite valuable because other people would be able to

benefit from learning about them, and our shared history would be gaining a completely new dimension. This realisation seemed to motivate the group. They did, however, voice concerns that other people might not see this as clearly as the Museum did, but on the day of the film launch at the Museum these fears were brushed aside by recognition and pride as the authentic experts met nothing but positivity and well-deserved praise for their valuable contribution to our collective social history.

The impact of this realisation was, and is, that the authentic experts found a use for their stories beyond the project. They may not *be* proud of their troubled past, but they can now make it valuable, put it in use for others to learn from, thereby turning the darkest and most hidden parts of their personal histories into something they can *share* with pride. This was also the case for the Museum. Janet Marstine has written about how 'In museums today creativity and risk-taking are often funnelled through one-off projects' (Marstine 2011: 5). *Hidden Danish Stories* was not a one-off, but a project that has encouraged the Danish Welfare Museum to take co-creation with authentic experts to new and more fundamental levels, deciding that co-creating the past with authentic experts should be part of the Museum's DNA.

Life stories and themes: authentic experts on film

Rasmine and Richardt

Rasmine was born in 1886 and grew up in an orphanage because her mother, who had given birth to her out of wedlock, was forced to hand her over to the authorities. At the age of 13, Rasmine left the orphanage and moved to Svendborg to live with her mother and her mother's partner. Shortly after moving in, Rasmine was molested by her mother's partner. In the months that followed, Rasmine was abused by seven other local men and by the time she turned 14, she was supporting herself, in part, by prostitution. This caused her

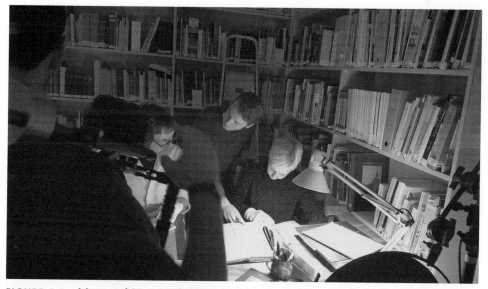

FIGURE 5.2 Mette and Henning looking for Albert in the archives.
Photo: Jon Bjarni Hjartarsson.

to be imprisoned and admitted to Svendborg poor- and workhouse five times when she was 14–18 years old between 1900 and 1904 (Hansen Friis 2017).

Richardt, born 75 years later in 1961, can relate to Rasmine in a way that most historians, fortunately, cannot. He can relate because something similar happened to him when he was a child and a young teenager. Richardt's parents were divorced when he was very young. His parents decided that he was to live with his father. Richardt's father was an alcoholic. When Richardt was merely six years old his father brought him to Havnebodegaen, a local pub in the Danish city of Kastrup. His father was playing billiards with a man – a bet was made. If the father lost the game, the man would win Richardt's company. That game of billiard was the beginning of years of sexual abuse committed against Richardt by his father and men Richardt did not know. In the years to come, Richardt would be handed over to several different orphanages, but he always ran away. With no means to support himself, Richardt accepted the offer of a stranger in Copenhagen. One day, when he was a young teenager, he was loitering in the town square when a grown man approached him and offered him money for sex. For years to come, Richardt continued to run away from many different care facilities. When he was on the run, he would support himself by prostitution. In short, Richardt can relate to Rasmine because he has experienced it all himself. These harsh experiences make Richardt an expert when it comes to shedding light on the emotional aspects of Rasmine's story. It makes the viewer painfully aware that the problems Rasmine was faced with are not problems firmly rooted in the past, not problems that Danish society has overcome, but rather problems that people, despite improved material, educational and financial conditions, are facing in Denmark today (Moreno 2016).

Themes

The nine theme-based documentaries are shorter, approximately three to five minutes long, comprising round table talks. The authentic experts chose the nine topics that they believed were the most important ones to discuss in the context of social vulnerability: substance abuse, neglect, pride, love, death, loneliness, homeless women, hierarchy and home. For each theme, the Museum wrote a short text that the authentic experts read out aloud to start the conversation. Each text connected the theme, which they were about to discuss from their own point of view, to Svendborg's poor- and workhouse. The talks give insight into some of the most basic elements of life for socially vulnerable people. For instance, death is ever-present when you live on the street and/or endure substance abuse. Two of the five authentic experts had been clinically dead and resuscitated. The historical input for the film about death was about a suicide committed in the workhouse by 78-year-old pauper Richard Flindt. As a historian who has never been remotely close to dying, death is sad and frightening, and the same was the case for Eli. For Eli, dying was horrible, it scared him and convinced him to try to change his life and give up drugs.

Richardt, on the other hand, said that when he was dead, he felt peace. 'It was the most peaceful time I have ever had … waking up was like being hit by a car'.[2]

These two very different reflections about death and the story of Flindt are extraordinary examples of why working directly with people who have experienced social vulnerability is so important. For most people, the story of Flindt's suicide is a tragic one, but what if it brought him peace? We will probably never know, and I'm not advocating that suicide is a form of resolution, but merely pointing out that Richardt and Eli with their honest and

experience-based exchange have given us a chance to somewhat understand what Flindt was going through on an emotional level.

Another example is the theme 'hierarchy'. For Henning, it is Danish society that is placing him at the bottom, telling him that he is worthless compared to 'normal' people.

Mette, however, believes that she herself and other socially vulnerable people are also to blame: 'I've had the feeling that sometimes I'm the one placing myself at the bottom of the hierarchy and that's not necessarily where other people would place me'.[3]

Richardt quickly turns his focus to hierarchy on the street: 'The hierarchy among homeless people is based on substance abuse. The drug addicts are less accepted than the alcoholics, who are not accepted by the homeless people who have no addictions'.

These are all valuable insights that contribute massively to the history of poor and homeless people in Denmark where individual reflections of the excluded are extremely rare both now and historically speaking.

Authentic experts

The participants in this project are experts. They know what they are talking about. They are not formally educated. They have not been taught how to tell a story, but they lived it. They are authentic experts.

Richardt has spent 11 years of his life living on the street. Mette was addicted to drugs, living in a violent relationship, which saw her standing on the street one day with nowhere to go. Eli's mother died when he was a child and he was sent to live with his grandparents who could not handle him; because of this, Eli was sent to live in a children's Home. He was supposed to stay there for a week but ended up living there for 11 years. Some years after leaving the Home, Eli met a woman who had four children. When the relationship ended, Eli started drinking, eventually turning to drugs. He is now clean. Henning, who is dyslexic and, in his own words, has been fighting the label 'stupid' since childhood, was formerly homeless and is now a recovering alcoholic. These problems are very similar to those that poor and socially vulnerable people were fighting 100 years ago, but their stories were never collected or deemed important by professionals visiting the poor- and workhouse.

In 1973 a curator from the National Museum of Denmark read in the newspaper that in Svendborg, a poorhouse was still in use. He decided to visit the poorhouse to document life in the old buildings. He photographed the paupers and the buildings and spoke to the warden. However, he left out one crucial piece: he did not interview one client living in the poorhouse, not a single person (Rasmussen and Smed 2017: 127). Or as Sandell puts it:

> the museum that fails to tell the stories of minority groups, not only denies access to its services for that group but also exacerbates their position of exclusion by broadcasting an exclusive image reinforcing the prejudices and discriminatory practices of museum users and the wider society.
>
> *(Sandell 2012: 567)*

Sandell is right, but we also have to ask ourselves if it is enough to simply 'tell the stories of minority groups' when they themselves can play an active part in telling these stories? We must not assume that because we are professionals we have all the answers. We don't. Apart from telling the stories of minority groups, we must acknowledge that there are things we do

not know, and we must widen our horizons when we search for answers to the questions we cannot answer ourselves. It is not enough to observe, collect, exhibit and document. Let us not repeat the mistake of the curator from the National Museum of Denmark who interviewed the warden and photographed the paupers but forgot the most important thing – the people whose lives he was hoping to portray.

Richardt and the other participants voiced similar concerns during their time on the project. They felt that *Hidden Danish Stories* presented them with a rare opportunity to relieve the burden of holding on to their pain. They feel a dissatisfaction with their society, one that is primarily born out of a feeling that in general, they have not been heard and are not taken seriously. Rasmine, Peter, Albert and the paupers who lived in the poorhouse in Svendborg never had the opportunity to share their stories and express their dissatisfactions, but with *Hidden Danish Stories*, with these films, the Danish Welfare Museum, Richardt and the other authentic experts, Henning, Mette, Eli and Christina, seek to give a voice to the people who were never asked or heard.[4]

Conclusion

Through *Hidden Danish Stories* and other projects – both current and planned for the future – the Danish Welfare Museum aims to fulfil the exact opposite of the aforementioned curator from the National Museum of Denmark. The Danish Welfare Museum actively is open to, pursues and welcomes a range of possibilities and learns from the insights and the help of the socially vulnerable who formerly would, with great probability, have been living behind the barbed-wire walls of the poorhouse. We work on creating an environment of inclusion rather than exclusion.

The approach utilised in the project was applauded by the manager of Forsorgscenter Sydfyn, Gitte Kromann Jacobsen, who noticed that the participants benefited massively from being met with ordinary expectations where the focus on their experiences with being socially vulnerable was based solely on the way that these experiences could contribute positively to the project and the story the project wanted to tell. To be met in this way, gave the participants a knowledge that they can use in the future (Rasmussen and Jacobsen 2018)).

So-called ordinary expectations are extraordinary for many socially vulnerable people. They are normally met with extraordinary expectations, because they depend on the aid of our social system, both financially and in other ways. This aid is not free. It might be in the direct sense of the word, but the aid comes with expectations and demands: you must earn the right to receive help if you are socially vulnerable. However, this was not the response of the Danish Welfare Museum to the authentic experts throughout the creation of *Hidden Danish Stories*. They were included so that they shared their stories and used their knowledge to teach us and whoever watches the short documentaries about social vulnerability across time. They know that they helped the museum and thereby helped themselves.

Working this way is hugely beneficial to the museum and to the co-creators (the authentic experts), who, in their own words, have acquired:

- strengthened sense of community
- improved social skills
- a feeling of being more open and less worried about sharing their story with others
- awareness of the fact that other people have similar stories to tell – they are not alone

- awareness of the fact that other people can learn from hearing their accounts of being socially vulnerable
- self-esteem
- a network of people who understand their problems.

These notions are a crucial lesson that working this way not only benefits the museum, not only provides us with new perspectives and new knowledge about the emotional aspects of poverty and social exclusion across time. It also makes a difference to the people who are sharing their stories.

Eli noted:

> This project helped me get away from my everyday life where I didn't know what the next day would bring and it put me in contact with some people who, like myself, had a background different from most people. To be part of this group and meet people who also had it tough, gave me new perspectives on my own life and who I am as a human being. Through this project, the process of making the short documentaries and by working with the people who were directing us and helping us share our stories, I rediscovered parts of myself and who I am that had been hidden or forgotten.

Mette spoke about the project and the story of Albert, her historical counterpart:

> I chose to be part of this project because I liked the concept. At the same time, I quickly realized that there were parts of Albert's story that reminded me a lot about myself and I found that intriguing. On a personal level, the project has helped me process some things that I never did before. It has been therapeutic in a way. I didn't know I needed

FIGURE 5.3 The authentic experts debating in the historical setting of the poorhouse.
Photo: Instafilm.

that. After sharing my story through *Hidden Danish Stories* and having witnessed the responses to the documentaries, I have started to feel proud of the person that I am today rather than ashamed of the person I used to be. When I see myself on screen, I see myself, but I'm much more confident and happier now.

Richardt said:

> Being part of the project has given me a different perspective on the life that I have led, it has given me peace of mind. There are aspects of my life that didn't make any sense to me before that make sense to me now, especially regarding my rootless nature. It has helped me understand why I have acted the way I have in certain situations. It has been a very positive experience. The project has developed me as a human being. It has been almost therapeutic. I feel that the person I see on screen is the person I am. I feel represented. I might look a bit older in the films than I feel, but it's an honest portrait of me. I think I'm different to many other socially vulnerable people because I don't think of my life as a bad experience. Life is too short for negativity. I think that the project succeeded because it was the right people who did it. I felt at home at the museum because the people there were serious about listening to me and learning from my story.

Acknowledgements

I would like to thank the participants: Mette, Eli, Henning, Christina and Richardt. I count myself lucky for having had the opportunity to work with you on *Hidden Danish Stories*. Your passion, honesty and bravery is, and was, truly inspiring.

Notes

1 Forsorgscenter Sydfyn is a care facility that helps homeless people get back on their feet by offering them temporary housing (typically 3–6 months), food and counselling. The users pay for the housing and food. There are about 50 care facilities of this sort in Denmark.
2 The film can be watched at https://vimeo.com/207132191.
3 The film can be watched by following this link: https://vimeo.com/207130814.
4 The theme-based films can be watched via this link: www.skjultedanmarkshistorier.dk/temaer. The life stories can be watched via this link: www.skjultedanmarkshistorier.dk/skaebner.

Bibliography

Åmand, R. (2018), Interview with the author, 27 June, trans. Jeppe Wichmann Rasmussen.
Hansen, M.F. (2017), 'Seksuelle eskapader', in J. Knage Rasmussen and S. Smed (eds), *Fattiggården (Year Book for Svendborg og Omegns Museum)*, Ringe: Mark and Storm, 42–47.
Løjmann Hansen, M. (2018), Interview with author, 22 June, trans. Jeppe Wichmann Rasmussen.
Lynch, B. (2014), 'Challenging Ourselves: Uncomfortable Histories and Current Museum Practices', in J. Kidd, S. Cairns, A. Drago, A. Ryall and M. Stearn (eds), *Challenging History in the Museum: International Perspectives*, London and New York: Routledge, 87–98.
Maqe, E. (2018), Interview with the author, 21 June, trans. Jeppe Wichmann Rasmussen.
Marstine, J. (2011), 'The Contingent Nature of the New Museum Ethics', in J. Marstine (ed.), *The Routledge Companion to Museum Ethics: Redefining Ethics for the Twenty-First-Century Museum*, London and New York: Routledge, 3–25.

Moreno, A. (2016), *Døden*. Film. Denmark: J. Quistgaard.

Moreno, A. (2016), *Hierarki*. Film. Denmark: J. Quistgaard.

Müntzberg, G. (Area Manager, Svendborg Social Services Department) (2016), Letter to the Danish Welfare Museum, 5 August.

Rasmussen, J. and Smed, S. (eds) (2017), *Fattigg a rden* (Year Book for Svendborg og Omegns Museum)

Rasmussen, J. W. and Kromann, J.G. (2018), 'Anbefalinger – Skjulte Danmarkshistorier', 19 September, viewed 30 March 2019, www.skjultedanmarkshistorier.dk/download/Anbefalinger-og-overvejelser-ifm-projektet-Skjulte-Danmarkshistorier.pdf.

Sandell, R. (2012), 'Museums as Agents of Social Inclusion', in B. Messias Carbonell (ed.), *Museum Studies: An Anthology of Contexts*, Malden, MA: Wiley-Blackwell, 562–574.

Svejstrup, A. (Head of the secretariat at SAND – the national organisation for homeless people in Denmark) (2016), Letter to the Danish Welfare Museum, 9 August.

6

DOORS, STAIRWAYS AND PITFALLS

Care Leavers' memory work at the Danish Welfare Museum

Stine Grønbæk Jensen

A comprehensive number of studies have pointed out that museums are playing an important role in the construction of collective memories: what we remember, what we forget and how we value our mutual past (Arnold–de Simine 2013: 7). This has been the case, for a long time, in those traditional national museums that tell the glorified tales of the nation state (Bennett 1995) but also in a new type of 'memorial museum' focusing on the dark chapters of our history (Williams 2007). However, museums are not only informative and educational spaces where the public is taught by the institutions' curators what to remember and how. They are also spaces where the visitors invest their own memories, feelings and values and become co-interpreters of meaning (Kavanagh 2000; Scott *et al.* 2014: 8). Interpreting the meaning-making processes in relation to a specific case study, I argue that museums can be powerful spaces for making sense of and dealing with difficult autobiographical memories.

In this chapter, I will draw on experiences from a specific project at the Danish Welfare Museum. For more than a decade, the museum has collected and exhibited cultural heritage and undertaken research related to the history and lives of children placed in orphanages in the twentieth century.[1] Through this work a close collaboration with former institutionalised children, or Care Leavers, has given us important knowledge about the everyday life in post-war institutions from the perspective of the children.

However, the engagement has also made it clear that many Care Leavers are struggling to live with their memories. Some feel shameful, marked or haunted by painful experiences in the past. Brown and Reavey define such memories as 'vital memories' – experiences that cannot be ignored or made irrelevant, yet painful to recall and troublesome to accommodate. Often such memories can take on the status of defining experiences and become pivotal when trying to make sense of life (Brown and Reavey 2015: 3).

Others are fighting with uncertainty and doubt around their early life. Often their lives have been repeatedly disrupted, and consequently, their memories are confused, fragmented or absent. As we do not remember ourselves as very young children clearly, many of our earliest memories are in fact recollections of stories we heard from adults about our childhood (Misztal 2007: 387). However, for children in vulnerable families, the grounding of self through

storytelling may be absent. Especially when children are removed from their parents, they can lose track of the past or lose it altogether (Kavanagh 2000: 26). At the same time, many Care Leavers lack material testimonies that can support their memories. Often documents, letters, pictures and the few belongings they had as children have disappeared or been destroyed in the absence of stable homes. Without a coherent account of their lives, many Care Leavers feel an existential insecurity. As Kavanagh has pointed out, in the absence of accurate and available details, 'the worst can be imagined or fantastic alternatives created' (Kavanagh 2000: 26).

Following this, the engagement with the Museum could be seen as a part of a more comprehensive existential effort among Care Leavers to remember, make sense of, and cope with difficult memories. They used the Museum to source information and images from their orphanage, to recall almost forgotten experiences or emotions, but they also used the Museum as an institutional instrument for making their version of the history count in a public space. For many Care Leavers, it mattered to share their stories, to have a more distinct voice in the history of the Danish welfare state and to support others who had been in similar situations. In other words, it appeared that many Care Leavers were helping themselves by helping the Museum.

In order to further explore this potential of the Museum, we developed the project *Memory Mondays*. As part of *Memory Mondays* we invited small groups of Care Leavers to spend the day in the Museum, where we encouraged them to tell and share their personal stories in interaction with objects, pictures, places, each other and Museum staff. The experiences from *Memory Mondays* were a source of great potential but also ethical dilemmas: the concrete space of the Museum offers metaphysical doors and stairways for Care Leavers' memory work, but also pitfalls.

Below, I will briefly examine the role of museums in the construction of memory. This is followed by an analysis of how the Care Leavers who participated in *Memory Mondays* made sense of their past. The analysis has two parts. Firstly, I focus on the observed potential of using museums as spaces for dealing with memories. Secondly, I will describe some of the ethical dilemmas and I will discuss how museums could handle these. Some museums researchers have argued that museums who actively engage in work with therapeutic potential should go into partnerships with, for example, social workers or psychologists. Acknowledging the advantages in following this path, I will argue that in some situations the absence of a therapeutic frame and lingo can be exactly what makes the museum potentially healing.

Memories, museums and the encounter as a 'dream space'

Memory has many forms and operates on many different levels. In this study I focus on autobiographical memory that relates to our ability to relive personal experiences and connect them to our personal life story (Misztal 2007: 379–380).

Autobiographical remembering is far from passive. There is a shared acknowledgement in 'memory studies' that remembering is a creative sense-making act in the present. The past is not simply re-represented, but reconstructed (Brown and Reavey 2015: 6). Memories are therefore highly context- dependent. When we remember the past our point of departure always begins from where we are right now and is shaped by our current concerns, needs and self-definitions (Brown and Reavey 2015: 5). Likewise, memories are formed by the language, dominant symbols, myths and values in our historical, cultural and political context

(Misztal 2007: 381–382). In that respect museums are important institutions when it comes to the construction of memories.

As a number of researchers have shown, museums from the nineteenth century often took an instrumental role in the politics of identity of the modern nation state (Bennett 1995; Misztal 2007: 389; Arnold-de Simine 2013: 7). However, in the past few decades there has been a marked increase in a new type of 'memorial museum'. These include Holocaust museums and museums such as the Hiroshima Peace Memorial Museum in Hiroshima, Tuol Sleng Museum of Genocidal Crimes in Phnom Peng and District Six Museum in Cape Town. The 'memorial museum' seeks to research, represent and commemorate histories of suffering due to genocide, war, dictatorship or displacement (Williams 2007). In other words, instead of a celebratory focus on the past, the 'memorial museum' seeks to embrace and recognise the victims of oppressive state politics and to include the counter-narratives of formerly marginalised or disenfranchised groups (Williams 2007).

What role can these and other types of museums play in the lives of vulnerable groups struggling with difficult memories? During the last few decades, researchers have stressed the potential of museums in general to make positive changes in people's lives. Museums are emphasised as valued public spaces for encountering and negotiating contested social issues and have been entrusted with combatting social exclusion, inequality, prejudice and discrimination (Sandell 2002, 2007; Sandell and Nightingale 2012). Also, practitioners and researchers have promoted the responsibility of museums to actively fight for social justice and stimulate individual and collective audiences to recognise themselves as subjects of human rights (Fleming 2012; Sandell and Nightingale 2012). Furthermore, it has been argued that museums can be powerful spaces for social work (Silverman 2010), improvement in health and wellbeing (Dodd 2002; Chatterjee and Noble 2013) and therapeutic healing (Silverman 2002).

A growing body of museum practice and research evidence shows that museums can make a positive change for disadvantaged and marginalised individuals. However, such studies tend to focus on the efficacy of programmes with the users as respondents (Scott *et al.* 2014: 4, 7, 14). In other words, the user tends to be seen as a passive receiver of institutional messages, rather than as a co-interpreter of meaning, whose prior knowledge, attitudes, feelings and values affect the encounter (Scott *et al.* 2014: 8). Studies focusing on how users experience the museum and the values they attribute to these experiences are rare (Scott *et al.* 2014: 14).

A way to capture these responses is by framing the meeting between users and the museum as a 'dream space' (Kavanagh 2000). Using the concept 'dream space' as the reflective experience of encountering yourself within the museum, Gaynor Kavanagh argues that our inner and outer experiences, our memory and our present, can fuse into one singular experience during the museum visit. When users visit museums, they learn and gain knowledge, but the interaction with objects can also awaken their subrational consciousness, their memories, imagination and feelings, in anarchic and unpredictable ways, not always considered by those who made the exhibition (Kavanagh 2000: 2–3). Inspired by the framework offered by Kavanagh, I will analyse how Care Leavers make sense of their memories in the museum in interaction with biographical objects, places, pictures, the exhibition, each other and the museum staff.

Memory Mondays

To investigate the potential of the museum for Care Leavers, in 2016, Sarah Smed (head of outreach) and I (researcher at the museum) developed *Memory Mondays*. Each Monday, we invited

three to five Care Leavers, who were familiar with the Museum. In some of the groups, the participants were siblings or knew each other from the same orphanage. In other groups, the participants were from different orphanages, and had not met before. The Museum is closed to the public on Mondays and so this scheduling ensured participants' privacy. During the five-hour- long programme the participants were encouraged to tell their stories in relation to personal belongings and in relation to specific places and exhibitions at the Museum as well as photos and objects. There was also time for ongoing reflections about memory processes and discussions about the representation of orphans and orphanages at the museum. Likewise, there was time for spontaneous personal reflections and conversation on subjects that mattered to them.

With the aim of documenting the stories, processes and interactions throughout the day, we recorded the conversations, took pictures and afterwards I wrote down my own observations and reflections. The participants were informed of the future use of the material for research and education and consent was obtained from participants.

Stories around personal objects

As part of the *Memory Mondays* we used personal objects as a stimulus for storytelling. Human beings are often described as storytelling creatures and the construction of coherent narratives is emphasis ed as the most natural way by which we make sense of the past (Kavanagh 2000: 41). Also, storytelling can be seen as a political act: a way to make your personal experiences count in public space (Jackson 2002). At the same time, researchers in the field of material culture have highlighted how personal objects play a significant role in the way we remember and construct meaning around the past. Personal belongings are reminders of specific life experiences, places, persons or times, and can make the past tangible, and become touchstones to memory (Kavanagh 2000: 21). Likewise, personal objects can be used as metaphors for the self, a pivot for reflexivity and a tool for autobiographical elaboration (Hoskins 1998). We therefore asked the participants to bring along an object that helped them recall their time at the orphanage: an object that meant something special to them or which represented their time in care. Indirectly, we thus asked the participants to bring objects from their 'personal museums' into the public museum.

In this particular framework, the participants mostly used the objects as metaphors, helping them to communicate biographical themes of great importance for them. A man brought a small yellow teddy bear with only one eye. He told us that it always had been there for him – in shifting institutions, through some very difficult years at his mother's house and during his adult life. As a child, he found in the teddy bear a sense of security and care that the adults around him were unable to give him. Especially, the teddy bear gave him comfort and solace during the time he lived with his mother, where he was neglected and exposed to violence. Today the significance of the teddy bear is slightly different. He explains that it is something stable in his life, otherwise dominated by disruption and uncertainty. The teddy bear is his life companion. Sometimes he loosens the scarf to see how bright yellow the fur once was. It brings him back in time and reminds him of his life story. The story about the teddy bear illuminates the lack of care in his childhood, but it also demonstrates children's ability to find their own way to fulfil basic needs, and the use of things as substitutes for care/companionship of other human beings.[2]

Objects testifying strong relationships to adults while in care were also brought by participants. In one of the *Memory Mondays* three brothers visited the museum together.

They appeared very close and shared their stories. When one of the brothers finished a sentence, another would take over. They recounted that the three of them grew up in poverty and were placed in care when their family could no longer care for them. On their way to the orphanage, they decided to run away from the home on the night of their admission. Fortunately, that never happened, they told. Not only did they feel the comfort of sleeping in their own bed for the first time in their life, they were also met by a strict and orderly but very loving headmistress who became their rescuer. One of the brothers brought with him an LP record by Joe Cocker, *Mad Dogs and Englishmen*. He told us that the headmistress gave it to him as a present around 1970. The cost of the record exceeded the provided sum for presents and on top of that, he reflected, the headmistress did not like the music at all. However, it was his only wish that Christmas, and so she gave it to him. For the brothers the LP record symbolises an approach to children where rules were of great importance, but care for the individual was even greater.[3]

The storytelling around personal objects seemed to stimulate concise life stories, highly charged with emotions as well as political messages. As a helping metaphor, the teddy bear illustrates the need for care among children, but also the total failure of responsibility on behalf of the parents and the welfare state. Thus, the teddy bear was used to communicate particular experiences, but also a critical stance towards the care system in general. Likewise, the brothers used the LP record to communicate a story about the care system that differs from the dominant public narrative. Currently, in Danish media there is a prevalent view of historical abuse and neglect in orphanages and it appeared important for the brothers to tell that helpful, loving orphanages also existed and that the history of childcare is not clear-cut.

As the two examples illustrate, the objects brought along were often comforting to the owners and gave them a sense of safety or strength. Objects that evoked disturbing or threatening feelings were seldom brought to the *Memory Mondays*. A man told us that he had a picture of the dilapidated house, where he grew up before he was taken away. The picture reminded him of being unloved and the cruelty he experienced as a child. He also told us that the picture was 'hidden in a drawer' because certain memories 'you do not need to be reminded of too often'.[4] The handling of objects is interwoven with the handling of memories.

Often the stories around personal belongings at the *Memory Mondays* were told with intensity and had a performative character. Most participants had reflected beforehand on which object to bring with them and it appeared that it was of importance for them to get a chance to contribute with their version of the story in a museum setting. As others have pointed out, offering personal stories as experts for the benefit of the museum can give a sense of agency, ownership and maybe even empowerment to the storytellers (Silvermann 2010: 80).

Places and memories

Memories and place are closely connected. Remembering often reconstructs events that can be specifically linked to particular places. It appears places can 'hold' our memories (Brown and Reavey 2015: 17). Conversely, we tend to remember specific situations when confronted with places and their material, symbolic and sensory qualities. As historical site-specific museums enable embodied encounters with buildings and physical remains of the past, they can therefore be powerful places in which to recall memories (Watson *et al.* 2012: 174).

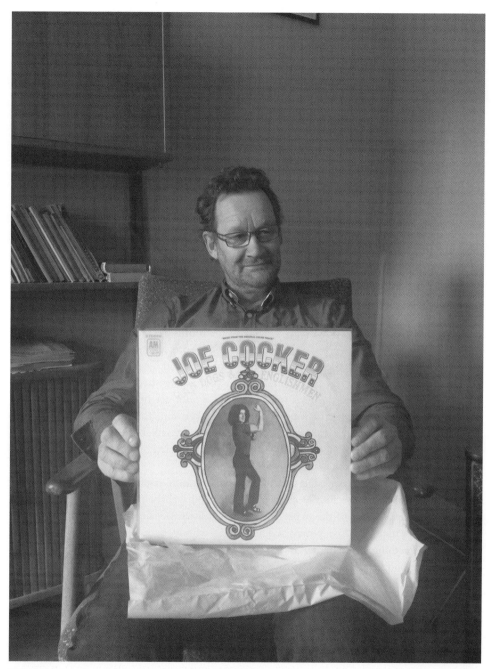

FIGURE 6.1 A participant with a treasured present, a Joe Cocker record, which was more expensive than the usual present for children at the orphanage.
Photo: Danish Welfare Museum.

During *Memory Mondays*, we use the physical spaces within the Museum in a variety of ways. The Danish Welfare Museum is located in an old preserved poorhouse from 1872 and the buildings and furnished rooms stand more or less as they did half a century ago. Although the workhouse was built to house poor and homeless people, it reflects the functional architecture and symbolic values of institutions and asylums at the time and therefore the rooms are in some ways similar to the ones at orphanages in the same period. We always begin and end the day in the apartment of the former warden, which is furnished and decorated with inventory from the 1950s. The insertion into this historical space often inspires the participants to immerse themselves in their past. Simultaneously, the homeliness of the old living room creates a safer and less formal atmosphere than a typical office meeting room would do.

During the day, we also walked through those rooms that were previously used by the residents: the bathroom, laundry room, isolation cell and dining room. Here memories are elicited by the sensory qualities of the rooms, the colours of the walls, the smell of polish, or the way in which light from the old windows falls upon the wooden chairs. Contrary to the coherent stories told around the biographical objects, the sites within the Museum seem to stimulate more spontaneous episodic memories and to bring the participant in contact with embodied experiences linked to specific places. An old stairway reminded a group of Care Leavers from the same orphanage of the rapid footsteps of the headmistress running down the stairs, and the tension they felt by the sound, knowing that it was their noise and hubbub that had caused her to come downstairs.[5] Likewise, the rooms often reminded the participants of emotionally charged places. For example, the storage room with shelves covered with blue working clothes carefully folded, reminded a man of the gentle seamstress at the orphanage and the sense of sanctuary he felt around her in the sewing shed.[6] In the laundry room, a woman remembered how the girls once a month would get up at four in the morning to do the laundry. The woman had previously not spoken much, but now standing among washboards and washing lines, she was recounting in great detail about the washing, but also the harsh and loveless atmosphere in which the work was carried out. As one of the youngest girls, it was her job to wash the sanitary towels.

There is relatively little consideration in museum literature regarding the role of heritage spaces, settings and sites specifically related to health and well-being (Chatterjee and Noble 2013: 35). However, some of the experiences from *Memory Mondays* suggest that encounters with places have transformative potential. The woman who recognised the laundry room later told us that something inside her fell into place during the visit. She told us that her memories for a long time had felt distanced, as if they belonged to another world, hostile, grim and difficult to imagine. Therefore, she had begun to question whether she could trust her own memories. She also said that she often had told herself to forget the past and move on. However, standing in the old workhouse laundry room, she felt the presence of the past so strongly that she stopped doubting her own memories. Also, she acknowledged that the memories from the orphanage were a part of her life and the person that she was.[7]

Photographs and memories

Photographs are often used to keep track of the past and most of us can recall the significance of family albums for our childhood memories, and for those stories that we share with our families. But also pictures which are not directly linked to our own childhood can trigger memories, emotions and moods and stimulate reflections. In his studies of photographs

Barthes uses the concept 'punctum' to explain how some pictures have an aspect, often a detail, which holds our gaze, 'pricks, bruises' and slowly but profoundly awakens memories, atmospheres and emotions from the past (Barthes 1981). Furthermore, researchers have argued that photographs not only stimulate memories, but also become important agents in the construction of memories themselves (Freund and Thomson 2011).

In order to explore how Care Leavers can use the collected photos of the museum, we presented a large number of photos of children and staff in different everyday situations from various orphanages and periods, which the participants were invited to touch and discuss. We then asked the participants to choose a picture that attracted them. After a few minutes looking at the picture, we asked them to describe it, and explain why they chose it and of what it reminded them.

The use of pictures as a medium for memories appeared to stimulate narratives of strong emotions. One man picked a photo of two small boys holding hands. This photo reminded him of a strong longing for his bigger brother from whom he was separated when placed in care. 'He was the one I was thinking of when I cried myself to sleep at night'.[8] Another chose a picture of a group of boys playing in the sea. Apparently, a happy image of joy, but for him, instead, the picture reminded him of a dominant feeling of being alone among others. 'I wanted to join them, but I was also afraid of the water, their rough play and I was thinking: If I were drowning, would anybody rescue me?'[9]

At the same time, the pictures and our conversation about them often motivate reflections about the situations where the pictures were taken. When, by whom and for what reason? Participants with personal narratives dominated by unhappy experiences often stress that the pictures tell an idealised story of life at a children's Home. While the images often are happy, the stories constructed around them often are sad.

Museum objects and memories

In museum studies, a comprehensive body of literature focuses on people's engagement with objects and how their intrinsic, symbolic and material properties trigger sensory, emotional and cognitive associations, memories and projections (Froggett et al. 2011: 7) and enable people to 'reflect creatively, sometimes transformatively, on themselves and others' (Dudley 2010: 3). In addition, handling objects can play a positive role in mental and physical health in clinical situations and through specific museum programmes (Scott et al. 2014: 20).

As a part of *Memory Mondays* we visit the permanent exhibition about children in care in the twentieth century: *You Shall Not Think about Your Father and Mother*. We invite the participants to walk around in the exhibition by themselves for a while and afterwards we ask them to tell about an object that they were especially drawn to.

One of the participants, who already had visited the museum several times, told us that every time he visits the Museum he spends some time in front of the case displaying the bedding and the rubber sheeting for children wetting the bed. It reminds him of 'piss stained sheets' and the humiliation he felt when the staff handed him the rubber sheets in front of the other boys. 'For me the rubber sheets represent some pretty painful memories. They were not exactly associated with stardom', he said and continued with a great deal of anger in his voice, 'but I just don't get, why the hell they never asked the question: Why is he pissing in bed at the ages of 13, 14, 15? No one asked that question, they just couldn't care less'. For this man the museum object seemed to help him express his feelings around experiences in the

FIGURE 6.2 Participants studying historical photos from different orphanages.
Photo: Danish Welfare Museum.

past. At the same time, it appears that the encounter gave him an opportunity to perform a reinterpretation of these experiences – from shame to anger, and from self-blame to critic.[10]

Another emotive object in the exhibition is a metal bed for infants. The bed carries imma-nent cultural meanings associated with hospitals and institutions. It stands freely in a room below a window, where you are allowed to touch the peeling paint, run your hand along the headboard with a metallic clatter or stroke the soft white duvet. As already mentioned, chil-dren placed in care as infants often feel a great deal of uncertainty about their first years of life. They have only a few inner images if any, and often they lack stories and tangible memories that can support their imagination. One of the participants – placed in care immediately after her birth – described her early childhood memories as a 'blank piece of paper'. When she saw the bed, a sadness ran through her, a feeling of being lost and lonely.[11] For another participant the encounter with the bed elicited other emotions. She was told that after being placed in

a Home for infants, she returned to live with her mother and her new husband, where she was exposed to physical and psychological violence. Having grown up with a sense of being unwanted, she feels a lot of anger towards her parents for taking her back when they were unable to be loving and caring. In front of the metal bed she had the experience that placed in care, lying in such a bed, she had been safe and felt comfort. After the visit, the woman wrote her reflections in a small booklet handed out to all participants at the beginning of *Memory Mondays* and sent it to the museum. She wrote that she had felt like climbing into the bed, that it was a positive experience and that she had the feeling of coming closer to herself as a child.[12] Although the pictures and objects at the museum can never replace personal stories or possessions, they can still give some images that can support life stories of Care Leavers.

Bringing people together

It is not only objects, places and pictures that stimulate reflections and stories about the past; also, the conversation between the participants is highly significant. Research has shown how museum experiences can yield growth in social relationships. As museums activate interaction and communication between friends or family members, the museum can enable them to better understand themselves, each other, and what binds them together (Silverman 2010: 18). This potential is amplified when the whole day is structured around telling and sharing stories.

During *Memory Mondays*, the participants listened to and commented on each other's stories. They asked each other questions and gave each other advice and often in ways that demand personal experiences from living in institutions. Participants from the same orphanage typically used a part of their visit to share and negotiate their collective stories and laugh about frequently told anecdotes. The conditions at orphanages varied a great deal in the post- war era, and so do the shared stories and attitudes towards the past. One group honoured the memory of a loved staff member by expressing their gratitude.[13] Another group handled strong experiences of subjection by fantasising about revenge in the afterlife.[14]

A day spent together at the Museum also gives the participants a chance to listen to each other's individual stories, learn more about each other and articulate feelings and experiences that have not been part of their shared stories. As one of the participants said at the end: 'This day has reminded me of how important it is that we have each other'.[15] Among participants who did not know each other, the chance to talk to others with similar experiences was valued. Often the participants asked the others about their experiences with feelings or thoughts surrounded by silence, doubt or insecurity. In one group, a man cautiously asked the others: 'Have you experienced some sort of emotional problem with trust?' After an exchange of experiences, he told that he found it easier to rely on others now, yet it had been a struggle to reach that point.[16] Likewise, the participants sometimes ask the others about their experiences with themes surrounded by taboo and shame – for example sexual intercourse and abuse between the children. Also experience with prejudice against Care Leavers is often shared with a great deal of resentment.

For the participants who did not know each other in advance, the Museum seemed to be a safe space where they could address topics that they might find difficult to talk about with those from a different background. A woman said to the others: 'What I value most from this day is the feeling that I am not the only one'.[17] Apparently, the exchanges of stories between the participants often supported a feeling of not being wrong, odd or all alone with difficult histories.

Inconvenient, repressed and contested memories

So far, I have highlighted examples that illustrate how *Memory Mondays* gave Care Leavers a chance to tell their stories and express their feelings, but also to reinterpret their experiences, recall almost forgotten memories and even shape some inner images where before was emptiness. Yet, was it always this positive for the participants to think and talk about their memories?

As oral historian Thomson (2013) has argued, when we remember the past, we often seek to compose a safe personal coherence out of risky, painful and unresolved pieces of past and present life. We try to compose a story we can live by. Sometimes our memories even take the form of what Plummer conceptualis es as a 'memory habit'. Memory becomes a habit when it 'starts to be seen as much less of an inner psychological phenomenon, and much more a socially shared experience' (Plummer in Edwards 2018: 30).

During *Memory Mondays*, most encounters with pictures, places, objects and the stories of others activate memories, feelings and reflections that appear consistent with the stories which the participants feel safe with, or which confirm their attitudes towards the past. In these cases, the activated memories usually give rise to the telling of stories shared previously. However, during a long intense day, the opposite can also happen. Suddenly the stories that the participants felt safe with are challenged, while memories and emotions they might have tried to keep at a distance become present. Such confrontations can be seen as ethically problematic, but not necessarily. A life is seldom solely good, nor only bad, and even though ambivalence can be disturbing or confusing, in certain circumstances, it can also be a powerful resource. Brown and Reavey note.

> Through the refusal to fix clear intentions and definitions of what happened, a space is opened up between past and present that can be productive, because it allows difficult questions about one's moral character and personal capacities to be reformulated
>
> *(Brown and Reavey 2015: 13)*

In the following, I will give some examples that illuminate some of the ethical dilemmas we as facilitators must balance when working with the memories of others at the museum.

In one of the groups where the participants came from the same orphanage, it was important for a couple of them to tell a story of how they grew up in a good and caring environment. A man even before he sat down explained that their orphanage was the best in the whole country, and that 'I never missed my parents'. In the exhibition, however, he was very touched by a quote about the loneliness of children who never received a visit from family members and when later we asked the group to draw a picture of a place special for them, he told a somewhat different story. On his paper, he had sketched a path behind the orphanage called the *Path of Love*. This path was important for him because he walked along it when he was secretly visiting his father. His father, who later committed suicide, was very depressed and therefore the participant was worried when walking to his house, and relieved that his father was still alive when walking back. The story was told with intensity and sentiment. Nevertheless, when tidying up after the day, I found the paper with the drawing ripped out of the booklet, folded and left on the table. Apparently, this story – too painful or incoherent with his life story – he did not want to carry with him, when leaving the museum.[18]

Another example concerns repressed or hidden memories. In one of the groups, a man told about an episode where he was sexually abused. He also told that it took him 30 years

to find the courage to confront himself with what had happened. This led to a conversation among the participants about their most painful and disturbing experiences. 'Dammit, things like that you need to forget, and you must do it quick', one of the other men said. This man several times during the day ended his stories by saying that this was not something he normally thought about. Care Leavers are coping with difficult memories in various ways. Some find it helpful to talk about their most painful memories in order to move on; others attempt to forget them. This man said he wanted to forget, and still inspired by the other participants' stories he told about his worst memories. Did he actually want to do that?[19] As Paul Connerton has pointed out, in the academic debate around memory, remembering and commemoration are usually regarded as virtues, while forgetting is seen as a failure. Yet while some types of forgetting can be repressive, forgetting can also be necessary in order for societies and individuals to move on. For example, forgetting can be constitutive in the formation of a new identity in a positive sense (Connerton 2008: 59).

Clashes between diverse interpretations also happen. As the previous examples show, memories are often dealt with by composing a certain version of the past that we feel safe with. When different interpretations of the past among the participants collided, it was therefore not just a question of what exactly happened in the past, when and why. What was at stake was also a contestation between different existential coping strategies. In situations where the participants' perceptions of the past were challenged by the others, some tried to negotiate or nuance their own understandings of the past, while others felt forced to reject the views of the others. In such situations, the other members of the group did not necessarily contribute to a sense of belonging or a feeling of finally being understood. On the contrary, the other members could come to represent a threat towards their sense of credibility, towards their memories, and the stories they felt safe with.

The last example I wish to highlight is related to the cultural representation of orphans and orphanages at the exhibition *You Shall Not Think about Your Father and Mother*. As museum staff, we stress continuously during the day that we value distinct voices and do not favour some versions of the past over others. However, the aim of the exhibition was to reveal an untold story of neglect. Even though we express this before we enter the exhibition, we cannot ignore the fact that objects such as the rubber sheets are telling a story about the darker side of living in an institution. Neither can we ignore that the use of showcases and big informative posters gives this particular version of the story a certain authority. As already mentioned, the clear critical positioning of the exhibition in some cases makes it easier for Care Leavers to reinterpret their memories in a way where internalis ed shame and guilt can be redirected towards the institution and the state. However, many Care Leavers are also fighting with absent, obscure or fragmented memories, which gives some of them a sense of insecurity. In these cases, there is a risk that the empty spaces in their memories when visiting the exhibition are filled with images more frightening and more uncanny than what they have actually experienced (Edwards 2012).

Working with memories

As Kavana gh has stressed, if handled with skill, facilitating the processes of remembering can promote positive feelings and enjoyment, and it can be 'empowering, liberating and life changing' (Kavanagh 2002: 120). However, as the example above illustrates, working with memories can also release negative emotions, and be challenging, confronting, disturbing or even damaging.

The museum staff therefore must reflect on the ethical dilemmas associated with working with difficult memories and have a sensitive approach. As facilitators, we neither can, nor should prevent confrontation or clashes. However, we must acknowledge the different stories that the participants feel safe with and strive to give space for different interpretations in the interaction with objects, photos, places and the exhibition. Likewise, we have seen it as our obligation to balance the interaction between the participants in a way that gi ves space for sometimes very different individuals with unalike memories and variant ways to make sense of them.

Simultaneously it is important to underline that the Care Leavers reaching out to the museum are already occupied with their memories. They are already in a process where they try to remember, reinterpret and make sense of their past, in order to handle it. It is therefore our experience that most of the participants at the *Memory Mondays* are very conscious about the processes of remembering and very much aware that memory work is associated with possibilities as well as risks.

In order to handle such risks, some museum practitioners and researchers recommend establishing formal partnerships with psychologists or social workers who can contribute with professional expertise on trauma (Besley and Low 2010). While acknowledging the strength and opportunities of such interdisciplinary approaches in museum settings, I will argue that in some cases it can be exactly the absence of a therapeutic approach and lingo that makes the museum potentially healing.

There are a number of reasons why this is the case when it comes to Care Leavers. First of all, the Care Leavers that have contact with the Museum do not seek therapy – at least not at the Museum – instead, they search history. They make contact with the Museum in order to find background information and a mirror for their own personal story, and in order to contribute to the history with their personal version of it. Likewise, it is important to emphasise that Care Leavers often have lived their lives surrounded by professionals. They have been evaluated or judged, treated or mistreated, cared for or neglected by psychologists, psychiatrists and social workers throughout their childhood and youth. Some have also in their adult life been through therapeutic counselling or they have had to negotiate with social workers in order to access social benefits and support. In contrast, at the Museum they are not clients or receivers of help. At the Museum, they are collaborators and experts who actively contribute to the history, who explore the Museum as a frame for processes of remembering together with museum staff, and who reflect on and discuss the representation of their history in a museum setting. For some this active role can in itself be empowering.

Conclusion

Museums all over the world are telling stories about suffering and conflict in order to contest injustice and make social changes. In this chapter, I have demonstrated that museums can contribute to this aim with more than educating the public *about* social exclusion and injustice. Museums can be powerful spaces *for* the very individuals and groups who have been subjects of exclusion and injustice; a space where they can make sense of and deal with distressing memories. Furthermore, when formerly marginalised men and women are perceived as experts collaborating *with* the museum and contributing to the explorations and reflections around the representations and uses of their history, the museum can support empowerment and agency.

Drawing on experiences from an explorative project at the Danish Welfare Museum and inspired by Kavanagh's concept of 'dream space', I have analysed how the participants experienced specific encounters with objects, places and photos at the Museum. I have thereby illustrated how memories, feelings, imaginations and reflections were awakened and how participants through particularly strong encounters managed to build a stronger sense of self, regain a trust in their own memories and even create some images, where memories were absent before. However, the stories that the participants feel safe with could also be challenged. On one hand, this can be seen as ethically problematic; on the other hand confrontation, confusion and ambivalence can be viewed as productive as they allow reinterpretations of the past but also of personal capacities. I have argued that we as facilitators neither can nor should prevent disturbances. Nevertheless, it is our obligation to balance the interactions in a manner that e nsures that all participants, despite their very diverse memories and different ways of interpreting them, can have a voice, be heard and acknowledged at the museum. Some researchers have argued that museums that facilitate demanding and highly emotional processes should go into partnerships with social workers and psychologists and I acknowledge the strength of such interdisciplinary approaches. However, the experiences from the Danish Welfare Museum and *Memory Mondays* strongly indicate that a focus on history, rather than healing, and an approach towards the participants as active contributors rather than passive receivers of help, can be empowering.

Recognising the atypical physical frames and the very specific target group for *Memory Mondays*, I believe that many museums could be used in a similar manner as spaces for different groups to reflect on and deal with the past while they contribute to the museum as experts. This approach might challenge us to rethink not just the role of the museum, but also the distribution of roles inside the museum. Such changes involve possibilities as well as risks for the participants and for the museum staff, but if we acknowledge that such risks might be necessary if museums are to make an actual positive change in people's lives, I consider the museum to be a safe and fertile space for investigating, negotiating and even adjusting difficult memories. And hopefully, the museum can also be a safe space, where you can leave behind the stories you do not want to carry with you.

Acknowledgements

I would like to express my profound gratitude to the C are L eavers who participated in the *Memory Mondays* and generously shared their stories with the Welfare Museum. I would also like to thank Sarah Smed for inspirational teamwork and Richard Sandell and Adele Chynoweth for valuable comments on this chapter.

Notes

1 The project also formed the basis of my PhD dissertation: 'At åbne skuffen' (2019).
2 *Memory Monday*, digital recording, 4 April 2016, Svendborg.
3 *Memory Monday*, digital recording, 28 August 2016, Svendborg.
4 *Memory Monday*, digital recording, 4 April 2016, Svendborg.
5 Memory Monday, digital recording, 28 August 2016, Svendborg.
6 Memory Monday, digital recording, 5 December 2016, Svendborg.
7 *Memory Monday*, digital recording, 27 June 2016, Svendborg.
8 *Memory Monday*, digital recording, 5 December 2016, Svendborg.

9 *Memory Monday*, digital recording, 5 December 2016, Svendborg.
10 *Memory Monday*, digital recording, 4 April 2016, Svendborg.
11 *Memory Monday*, digital recording, 7 November 2016, Svendborg.
12 *Memory Monday*, digital recording, 4 April 2016, Svendborg.
13 *Memory Monday*, digital recording, 9 January 2017, Svendborg.
14 *Memory Monday*, digital recording, 5 December 2016, Svendborg.
15 *Memory Monday*, digital recording, 28 August 2016, Svendborg.
16 *Memory Monday*, digital recording, 20 June 2016, Svendborg.
17 Memory Monday, digital recording, 27 June 2016, Svendborg.
18 *Memory Monday*, digital recording, 9 January 2017, Svendborg.
19 *Memory Monday*, digital recording, 20 June 2016, Svendborg.

Bibliography

Arnold-de Simine, S. (2013), *Mediating Memory in the Museum: Trauma, Empathy, Nostalgia*, Basingstoke: Palgrave Macmillan.

Barthes, R. (1981), *Camera Lucida*, New York: Hill & Wang.

Bennett, T. (1995), *The Birth of the Museum: History, Theory, Politics*, London and New York: Routledge.

Besley, J. and Carol L. (2010), 'Hurting and healing: reflections on representing experiences of mental illness in museums', in R. Sandell, J. Dodd and R. Garland-Thomson (eds), *Re-representing Disability*, London and New York: Routledge, 130–143.

Brown, S. and Reavey, P. (2015), *Vital Memory and Affect: Living with a Difficult Past*, London and New York: Routledge.

Chatterjee, H. and Noble, G. (2013), *Museums, Health and Well-being*, New York: Ashgate Publishing Company.

Connerton, P. (2008), 'Seven types of forgetting' *Memory Studies*, 1 (1), 59–71.

Dodd, J. (2002), 'Museums and the health of the community', in R. Sandell (ed.), *Museums, Society, and Inequality*, London and New York: Routledge, 182–189.

Dudley, S. (2010), 'Museum materialities: objects, sense and feeling', in S. Dudley (ed.), *Museum Materialities: Objects, Engagements, Interpretations*, London and New York: Routledge, 1–17.

Edwards, D. (2017). *Cultural, Autobiographical and Absent Memories of Orphanhood: The Girls of Nazareth House Remember*. Cham: Springer.

Edwards, D. (2012), 'Remembering the Home: the intricate effects of narrative inheritance and absent memory on the biographical construction of orphanhood', in E. Boesen, F. Lentz, M. Margue, D. Scuto and R. Wagener (eds), *Peripheral Memories: Public and Private Forms of Experiencing and Narrating the Past*, Bielefeld: Transcript Verlag, 161–182.

Edwards, D. (2018), *Cultural, Autobiographical and Absent Memories of Orphanhood: The Girls of Nazareth House Remember*, London: Palgrave Macmillan Memory Studies

Fleming, D. (2012), 'Museums for social justice: managing organisational change', in R. Sandell and E. Nightingale, (eds), *Museums, Equality and Social Justice*, London and New York: Routledge, 72–83.

Freund, A., and Thmpson A. (eds) (2011), *Oral History and Photography*, Basingstoke: Palgrave Macmillan

Froggett, L., Alan, F., Konstantina, P., Safan, O. and Freud, A. (2011), *Who Cares? Museums, Health and Wellbeing Research Project: A Study of the Renaissance North West Programme*, UCLAN: University of Central Lancashire.

Hoskins, J. (1998), *Biographical Objects. How Things Tell the stories of people's lives*, London and New York: Routledge.

Jackson, M. (2002), *The Politics of Storytelling: Violence, Transgression, and Intersubjectivity*, Copenhagen: Museum Tusculanum Press.

Jensen, S. G. (2019), 'At åbne skuffen: om tidligere børnehjemsbørns transformationer af selvet og den sociale verden gennem erindringsarbejde', Ph.D thesis, Syddansk Universitet, Odense.

Kavanagh, G. (2000), *Dream Spaces. Memory and the Museum*, Leicester: Leicester University Press.

Kavanagh, G. (2002), 'Remembering ourselves in the work of museums: trauma and the place of the personal in the public', in R. Sandell, *Museums, Society, Inequality*, London and New York: Routledge, 110–122.

Kragh, J., Jensen, S., and Rasmussen, J. (2015), *På kanten af velfærdsstaten: anbragte og indlagte i dansk socialforsorg 1933–1980*, Odense: Syddansk Universitetsforlag.

McAdams, D. (1993), *The Stories We Live By: Personal Myths and the Making of the Self*, New York: Guilford Press.

Misztal, B. (2007), 'Memory experience: the forms and functions of memory', in S. Watson (ed.), *Museums and their Communities*, London and New York: Routledge), 379–396.

Murphy, J. (2010), 'Memory, identity and public narrative', *Cultural and Social History*, 7 (3), 297–314.

Plummer, K. (2001) *Documents of Life 2: An Invitation to a Critical Humanism*, London: Sage Books.

Rytter, M. (2011), *Godhavnsrapporten*, Odense: Syddansk Universitetsforlag.

Rytter, M., and Rasmussen, J. (2015), 'A great find: turning the world upside down', *Journal of the History of Childhood and Youth*, 8 (1), 9–16.

Sandell, R. (ed.) (2002), *Museums, Society, Inequality*, London and New York: Routledge.

Sandell, R. (ed.) (2007), *Museums, Prejudice and the Reframing of Difference*, London and New York: Routledge.

Sandell, R., and E. Nightingale (eds) (2012), *Museums, Equality and Social Justice*, London and New York: Routledge.).

Scott, C. (2002), 'Measuring social value', in R. Sandell (ed.), *Museums, Society, and Inequality*, London and New York: Routledge, 41–55.

Scott, C., Dodd, J. and Sandell, R. (2014), *User Value of Museums and Galleries: A Critical View of the Literature*, Arts and Humanities Research Council.

Silverman, L. (2002), 'The therapeutic potential of museums as pathways to inclusion', in R. Sandell (ed.), *Museums, Society, and Inequality*, London and New York: Routledge, 69–83.

Silverman, L. (2010), *The Social Work of Museums*, London and New York: Routledge.

Thomson, A. and Freund, A. (eds) (2011), *Oral History and Photography*, Basingstoke: Palgrave Macmillan.

Thomson, A. (2013), *Anzac Memories: Living with the Legend, Melbourne,* Clayton: Monash University Publishing.

Williams, P. (2007), *Memorial Museums: The Global Rush to Commemorate Atrocities*, Oxford: Berg.

Watson, S., Kirk, R., and Steward, J. (2012), 'Arsenic, wells and herring curing: making new meaning in an old fish factory', in S. Macleod, L. Hanks, J. Hale, *Museum Making. Narratives, Architectures, Exhibitions*, London and New York: Routledge, 166–175.

7

'WE CANNOT CHANGE THE PAST, BUT WE CAN CHANGE HOW WE LOOK AT THE PAST'

The use of creative writing in facing up to personal histories at the Danish Welfare Museum

Trisse Gejl

Translated by Steven Sampson

In a brightly lit room overlooking the cobblestone courtyard at the Danish Welfare Museum, ten adults sit and write. The pencils scratch the paper pads, thoughtful eyes gaze out of the windows. With a few exceptions, the ten writers do not know each other. Nevertheless, they have one important thing in common: their childhood. They have all been placed in orphanages and experienced severe neglect. This article stems from an experiment into how a literary approach to their history may contribute to their own healing and to the representation of the history of institutional care. The writing workshop is part of a larger research project on the history of children placed in orphanages and the participants' narratives about their experiences. I found the participants with the aid of the Danish Welfare Museum and the two PhD students attached to the project, and we quickly agreed to use the Museum's brightly lit, historically restored premises in Svendborg.

It has required preparation and telephone conversations with several of the participants in order to build a relationship of trust, to challenge their fears of not being able to write well enough, of not spelling or using commas correctly. Of not having been smart enough in school, perhaps. But that's not what this is all about. It is about expressing oneself aesthetically. It is not important to write about one's childhood, one's trauma or accompanying diagnoses. It is important to discover writing as an aesthetic form of expression, as a language that can narrate in a form that the diary cannot. Texts that have a value in themselves and that are read. There is a great difference between the therapeutic and the aesthetic form of writing.

The workshop

In order to try and illustrate the difference, I begin this day in Svendborg with simple writing exercises. Each of us casts two dice, and the participants must write according to the age shown on the two dice. For example, if the dice show a total of seven, the sentence should begin with, 'When I was seven years old …' It goes without saying that in this group, the result will end up

somewhere in their childhood, which with two dice can be no more than 12 years. This will often spawn painful memories, but not always. Typically, the participants write in the form of a diary, recalling things. And almost always from the vantage point of an adult's reflection after the fact, and almost always visually recalled like a silent movie running far away. Maybe a bit like a diary. Then this happened, and then that. They read the texts aloud to each other, and several nod in recognition. Now they throw the dice again, and this time they must write in the third person present tense: 'She is seven years old …' and they must connect at least two senses more than just their sense of sight. Here the texts become more vibrant. We notice the little girl who for the first time gazes into the large dining room and how the smell of sauerkraut creates a sense of nausea and reveals a new, frightening world to a little child, right then and here. It can also be the smell of sawdust, for that one time a year when this little boy goes to the circus and for two full hours forgets that he is in an orphanage. For two hours, there is only circus music, and he is 'normal'.

They can often write more freely because they can transform their personal experiences into a third person right now. They can perhaps even have a feeling of caring for the child or they can write about the difficult times because they do not use the 'I' form. In addition, they discover that senses can pull the reader into a text in a different way than just telling what it was they were thinking. The smell of sauerkraut reveals the fear. The sound of circus music gives hope. They discover aesthetic tools, they discover that they can sometimes *show* the situation instead of just *retelling* it. In short text fragments, the participants illustrate how it is. Instead of telling how it was.

The writing workshop revolves around the subjective truth. The truth about how the participants themselves experienced their own history, despite what was written about them in the system's personal files. Files that most of the participants have difficulty obtaining. Here they have the chance to relate their own experience of their own story without being confronted with 'That's not what it says about you in the files', which are also written by people in a system with divergent discourses depending on whether we are talking about the 1950s, 1960s, 1970s or 1980s.

The vulnerable space

The participants rapidly discovered that this was an intensely emotional space to move into, and the intention was not therapy. The intention was to see whether the text works, whether it leaves an impression, rather than relating to some sort of authentic background behind it.

There were also some participants who were concerned about the anonymity of the texts they produced. Of course, they had been informed that if they gave their permission, we would like to use their texts for an exhibition as well. They wanted to contribute but found it difficult to come forward. So already on the first day, I changed course, and we started writing anonymous 'collective texts' inspired by the Oulipu movement in the 1960s and the Surrealists in the 1920s, both of which were preoccupied with freeing the text.[1]

Easy to explain, for example, are the 'folded poems': each of the ten participants has their own sheet of paper, on which they write a sentence that starts with 'If…'. They then pass the sheet on to the next person, who then writes a sentence beginning with 'Then…', where-upon they pass it onward to the person sitting next to them, who again starts a sentence with 'If…', and so on. All this time, the paper is folded, so that the next person can only see the previous sentence. But it constantly changes between 'If…' and 'Then…'. Clearly this

exercise generates some nonsense poems, but as there is a constant association with the previous sentence, a unique poetic context also emerges, as well as a form of community. Here we should also mention that on two occasions, I was accompanied by an informal observer who participated in the workshop and wrote texts in the same manner as the others. I felt that it was important that researchers obtain insight into what the workshop does. The two observers did not take notes. The first time it was postdoctoral researcher Susanne Kemp, who is also affiliated with the general *Welfare Stories: On the Edge of Society* project. On the second occasion, I was accompanied by Sarah Smed, head of the Museum, who was also affiliated with the project. She also facilitated breakfast and lunch and participated as well. This point is important, since I am convinced that a silent, note-taking observer would have altered the atmosphere in the room, while a participating researcher could help maintain the kind of open atmosphere for the vulnerable space of writing.

Here is one example

> *If my father had not drunk*
> *Then I would have gotten hold of my files*
> *But it is difficult to relate to not knowing the truth*
> *If you yourself have difficulty handling it*
> *If there now comes a day*
> *Then the future must show more soul than system*
> *If systems had more to do with the future*
> *Then I don't know what it has to do with the past*
> *If I cannot get hold of my case records*
> *Then I have to accept it*

The text is anonymous. Nobody knows who wrote what, but as most people write based on their own story, and as the group shares their history to some extent, a theme emerges which would not otherwise emerge in an adult education course where the participants come from entirely different backgrounds. They jointly write about their childhood as being institutionalized. There emerges a collectively authored work in the group.

A glossary of an orphanage childhood

Another text we worked with, not only at the first workshop but throughout, where the participants had time to edit their contribution in between, was *My Orphanage Glossary of Childhood*. It was inspired by the Danish poet Kristen Bjørnkjær, who in 1969 wrote *My Agricultural Glossary of Childhood (Min landbrugsleksialske barndom)* and by the Danish poet Inger Christensen, who in her collection of poems entitled *Alfabet* paired the alphabet with the numerical series of numbers known as the Fibonacci sequence (first described in 1202 by the Italian mathematician of the same name).

Each participant was given seven to eight letters of the alphabet, with the task of creating a word list about their institutionalisation. This is a method of free association, and we were struck by the fact that if a participant had been given the letter T, it became T for 'tis' (peeing) in bed. Had they been given an S, they wrote *'sengevædning'* (bedwetting). Those who had drawn the letter U wrote *'uheld'* (accident) in bed at night, and those who drew the letter

Hvis jeg følte mig alene i verden
så ville jeg glad da ingen kunne
se mig

hvis vi skal lære noget af en dårlig barndom
Så er det, at vi har været stærke

Hvis vi ikke havde været stærke,
kunne det være endt tragisk
Så siger du at vi skal på udflugt idag
Hvis du holder, hvad du lover

så skal det hele nok gå
Hvis du selv tror på det.

Så skal det nok lykkes
Hvis lykken står den række bi
Så kunne livet være vidunderligt.

FIGURE 7.1 Collaborative poetry produced by Care Leavers participating in the writing
workshop.
Photo: Danish Welfare Museum.

N ended up writing the word *'nattevædderi'* (night wetting). Under B, several participants impulsively wrote the word *'besøg'* (visit). Under E, it was *'ensomhed'* (loneliness). The word *'værelse'* (room), on the other hand, remained unelaborated, with no further commentary. The same was true for the word *'skam'* (shame). In this form, which mimics a dictionary, words like 'shame' and 'room' can suddenly stand powerfully alone, without explanation. There is an invisible exclamation mark behind these words because they lie embedded among the more elaborated definitions of the other words. For 'shame' and 'room', there are no more words. The words themselves say it all. In the context, at least. Here is a random excerpt of what became a ten-page document (alphabetical in Danish):

My Glossary of an Orphanage Childhood – a Choir in Several Voices (in alphabetical order according to the Danish words)

> Ballroom gowns [*Balkjoler*]: I went to dancing lessons. For the ball, the princess' dreams obtained wings. The orphanage had three ballroom gowns for sharing, pink with tulle skirt. It was great when, on a rare occasion, I would be allowed to dress up in one of them. But they always had to be returned.
>
> Visit [*Besøg*]: Something that others had.
>
> Buns [*Boller*]: The very first time I buttered homemade buns, I was scolded because I did not butter all the way to the edge.
>
> Visits at the orphanage [*Børnehjemsbesøg*]: I was two to three years old. Once my mother came to visit the orphanage. She damn well wanted to show the staff who was the boss … She thought that I should have a bath. I did not feel safe, so I cried loudly and wanted to get out of the bathtub. But she got angry and washed my hair so violently that I got soap in my eyes and mouth. My sister was standing in the doorway and wanted to help me, but she was also afraid of the adults.
>
> Loneliness [*Ensomhed*]:
>
> Miss Nielsen [*Frøken Nielsen*]: That's what I should call my mother, because her employer was not supposed to know that she had a child.
>
> Ice cream sandwich [*Isbåd*]: A fragile delicacy that melts before you behave!
>
> Janus: My brother is named Janus. He was beaten in the shower.
>
> Middle-ear infection [*Mellemørebetændelse*]: Yet another word you did not want to hear, because it often meant another placement.
>
> Lost relationships [*Mistede relationer*]:
>
> Attention [*Opmærksomhed*]: Some adults thought I was looking for too much of it.
>
> Pillow room [*Puderummet*]: Contains good memories. The pillow room is a playroom in the orphanage. A place where there is free play, where you tumble around, make nonsense and play.
>
> Shame [*Skam*]:
>
> Boxes [*Æsker*]: Something I used for hiding small important things. They were easy to hide so the things were not stolen – and to quickly pack up if I suddenly had to move.
>
> *Øster, Hans*[2]: Teacher at the orphanage who introduced pets (such as rabbits and chickens). He perhaps did not know then how much a soft fur coat could do for an institutionalised child. But he probably still had the feeling. It was something to care about and to hold. And we went to his home when the rabbits were going to be mated. Suddenly had to move.

Inclusion of professional literature

Between the writing exercises, I read selected professional literature aloud. These were texts related to vulnerability, secrets and being exposed. But also other texts that just illustrated a beautiful aesthetic form with which one could order the things one wanted to say.

They also served as small interludes where the participants could sit back and someone would read aloud. It was perhaps an element that could be prioritized. I think it is important that there is no homework, no preparation, that you just have to come and be in it together.

The meaning of place

The Danish Welfare Museum is located in the middle of the country. The participants in the project came from all parts of the country, and meeting here in Svendborg made geographical sense. It also turned out to make symbolic sense as well. There are places with or without meaning. This is a meaningful place. Drinking our morning coffee in the cobblestone courtyard, where the barbed wire still hangs over the walls. Eating lunch together in the beautiful park, where the big herb garden has been restored, where the paupers were sent to do forced labour. We could see the bars still sitting on the windows, even though the gates were no longer locked.

It is a good framework for writing one's vulnerable story, for conversing, for recapturing one's own story, to get control of it. The walls murmur, the cobblestones murmur, the old quotes on the walls, the giant loom for production of the coconut mats for sale, the place where stone was cut, the place where you hammered nails into coffins. The place carries an atmosphere, a mood that coincides with the story and the collective memory of being involuntarily institutionalised, even though this experience was not confined to Svendborg.

Since it has proved logistically difficult to assemble everyone in Svendborg every time, I facilitated one workshop in Aarhus, at the Jutland participants' own social centre, *Baglandet*. It also went well, the atmosphere was already intimate and secure, although without the historical rush of emotion.

Between workshops

In between workshops, we created a closed Facebook group for exchanging ideas and writing, for example. Some participants were active, others barely so. My idea was that they should work more on their writing and get responses, but I think it would be easier to maintain the dynamics if participants also undertook various smaller writing exercises, every 14 days, for example. Those active in the group have exchanged their writing among themselves, responded and assessed each other.

It is interesting to see that some of them pursue the autobiographical idea while others are more interested in writing fiction without any special connection to their own lives. We have experimented with the conditions of narrative: Do you speak in the first or third person? Do you narrate in the past or present? My own response to the texts has, in principle, been the same as when I teach my creative writing course at the University of Southern Denmark, namely to focus on the potential of the text, on what can improve it, for example.

Benefits and perspectives

It wasn't long after the first writing workshops before a participant said: 'I suddenly feel normal'. The common denominator of experiences is overwhelming, even though everyone is now somewhere else in their lives. This feeling could also be sensed from attending coffee meetings and exchanging experiences. What, then, can the writing workshop do?

In an evaluation one participant wrote:

> What we do is to bring to light the events and experiences from our institutionalisation in text form. Then we can discuss and analyse them – see them from all sides, and perhaps find an entirely different angle to our stories. We cannot change the past, but we can change how we LOOK AT the past. When we put words down on paper about elements from our life story, they suddenly become much more concrete. Take feelings of guilt, for example. We can hold them up in front of us, look at them, hold them up against what we were back then and what we were up against, and then they suddenly lose some of the power they had over us.

Another wrote:

> The writing workshop has been like Sesame. Open, Sesame, my forgotten and repressed past. The memories have colours. The colour blue: heavenly freedom, the colour red: the red poppies, the colour green: the scent of the grass, the colour yellow: the scent of the dandelion. I got some of my senses thawed out from the permafrost. The writing workshop was the missing code.

To work with writing on its own terms and not on the basis of therapy, apparently provides a tool for viewing autobiographical experiences from the outside. The participants do not tell how a particular scene played itself out and how it influenced them, as would be done, for example, in the diary, where one does not imagine an uninformed reader. Instead, they describe the experience, so that as an outside reader, I can suddenly sense how it was, how it felt.

And what is objectivity? What is the true story and who can tell it? A lot of research in museums is based on interviews, old sources, numbers, cool facts. What we did here was to provoke a clash between subjectivity and objectivity; perhaps the two together can tell mere true stories.

For example: In objective journals from the seventies, it seems that there was a trend to diagnose young women as sexually aggressive. Who wrote these journals? People observing the young women. When these women tell their own stories in their own words and do not recognize the descriptions in the journals, are these stories less true?

I can't see why this method of creative writing should not be able to contribute to any exhibition in any museum involving human stories, and nuance the research. By one of many ways, the public can enter an exhibition. A wonderful piece of creative writing, concerned about the quality of the reader's experience more than the reader's learning.

We did this in the Danish Welfare Museum. Several pieces of creative writing from the former orphans were part of the exhibition along with photos and great results of research. We transferred memories and diaries into sensual texts to be understood with the body more

than with the intellect. Are these stories true? Well, it was how these people, these subjects, experienced what happened. The body remembers. The body interprets. Therefore a different dialogue occurs with the public entering the museum.

Recently we had a new prime minister in Denmark. She chose finally after many years to give a national and public apology to Danish Care Leavers placed in care between 1945 and 1976. The state of Denmark symbolically said: I am sorry. I am sorry for the rapes, the violence, the way we treated our children. Peer was there. He had attended the workshops. In his pocket he had a poem describing his time as an orphan and what this excuse meant to him today. He gave it to the prime minister. What is the difference between a poem and all the official letters written through time by this group of former orphans? Perhaps the way we meet each other, perhaps an example of what poetry can do.

Here it is important to say, 'Don't do this at home'. As I said, the body remembers. Sometimes very suddenly. We are not interested in one person's specific memory, we are interested in the text. Does the text work as art, does it evoke the memory, so that somebody else without that memory can feel it.

My assessment of the teacher role is that while the exercises are open to everyone, not anyone can conduct these workshops and respond to the texts and to the processes. The author's professionalism is to deal with the writing processes, the writing, the linguistic details, the timbre and voice in the text. I needed these experiences in the writing workshop, in order to convey the joy of writing to a group of participants who did not have any previous rela-tionship to literature, but also in order to provide an empathetic and nuanced response at eye level, regardless of the participants' level of language skill or literary knowledge.

In the writing workshops, we deal with the text that is written, not with the reality behind it. Here one is a writer. The teacher must open up a space where the participants, entirely independent of their personal stories, can have some aesthetic experiences. It requires a trained writer, or at least someone trained in the nuances of language use, someone used to dealing with the writing process, to maintain that space and keep the focus centred on the text, on the intimate details that the untrained eye does not see, the small changes in a text that elevate it and make it better. Tranquillity is good, silence is devastating.

In the potential of the text also lies the potential for its circulation. With an editor or author, one can work further with the texts, refine them, as an author would, with the inten-tion of making the text as good as possible. These texts can certainly be included in publica-tion material in, for example, a museum context.

The head of the Museum Sarah Smed described it this way:

> When literary texts, with strong authentic voices, become part of an exhibition concept at the museum, it enhances the exhibition's standard practice of telling stories, tradition-ally based on museum objects, informative texts, spaces and photographs. For the visitor, the museum experience will become that much more relevant, and many will be drawn to the exhibition's message through the immediacy and power of the texts.

Since then, some of the course participants have worked further on their writing, and the head of the social centre in *Baglandet* in Aarhus is researching the possibilities of obtaining start-up funding for a literary blog about being institutionalised, then and now. The purpose is that the group of (formerly) institutionalised persons can express themselves and see them-selves by reflecting upon each other's experiences, as well as disseminating good texts to an

FIGURE 7.2 Participants Peer Balken (left) and Hjalmar Kinner (right) after reading their own poetry out loud at an exhibition opening at the Danish Welfare Museum. Photo: Jon Bjarni Hjartarsson (Danish Welfare Museum).

external audience in the form of short prose, poetry or short stories. It is about creating small texts that have an aesthetic value in themselves and which can thereby create dialogue in a space that we all share, namely the aesthetic.

In the long run, we hope that these writing workshops can be placed under the health insurance system as part of a growing interest in the use of culture for health reasons. Up to now, art has been used within the framework of other domains, such as advertising, therapy, storytelling in commercial companies, for example. Perhaps the time has come to use art on art's terms and to see what it can do.

Acknowledgements

I would like to thank all participants in the writing workshops.

Notes

1 According to the Oulipo movement (*Ouvroir de littérature potentielle*, which can be translated into 'workshop for potential literature'), founded in 1960 by French writer Raymond Queneau, one is always subject to limitations when writing, limitations that may lie in one's own tendencies or in the language itself. Instead of seeking liberation from these ties, the Oulipo authors' idea was to create new literary form by recognising and visualising the structures that govern the writing. They often let their texts be governed by spontaneity. The language appears as a material that can be transformed rather than acting as something flowing from an elevated instance. Both contribute to

an unpretentious approach to the literary text. Well-known publications inspired by Oulipo include Georges Perec's 300-page novel, *La Disparition* (1969), which does not use the letter 'e', and is meant as a comment on the Holocaust, in that he eradicated the most used letter of the alphabet. Or Raymond Queneau's *Exercices de Style* (1947), where in 99 small texts he reproduces the same mundane daily event – that of a man getting up from on a bus seat – in a variety of styles, such as a telegram, described auditively, in a tactile mode, and as a form of interrogation.

2 A pseudonym has been used here.

8

INVITE, ACKNOWLEDGE AND COLLECT WITH RESPECT

Sensitive narratives at the Vest-Agder Museum, Norway

Kathrin Pabst

Since 2008, the Vest-Agder Museum (VAM) has initiated several projects on sensitive topics, working in close co-operation with the local community in southern Norway. VAM is a publicly funded regional museum of cultural history dedicated to the collection, conservation, research, interpretation and presentation of cultural phenomena related to the county of Vest-Agder. The Museum has approximately 55 full-time employees, working at 11 geographically spread locations which together constitute the Museum. Besides its main work within traditional areas such as research, collection management or dissemination to different target groups, the Museum has been working for more than ten years on documentary and exhibition projects that highlight taboo topics, using personal narratives of those who live in the region. VAM has completed several collaborative projects with other Norwegian museums on difficult issues, and has also taken on a national role in this work. The employees have worked strategically to communicate knowledge about this field throughout VAM. Since 2015, the Museum has received two grants from Arts Council Norway for two three-year projects concerning community engagement. Last but not least, VAM was awarded Best Museum of the Year 2016 in Norway, mainly because of its work in this field.

After a professional evaluation of relevant, sensitive topics and subjects subsequently chosen by the Museum, the projects were linked through invitations to local citizens to provide personal accounts. These topics included the sexual abuse of children, as several cases had lately been revealed in the region. Body image was also included, as more and more young girls were developing eating disorders and were willing to undergo operations to change their physical appearance. The issue of religion was also of interest as the region is known for an increasingly strict and more conservative approach, with behaviour being prescribed according to biblical teachings. This has been accompanied by exclusion of people who are not religious.

What these topics had in common was their recognition and inclusion of individuals who were regarded as a part of the so-called majority by others but did not feel so themselves. Approximately 70 people have participated in these projects, each with a personal story which was difficult to share. The Museum is highly conscious of its responsibility when first issuing an invitation to individuals to participate and in subsequent follow-up. This sense of responsibility has been developed in both a theoretical and practical sense. A doctoral thesis examining

the moral challenges museum employees face when working with sensitive issues and external participants has been initiated and completed. The objective has been to empower the Museum staff to meet the individuals and facilitate their contributions in the best way possible for both the individuals and the visitors (for example Pabst 2014).

The latest project at the museum, a project on poverty, entitled *'Not Quite All Right?!': A Project on Being Poor in Southern Norway*, demonstrates the sensitive nature of the subject and how the Museum represents this to its visitors. Poverty remains an important issue for our community, as it affects around 12 per cent of residents in the Agder counties of southern Norway. Newspaper articles, conversations with those organisations that provide free meals and a strong advocatory presence on social media, suggest that the poor feel too ashamed to talk about their situation. The result is that they experience a sense of being lonely outsiders, while the wealthy do not see the 'minority in the majority' because nobody talks about it. In the following chapter, I would like to use this project to illustrate how we collect stories about taboo-laden subjects and the consequences in dealing with real-life challenges both inside and outside our institution.

Even though the Museum's work with individuals and their personal narratives is aiming for both activism and social change, the outcome has, until now, been much more indirect and subtle than we would like it to be. This is mostly symptomatic of a traditional institution's insecurity and fear of how to proceed as well as concerns about how differing stakeholders may react. It also reflects the different personalities of the employees involved (Pabst *et al.* 2016), who, overall, regard the Museum as an institution that has high credibility within the local community. The Museum wishes to use this advantage as a framework to lift up those among us who struggle to be heard. We do this by consulting with members of the community and representing their personal narratives. But – and this is a huge 'but' – it is still the Museum that provides and defines the framework, that makes the final decisions, that limits the direct contact with the contributors, and that dilutes their related experiences. This raises the question of how helpful such an approach really is, and underlines the main criticism raised in this book, that many museums support the status quo instead of challenging it. Are we on the right track? If so, where on the track are we, taking the procedures and outcomes into consideration? This is the question I will try to answer after having presented this project in more detail.

'Not Quite All Right?!': A Project on Being Poor in Southern Norway

Statistics suggest that income disparity in Norway is increasing, and that a growing number of people are experiencing financial difficulties. The governmental agency Statistics Norway (SSB) defines poverty as individuals who continuously have a low income, implying that their gross household income is less than 60 per cent of the average. Moreover, SSB uses multiple definitions; for example, a different approach suggests that individuals are poor when their lack of income limits their opportunity to participate in society on an equal basis with others in their surrounding community. Approximately 10 per cent of the population is poor, and in the southern part of the country, ten per cent of all children fall into this category.

Research suggests that the individuals who are affected by poverty feel that they are alone and yet surrounded by others who seem easily to be able to afford a nice house, a car, a cabin or boat, all of these 'typical' assets for many families in southern Norway. The feeling of being one of the very few who are affected, by standing apart from the rest of society, in which most people appear to get on very well, looks like one of the major challenges – in addition

to all the limitations that follow – of not having enough money to take part in the social life that is observable elsewhere. Poverty is a relative term with a range of causes. However, for those concerned, poverty also comprises feelings of guilt and shame while simultaneously feeling invisible. Feeling ashamed often leads to individuals retreating from others, leading to increased isolation.

The significance of poverty – more than 10 per cent of the Norwegian population – along with its associated consequences, prompted our curiosity. Where were the voices of the people affected? There were articles in newspapers and social media written by volunteer organisations, with alarming news about the increasing number of families who needed help to have food on the table at Christmas. We also read reports from schools about more and more youngsters not joining social gatherings because they did not own a bicycle or ski equipment. Youngsters felt isolated at school for not being able to show off certain brands or new technological equipment, increasingly avoiding social contact in order to hide what they could not compare. But the people and youngsters the articles referred to – who were they? They were somehow socially invisible. We knew that they were out there somewhere, but they did not speak out and could not be identified. Despite the articles, it is therefore easy to gain the impression that there are not many poor people – or that the topic is something one just does not want to talk about. So we were left wondering: Who were 'the poor', and what did they think about having little money? How did their difficult financial situation affect them – and why was this such a taboo subject? In other words, we were interested in increasing our understanding of the societal challenge of poverty, not only based on factual conditions but, first and foremost, on the *feelings* those affected associated with not having the means to be a part of the social community on an equal footing with others in their local community. Those feelings we hoped to communicate while working as 'intermediaries' with those affected by poverty and those who were not. Could we contribute to more openness about the challenges one experiences when being poor and help those affected feel less alone and those not affected be more understanding? Might the latter group even understand that their often expensive buying habits, especially to the benefit of their kids, contribute to highlighting social differences between youngsters?

A broad approach

This formed the basis for our project, and we decided early on that we would attack it from several positions. Not only would we meet people who were affected by poverty today, but we would also actively use their stories to lift up the societal challenge of poverty to a higher, more visible level in order to illustrate how widespread poverty actually is. The 10 per cent affected were to understand that they were not alone, the 90 per cent not affected were to develop a greater understanding for the consequences that poverty had for the individuals experiencing it. The factual information about how poverty could lead to withdrawal and social isolation aimed to lead to reflection and new patterns of behaviour among our informants and members of the public. Not least, we as museum staff wanted to place poverty in a larger historical perspective. We never considered a larger degree of inclusion and participation of the informants, because we automatically assumed that we not only had the professional knowledge needed to do the work in the best possible way, but also that the participants would not be interested: after all, poverty seemed to be related to a high degree of shame.

'*Not Quite All Right?!': A Project on Being Poor in Southern Norway* resulted in a comprehensive documentation, an exhibition and an outreach project about poverty in southern Norway, receiving financial support from Arts Council Norway and other contributors. The work started at the end of 2015, leading to the publication of a book and the opening of an exhibition in November 2016, dissemination to 2,700 school pupils through workshops, and exhibition guiding throughout all of 2017 (Vest-Agder-museet 2016). Continuous ripple effects have become increasingly visible over time. At the time the exhibition was taken down, it had been shown in five cities. Approximately 30,000 visitors were registered by an automatic counting system.

The project team consisted of five education officers, an exhibition designer and myself as project manager, coordinating and also instructing my colleagues, based on the findings in my PhD thesis. Several other Museum staff members were also incorporated into various elements of the project. I had a broad background in working with personal accounts, and this experience and knowledge were to be transferred to my colleagues, mainly because we wanted to anchor and consolidate knowledge about this field of work amongst as many of the Museum's employees as possible. In addition, we saw valuable advantages if the Museum's education officers themselves could meet the participants, summarise the conversations and actively ensure that this touring exhibition was visited by school groups. This way, the subsequent messaging would most probably become more personal, more efficient and better targeted towards our audience.

The exhibition

The exhibition became the most visible result of our work, consisting of four movable units that were connected with one another to form a display of approximately 70 square metres. The units could easily be disassembled and reassembled, thereby making it easy to install them in central locations in cities (square, parks, close to a shopping centre) and between the Museum's widely spread areas. Visitors first entered an 'historical entrance hall' where a film and timeline were shown containing information and images of poverty from earlier times. Thereafter one entered the main room, where one could see 100 people, men and women, painted on the walls, in height and shape corresponding to real people. These we regarded as stakeholders for the 13 people we had talked to and whom we called our informants. The 100 figures illustrating people on the walls of the exhibition room had no facial features – our way to anonymise them and demonstrate that one actually cannot recognise whether someone in a crowd is poor – but 13 of the 100 anonymous faces could be illuminated. At the same time as light would fall on a face, a voice recorder hidden behind the figures would start to display the story the informant had shared with us. As the informants were too afraid to be recognised by others when talking themselves, we had summarised the interviews to personal narratives for them, short stories using the first person 'I', thereby expressed as written by themselves, telling about concrete experiences and feelings related to being poor, which the informants had approved. The moment one voice finished talking, a new face was lighted up and a new voice started.

We had made sure both that the lit figures matched the participants' bodies in age and gender and that the voices, recorded by professional actors who read the stories, fit the same criteria. The voices continued without pause from the moment visitors entered the main room until they left. Even before visitors entered, they were encouraged to listen to the voices

as long as they were able to – and register the brevity of their attention span. All anonymised personal accounts, columns of factual information about poverty in the region and contact details of support organizations were also published on the Museum's website.

The starting point

We identified five premises in advance:

1. Open invitation to members of local society affected by poverty.
2. Use of participants' personal accounts to communicate to, and awaken *emotions* within, the public who visited the travelling exhibition. Here, we wanted to educate or inform our visitors, whom we divided into two groups: those affected by poverty themselves and those who had not thought much about the issue. We wanted those affected to understand that they were not as alone as they might feel, and to those not affected, we wanted to educate and inform them about how it felt for the poor to live side by side with richer fellow human beings. By awakening more consciousness about the challenges which follow in the wake of poverty, we hoped to change some money-spending attitudes.
3. Being a museum, we wished to draw historical parallels from a society of the past to our contemporary society.
4. Using the project to involve new Museum employees actively in the project to anchor this kind of work in as many departments and working areas as possible.
5. Method development that would benefit other museums in Norway. *'Not Quite All Right?!'* was part of a larger project concerning how museums can function as active social players with regard to sensitive topics, a project which the Norwegian Arts Council has supported. Here, we worked closely together with two other Norwegian museums which also addressed poverty in their projects, and compared results of our shared methods. One result of the cooperation was a short movie summing up our experiences for other professionals (Vest-Agder-Museum 2017).

Although we have worked on all areas and premises with an equal amount of intensity, in the following section, I focus on gathering and disseminating our informants' personal accounts. This was the most demanding work – and the most rewarding. We spent a great deal of time thinking about how we wanted to move forward and how we could best react to the informants' stories and wishes. Most importantly, we wanted to find the best solutions to retelling the stories told to us by our informants to the public.

Contact and collaboration with our informants

What is it like to not have money to buy proper food? What is it like to lose one's job, have a breakdown and as a result not be able to pay back loans and debt? How does it feel to not be able to give one's children the same things that other children have? What is it like to be a pensioner receiving very low allocations without the opportunity to spend the end of one's life in the manner one had hoped and worked for? And what can be done in order to ensure that this deprivation won't be visible to others? These were some of the questions we wanted to explore. Similar to past projects, we posted an open invitation in newspapers and social media, asking, 'Have YOU ever felt poor? There are many reasons for being poor today – what's

yours?' We made it clear that we were interested in finding out about individuals' experience and observations, guaranteeing complete anonymity and control over how their own story was presented, within our previously determined framework.

Fifteen people contacted us, among them two who changed their mind after having read our summaries of their stories. They were overwhelmed by their own experiences, which suddenly – in written form – felt even stronger than before. Thirteen were thereafter represented in the exhibition and on our website. They told moving stories about what it is like to not be able to work because of illness and what it is like to have neither money nor a social network. They spoke about how it feels not to be able to afford food and so go hungry, leaving the last slice of bread for one's children. What it is like to not be able to work because one is too ill. How people sometimes pretend that their children are 'sick' when their friends invite them to their birthday because they do not have the few kroner it takes to buy a gift. What it feels

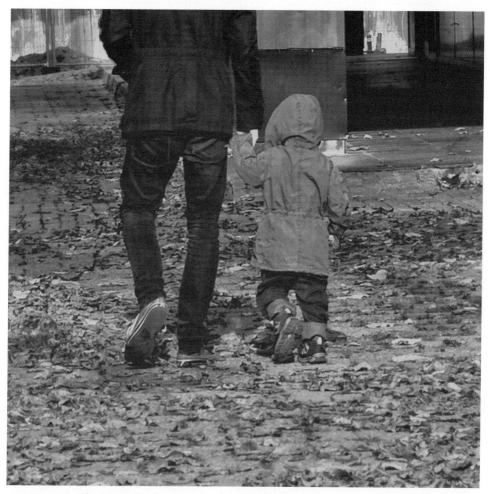

FIGURE 8.1 The topic of poverty has been the topic with the most taboos we have ever worked with to date.
Photo: Anita Nilsen.

like to become more and more isolated because one doesn't have the money to meet friends at a café because it means having to pay for coffee. How much it hurts to celebrate Christmas with one's family and not be able to buy a single gift for them; and how hard both adults and children work to hide the fact that they cannot afford to go to social gatherings with friends or acquaintances.

Meeting the participants

We collected these stories during one-on-one meetings with the thirteen informants. Most of them contacted us by e-mail, while we contacted others through organisations working to eradicate poverty. Upon receiving these inquiries, we divided the participants among the education officers who were to conduct the interviews, each of whom were assigned around three participants whom they were to follow up. However, the museum educators had never before conducted interviews, at least not interviews which we anticipated as being sad, difficult or tough. Meeting a stranger who perhaps had children the same age as one's own, and who then related that their children had to be 'sick' whenever they were invited to birthday parties because one did not have any money to buy a small gift, appeared daunting. No one knew what the participants would talk about once the meeting had been set up, or how they would react to our questions and planned approach of recording these interviews on tape. We knew only their name, age and a few key words that were of primary concern to each interviewee.

Preparations

In order to make the most of the interviews, as a starting point, we used experiences sourced from previous projects and research (Pabst 2014). For example, did these findings suggest that, in general, participants make an informed and active choice to contact a museum and that a display of their personal narratives in such an institution often is reconsidered as an acknowledgement and sign of respect that they long for? Our experiences suggested, also, that we had to take care of ourselves during the process as face-to-face-meetings and sensitive stories could be difficult for staff members to handle. At the same time, we had to be extremely conscious how to proceed and to treat participants ethically. Our starting point was informed by previous experience, recent research results and an ethical approach informed by acknowledgement and proximity theories. We prepared lectures and a subsequent workshop for the education officers who were to conduct the interviews. The workshops were prepared as a series of cases one had to handle: the education officers met amateur actors who pretended that they were participants who would tell troubling stories. The aim of this exercise was to practise what could or could not be said, to decide when the interviewer should either remain silent or ask follow-up questions. For instance, how should they respond if a participant started to cry, what could they promise them and what should they deny them?

This type of workshop had to be incomplete, given that all life situations are different, all people are different, and all encounters are different. But we did agree on a certain number of basic guidelines: the participant could decide where we would meet them, either at home or the Museum – or some other public place where these conversations could take place in private. The interview would be recorded on tape. All participants would remain completely

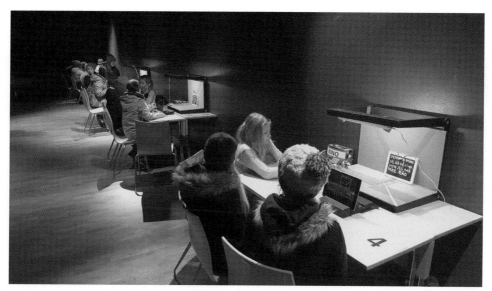

FIGURE 8.2 We offered different workshops for small groups of pupils, challenging them to find possibilities to include all of their friends in activities which normally cost money. Photo: Anne-Lise Stangenes.

anonymous: the only information that would be given about participants' identity would be their gender and age, perhaps even with a different first name. All participants, with their signed consent, would have complete control over their story, comprising an interview summary written by us and submitted to the participant for their input, corrections and approval. We then took the approved story and used it as we considered most appropriate and useful, aiming at the best mode of representation possible.

In order to be able to talk about our own experiences and reflections, and to gain support in making the best possible choices throughout the project, it was agreed that the project group would meet regularly and that everyone at any time could turn to others if they had questions. Additionally, everyone was to keep personal notes written immediately after interviews which comprised reflections during the entire process, whenever contact was made with the participants. These notes would help us sort out our thoughts and provide insight into any point to which it seemed especially difficult to relate. In order to allow our experiences to benefit other museums, we made a film summing up the reflections of a total of 13 museum staff members in collaboration with 2 other museums that were working on parallel and similar projects. The film *Nobody Is Simply What You See* is now available for free on the Museum's and other websites. Parallel to the interview process, the education officers worked on an educational programme for school pupils aged 9 to 12.

Some theoretical frameworks

The project was based on theoretical frameworks such as acknowledgement theory and proximity theory and the wish to ensure positive social outcomes. It is assumed that through asking critical questions about established truths and by bringing forward current societal challenges, museums can contribute to positive societal change. In order to be socially relevant, one

must find the best ways of reflecting this diversity in all its nuances. Museum projects that for example deal with abuse, life in closed institutions, poverty, mental illness or alcohol abuse, can challenge the perceptions of individuals or groups in a local community. These topics require separate consideration and individual solutions (Pabst *et al.* 2016).

While personal narratives were previously used as merely good examples to be included in the overall social narrative, the current aim of researchers is often to highlight alternative voices that bear witness to society's diversity and complexity. Sometimes these break with the overall narrative, while at other times they add nuance to the story based on people's daily life experiences.

When museums today want to be socially relevant, personal narratives can contribute to illustrating aspects of current or past societies that have had or still have consequences for people, both individuals and groups. Research shows that it can be good for people who have been subjected to a difficult experience, who have not been heard or who have been wronged, to be able to tell their story at a museum. Proximity ethics and recognition theory are good starting points for theoretical approaches (Honneth and Holm-Hansen 2008; Løgstrup 2000). If one is well received by the museum staff, one may feel oneself being brought forward and able to help others by sharing one's story. Visitors will for their part be able to learn more through hearing fellow human beings tell about their experiences: empathy can – if triggered in the right way – lead to more learning. The main challenge is therefore to find the right way to do so, meaning meeting mainly the needs of both the informants and the visitors at the same time (Kavanagh 2002; Bonnell and Simon 2007; Kidd 2011: 245–246; Simon 2011a; Simon 2011b; Tinning 2013).

Conclusion: invited, acknowledged and utilized appropriately – in a good way?

The topic of poverty has been the most tabooed topic we have ever worked with to date, and all interactions with the participants have been influenced by the desire to provide them with a good experience during their contact with the Museum.

The ripple effects from the project were highly significant. The Museum received inquiries from municipalities that had created new task forces in order to stamp out poverty. The newspapers in each of the cities in which the exhibition was shown were quite interested in the project, and school groups began collecting clothes to give away to the needy. Our main intention had been to point out a taboo-related topic which had huge consequences for 10 per cent of the population. Here, we were less interested in setting a political agenda as such than in eliciting a new degree of understanding among individuals who, through new attitudes and actions, could contribute to some extent to a better and more inclusive society. But the project also reached politicians at the national level as the subject of poverty and especially the children and youngsters affected seemed to be high on that year's political agendas, and a great deal of work was done to get the exhibition mounted in the capital city of Oslo. Although in the end this was not possible, the museum has both lifted up an important topic and clearly made a name for itself both regionally and nationally.

We concluded that our approach had worked out as we had hoped. Several of the participants have expressed that they found it positive to participate in the project and many thanked us. The museum has gained increased attention in the media and highlighted a social challenge that is overlooked. Visitors said that the exhibition has touched them and let us

know that they have gained a greater understanding of something about which they previously knew little or nothing. From the very beginning we had anticipated that the topic of poverty would be taboo and quite sensitive for all of those affected by it, and had foreseen as well that the reactions among the public would hardly be negative: First and foremost, the topic awakens positive feelings of empathy, not the anger or irritation that one can usually see in projects having topics that challenge visitors' identity.

Despite all these positive results, I would like to conclude with a critical reflection on our approach. In my opinion, there is no doubt that we, regardless of the outcomes mentioned above, are still in a place that I would call 'a safe place in-between', a place with varying degrees of both support and helpfulness as well as eagerness to point out injustice and iniquity, but also paternalism, limited access to real involvement and limited actions as social activists. We are aiming to support the marginalised and do believe that we make a difference in their lives, but we neither encourage action nor call for empowerment apart from the empowerment that follows new insight. We are aiming to contribute to a better society by pointing out social differences and wrongs, but we do it mainly by being intermediaries between members of the local communities, transferring personal narratives from informant to visitor, setting them into a historical context and thereby possibly increasing public understanding and lucidity. But it is *us* dictating the frameworks, *we* invite to one thing and one thing only – contributing with personal narratives – and *we* use the narratives in contexts *we* regard as appropriate. And last but not least, do we also evaluate ourselves, internally in the Museum, without giving the participants a real chance to comment on the results? This can easily be seen as partly paternalistic and partly unwilling to share our power to decide the mode of dissemination with non-professionals.

Could we approach this differently taking the framework and conditions at the Vest-Agder Museum into consideration? I am not sure. We have not even considered a larger degree of participation, among other reasons because we had assumed even before we started that poverty would be so shameful that the participants under no circumstances would like to be visible in decision-making processes. We are after all also a middle-sized regional museum with 11 different locations and many different working areas. It is neither possible nor desirable to concentrate our entire effort on one type of social topic and 'go all in'. We have never pretended to do anything else than we do and have been clear about the limitations of our projects, both when it comes to the time we will spend on them and the degree of involvement. Regarding the specificities of our widely spread cultural heritage sites and the diversity of our working areas, trying to anchor the use of personal narratives from members of the local societies in as many of the museum's activities as possible, seems manageable and a good way to connect with our surroundings more personally than before – so this is what we have done until now.

But there is much more to do and, in our opinion, also a huge potential embedded in taking a closer look at the framework, which seems fixed, but may not be as inflexible as we think. We, as most of the other museums in Norway and around the world, might need to make a real and total shift in our thinking and approach to cooperation with vulnerable people. Do we regard them as so vulnerable that we offer a kind of protection, which might be neither wished for nor appreciated? There is always a stamp following such 'protection'; a stamp that marks people as more vulnerable as they might be in reality, a stamp that might increase and state vulnerability instead of promoting self-reliance, self-help and pride. As long as museums and museum professionals continue to approach minorities and vulnerable

people in a kind of top-down way, regardless of the good intentions, there will not be any real inclusion.

I regard it as extremely difficult to change these underlying assumptions and approaches, because of their basic and unconscious nature, which makes it almost impossible for museum employees to be aware of their scope and consequences. At the same time, I regard a real and fundamental shift in museums' approach towards 'vulnerable people' as so crucial and important that we have to do whatever it takes to develop a higher degree of consciousness and awareness. As a start, we will now work on two new projects, one international and one regional, where we are focusing on more involvement and more interaction with communities, while at the same time ensuring more internal anchoring of a new way to *think collaboratively* and new ways to act on it. It will be challenging, interesting and hopefully rewarding for all partners involved to find the right approaches and guide the process in the best possible manner, successfully facing any and all challenges that may arise along the way.

Bibliography

Bonnell. J. and Simon R. I. (2007), '"Difficult" exhibitions and intimate encounters', *Museum and Society*, 5 (2), 65–85.

Holm-Hansen L. (2008), *Kamp om anerkjennelse: Om de sosiale konfliktenes moralske grammatikk* (Oslo: Pax).

Jonas, H. (1979), *Das Prinzip Verantwortung: Versuch einer Ethik für die technologische Zivilisation* (Frankfurt am Main: Insel-Verlag).

Jonas, H. (1999), *Ansvarets princip: Udkast til en etik for den teknologiske civilisation* (København: Hans Reitzel).

Kavanagh, G. (2002), 'Remembering ourselves in the work of museums: Trauma and the place of the personal in the public', in R. Sandell (ed.), *Museums, society, inequality* (London: Routledge), 110–141.

Kidd, J. (2011), 'Challenging history: Reviewing debate within the heritage sector on the "challenge" of history', *Museum and Society,* 9 (3), 244–248.

Løgstrup, K. E. (2000), *Den etiske fordring* (Trondheim: Cappelens Forlag).

Pabst, K. (2014), *Mange hensyn å ta – mange behov å avveie. Moralske utfordringer museumsansatte møter i arbeidet med følsomme tema* (Kristiansand: Universitetet i Agder).

Pabst, K. (2015), 'Med fokus på de besøkendes følelser: Jo mer disponering, jo mer læring?', *Nytt Blikk: Årsskrift fra Stiftelsen Arkivet*, 60 – 73.

Pabst, K., Johansen E. and Ipsen M. (2016), 'Towards new relations between the museum and society', in K. Pabst, E. Johansen and M. Ipsen (eds), *Towards new relations between the museum and society* (Kristiansand: ICOM Norway/Vest-Agder-museet), 7–16.

Simon, R. I. (2011a), 'Afterword: The turn to pedagogy: a needed conversation on the practice of curating difficult knowledge', in E. T. Lehrer, C. E. Milton and M. Patterson (eds), *Curating difficult knowledge: Violent pasts in public places* (Basingstoke: Palgrave Macmillan), 193–209.

Simon, R. I. (2011b), 'A shock to thought: Curatorial judgement and the public exhibition of "difficult knowledge"', *Memory Studies*, 4, 432–449.

Tinning, K. (2013), 'Museum pedagogy and the evocation of moments of responsibility', *Nordisk museologi*, 2, 67–78.

Vest-Agder-museet (2016), '… at maatte erholde en liden Hjelp': Fattige og fattigvesenet på Agder fra 1786 til 1920, Kristiansand, www.vestagdermuseet.no/the-project-not-all-good-on-being-poor-in-southern-norway/

Vest-Agder-museet (2017), *Nobody is Simply What You See*, viewed 8 August 2019, www.youtube.com/watch?v=tbWGuycGX3c.

Vetlesen, A. J. (1994), *Perception, empathy, and judgement: An inquiry into the preconditions of moral performance* (University Park: Pennsylvania State University Press).

Vetlesen, A. J., and P. Nortvedt (1996a), 'Empati, persepsjon og dømmekraft', in A. J. Vetlesen and P. Nortvedt (eds), *Følelser og moral* (Oslo: Ad Notam Gyldendal), 62–116.

Vetlesen, A. J. and P. Nortvedt (1996b), 'Føleser og nærhetsetikk', in A. J. Vetlesen and P. Nortvedt (eds), *Følelser og moral* (Oslo: Ad Notam Gyldendal), 158–214.

Vetlesen, A. J. and P. Nortvedt (eds), (1996c), *Følelser og moral* (Oslo: Ad Notam Gyldendal).

9

'NOTHING ABOUT US WITHOUT US'[1]

The journey to cultural democracy at Amgueddfa Cymru – National Museum Wales

Sioned Hughes and Nia Williams

It is over 70 years since the Universal Declaration of Human Rights affirmed basic liberties. Article 27 specifically states that 'Everyone has the right freely to participate in the cultural life of the community, to enjoy the arts and to share in scientific advancement and its benefits' (United Nations 1948). Culture was clearly declared as an aspect of human rights in 1948 with the aim of assuring the enjoyment of culture and its components in conditions of equality, human dignity and non-discrimination. Twenty years later UNESCO provided a definition of culture as 'a human experience … as the totality of ways by which men [sic] created designs for living. It is a process of communication between men [sic]; it is the essence of being human'. UNESCO called for 'a full recognition of the diversity of cultural values, artefacts and forms wherever these appear' (UNESCO 1968).

A small number of museums exhibit historical and contemporary violations of human rights, and as such act as custodians of a 'human rights culture' (Duffy 2001: 16). But arguably, most museums have been slow to respond to a cultural rights agenda. Although all museums work with a variety of 'cultural communities', few museums question how cultural heritage is defined, who controls stewardship, and how equality works in terms of minority cultures and cultural diversity. At Amgueddfa Cymru for example, it is only relatively recently that we have started to challenge inequality and champion the need for social change, adopting a rights-based approach to our work (Sandell 2017: 10).

The Universal Declaration does not elucidate the specific relationship between individuals, communities and nations. Museums have made little attempt to define and clarify how conflicts among these three entities could or should be resolved (Silverman and Ruggles 2007). Discussion regarding conflicts of interests against the backdrop of cultural assertions is therefore still in its infancy. Cultural rights are a 'crucial part of the responses to many current challenges, from conflict and post-conflict situations, to discrimination and poverty' (Human Rights Council 2016: 3).

In this chapter we will examine the role of a museum in supporting cultural rights, explored by an evaluation of a case study mapped against the United Nation's associated definition. The case study was a partnership project between Amgueddfa Cymru – National

Museum Wales and the learning disability charity Mencap Cymru on the *Hidden Now Heard* project. It demonstrated the Museum's commitment to protect the cultural rights of some of the most vulnerable communities in Wales. We will consider how the project indicated a new way of working for both Mencap Cymru and Amgueddfa Cymru, and consider whether the impact of such initiatives can influence long-term change in policy, structures and practice at Amgueddfa Cymru.

The journey towards cultural democracy

At Amgueddfa Cymru we have started on a journey towards cultural democracy. Our ten-year vision, *Inspiring People, Changing Lives*, is a call to action. It places social justice at the heart of our operation with a view to changing the way we contribute to and influence civic society. Seven free-entry museums, spread across Wales, form part of Amgueddfa Cymru's family of museums. The largest of these, St Fagans National Museum of History, is Wales' most popular heritage attraction with over 600,000 visitors a year. Positioned on the outskirts of Cardiff, it is home to Wales' national collection of history and archaeology. St Fagans has undergone a transformation between 2012 and 2018 as a result of a £30 million redevelopment project, supported by the Welsh government and the National Lottery Heritage Fund. The redevelopment at St Fagans, entitled *Creu Hanes – Making History*, has embodied Amgueddfa Cymru's vision and philosophy.

Throughout the *Creu Hanes – Making History* project, St Fagans remained open and the redevelopment project itself became the content for the public participation programme. Over 120 third and public sector partners and individuals collaborated on all aspects of the redevelopment; from concept design to gallery content development, from participating in construction work to devising new activity programmes. The construction company was requested to deliver a Community Benefit Plan as part of their work. From the outset, a desire to work collaboratively was embedded in all aspects of the project; the focus was on creating history *with* rather than *for* the people of Wales.[2] We recognise that participation and co-production through culture are not the same as social change. Culture is a living, breathing process and the new spaces and galleries enable St Fagans to continually evolve and provide contemporary relevance. Participation is not an end in itself. For us participation is about the way we operate as a museum as much as the experiences we provide for our visitors. The *Creu Hanes – Making History* project has provided a platform for experimenting with co-production methodologies across all areas of work. Deep engagement with vulnerable communities has opened up new ways of looking at and framing collections, informed by a concern for social justice, and an awareness of social inequalities.

The political context in Wales

Amgueddfa Cymru is a Welsh-government-sponsored body, and its strategic direction and function are influenced by government policy. Amgueddfa Cymru's journey towards cultural democracy and embedding a rights approach should therefore be considered within this context.

In Wales the discourse between minority versus majority cultural assertions has particular relevance. Wales is a small nation, accounting for only 5 per cent of the UK population. Wales is a bilingual country, Welsh is an official language, and over 75 other living languages

are spoken (National Archives 2011). A devolved country since 1999, Wales is growing in self-confidence, but faces huge challenges of social and economic deprivation. The process of developing new economies and regenerating post-industrial communities is a challenge. Despite numerous strategies over the past decade by the Welsh government to tackle poverty and improve outcomes for low-income families, child poverty in Wales remains the highest in the UK at around 30 per cent (Andrews 2015). With recent changes to the benefit systems, the latest projections from the Institute for Fiscal Studies suggest that a shocking 40 per cent of children in Wales are likely to live in poverty by 2020 (Hood and Waters 2017; Blake 2018).

Such damning statistics have in part led to more radical legislation. Baroness Kay Andrews' report *Culture and Poverty: Harnessing the Power of the Arts, Culture and Heritage to Promote Social Justice in Wales* (Welsh Government 2014), challenges organisations to collaborate more effectively, emphasising the importance of integrating policy, information, assets and services to protect access to and support participation in cultural heritage. One outcome was the establishment of *Fusion: Creating Opportunities through Culture.* Amgueddfa Cymru is a key delivery partner. Eight areas across Wales now deliver strategic cultural programmes together (Welsh Government 2014). Partners deliver programmes to support confidence and motivation, gaining skills and routes to employment, learning for all ages, and improving physical and mental health and well-being. These programmes do not occur in isolation but are part of a wider provision for the people involved. This initiative challenges the current lack of equality in terms of cultural rights and how this, combined with economic and social inequalities, works against people's personal autonomy and right to development (Welsh Government 2017).

In 2015 Wales passed a key piece of legislation to reframe and shape the public sector in Wales. The Well-being of Future Generations (Wales) Act 2015 (Welsh Government 2015) seeks to improve the social, economic, environmental and cultural well-being of Wales. Amgueddfa Cymru, listed in the Act, has framed its vision objectives against the goals and sustainability principle detailed in the Act.[3] The goals focus on improving the economic, social, environmental and cultural well-being of Wales. The sustainability principle emphasises that public bodies must 'seek to ensure that the needs of the present are met without compromising the ability of future generations to meet their own needs' (Welsh Government 2015: 5).

One of the seven goals focuses on culture, placing a specific value on the cultural well-being of Wales: 'A Wales of vibrant culture and thriving Welsh language. A society that promotes and protects culture, heritage and the Welsh language, and which encourages people to participate in the arts, and sports and recreation' (Welsh Government 2015: 4).

Cultural rights and museum practice

In 2009 the Human Rights Council provided the following definition:

> Cultural rights protect the rights for each person, individually and in community with others, as well as groups of people, to develop and express their humanity, their world view and the meanings they give to their existence and their development through, inter alia, values, beliefs, convictions, languages, knowledge and the arts,

institutions and ways of life. They may also be considered as protecting access to cultural heritage and resources that allow such identification and development processes to take place.

<div align="right">(Human Rights Council 2010: 5)</div>

A further report in 2016 emphasised that culture belongs to everyone regardless of location or certain categories of people, and that as human constructs, cultures can be constantly reinterpreted (Human Rights Council 2016: 5). In its preliminary recommendations, the report calls upon states to:

> Ensure the right of all persons, including women, to access, participate in and contribute to all aspects of cultural life, including in identifying and interpreting cultural heritage, and deciding which cultural traditions, values or practices are to be kept intact, modified or discarded altogether and to do so without fear of punitive actions. States should similarly ensure this right with respect to other groups, including persons with disabilities, migrants, indigenous peoples, lesbian, gay, bisexual, transgender and intersex persons and persons living in extreme poverty.

<div align="right">(Human Rights Council 2016: 20)</div>

The work of the Special Rapporteur in the field of cultural rights, who reports to the Human Rights Council annually, is a useful body of work for all museums that are exploring how a rights-based approach can shape their work (Human Rights Council 2019). With support from the Paul Hamlyn Foundation, we are currently developing a framework for cultural rights at Amgueddfa Cymru with a focus on three strategic areas: cultural participation, cultural inclusivity and cultural agency.[4] Being free to all people of all backgrounds is not enough on its own to eliminate barriers and inequality. We need to reimagine what is public and open to participation. As we work towards cultural inclusivity we are exploring different collecting models, more inclusive interpretive methods and ways of diversifying our workforce. Providing platforms for different cultures and voices to co-exist is challenging, complex and often contentious. Ensuring cultural agency and a voice in decision-making is essential for cultural rights to be fully realised, providing fair and equitable access to cultural resources. We are working towards different governance models and as part of this organisational change are challenging where power and control sit and are managed.

The following case study of Amgueddfa Cymru's partnership with Mencap Cymru on the *Hidden Now Heard* project provides an example of the way we are working towards cultural participation and cultural inclusivity. It is one model of working which may prove useful for museums seeking to develop their participatory practice; it acknowledges honestly that a range of models is required to start to address the historical inequalities regarding representation. Our intention was not to focus on social change but to work towards providing more equitable representation in the interpretations and collections that are part of the national collection at St Fagans; to refocus our methods of working and collecting and represent the diversity of histories and experiences.

It is informed by the latest Human Rights Council report that addresses how 'Humanity dignifies, restores and reimagines itself through creating, performing, preserving and revising its cultural and artistic life' (Human Rights Council 2018: 1). It considers how, as a national

museum, we can develop a rights-based approach to shape our practice and our ambition to diversify the collection and become more inclusive. As our definition and understanding of cultural rights develop, the closer we will get to establishing cultural democracy.

'All people and all peoples have culture, not merely certain categories or geographies of people'[5]

The *Hidden Now Heard* project marked an important milestone for Amgueddfa Cymru on its journey towards cultural democracy. It was indicative of a more active approach to partnership working; one where the Museum worked in partnership with another organisation to maximise expertise and reach beyond certain categories or geographies of people in Wales; a recognition that 'shared authority is more effective at creating and guiding culture than institutional control' (Lynch and Alberti 2010: 15). It may provide an interesting case study for organisations seeking to develop longer-term collaborations and working towards achieving shared outcomes and impacts with partners.

In adopting this radical trust approach (Lynch and Alberti 2010: 15), the Museum acknowledged that its collection was not diverse enough. This realisation was informed by consultation work carried out as part of the *Creu Hanes – Making History* project, in addition to recommendations made by the Museum's Diversity Forum. The Diversity Forum was established in 2013 as one of a number of fora set up to advise the Museum on all aspects of the *Making History* project.[6] It looked in detail at representation within the Museum's collection. The group found that the collection was weakest in its representation of disabled people, especially people with a learning disability, and black communities in Wales. The museum prioritised the development of the collection over the next ten years to become more representative in these areas.

The *Hidden Now Heard* project helped us begin to loosen our institutional control over the collection and reflect on our institutional preconceptions and prejudices. The National Lottery Heritage Fund supported a three-year oral history project. It captured the untold and often painful living memories of patients, their relatives and staff from six former long-stay hospitals in Wales, most of which had closed by 2006. The Mental Deficiency Act of 1913 called on local authorities to establish long-stay hospitals for people with both mental health conditions and learning disabilities. Dubbed 'colonies' for the 'mentally defective' (McCrae and Nolan 2016: 61), many of those who were admitted were misdiagnosed and became isolated from society. Under the campaign headline 'The Longest Waiting List', Mencap Cymru played a lead role in the closure of these long-stay institutions in Wales.

Over a period of three years (2015–2017), the project generated 97 oral history recordings with 85 individuals – all deposited in the archive at St Fagans – and 6 temporary exhibitions in regional museums across Wales.

'Sharing and developing knowledge'[7]

Mencap Cymru approached the museum with the idea for the project in 2013. They had realised that patients of the former long-stay hospitals were passing away, and that there were increased incidences of age-related memory loss. They wanted to secure this heritage to prevent society from ignoring institutionalisation and to encourage reflection on the lives of people with a learning disability today (Horler 2017: 8).

From the start, our approach was to provide guidelines for the development of an inter-pretive framework for the collection of oral histories, archives and objects relating to the pro-ject. The Museum's letter of support for the project stated:

> We will facilitate a series of workshops and provide written guidelines to partner organisations to develop an interpretative framework for the collection of oral history, archives and objects relating to the project.
> We will provide opportunities for partner organisations to participate in forming the methodology for the interpretation of the objects generated by the project. A partici-patory approach will be adopted so that the touring exhibition will capture multiple voices, opinions and responses to this important history.
>
> *(Thomas 2013)*

The Museum believed it was adopting a radical trust approach but in reality we controlled the process and the product (Lynch and Alberti 2010: 15). Reflecting on the process of sharing and developing knowledge with Mencap Cymru, we can see that the Museum's approach was pater-nalistic. The Museum shaped the proposed outcome from the project by imposing the Museum's interpretive framework, and providing written guidelines for Mencap Cymru to follow, rather than co-producing the interpretive framework and engaging in an honest and thorough discus-sion at the start of the project about control of the process and ultimately, the product.

The project's early focus was on developing and sharing skills, the Museum providing training in the ethics and techniques of collecting oral testimony, and Mencap Cymru pro-viding understanding of the issues relating to learning disability in Wales. Based in a public history approach,[8] the emphasis from the start was not on the Museum collecting the histories of people with learning disabilities, but enabling and empowering people with a learning dis-ability to collect their own history and experiences – to use their own pasts to make sense of the world and interpret their own histories.

Project officer Sara Pickard, who herself has a learning disability, was one of the field workers trained to collect oral testimonies by Dr Beth Thomas – the Museum's accredited oral history trainer. After completing the project, Sara reflected on the challenges she faced and the effect it had on what the participants wanted to share with her:

> We felt that having someone like myself as part of the interview would help us get the best interview possible. In some cases, me being there has helped our interviews. I think by having a person with a learning disability present it can help put people at ease, not just the former patients but the support staff because we have shared experiences as people with a learning disability.
> One man used the word 'mongolism' in my company. At first I found this shocking, but on reflection he had only worked in a hospital for three years in the sixties and never again worked with learning disabilities. He was simply using the term he used in everyday conversation. This is why history is important, something as simple as the words we use can tell us how far we have come, and how far there is to go.
>
> *(Pickard 2017)*

However, the project's original aim of empowering people with a learning disability to collect their own history was only partially realised. Of the 97 oral histories collected from

85 participants, only 20 per cent were from former patients with learning disabilities; 38 former patients were consulted about taking part in the project, but 15 withdrew. Some of the main barriers to participation were identified as staff suspicion that the project was trying to uncover abuse stories. There were also issues regarding certain individuals' capacity to give consent. Although by law, capacity is assumed unless proved otherwise, in practice, this does not happen, and a paternalistic approach is often displayed by staff (Horler 2017: 30). Although the project generated a number of recordings from people with a learning disability, the main body of work came from former staff members and family. In the evaluation report for the project, Mencap Cymru recognised that building trust takes time. Making time for developing trust is important but often at odds with tightly programmed externally funded projects.

'Identifying and interpreting cultural heritage'[9]

Some of the oral histories collected opened up new ways of seeing and understanding objects in Amgueddfa Cymru's collection that previously had little or no interpretation. It also highlighted the narrow classification of objects which in itself provides barriers to identifying and accessing collections. We recommend challenging traditional classifications as an essential step to reframing the understandings and interpretations of collections.

One example is a psychiatric patient's dress that was collected in 1994 and catalogued under the broad classification 'Women's Clothes'. It was given to the Museum by a local contract clothing supplier who had provided various hospitals in South Wales with institutional clothing and nurses uniforms since the early 1900s. This original unworn dress was intended for a female patient at Hensol Hospital – one of the hospitals featured in the *Hidden Now Heard* project. Dating from the late 1930s, the dress has a series of rubber buttons that meant the wearer could not undress herself. Although collected relatively recently, it had never been on display, and the story never told. The *Hidden Now Heard* project has given the dress a new relevance and resonance. It places it in a broader narrative illustrating the continuity of experience at the long-stay hospital for over a hundred years – one where patients followed a regimented and depersonalised routine regardless of their abilities.

The dress, and four other objects generated by the *Hidden Now Heard* project, are now displayed in the *Life Is…* gallery at St Fagans. The labels for the objects are quotes from the oral history interviews. A large teapot is one of the focus objects and is interpreted by a former member of staff who recalls the milk, sugar and tea all going into one big pot in a one-size-fits-all approach. A pantomime programme for a performance put on at Hensol Hospital is similarly interpreted by a former staff member who refers to 'how they [patients] used to like to sing and they used to like music'. Only one of the displays uses a quotation from a person with a learning disability. Ken Roberts refers to a pair of engagement rings from his relationship with Olive, also a former patient:

> I was her boyfriend. I used to take her out for a walk to the Recreation Hall and we used to play golf. We used to talk about things … I was the one who bought the ring … I liked her. I used to put me arm around her.
>
> *(Roberts 2015)*

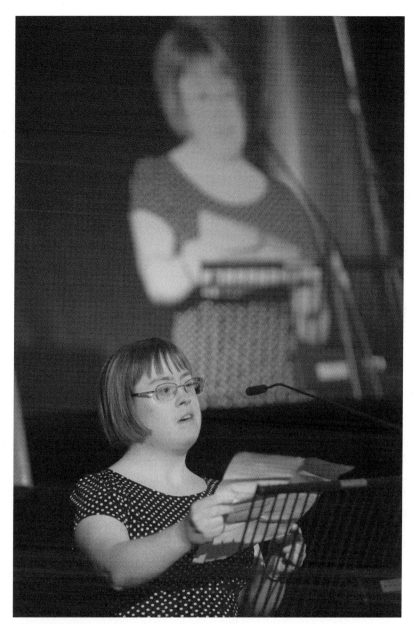

FIGURE 9.1 Sara Pickard addressing attendees at the completion event at the *Creu Hanes –*
Making History project at St Fagans National Museum of History, 18 October 2018.
© Amgueddfa Cymru – National Museum Wales. Photo: Darren Britten.

Although the exhibition features the material culture collected as part of the project, the oral
histories were edited by the museum, not the participants themselves. They were edited to fit
the Museum's interpretive framework. Of the four interpretive labels, only one is the voice
of a person with a learning disability. This raises the question whether an exhibition was the

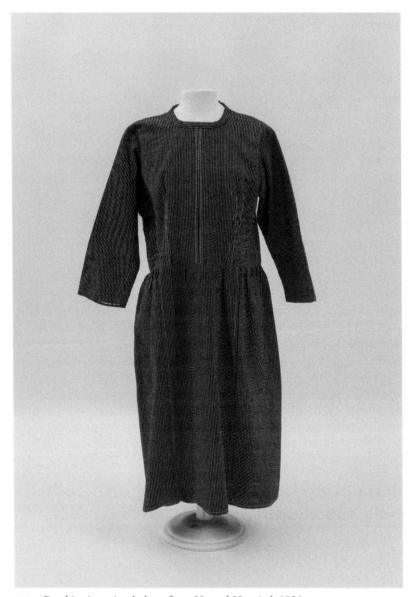

FIGURE 9.2 Psychiatric patient's dress from Hensol Hospital, 1930s.
© Amgueddfa Cymru – National Museum Wales. Photo: Robin Maggs.

most effective platform for sharing the material generated by the project. With reflection we were probably too outcome-oriented as a museum, rather than focused on addressing key issues arising around consent with Mencap Cymru during the process of the project. We are starting to define the process of working as an outcome in itself and this will inform the way we develop content with partners in the future. Is an exhibition the most effective platform for co-produced content? This is a question that all museums should ask.

'Cultural rights protect the rights for each person … to develop and express their humanity, their world view and the meaning they give to their existence'[10]

The Oral History Society has played a leading role in the development of oral history, both in Britain and internationally, for the past 30 years. It defines oral history as:

- A living history of everyone's unique life experiences.
- An opportunity for those people who have been 'hidden from history' to have their voice heard.
- A rare chance to talk about and record history face-to-face.
- A source of new insights and perspectives that may challenge our view of the past.

(Oral History Society 2018)

Oral history is to some extent a methodology that supports the shaping of personal or community experience into a narrative. Participants can often determine the meaning surrounding difficult past events in their lives, regaining a measure of control over their personal story. The 2018 Human Rights Council report in the field of cultural rights emphasises the importance of listening to and telling stories and empathising with the suffering of the other:

> Artists and cultural workers can serve as listeners, help people once deemed adversaries compose their stories in ways that 'others' can hear and raise questions about … Loosening the grip of a particular monolithic narrative … opens possibility for more nuanced stories and more complex understandings of history.
> *(Human Rights Council 2018: 11)*

Although the number of oral histories from people with learning disabilities was much lower than originally anticipated by both Mencap Cymru and Amgueddfa Cymru, the body of work generated by the project still provides a valuable insight into the history of the long-stay hospitals in Wales. The participants felt the project made a difference to them. All responded in a positive way to being part of the process and would take part again in a similar project. In the evaluation report for the project, a former hospital staff member stated: 'I found it cathartic. Made me think and reflect on what has changed. At the time, we thought we were so forward looking, looking at own rooms, not sharing vests' (cited in Horler 2017: 25). Sara Pickard reflects that she had known next to nothing about the history of learning disability before the project: 'Now that I do know about the history, I think it can help even more because I know what life was like and what life is like' (cited in Horler 2017: 25). Clothing as a theme resonated with a number of the project participants, both former staff members and patients. Many of the recordings from both staff and patients from Hensol Hospital detailed how clothing was used to exercise institutional control over the patients and their bodies, stripping away their identity. Through participation in the oral testimony interviews, staff and former patients had an opportunity to express their lived experiences and the meanings they associated with these experiences – in effect an opportunity to express their humanity. One former staff member who worked at Hensol Hospital in the late 1960s recalls shared clothes that were worn by everybody:

They had best clothes, I seem to remember. I'm sure that people had, like a bundle they used to call them, they'd have a bundle of clothes that were best clothes that they kept for visitors. I remember everybody was really excited, everybody was going to get their own locker and their own clothes, and I think that was about 1976–7, I think. Up until then it was all shared clothes. Everything was shared, the laundry just washed all the clothes and everybody got a bag full of clothes and you had to sort them out for people, you know.

(Williams 2015)

Another former staff member also remembers that clothes were not individualised:

It was a dormitory, so it would be beds that lined up with a wardrobe in between them. And, even the clothes weren't individualised. You used to put together packs. You'd do that in the evenings. You'd get a vest and a pair of underwear, you know, a dress that looked about the right size or trousers that looked about the right size. You'd roll it all up into a ball and you'd put it there ready for the morning … they weren't uniform, but they were certainly, I think from a similar supplier. Let's just say that!

(Thomas 2014)

The oral testimonies revealed that although there were negative aspects to life within the long-stay hospitals, there were also friendships and a sense of belonging to a community. On completion of the project, Sara Pickard reflected that she had assumed that all of the stories would be negative or sad – but they weren't: 'I was surprised to hear that patients got married, and that sexual relationships for those who were capable, were accepted as a thing that happened and should be supported, not something that should be denied' (Pickard 2017).

'Deciding which cultural traditions, values or practices are to be kept intact, modified or discarded'[11]

As part of the project evaluation, Mencap Cymru recognised that not only had the content of the oral histories been unexpected, but conceded that the testimonies collected had fundamentally challenged the charity's perception of past and present care practices:

what the project has exposed is the assumption that people with a learning disability have only experienced gains since re-settlement. Of course there have been significant advances – but the stories of former patients and staff also show that there has also been regression. People lack friendships, relationships, belonging and autonomy. The process of capturing stories also told us that much work needs to be done beyond the at times superficial idea of 'living in the community'. People with a learning disability are often denied the chance to make decisions – either because of a misinterpretation of what constitutes capacity or the dominant culture of risk aversion. The legacy of the project for people with a learning disability must be to continue this dialogue at an individual support, organisational and policy level.

(Davies 2017: 4)

All testimonies collected now form part of Amgueddfa Cymru's National Oral History Archive at St Fagans. The partnership between the Museum and Mencap Cymru continues to develop, and both organisations recognise that they are on a journey. Both organisations

grapple with challenging paternalistic attitudes and issues around authority. Providing time and space for honest collaborative reflection is one transferable lesson both organisations can take to other initiatives. We are currently working together to record the histories of young people with a learning disability living in Wales today. The *Our Social Networks* project will support participants to share their stories of friendships, of forming relationships and of belonging. As the relationship between the organisations develops, we need to go beyond project-based working. In the Museum this means redefining what we see as our core work.

'Protecting access to cultural heritage'[12]

The project raised interesting issues around informed consent from participants with a learning disability, revealing the deeply entrenched traditional museum practices that had not developed or changed to reflect the changing needs of users. The complex legal language of the traditional consent forms used by Amgueddfa Cymru, whilst recording and collecting oral testimonies, exposed subtle barriers to participation and access. In partnership with Mencap Cymru, we revised the language, layout and format of our conventional consent and copyright forms to an easy-read visual format that simply demonstrated the different uses that could be made of the testimony in the future. Prospective interviewees were given the option of being recorded on video, or audio only, in the location of their choice. The revisions meant that the forms were accessible for a diverse range of people. Reviewing collections management procedures and complex forms with community partners is a useful exercise for both the museum and community partner, resulting in really useful documents that can be used by both organisations, and others, in future projects.

> The purpose of the mandate is not to protect culture or cultural heritage per se, but rather the conditions allowing all people, without discrimination, to access, participate in and contribute to cultural life in a continuously developing manner.
>
> *(Human Rights Council 2016: 4)*

The *Creu Hanes – Making History* project has already generated projects such as *Hidden Now Heard*, that have gone some way in protecting the cultural heritage of people with a learning disability in Wales. It can also be argued that the redevelopment has created a protected environment and culture that allow and enable the people of Wales to access, participate in and contribute to cultural life.

However, the Museum is still overwhelmingly dominated by some cultures, and part of our work over the next ten years is to diversify the voices that form part of the national collection, putting the 'nothing about us without us' mantra into practice. We have started the process of developing an inventory of cultural rights in practice. We recognise that both the collection and archive are incomplete, but as our networks of diverse partnerships continues to evolve, so too will our ability to support people, without discrimination, to access, participate in and contribute to Wales' rich cultural life.

The Museum has further developed the *Hidden Now Heard* skill-sharing model as a framework for working with other community groups. St Fagans is now an oral history training hub and repository for organisations that are actively collecting the histories of their service users. Sustained relationships have formed with many organisations across Wales, and the histories of often vulnerable communities are making their way into the National Oral History Archive. As with Mencap Cymru, our investment in these partnerships is for the long term.

This skill-sharing model is dependent on valuing and recognising each other's expertise, and playing to these strengths. It takes time to develop trusted relationships. The *Hidden Now Heard* initiative demonstrated that forming active and sustainable partnerships is dependent on a willingness to change, experiment and reflect on new ways of working.

This collaboration, whilst not directly changing the lives of those who donated their narratives, has challenged organisational practice and changed Mencap Cymru and Amgueddfa Cymru policies.

Conclusion

Culture continuously evolves and cultural rights are dynamic 'due to the fact that culture is a living and growing organism, always manifesting itself in new ways' (Niec 1998). As a national museum, Amgueddfa Cymru has a duty to represent the ever-changing manifestation of cultures in Wales. It plays a role in protecting the cultural rights of the diverse peoples of Wales and in providing settings for all people to access, participate in and contribute to cultural life in Wales. Providing cultural agency means repositioning our place in society, challenging our traditional governance models, and radically changing our practice. Building on the completion of the *Creu Hanes – Making History* project in October 2018, we will develop programming that is informed by some of the recent recommendations put in place by the Human Rights Council in relation to the role of cultural institutions in the protection of cultural rights: 'Commit to featuring a variety of socially engaged perspectives, including the works of artists and marginalized voices, in their exhibitions, performances and public programmes to facilitate interactions among people holding different views, in accordance with international standards' (Human Rights Council 2018: 19). All people have culture, and culture is not elitist. In Raymond Williams' words:

> Culture is ordinary: that is the first fact. Every human society has its own shape, its own purpose, its own meaning. Every human society expresses these, in institutions, and in arts and learning. The making of a society is the finding of common meanings and directions, and its growth is an active debate … We use the word culture … to mean a whole way of life – the common meanings; to mean the arts and learning – the special processes of discovery and creative effort. Some writers reserve the word for one or other of these senses; I insist on both, and on the significance of their conjunction … Culture is ordinary, in every society and in every mind.
>
> *(Williams 1989)*

Acknowledgements

We would like to thank Mencap Cymru for their work and support during the *Creu Hanes – Making History* redevelopment project at St Fagans. We look forward to developing our partnership work with them in the future.

Notes

1 The 'Nothing about us without us!' slogan has its origins in Central European political traditions. It came into use in its English-language form during disability activism in the 1990s. In 1998 the slogan was used as the title for two books on disability rights, one published by James Charlton and the other by David Werner.

2 St Fagans has always been a museum about the people of Wales, and the transformation has been sympathetic to the original vision of providing the people of Wales with a strong foundation and a healthy environment as a living community center. The *Creu Hanes – Making History* redevelopment is also influenced by the approaches developed by Nina Simon (Simon 2010). The Activity Plan for the redevelopment was created by Beth Thomas, then Keeper of History and Archaeology at Amgueddfa Cymru, and Nia Williams, then Head of Learning and Interpretation at Amgueddfa Cymru.

3 The Act has seven enshrined well-being goals: a prosperous Wales; a resilient Wales; a healthier Wales; a more equal Wales; a Wales of cohesive communities; a Wales of vibrant culture and thriving Welsh language; a globally responsible Wales. The Act also focuses on the Sustainable Development Principle, making sure that public bodies act in a manner which seeks to ensure that the needs of the present are met without compromising the ability of future generations to meet their own needs. In order to act in accordance with the Sustainable Development Principle, public bodies must take account of the five ways of working: long-term, prevention, integration, collaboration and involvement.

4 Amgueddfa Cymru participated in the *Our Museum: Communities and Museums as Active Partners* initiative (Paul Hamlyn Foundation, no date), and is now funded by the Paul Hamlyn Foundation as part of the *More and Better* programme. The *Our Museum* initiative facilitated the start of a process of development and organisational change at Amgueddfa Cymru.

5 Human Rights Council 2016.

6 Membership of the Diversity Forum at the time included Race Council Cymru; Romani Arts Wales; Diverse Cymru; Draig Enfys, an organisation that represents LGBTQ+ organisations in Wales; Oasis Cardiff, an agency that supports asylum seekers and refugees in Cardiff; Disability Arts; and Mencap Cymru. The forum is still active and its membership is continually evolving.

7 Human Rights Council 2016: 5.

8 Public history is a conceptual framework for exploring the varied and complex ways in which people connect with the past (Kean and Martin 2013). The Museum established a Public History Unit in 2013 to provide strategic direction for its work with community groups and the collection.

9 Human Rights Council 2016: 50.

10 Human Rights Council 2016: 5.

11 Human Rights Council 2016: 5.

12 Human Rights Council 2016: 5.

Bibliography

Andrews, K. (2015), *Child Poverty Strategy for Wales* (Cardiff: Welsh Government) viewed 5 September 2019, https://gov.wales/sites/default/files/publications/2019-06/child-poverty-strategy-for-wales-report.pdf.

Blake, J. (2018), 'With no sign of child poverty disappearing, Jo Blake looks at what's ahead for 2020', Sefydliad Bevan Foundation website, 13 February, viewed 30 March 2019, www.bevanfoundation.org/commentary/future-child-poverty-wales.

Davies, S. (2017), *Overview of External Evaluation*, Cardiff: Mencap Cymru.

Duffy, T. (2001), 'Museums of "human suffering" and the struggle for human rights', *Museums International*, 53 (1), 10–16.

Hood, A., and Waters, T. (2017), *Benefits Cuts Set to Increase Child Poverty, with Biggest Rises Likely in North East and Wales*, London: Institute for Fiscal Studies, viewed 5 May 2018, www.ifs.org.uk/publications/10029.

Horler, H. (2017), *Mencap Cymru Hidden Now Heard Project Evaluation report*, Cardiff: Mencap Cymru.

Human Rights Council (2010), Report of the Independent Expert in the Field of Cultural Rights, A/HRC/14/36, viewed 23 November 2018, www2.ohchr.org/english/bodies/hrcouncil/docs/14session/A.HRC.14.36_en.pdf.

Human Rights Council (2016), Report of the Special Rapporteur in the Field of Cultural Rights, A/HRC/31/59, viewed 23 November 2018, http://undocs.org/A/HRC/31/59.

Human Rights Council (2018), Report of the Special Rapporteur in the Field of Cultural Rights, A/ HRC/37/55, viewed 23 November 2018, http://undocs.org/A/HRC/37/55.

Human Rights Council (2019), *Report of the* Special Rapporteur in the Field of Cultural Rights, viewed 7 October 2019, www.ohchr.org/EN/Issues/CulturalRights/Pages/SRCulturalRightsIndex.aspx.

Kean H. and Martin, P. (eds) (2013), *The Public History Reader*, London and New York: Routledge.

Lynch, B.T., and Alberti, S. J. M. M. (2010), 'Legacies of prejudice: racism, co-production and radical trust in the museum', *Museum Management and Curatorship*, 25 (1): 13–35.

McCrae, N. and Nolan, P. (2016), *The Story of Nursing in British Mental Hospitals: Echoes from the Corridors*, London and New York: Routledge.

National Archives (2011), 2011 Census: Quick Statistics for Unitary Authorities in Wales, viewed 11 September 2019, https://webarchive.nationalarchives.gov.uk/20160107133517/, http://www.ons. gov.uk/ons/rel/census/2011-census/key-statistics-and-quick-statistics-for-electoral-divisions-and-output-areas-in-wales/rft-qs204ew.xls.

Niec, H. (1998), 'Cultural rights: at the end of the World Decade for Cultural Development: United Nations Educational, Scientific and Cultural Organisation', Intergovernmental Conference on Cultural Polices for Development. Stockholm, Sweden, 30 March – 2 April 1998.

Oral History Society (2018), Website, viewed 26 April 2019, www.ohs.org.uk.

Our Museum (no date), Website, viewed 5 September 2019, http://ourmuseum.org.uk.

Pickard, S. (2017), 'Challenges of recording oral histories – the perspective of someone with a learning disability', Hidden Now Heard Learning Event, Cardiff, UK, 20 June.

Roberts, K. (2015), Transcript of *Hidden Now Heard* oral history (recording number 12006), conducted by Mencap Cymru, archived at St Fagans National Museum of History.

Sandell, R. (2017), *Museums, Moralities and Human Rights*, London and New York: Routledge.

Silverman. H. and Ruggles, D.F (eds), *Cultural Heritage and Human Rights*, New York: Springer.

Simon, N. (2010), *The Participatory Museum*, Santa Cruz: Museum 2.0.

Thomas, B. (2013), Letter to Mencap Cymru, 16 August.

Thomas, H. (2014), Transcript of *Hidden Now Heard* oral history (recording number 11837), conducted by Mencap Cymru, archived at St Fagans National Museum of History.

UNESCO (1968), *Cultural Rights as Human Rights*, Studies and Documents on Cultural Policies, Paris: UNESCO.

United Nations (1948), *The Universal Declaration of Human Rights*, Paris: UN General Assembly, viewed 23 November 2018, www.un.org/en/universal-declaration-human-rights.

Welsh Government (2014), *Culture and Poverty: Harnessing the Power of the Arts, Culture and Heritage to Promote Social Justice in Wales*, Cardiff: Welsh Government, viewed 13 May 2018, https://gov.wales/ sites/default/files/publications/2019-06/culture-and-poverty-harnessing-the-power-of-the-arts-culture-and-heritage-to-promote-social-justice-in-wales.pdf.

Welsh Government (2015), Well-being of Future Generations (Wales) Act 2015, Cardiff: Welsh Government, viewed 26 April 2019, https://futuregenerations.wales/wp-content/uploads/2017/ 01/WFGAct-English.pdf.

Welsh Government (2017), *Fusion: Creating Opportunities through Culture Programme, Second Year Review*, Cardiff: Welsh Government, viewed 5 September 2019, https://gov.wales/sites/default/files/ statistics-and-research/2019-07/170822-fusion-creating-opportunities-culture-programme-second-year-review-en_0.pdf.

Williams, R. (1989), *Resources of Hope: Culture, Democracy, Socialism*, London: Verso.

Williams, W. (2015), Transcript of *Hidden Now Heard* oral history (recording number 12020), conducted by Mencap Cymru, archived at St Fagans National Museum of History.

10

SLOW, UNCOMFORTABLE AND BADLY PAID

DisPLACE and the benefits of disability history

Manon S. Parry, Corrie Tijsseling and Paul van Trigt

Framing culture as a curative

The cultural spaces of museums and archives are a primary arena in which a society's values are defined, preserved, reified, and shared, shaping who is valued and included in a country's notion of citizenship. The movement of museums for health and well-being builds on the idea that culture plays a significant role in society to investigate how museums can contribute to wellness – by combating loneliness or isolation, challenging stigma and inequality related to disabilities or mental illness, and condemning discrimination related to race, gender, or sexuality (Chatterjee and Noble 2013). While such work can be helpful, emerging critiques are raising questions about some of the strategies used and the assumptions behind them. Ideas about the 'therapeutic museum', for example, often rely on notions of inclusion and access that are inadequate to address the complex interaction of prejudices, policies, structural and attitudinal barriers that shape everyday life (Silverman 2010).

Initiated for people with disabilities, rather than with or by them, projects are more likely to embrace the goal of increasing access to institutions rather than undertaking a more radical rethinking of how collecting and exhibiting habits may be unhelpful, and even unhealthy, for diverse audiences (Niciu 2019). A more participatory and transformative, disability-led methodology could address these problems, as we discuss here. We begin with a brief overview of some of the major factors limiting the representation of disability in museums, drawing on recent research as well as Parry's own curatorial work. We then turn to a collaborative project we are involved in, to build a digital archive of disability history in the Netherlands, to examine some of the lessons learned and the challenges that remain. DisPLACE is a digital platform for the collection and interpretation of experiences of disability, past and present, by people with disabilities in collaboration with other students, researchers, disability service organisations, and the creative industries. The project prototype was launched in 2019, and the site is intended to serve as the first archive in the Netherlands to gather and analyse a broad range of historical sources on disabilities together, the first shared virtual environment to utilise the cultural heritage of disability, and the first to make these accessible online to people with a wide variety of disabilities. The project is part of a larger initiative by the BIB Network

(*Bronnen voor Inclusief Burgerschap*), working to stimulate the collection and interpretation of disability history. Throughout, we draw on the 'social model' of disability proposed by critical disability studies scholars, which focuses on the ways that difference or impairment become disabling through the design of institutions and infrastructures to suit some and which exclude others.

The underrepresentation of disability

Until relatively recently, disability and disfigurement were a much more visible part of public life, and would have been encountered by the majority of society even if not directly experienced (Ott 2005). Yet this history has gone largely uncollected, contributing to the absence or invisibility of disability in archives and museums. When relevant objects have been collected, they are sometimes catalogued without information that illuminates their connection to disability, obscuring their relevance for subsequent use. Moreover, museum professionals have reported anxiety about exhibiting such materials, for fear of offending people with disabilities (Dodd *et al.* 2008).

Currently 15 per cent of people worldwide have a disability, and many more will know a family member, friend, or colleague who does (World Health Organisation 2011). The demographic changes underway in aging societies ensure that growing proportions of populations will be living longer, and thus living with age-related disabilities. Museums have only recently begun to address the institutional barriers that exclude many of these potential visitors, although such efforts are gaining momentum as funders, consulting groups, and the sector's professional bodies increasingly highlight the issue (e.g. Disability Cooperative Network, no date). However, activities that address physical barriers, by installing wheelchair access ramps, organising sign language interpretation tours, or sensory experiences for blind and visually impaired visitors, usually fail to account for other obstacles such as transportation to the venue and the fees to enter, as well as underdeveloped connections to the target groups. As we and our colleagues in the field have experienced, if resulting visitor numbers do not match expectations, initiatives evaluated simply on the costs incurred may be deemed unsuccessful or discontinued as too costly for the (low) level of impact.

Furthermore, these projects rarely address the content of collections to consider ways in which experiences of disability are, or could be, represented in exhibitions. Alongside limited holdings and a lack of knowledge about them, as well as a lack of confidence in exhibiting on the topic, many museum professionals also underestimate the relevance and appeal of disability-related histories for a diverse audience. The assumption remains that disability is a marginal category applying only to a small group in society. In fact, ideas about disability are also implicated in the identity of 'non-disabled' and influence virtually every aspect of how we organise our society. Like categories of races, genders, and sexualities, disability and able-bodiedness are mutually constitutive, deeply entangled, and meaningful precisely because of their interaction.

The widely held misperception of disability as a burden discourages cultural venues from engaging with the subject. In Parry's previous role as a curator of exhibitions on the history of medicine, on a scientific research campus where you might logically expect a focus on disability as part of the range of activities, some stakeholders were reluctant to allow such a project, arguing that the subject would not attract an audience and would be 'too depressing' for the general public. Institutions that do take on the topic are then limited either to tragic

narratives of disability as a terrible fate in history, or to celebratory examples of people with disabilities overcoming their challenges (Sandell *et al.* 2010).

All of the factors above contribute to a cultural silence that misrepresents the presence of disability in the past and contributes to a narrow view of the roles of people with disabilities today – which in turn limits expectations as well as opportunities (Ott 2005; Haller 2010). Overall, this fuels negative assumptions that can lead to discrimination against others as well as personal anxiety about becoming older or disabled. Both can have life-threatening consequences, from denying treatment or opportunities to someone deemed 'too disabled' to benefit, to depression or difficulty coping with the changes associated with aging or following an accident or injury (Corrigan 2014).

Strategies for overcoming some of these obstacles include reframing disability history within narratives more commonly featured in museums, linking projects to national or international anniversaries and events, and developing activities beyond the museum walls. Smithsonian curator Katherine Ott curated an exhibition on the history of polio, for example, to mark the 50th anniversary of the development of the Salk vaccine. She suggested a war-related exhibition, for example, as one way to bring disability in under a more 'popular' topic, and indeed Parry gained approval at the National Library of Medicine for the onsite, online, and travelling exhibition *Life and Limb: The Toll of the Civil War*. At the same institution, Parry incorporated aspects of disability history into a travelling exhibition on the definition and treatment of mental illness in the nineteenth century (*The Literature of Prescription: Charlotte Perkins Gilman and 'The Yellow Wallpaper'*). The 60th anniversary of the World Health Organization provided another opportunity to address disability, in *Against the Odds: Making a Difference in Global Health*, a major gallery exhibition and travelling version hosted by sixty venues across the United States on the theme of health and human rights (Parry 2016).

Although each of these projects provided an opportunity to temporarily incorporate missing perspectives, none of these interventions permanently altered collections or ways of working. Like other short-term activities, which over time may contribute to an accumulation of new approaches, individually, they risk being overlooked and forgotten about. In fact, occasional activities may be used as a substitute for more substantial change, as decision-makers can argue they have already addressed an issue or a group and move on to focus on something else.

In the rest of this essay, we turn to a digital project intended to address some of these issues by carving out a new platform and process for collecting and interpreting disability history. DisPLACE is a Dutch digital archive project, intended to make the collection and interpretation of historical objects accessible to users with a diverse range of disabilities. The project is an initiative of the BIB Network (*Netwerk Bronnen voor Inclusief Burgerscha*p – meaning 'Sources for Inclusive Citizenship'), a cooperation between people with disabilities involved in a range of institutions and history projects, including the National Museum of Education, the network Ieder(in), the website Canon Social Work, and university-based researchers. The prototype was developed by Driebit, a digital heritage company, and funding was secured from the Netherlands Organisation for Scientific Research (NWO) through a joint application by academics Parry, van Trigt, and Paul Bijl, supported by DSiN/Disability Studies in Nederland, a foundation with public and private partners for the advancement of disability studies in Dutch institutions. Tijsseling and van Trigt are co-coordinators of the BIB Network. Parry participates as a network board member and public historian teaching at the University of Amsterdam. The prototype was launched in March 2019 and led to positive press coverage

highlighting the importance of disability history both in the national press and from the country's leading organisation for professional historians (Mudde 2019; Wiersma 2019).

DisPLACE: a digital disability archive

In the absence of a commitment within (unhelpful!) institutions to permanently shift their approach, digital tools offer a means to present alternative narratives online, using material already digitised by archives and museums but underused or narrowly framed in existing projects. A digital initiative can also draw on diverse collections from a range of museums and archives, compensating for silences in specific collections and creating new resonances by juxtaposing objects from very different origins and initiatives. DisPLACE also includes materials from the personal collections of individuals, as a way to draw attention to historically significant assets that have been overlooked by heritage institutions. The website will be the first archive in the Netherlands to gather a broad range of historical sources and interpretations in one location and the first to make these accessible online to people with a wide variety of disabilities, going far beyond the basic standards of universal design.

The design as well as the content of the website are being developed in consultation with people with disabilities, and the narratives included will prioritise their reflections on the past. The first phase of the project focused on the theme of 'living', with short entries featuring photographs, archival materials, and the reflections of people with disabilities (interviewed by public history students), combined to address key issues from personal perspectives. Topics included innovative independent living projects, navigating sexuality as a young person living with parents or in university housing, and community life. The narratives often feature multiple viewpoints, to highlight the range of opinions on a particular policy or housing system, for example, as BIB Network members stressed the importance of illustrating the diversity of opinions across communities rather than aiming for more simplistic evaluations of 'good' or 'bad' strategies. The texts are written for a broad audience, and presented in an uncluttered style with clear options for navigating back and forth or accessing other related materials.

Other themes will be explored in future phases, such as work, parenting, and leisure. With additional funding, we hope to develop an expanded interpretive zone with online exhibitions, digital documentaries, scholarly essays, policy proposals, and teaching resources. The third component will be a networked community forum, linking members affiliated with the project as well as people interested in contributing or using the material, so that they can exchange information and advice.

The collaboration is complex and has revealed how existing social inequalities are reinforced by the structures in which the project is being undertaken. In the discussion below, we focus

FIGURE 10.1 Logo for the DisPLACE website.

on three main aspects of this: funding, design processes, and the practice of content development. For this last topic, we draw on our experiences leading a group of master's students as part of a practical course on digital public history, taught by Parry. While the context is educational, the lessons learned are equally applicable to collaborative projects between museums, creative industry partners, and the broader public.

Funding

After the financial crisis of 2008, government funding for museums was substantially reduced in the Netherlands. In addition, the allocation of funds for cultural work related to health and well-being is less developed there than in the UK, for example, where there are established networks of museums and art galleries undertaking such projects (e.g. Culture, Health and Wellbeing Alliance, no date). National investment in academic research is increasingly tied to specific 'societal challenges', largely driven by priorities set at the European level. Although disability is an underrepresented topic in the range of funds allocated for cultural heritage and humanities research, collaboration between universities, creative industries, and the cultural sector is actively encouraged as a means to disseminate research results and benefit society.

While this helps to motivate cooperation between the different groups, the allocation of resources *within* projects heavily favours the academic partners. Although the team was successful in securing funding from the government-funded NWO, the main applicant was required to be a researcher employed at a university on a permanent contract (Parry 2016). A co-applicant on the grant, historian Paul van Trigt, plays an instrumental role as co-coordinator of the BIB Network, but as he is employed on a temporary contract as a postdoctoral researcher, he cannot serve as the lead applicant or primary investigator on the grants we have targeted so far. This is particularly unfortunate because his credibility with the network of partners with disabilities has been crucial to the project, and his coordination of our collaborative activities depends significantly on his skill at parsing opinions, navigating conflicting views, and building agreement to move forward with particular activities.

Equally important is the role of the fellow co-coordinator Corrie Tijsseling, who is deaf, as she connects the project to a wide community of people with disabilities as well as service and advocacy organisations. Tijsseling completed a doctoral degree in philosophy and history of education, but was not able to follow her PhD with a university career 'because academia these days is disabling'. The pace of grant-writing has proven a particular challenge in our collaboration. As she noted during a hurried scramble to submit a proposal, quick turnaround times between the publication of the call for applications and the deadline limit the participation of team members who cannot meet at short notice as they need time to arrange sign language interpretation. For participants with other disabilities, such scheduling also makes it difficult to organise accessible travel.

While we would hope to attract young researchers with disabilities to the project, there is clearly a 'pipeline' problem at earlier stages of university education too, although institutions are now focusing on this as an area for improvement. However, the ableist character of an academic career identified by Tijsseling is increasingly hostile to people with disabilities as workloads intensify and expectations for output increase. Levels of stress, depression, health problems, and burnout are rising across the sector, making an academic career particularly unhealthy for those who may require more support services or time to complete their daily

activities, and who are likely to encounter discrimination and barriers in the process (Dolmage 2017).

The academic historians in the group are able to undertake their roles in the project as part of their salaried research, creating another imbalance as others, who are for the most part themselves disabled, volunteer their time to ensure that their histories are collected and preserved. While we strive to pay these participants for their role in specific parts of the project, such as advising on the design and testing of the website, the funds that are most likely to finance the work prioritise 'scientific researchers', must cover large overhead costs for the university, and have limited scope for paying for other kinds of expertise. As with marginalised groups, some of these volunteers already have extensive leadership responsibilities in other, often underfunded, projects. Funds administered by the university are also highly bureaucratised, meaning that payments are hard to request and slow to process.

In general, it is difficult to pay individuals who are not employed by an institutional partner (such as a museum or web design company) with these kinds of grants. As a result, the amount that can be allocated for such participants is fairly small, and embedded within general categories of funds for travel or meetings. This poses an additional problem as these then become 'hidden costs', while grant reviewers with expertise in participatory research are likely to look for a fairer allocation of the money as part of their evaluation of a project proposal. We hope that by drawing attention to these issues they can be taken into account in the design of funding in the future. At the project level, our aim is to secure funds to build career tracks instead of occasional opportunities to work together.

The prototype addresses one of twelve themes as a way to organise the range of potential histories that will be collected in the website. Once the format is finalised and the technical tools for uploading new content are built, funding can be sought to address other themes, meaning that the process should become smoother over time as the group repeats similar steps even as they need to reach new contacts and locate historical assets and perspectives on different topics. This structure also means that sustained work can be planned over years even before the money is available to undertake any of it, rather than proposing new projects whenever another funding opportunity arises. We hope to be able to select themes that map with new funding calls, while reusing the overall framework for multiple types of funding bids, from museum collection digitisation funds to PhD research opportunities and public engagement or digital humanities grants. This strategy is especially important as other projects have suffered due to the late awarding of funds too close to the project delivery deadline, meaning that once again, the most excluded groups are not reached in time to participate, especially given the need to build relationships and credibility, to adapt ways of working, and then to collaborate to refine the project proposal.

Design process

The majority of the project funds were allocated to the design company Driebit to develop the prototype website (www.displace.nl). Driebit has worked on museum and commercial projects. Because the founder, Bram Opdam, was interested in supporting a socially oriented activity, he agreed to take on the scope of work for a more limited budget than usual. Although accessible digital design is an increasingly important area of development in the Netherlands, there has not been much creative specialisation in this realm. There is great potential to develop expertise that goes beyond simple functionality and is more aesthetically innovative with

greater scope for user interaction. The BIB Network could thus provide Driebit with advice and testing by people with a range of different disabilities, greatly increasing their knowledge of key issues, and helping them to develop techniques that they can apply to other projects.

In order to facilitate this process, Driebit had to adjust their way of working significantly from the outset. First, we negotiated for a larger group of people to participate in the kick-off session than is preferred. The session was also lengthened, to accommodate the larger amount of input that would be generated by a bigger group, as well as time for breaks needed by participants as they had to translate, rethink, and adapt to working in a non-disabled-friendly environment. Interpreters also needed regular breaks. As in other meetings of the BIB Network, Parry is the only non-Dutch participant, and while she can understand (most of) the Dutch discussion, she speaks in English. Sign language interpreters thus listen to alternating Dutch and English to sign for deaf participants, while other attendees translate her remarks into Dutch summaries for those who do not understand English. As a result, all our meetings invariably take longer and move more slowly than if these processes were not involved.

It has been interesting to experience the shifting dynamics that this creates. At first, as some participants adjust to the different pace, there is often a sense of impatience or frustration. It may even seem inefficient as a way of working. What is becoming more apparent as the process continues, however, is that pushing through quickly is a sure-fire way to exclude some perspectives, and that by moving more slowly, another ideal of efficiency can emerge – it is more efficient to test ideas with intended audiences and refine them together, rather than deliver something finished more quickly but that has limited appeal or relevance to a group assumed *for* but planned *without*. By slowing down, participants also have more opportunity to exchange skills, building the capacities of the group during the process. Instead of trying to create 'buy-in' for ideas that are pitched by a designer to the clients they are working with, for example, the designer breaks down the processes of development for the academics, the community representatives, and organisational partners, who then collaborate in development of the project plans.

Other points of tension stemmed from the complexity of designing the structure and functionality of the website for a very diverse audience. At the initial design meeting, it was clear that the usual method of categorising target users was problematic. If our aim was to challenge the categories that separate people with different kinds of disabilities, as well as between people with and without disabilities, how could we still define target groups clearly enough to shape our approach? 'Design for all' was deemed too broad to be useful, while designing for people with disabilities encompassed a range of different, and sometimes incompatible needs. It is difficult, for example, to keep web pages clean and uncluttered but still provide the navigational options that will suit a range of users. We have concluded that the public launch of the prototype will have to become a next step in testing the impact of the compromises made. This will allow us to assess the impact over the longer term, where we maybe can evaluate the preferences of a larger group of users.

Accessibility consultants to the museum sector have frequently noted that they are brought in too late in the design process to have much influence. Indeed, user testing for digital tools is often the last stage of exhibition development and frequently cut short or cut out due to lack of time or funds. Building this process from the outset was crucial, although we suspect the time subsequently spent on the development greatly exceeded the expectations of the team at Driebit.

Content development

The design process is also usually much more closely integrated with the intended content for a project. In that way, the form can be tested for how well it suits the assets used, such as images or video, as well as the flow of the narrative and its organisation into themes, subsections or interconnected storylines. However, due to the underrepresentation of disability history in archives, museums, and academic scholarship, we began the project with very little source material. In addition, every member of the content team was engaged in other work – meaning that this was not the sole project, or even priority project, as each of us juggles other jobs, teaching, or research responsibilities.

Although we had anticipated that our other relevant activities could feed into the DisPLACE website, it became clear that a more consolidated period of work was needed to research storylines, identify assets, finalise and review the scripts, and then input the material into the online content management system. Our solution was to integrate the project in a master's-level practical course on Digital Public History, which Parry teaches over two months every autumn, following an introductory course on the topic. Students were provided with readings on the significance of disability history and museum approaches to the subject, and met with BIB Network members to discuss potential topics. The students worked in pairs (in groups formed by the teacher), and were responsible for two storylines for the website, on the theme of living. In class sessions, we discussed strategies for representing the experiences of people with disabilities, including the strengths and weakness of existing approaches. In one exercise, students rewrote entries from the *Encyclopedia of American Disability History*, and researched potential images or historical documents to incorporate in a shorter script suitable for online use. The exercise demonstrated that although students had taken on board the importance of telling these histories from their subjects' perspectives, they usually reverted to their own priorities – beginning their narratives with the type of disability and how it was acquired rather than the accomplishments or experiences of their chosen historical figure.

In an effort to avoid this, students tended to focus on interviews with members of the BIB Network or their contacts, rather than archival materials. This also reflected the scarcity of known historical sources, but as van Trigt noted, raised additional complications regarding how to integrate individual perspectives in a larger historical context. There were practical problems too, in finding interviewees in the short timeframe of an eight-week course – and without an existing website available to show people how their stories would be used. The situation was also shaped by inequalities and their legacies. The managers of an institutional living facility, for example, would not allow students to present their requests for participants to residents, citing privacy concerns but also rather paternalistically declining participation on behalf of their clients without consulting them. A practising psychiatrist deferred, concerned that their work might be harmed by publicly discussing their activities. Students also struggled to find people willing to reveal the most intimate aspects of their lives, such as sexuality and personal relationships, while more were happy to talk about the impact of laws, welfare systems, and services. Illustrating these latter, more bureaucratic, issues in compelling ways and with an appealing array of primary source material was also a challenge.

A positive outcome of these difficulties was the need for students to draw on their own networks – this process made several aware of existing connections to people with disabilities whom they had not previously thought of in this way. This served a larger goal of the project as a whole, to challenge assumptions about who is designated as disabled and the tendency

to see the worlds of the disabled and non-disabled as completely separate spheres. Another benefit was that almost every student reported new awareness of the importance of collecting and representing disability history. As future public historians they can potentially advocate for or implement such work in their own careers. While several expressed anxiety about offending people, using the wrong terminology, or asking questions that were considered offensive, all who raised this issue in their final assignments stated that the interactions they had were positive and made them more confident that they could do such work successfully. A couple said it was upsetting to hear people's personal stories of discrimination, with one reflecting that she then felt it was inappropriate to show her emotional response, but struggled to hide it. For most, this was their first exposure to these kinds of experiences, perhaps especially confronting due to the general presumption of Dutch society as relatively progressive or notions of charitable benevolence towards people with disabilities (Brants *et al.* 2017). We had also talked about the tendency in media and culture to represent life with a disability as something to be pitied, making students anxious about appearing to do the same (Haller 2010). Although Parry emphasised the value of authentic responses and discouraged the suppression of emotions, we recognise that encounters that expose the very different lived realities of participants can be problematic.

Overall, both the BIB Network and the students were extremely pleased with the end result – with both groups also expressing great satisfaction from having worked together and sharing in the excitement of developing the first material for the prototype. However, when Parry read the final assignments, she was shocked to see that one had found the process very difficult but felt unable to raise this during the course. This student wrote that she has a disability, that she would have hated to be one of the people interviewed for the project, and that the activity went against her values by forcing her to put someone else under the kind of scrutiny she herself would avoid. She and Parry met to discuss these comments, and with permission, we include her remarks here.

This student considers her 'high-functioning depression' a disability. She has been frequently 'studied' by healthcare providers and those in training, especially psychologists, as she is able to function well in public but can be extremely depressed when alone at home. She found it difficult to tell her teacher about her reactions to the project proposal, as she felt she was the only person in the group struggling while classmates talked excitedly and appeared very motivated. She was also wary of discussing her depression as she has previously lost friends and relationships following such disclosures. She and her project partner did not work closely together, and although she tried to explain the reasons for her misgivings, her teammate did not seem to listen or recognise what she was saying. These issues were exacerbated because other students from the same class were bullying her by excluding her from group work in another course, and criticising her skill set.

This situation is not specific to a classroom setting but rather, highlights the challenges of transforming deeply entrenched attitudes within any context where there are likely to be participants who have been negatively affected by the same values the project is intended to revise. While some participants gained a new appreciation for the experiences of people with disabilities, this appreciation may remain confined to the specific people they met during the project, or encompass only their particular types of disabilities. Awareness of the invisible disabilities, especially within the students' own peer group, has been harder to address. Overall, a more fundamental shift, recognising the range of abilities and roles that exist throughout society, may not have occurred.

Conclusion: beyond inclusion

In our view, this is precisely the reason to keep engaging in such work. The goal should not be one moment of transformation but an ongoing range of activities, building the capacity of a broadening group of participants to work together. In the process, by encountering problems, the various stakeholders gain valuable experience, strategies, and confidence. This is unhelpful, however, if we fail to reflect on the potential harm caused in the process – by making assumptions about who should do these activities, or what they can contribute; by underestimating the range of approaches that can result in a successful outcome; and by expecting the process to be painless or problem-free. In the spirit of this edited collection, we have described some of the uncomfortable truths made apparent by this project, as a means to critically reflect on the realities of doing undervalued work in an imperfect world.

Acknowledgements

The authors would like to thank the BIB Network, and in particular those members who worked with students to develop content for the first submissions to the website – Paul Bijl, Conny Kooijman, Jacqueline Kool, Inge Mans, Jan Troost, Coleta Platenkamp, Jan Troost, Agnes van Wijnen, and Ad van der Waals.

Bibliography

American Alliance of Museums (no date), 'Accessibility and Inclusion Resources of the American Alliance of Museums', viewed 30 September 2019, www.aam-us.org/programs/resource-library.

Brants, L., van Trigt, P., and Schippers, A. (2017), 'A Short History of Approaches to Disability in the Netherlands', in R. Hanes, I. Brown, and N. E. Hansen, *The Routledge History of Disability* (London: Routledge), 151–163.

Burch, S. (ed.) (2009), *Encyclopedia of American Disability History* (New York: Facts on File).

Chatterjee, H. and Noble, G. (2013), *Museums, Health and Well-Being* (Farnham and Burlington, VT: Ashgate).

Corrigan, P. W. (ed.) (2014), *The Stigma of Disease and Disability: Understanding Causes and Overcoming Injustices*. Washington, DC: American Psychological Association.

Culture, Health and Wellbeing Alliance, viewed 2 October 2019, www.culturehealthandwellbeing. org.uk.

Disability Cooperative Network (no date), 'Inclusive Practice in Museums and Heritage: Disability Co-operative Network', viewed 30 September 2019, www.heritagefund.org.uk/discussions/ inclusive-practice-museums-and-heritage-disability-co-operative-network.

Dodd, J., Sandell, R., Jolly, D. and Jones, C. (2008), *Rethinking Disability Representation in Museums and Galleries* (Leicester: Research Centre for Museums and Galleries).

Dolmage, J. (2017), *Academic Ableism: Disability and Higher Education* (Ann Arbor: University of Michigan Press).

Haller, B. (2010), *Representing Disability in an Ableist World: Essays on Mass Media* (Louisville, KY: Advocado Press).

Mudde, Tonie (2019), 'Waar blijft de blik van mensen die zélf leven met een beperking?' *De Volkskrant*, viewed 30 September 2019, www.volkskrant.nl/wetenschap/ waar-blijft-de-blik-van-mensen-die-zelf-leven-met-een-beperking~be2a3894.

Niciu, S. (2019), 'Rethinking Disability – Time for Change within the Museum', *Disability Arts Online*, 13 March 2019, viewed 30 September 2019, http://disabilityarts.online/magazine/opinion/ rethinking-disability-time-change-within-musem.

Ott, K. (2005), 'Disability and the Practice of Public History: An Introduction'. *Public Historian*, 27 (2), 9–24.

Parry, M. S. (2016), 'abNormal: Bodies in Medicine and Culture', in S. Butler and E. Lehrer (eds), *Curatorial Dreams: Critics Imagine Exhibitions* (Montreal: McGill-Queen's University Press), 246–264.

Sandell, R., Dodd, J. and Garland-Thomson, R. (eds) (2010), *Re-presenting Disability: Activism and Agency in the Museum* (London: Routledge).

Silverman, L. H. (2010), *The Social Work of Museums* (London: Routledge).

Wiersma, A. and KNHG (2019), 'De lancering van DisPLACE: verhalen doorbreken de stilte', viewed 30 September 2019, https://knhg.nl/2019/03/21/de-lancering-van-displace-verhalen-doorbreken-de-stilte.

World Health Organization and World Bank (2011), *World Report on Disability* (Geneva: World Health Organization).

PART III
Taking back

11

THE ACT OF EMANCIPATING ONESELF

The museum and the release of adult Care Leavers' case records

Jacob Knage Rasmussen

Abstract: How important is it to know and understand your own history? For those institutionalised as children, it is of enormous importance. The need for the 'supported release' of personal case records has been stated by Care Leavers and researchers all over the world. But what role can a museum play? In Denmark, the Danish Welfare Museum has developed a model of 'supported release', consisting of three equally important stages: before, during and after access. As these key elements stand, the importance of acknowledging Care Leavers' own agency and supporting their right to challenge the professionals who wrote the case record is primary. In 'Peer's case', Jacob Knage Rasmussen demonstrates how the model works on a practical level, and how the model has the potential of developing active agency and creating collaborative social change, while nuancing our historical knowledge and minimising the negative, and highly sensitive, personal impact of accessing case records.

Stored away at the Danish National Archives, protected against light, moisture and curious gaze, lie thousands of collected and preserved case records, from a variety of Danish children's homes. They consist of documents 'collected and sorted by the staff of the institution, originally intended to keep track of and to monitor children over a period of time' (Brickell 2013: 51), They were never meant to be read by the children that they were created to portray so thoroughly, and least of all, to be questioned or challenged. However, in recent decades an increasing number of adult Care Leavers are beginning to look into the history of their own childhood (De Wilde and Vanobbergen 2017: 384–397). To use a term from John Murphy,[1] they can be described as 'Archivists of the self' (Murphy 2010). In Denmark, it has been an ongoing process, especially since the Godhavn Inquiry in 2011.[2] Amidst a lack of life witnesses, family photos, documents or other arte facts from a childhood in care, adult Care Leavers often share a feeling of being in a 'genealogical bewilderment' (Murphy 2010: 302) with very little or fragmented knowledge of their own childhood. As described by Leonie Sheedy, an Australian survivor and adult Care Leaver:

> Being a parentless person is a most difficult thing … I have no sense of belonging to a
> long line of extended relatives, no parents, brothers, sisters, aunts, uncles, cousins, second

> cousins ... I feel that I have no past, that my life only began at three years old. The
> documents and family photos of a normal family life are missing.
>
> *(Swain and Musgrove 2012: 6)*

In search for answers or in an attempt to create a coherent life story, the so-called case records[3] often play an important role for Care Leavers as keys to the past. In some cases, they are the only artefact that remains of their childhood. Accessing case records can be a life-changing event, and for Care Leavers the impact can be significant. Some researchers (Pugh 1999; Goddard, Feast and Kirton 2015; Winter and Cohen 2005), focusing on the positive impact, suggest that accessing case records, with their mixture of new and forgotten information, can help Care Leavers build a stronger sense of identity, provide answers, retrieve lost memories and help them to understand how they have become the person they are. Others who focus on the negative impact suggest that accessing case records results in 'overwhelming emotions of grief, loss, loneliness, and lack of control' (Murray *et al.* 2018: 248) and in some cases serves 'to further marginalise individuals who have already been traumatised by the care system' (MacNeil *et al.* 2017: 9).

Consequently, some researchers (Pugh 1999; Murray 2017) argue for supported release of case records, in order to minimise the negative impact of access. In other countries, such as Australia, this kind of service is provided by Find & Connect (a national resource), various past providers and record holders,[4] and user-controlled places driven by social workers and Care Leavers[5] – a mixture of government-funded services and different types of non-government organisations. In Denmark, no such services exist, and with no other place to go, adult Care Leavers often turn to the Danish Welfare Museum for help and support. The reasons for this choice may be found in the Museum's year-long focus on the history of child welfare, numerous exhibitions, and continuous involvement in public welfare debates. As Care Leavers quickly came to realise, the Danish Welfare Museum has a genuine interest in their own history, and they strive to create an interaction of knowledge and experience, benefiting both Care Leavers and the Danish Welfare Museum.

This chapter deals with the response of the Museum, and examines the potential and dilemmas involved when a museum engages in supporting the release of case records.

A model for supported release of case records

In 2001, when the Danish Welfare Museum began working with the history of institutionalised childhood, making exhibitions, interviewing Care Leavers and analysing case records by the hundreds, we gradually became an important site for adult Care Leavers. As we encouraged them to contribute with their insight and knowledge, they began to see the Danish Welfare Museum as a safe place that represented their history with no judgement or hidden agenda. Consequently, they began to contact us when they needed help and support, especially in their search for case records. Often, they could not do it on their own, and they trusted the staff of the Danish Welfare Museum, in contrast to traditional social workers and archivists, whom they experienced as bureaucratic or lacking empathy and understanding. One of the Care Leavers contacted us and pleaded for help: 'Promise you will help me find my case record! I just want to move on with my life' (Rasmussen 2015: 54). Another added: 'As a child I cried myself to sleep and asked myself, why am I here? The question has followed me ever since, and now I want the answers' (Bjerre et al. 2017: 76). The majority were driven by a deep desire

to obtain answers about a lost childhood. Others had a more specific agenda for accessing their record. Some wanted access in their attempt to obtain a post-traumatic stress diagnosis from their doctor, and others were looking for proof of abuse and neglect in their demands for financial compensation from the state. All of the requests involved cases from the period 1945–1990 and were handled equally carefully and with great seriousness. The many requests were a major recognition of our work, and early on, we decided to engage and help. We had no state funding, and our knowledge of supported release was very limited from the beginning. We engaged because we felt it was the right thing to do, and because we had a grounded belief in our potential as a museum, bringing real change and social justice for Care Leavers. At the same time, our engagement would give us a unique insight into the history of Care Leavers and their individual life stories.

We worked case by case with no formalised model or way of conduct. It was learning by doing, based on openness and a willingness to experiment and adapt. We were challenged in many ways, and as the years passed, the need for a model which could handle the many queries in a professional, ethical and socially responsible manner became increasingly necessary. The main goal for the Museum was to develop a model that could strengthen the positive impact of accessing case records and minimise the negative ones – a central challenge in all attempts of supported release. As key elements, we found that matching of expectations, informed consent and supporting Care Leavers own agency, both *before*, *during* and *after* access, were central in solving this challenge and had to be incorporated into the model. At the same time, we had to acknowledge that people are different, and so is their need for help and support. As a guideline, we wanted the model to be flexible, giving space for any kind of individual wishes. Inspired by the Action Research Method[6] and in close cooperation with Danish Care Leavers, we gradually developed a model for supported release of case records, which we named 'Meeting the case record'. The model consists of three equally important stages: *before*, *during* and *after* access. Normally, the duration of all stages is 6–12 months and is documented and preserved with either logs or sound recordings by the Museum. Copies are always offered to Care Leavers at the end of the process.

Before access starts when the Museum is contacted for the first time and lasts until access is achieved. Matching of expectations and involvement from both sides is central at this stage, and every case depends on an open dialogue between curator and Care Leaver. The Museum always invites Care Leavers to be a part of the process instead of being spectators. In the beginning of the dialogue, Care Leavers are invited to express their wishes and expectations, and the Museum informs them of their rights and what we can do for them. The Museum also explains what type of information Care Leavers can expect to find in their case record, and perhaps even more importantly, what they should not expect to find. We always explain why the case record was constructed in the first place, who wrote it, and for what purpose. Finally, we inform them of the risk in getting access and the negative impact it can bring on a personal level. Ultimately, the choice whether to access or not is always theirs. If they decide to proceed, we offer to help them write applications to the Danish National Archives and to search for other types of information, such as photos, health records or anniversary books from the institution. At this stage, we also invite Care Leavers to narrate and share their own life story.[7] By doing this, we acknowledge and support their version of the truth and we encourage them to trust their own memory. In our experience, this gives Care Leavers a mental strength for when they are later confronted with their case record.

During access is the next stage in our model and is defined as the limited period when Care Leavers actually have the chance to access and read their own case record. It is a very

vulnerable stage and characterised by Care Leavers' mixed feelings. We always recommend Care Leavers to seek support at this stage, whether from relatives, friends, psychologists or the Museum. The essential part is never to be alone while reading. If Care Leavers seek our support at this stage, we always offer to read the case record out loud, in some cases several times, as various documents often need to be read two or three times. Harsh and degrading descriptions are often a part of the records' wording and these sentences require extra attention and empathy, when reading out loud. We also offer to 'translate' professional terms and to put the content into a historical context. In this respect, the Museum, as a historical and cultural institution, has unique knowledge and insight. Confronted with the actual wording of the case record, reactions from Care Leavers vary, and so do our responses.[8] In some cases, the wording of the case record is *accepted* as the truth and a source of new knowledge. In other cases, the wording of the case record is *rejected* as being false, trivial, insignificant, misleading, fragmentary, irrefutable or offensive in its language, content and structure. When Allex, who had been in care between 1947 and 1962, read his case record, he could not recognise himself or the child described, and he reacted with distrust and anger: 'It's all lies upon lies. They are hiding their own mistakes and covering their tracks. I know they are not telling the truth!'[9] Whether Care Leavers accept or reject their case records, we always respond by helping them build chronology, making timelines, structuring the new type of information, and by answering their many questions. We never respond by challenging the truth-value of Care Leavers' own narratives, or by defending the actual wording of the case record or the professionals who wrote in it. The history of institutionalised childhood is at stake, but so are the well-being of Care Leavers and their sense of identity. The curator also needs to ensure that the dialogue does not transform into a therapeutic conversation, for which we are neither trained, nor have any intention to pursue. We are not looking to 'cure' or to analyse that individual's state of mind. In some cases, we experience how Care Leavers react by using their *voice*[10] and start commenting, replying and nuancing the record wording, thus challenging the knowledge, the narratives and concepts of 'truth'. Reading the case record then becomes a zone of conflict. Pia, who was placed into care at Vejstrup Girls Home in 1959–1961, an institution for so-called 'immoral girls', is an example of Care Leavers using their voice. She could read the staff's rather harsh description of her: 'Pia is unreliable, deceitful, defiant, stubborn, restless, always in opposition, violent reactions, is without inhibitions' (Kragh et al. 2015). Pia was unable to recognise herself, and while reading she instantly and impulsively responded: 'I felt lonely and abandoned … I should never have been on Vejstrup. I was such an innocent girl … Who did they think I was?' (Kragh et al. 2015). Several researchers in the field argue for the right of Care Leavers to confront and challenge the wording of the case record as a kind of 'insider researcher', an expert on their own life (Swain and Musgrove 2012; Wilson and Golding 2016). In their view, case records should not be seen as inviolable, but should involve the direct participation of those who experienced the matters contained in the record. In Australia you actually have the opportunity to correct the information contained in your case record, if it is 'inaccurate, out of date, incomplete, irrelevant or misleading'. You also have the right to add your own statement into the record, in such a way that it will be apparent to users of the information in the future (Officer of the Australian Information Commissioner 2014: 17–18.). According to Frank Golding, a prominent member of CLAN (Care Leavers of Australasia Network), this opportunity is seldom used by Care Leavers, due to either ignorance or fear of the bureaucratic process it involves. 'Care Leavers are not routinely told about this right and, even when they learn about that opportunity, there is understandable reluctance to take it up'

(Golding 2017: 4). Giving space for Pia's voice, supporting Care Leavers' agency and right to challenge the professionals of the past and the future, is a key element in our response and at this stage of our model.[11]

After access is an importance stage as well and should never be underestimated. The time that follows the actual reading can be characterised by Care Leavers' feelings of confusion, sadness and anger, but also by feelings of empowerment, relief, closure and enlightenment. We always support and keep in contact and encourage Care Leavers to reflect on the entire process and what it meant to them. Debriefing is essential at this stage, not only for the sake of Care Leavers, but for the curator as well. Recent research in vicarious trauma indicates that when exposed to narratives of abuse and neglect over a long period of time, negative consequences can occur, such as depression and a feeling of burnout (Swain 2015). When the question of whether or not accessing the case record has lived up to expectations occurs, we always recall the words of Amanda Parish and Pam Cotton from their study and report (1989) concerning adopted people. They write about the impact of accessing case records: 'Good outcomes are not necessarily happy outcomes' (Pugh 1999: 20). Implementing our model has a clear emancipatory potential as it supports Care Leavers' agency and helps them make sense of their own past. As we experienced working with the model, the potentials clearly reach beyond this. Knowledge and experiences are being shared, benefiting both Care Leavers and the Danish Welfare Museum. Care Leavers, for example gain new information about legislation and administrative practices, while the Museum acquires knowledge of individual strategies and emotions among orphanages. This kind of knowledge exchange may easily apply to other groups and other types of museums. To illustrate the different potentials and the way we work on a practical level, we present the case of Peer.

Peer's case[12]

When Peer contacted the Danish Welfare Museum in April 2016, he was frustrated and needed help. He had been institutionalised for most of his childhood, throughout 1955–1972, but had very limited knowledge from those years. He had one simple request: 'If you can help me find head and tail in my childhood, I would love to hear from you.'[13] The Museum called back, and contact was established. Matching of expectations was made at an early stage, and information exchanged. *Before* access, Peer told us about his own motivation for wanting access. He was driven by a general curiosity and a desire to find every institution he had ever been placed in. He had mixed expectations, and without knowing the content, he suspected the case record of being false and not documenting episodes of abuse and neglect, which were central in his own narrative. At the same time, he had a slight hope that some of the staff members had seen who he really was, and why he acted as he did as a child. Together we made a plan for access. The Museum agreed to write applications, as he himself had long given up writing. Talking face to face is always the best way to engage in an open dialogue so we agreed to meet in his flat a week later. Sitting in his kitchen, he began to share his life story. As a child, his mother was often sick, and he was in and out of up to 25 different institutions. 'My mum had bad nerves and things like that', Peer said. He also shared details from his experience with being institutionalised, which consisted of abuse and neglect, but also of different survival strategies and friendship. After care, he had a rough life with drug abuse, homelessness, and several prison sentences. At present, he is a recovering substance abuser, and lives in his own flat in Copenhagen.

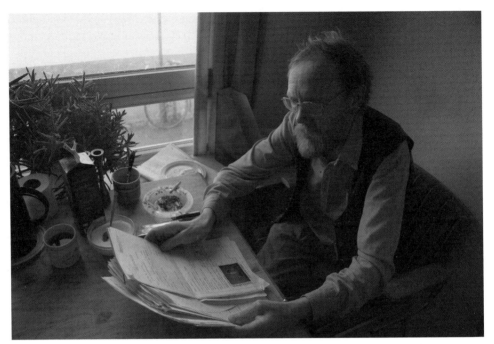

FIGURE 11.1 Peer in his kitchen looking at his case record.
Photo: Jacob Knage Rasmussen, 2016.

When we finally had the chance to look at his case record from Godhavn Boys Home, we were sitting in the kitchen at his flat once more. The case record consisted of 48 pages, including pictures, letters, reports and psychiatric descriptions. *During* access quickly became a zone of conflict as Peer consistently began to use his voice as the pages were turned. Encouraged by Peer, I began to read his case record out loud. One of the first documents consisted of a character description of Peer: 'Peer is polite and accommodating, sometimes a little smarmy, but his numerous and sometimes gratuitous falsehoods mean that he is actually not to be trusted.' Peer disagreed with the staff's description and immediately began to comment:

> I can't quite follow the staff's description of me. They left something very important out, and that was the reason why I behaved like I did … Ever since the early accounts of sexual abuse in my childhood, I adopted a special way to approach adult men. I had the feeling that they wanted me to be in a particular way … Maybe that's why the record uses the word smarmy.

Peer's reply provides us with a new angle on the case record by adding his own perspective and version of the episode. When he behaved as described, the corresponding record should not, according to Peer, be perceived as characteristic of him. The reason for his behaviour should, instead, be found in previous events when he as a five- to six-year-old boy was sexually abused by a doctor at an orphanage. The episodes came to influence the rest of his life, and the way he approached other adults as a child.

After a short break, I continued to read the case record out loud:

> Peer is rather careless in his dealings with the truth … Among other things he came up with a completely groundless accusation against a staff-member. This staff member allegedly was beating him, even in the sight of other children, who deny it. He later withdrew the accusation and could not explain why it was made.

Peer recalls the episode the document refers to, but rejects the interpretation made by the staff members. Peer immediately explains why he had made the 'accusation':

> A staff member dragged me all the way up the stairs and into a room and locked the door. I got bruises all around the upper arm. One could clearly see exactly where he had grabbed me … I had the bruises to prove it, but as they continued to say that I was not telling the truth, I finally withdrew the accusation. I did so, because I wanted to stay on good terms with the staff members, not because I was lying.

This is a good example of differing evidence between the version in the case record and Peer's own version, as to whether the incident ever occurred or not. From the institution's perspective, their perception of Peer as untruthful was confirmed, seeing as he withdrew his accusation in the end. Peer had another explanation as to why he withdrew his accusation, and he explained the strategic considerations behind the action, namely that he wanted to keep on good terms with the staff. Truth-seeking is not the agenda of our model, but Peer's response to the record's wording contributes new perspectives both to the specific episode and more generally to some of the strategies that children in care use, in the past as well as in present times.

I continued to read out loud: 'Peer suffers from bed-wetting and gets medicine for this … He denies the bed-wetting himself and is not quite honest in his explanations.' Peer replied to the question about whether he lied or not: 'It's probably true' he said, accepting the record's claim as knowledge, but added:

> If you urinated in the bed, and the staff found out, you were put into the hallway together with the bedding. Then you had to stand and wait, while the other boys went down and ate … When they were finished eating, you could go out in the bathroom, and if there was time, get some breakfast afterwards … Standing in the hallway for a long time, waiting for the other kids to be finished, so you could get something to eat, wasn't funny at all.

For Peer, this part of the case record also confirmed his own suspicion as to whether he had been medicated for his bedwetting or not. It was important and new knowledge for Peer and an example of how the record can confirm vague memories. But as Gillian Pugh writes in her book *Unlocking the Past*, concerning the impact of getting access to records: 'No matter how much information was contained in the records, it never provided all the answers to people's questions' (Pugh 1999: 96). *After* access Peer shared his disappointment, especially at the staff's description of certain episodes, which he felt were misleading at best. He felt that they did not see behind his actions and understand who he really was as a child, and why he acted like he did. He felt that 'lies were repeated, again and again'. Using his voice and agency also gave

Peer a positive experience and a chance to challenge the 'lies' of the past. The institution's power to determine across time what was right and what was wrong was challenged when Peer began negotiating his case record. When asked if he would do it again, he replied without hesitating: 'You never know what you will find … but I think it's worth it!'

Concluding remarks

When the Danish Welfare Museum decided to engage in supported release, bringing case records into the light and giving a voice to Care Leavers, it challenged the general understanding of who is allowed to speak and be heard in the past, present and future. What began as a reaction to the lack of supported release of case records, gradually developed into a new museum practice, with its own justification. Our methodology encourages participation and involvement from vulnerable stakeholders, thereby transforming the museum's traditional role. First and foremost we want to recognise our social responsibility, and to make a difference for those people whose history is on display at the Danish welfare Museum. Our model offers agency and empowerment and minimises the negative impact of accessing case records in a very practical fashion. It gives Care Leavers a chance to explain themselves without being questioned or victimised, recreating their own identity and closing a chapter of their life, in dignity and control. We acknowledge their version of the past, and use it as a way of raising new historical questions, supporting public debates and critical thinking. Implementing our model contains a huge emancipatory potential and has the potential to create social change. At the same time, the model gives us an understanding of how adult Care Leavers live and come to terms with their own history, as well as an insight into different perspectives, strategies and power relations – now and then! It nuances our historical knowledge and deepens our understanding of different causalities and explanatory models.

To succeed, it requires commitment and a firm belief that vulnerable stakeholders are creators as well as consumers of knowledge. It requires a willingness to respect and listen to their voice, as a way of understanding our common past, present and future. Our engagement also has consequences for the way we, as a museum, can write the history of institutionalised childhood, create new exhibitions, and support vulnerable stakeholders in the future.

By presenting our model, we encourage all museums and archives working with the history of vulnerable stakeholders of other identities and circumstances, to strive for the same goal. Whether it involves people from psychiatric institutions, workhouses, care homes or institutions for people with disabilities, they all deserve social justice – and a place in history. As a museum, we can make a difference and we have the potential to change people's lives!

Acknowledgements

First and foremost, I would like to offer a special thanks to Peer for his generosity and willingness to share his story. I would also like to thank all of my other interviewees and the Panel of Experience at the Danish Welfare Museum for their input and support.

Notes

1 Professor at the University of Melbourne. Among other things, he works with political and policy history, public narratives about welfare and memory.

2 The first Danish inquiry into child abuse and neglect at children's homes, financed by the Ministry of Social Affairs (Rytter 2011).

3 The Danish National Archive has collected and preserved large numbers of Case Records, and is by far the country's largest record holder. The material is by no means complete. In Denmark Care Leavers have the right to access their own case record: Arkivloven, kapitel 7, §30, Stk. 3.

4 For example, Mary MacKillop Heritage Centre and Child and Family Services Ballarat.

5 For example, Open Place employs a Care Leaver.

6 Introduced in 1946 by the German-American psychologist Kurt Lewin.

7 A similar model is discussed by Atkinson (1998).

8 Inspired by A. O. Hirschman and his concepts of 'exit, loyalty or voice'; see Witt 2011.

9 Interview by Jacob Knage Rasmussen, 25 May 2016 (translated).

10 In our theoretical understanding of the term, *voice* refers to any attempt to change, rather than escape a given dissatisfying situation.

11 In doing so, we also draw on the works of Humphreys and Kertesz (2012) and their description of the 'Knowledge Diamond'. All social policy knowledge draws from four sources: experience from adult Care Leavers, practice wisdom, policy data and research evidence.

12 Interview by Jacob Knage Rasmussen, 25 May 2016 (translated). Peer's case has previously been described in Bjerre *et al.* (2017).

13 Email correspondence with author, 16 April 2016.

Bibliography

Atkinson, R. (1998), *The Life-Story Interview*, Thousand Oaks, CA: Sage.

Bjerre, C., Rasmussen, J.K. and Jensen, S.G (2017), 'Journalens potentialer: Konstruktioner af og møder med journalsager i børneforsorgens regi', *Temp*, 14: 76–94.

Brickell, C. (2013), 'On the Case of Youth: Case Files, Case Studies, and the Social Construction of Adolescence', *Journal of the History of Childhood and Youth*, 6 (1): 50–80.

Child and Family Services Ballarat (no date), Website, viewed 3 September 2019, www.cafs.org.au.

De Wilde, L., and Vanobbergen, B. (2017), 'Puzzling History – the Personal File in Residential Care: A Source for Life History and Historical Research', *History of Education*, 46 (3): 384–397.

Find & Connect (no date), Website, viewed 3 September 2019, www.findandconnect.gov.au.

Goddard, J., Feast, J. and Kirton, D. (2015), 'A Childhood on Paper: Accessing Care Records under the Data Protection Act 1998', *Adoption & Fostering Journal*, 29 (3): 82–84.

Golding, F. (2017), 'Capturing the Record – Building a Storehouse of Hope', Presentation at the Records Management Network Meeting, Melbourne, 19 May 2017.

Horrocks, C. and Goddard, J. (2006), 'Adults who Grew up in Care: Constructing the Self and Accessing Care Files', *Child & Family Social Work*, 11 (3): 264–272.

Humphreys, C. and Kertesz, M. (2012), 'Putting the Heart Back into the Record: Personal Identity Records to Support Young People in Care', *Adoption and Fostering*, 36 (1): 27–39.

Kragh, J., Vaczy, J., Grønbæk, s. and Rasmussen, J.K. (2015), *På kanten af velfærdsstaten: Anbragte og indlagte i dansk socialforsorg 1933–1980*, Odense: Syddansk Universitetsforlag/Svendborg Museum.

Laing, L., Humphreys, C. and Cavanagh, K. (2013), *Social Work and Domestic Violence: Developing Critical and Reflective Practice*, Thousand Oaks, CA: Sage.

MacNeil, H., Duff, W., Dotiwalla, A. and Zuchniak, K. (2017), 'If There Are No Records, There Is No Narrative: The Social Justice Impact of Records of Scottish Care-leavers', *Archival Science*, 18 (1): 1–28.

Mary MacKillop Heritage Centre (no date), Website, viewed 3 September 2019, www.mmhc.org.au.

Murphy, J. (2010), 'Memory, Identity and Public Narrative: Composing a Life-story after Leaving Institutional Care, Victoria, 1945–83', *Cultural and Social History*, 7 (3): 297–314.

Murray, S. (2017), *Finding Lost Childhoods: Supporting Care-Leavers to Access Personal Records*, Basingstoke: Palgrave Macmillan.

Murray, S., Malone, J., and Glare, J. (2018), 'Building a Life Story: Providing Records and Support to Former Residents of Children's Homes', *Australian Social Work*, 61 (3): 239–255.

Officer of the Australian Information Commissioner (2014), *The Australian Privacy Principles: From Schedule 1 of the Privacy Amendment (Enhancing Privacy Protection) Act 2012*, Sydney: Australian Government.

Open Place (no date), Website, viewed 3 September 2019, www.openplace.org.au.

Rytter, M. (2011), *Godhavnsrapporten*, Odense: Syddansk Universitsforlag.

Pugh, G. (1999), *Unlocking the Past: The Impact of Access to Barnardo's Childcare Records*, Aldershot: Ashgate.

Rasmussen, J. K. (2015), 'Det handler om at få sat historien på plads', *Vera – tidsskrift for pædagoger*, 72 (September).

Swain, S. (2015), 'Transitional Justice Workers and Vicarious Trauma', in Sköld, J. and Swain, S. (eds), *Apologies and the Legacy of Abuse of Children in 'Care': International Perspectives*, Basingstoke: Palgrave Macmillan.

Swain, S., and Musgrove, N. (2012), 'We Are the Stories We Tell about Ourselves', *Archives and Manuscripts*, 40 (1): 4–14.

Wilson, J. Z., and Golding, F. (2016), 'Latent Scrutiny: Personal Archives as Perpetual Mementos of the Official Gaze', *Archival Science*, 16 (1): 93–109.

Winter, K. and Cohen, O. (2005), 'Identity Issues for Looked After Children with No Knowledge of Their Origins: Implications for Research and Practice', *Adoption & Fostering Journal*, 29 (2): 44–52.

Witt, M. T. (2011), 'Exit, Voice, Loyalty Revisited: Contours and Implications for Public Administration in Dark Times', *Public Integrity*, 13 (3): 239–252.

12

A CALL TO JUSTICE AT THE NATIONAL MUSEUM OF AUSTRALIA

Adele Chynoweth

> If you sit down and try to have a robust conversation with professionals, they melt down and go on stress leave.
>
> *John Murray (2017), Forgotten Australian and recipient of*
> *Human Rights Commission Award*

This discussion concerns a specific exhibition at the National Museum of Australia (NMA). The NMA has gained much international sympathy for its difficult birth, complicated by the history wars led by the conservative Howard government at the time. The NMA opened in 2001 as a key Centenary of Federation project, preceded by various calls, throughout the twentieth century, for a national museum. These bids were interrupted by two world wars, financial concerns and government inaction. It was the 1975 Pigott Report that resulted in the passing of the National Museum of Australia Act in 1980 and led to the National Historical Collection that focused on three connected themes:

> Aboriginal and Torres Strait Islander history and culture
> Australia's history and society since 1788
> the interaction of people with the environment.
>
> *(National Museum of Australia, no date, a)*

Dawn Casey, the inaugural Director of the National Museum of Australia, led a pluralistic view of history which was at odds with the preference of the then Prime Minister, John Howard, for an emphasis on Australia's heroic achievements. Howard stacked the Museum's Council with colleagues who shared his ideological views who, in turn, leaked to the press their objections to Casey's approach. In 2003, the Council only renewed Casey's contract for 12 months.[1] The hangover of these so-called 'history wars' is seemingly characterised by an ongoing sensitivity to any direct government involvement in museum content in Australia. This chapter concerns a government initiative well-distanced from Howard's history wars, separated by years as well as ideology. A new Labor government, led by Prime Minister Kevin Rudd, was formed in 2007 and revisited the recommendations of the 2004 Senate Inquiry

into Children in Institutional Care. The recommendations were informed by submissions and public hearings and included a proposal for a touring exhibition. In 2009, the Rudd government financed this recommendation.

I am not only interested in how the National Museum of Australia responded to this democratic initiative. This discussion also challenges any views throughout the international museum sector that position the NMA as a mere victim of the history wars. Instead, I invite the reader to contemplate whether the NMA, well after the term of the Howard government, has, of its own choosing, unprompted by external forces, internalised a conservative, reactionary approach to projects that could bring about social change. Does this observation apply to the ethos of other museums? Whilst austerity measures, efficiency dividends and right-wing populism pose real threats to the fight against inequity, might they also be used to feed a culture of well-disguised excuse-mongering throughout the unhelpful museum?

My last day at the National Museum of Australia, in Canberra, coincided with the opening of the exhibition that I co-curated, *Inside: Life in Children's Homes and Institutions*. This exhibition was based on the personal histories of those who, when they were children, experienced life in an orphanage, residential Home or institution, and was publicised as 'a voice for those who were inside and a chance for others to understand'. To celebrate the opening of the *Inside* exhibition on 16 November 2011, I had organised a live concert in the Museum's entrance hall. The concert was a joyful event – joyful in the sense that a difficult period of Australian history had been recognised and validated. But perhaps it is more apt to describe that there was sense of relief and release that the personal had now become public – a burden shared. Whatever the emotional impetus, people were dancing. Not so, for two women survivors who were there. They sat at a table. They were angry. Over the two years that I had worked at the Museum, I had come to know these women and their personal histories were included in the exhibition.

These two women didn't display a mood of celebration at the opening of the *Inside* exhibition. Instead, they complained, 'This exhibition is all very well and good. Yes – it did get our stories told and finally after all these years we are believed. But what now? Are we supposed to just go home now? Is that it?'

And then came the big question.

One of the women turned to me and asked, 'Are you going to help us get justice?'

How to respond? But first, what were the challenges in creating the *Inside* exhibition and what are the implications of these points of tension for survivors of institutionalised child abuse? And how might such contestation inform or denote an obstacle to activism and social change?

The exclusion of the working class

Most of the trials in producing the exhibition came from within the Museum itself. The majority – 88 per cent – of children who experienced out-of-home care were non-Indigenous, domestic Australian children. These are known as the 'Forgotten Australians', from the title of the Senate Report (2004), or also referred to as 'Care Leavers'. The difficulty stemmed from the fact that the National Museum of Australia had been reluctant to represent any narratives of institutionalised 'care' except those pertaining to the Stolen Generations – the term used to describe the policy, supported by government legislation, of Australian Aboriginal children taken away from their parents to be put in the care of whites (Read 1981). The National

Museum was hesitant to exhibit the narratives of non-Indigenous institutionalised children despite the findings of an Australian government inquiry into children in institutional care, conducted in 2003, comprising over 500 public submissions and a series of public hearings. The inquiry was inundated with testimonies of horrific neglect and abuse experienced by non-Indigenous Australian children who were, more often than not, victims of poverty. The inquiry found that children placed in 'care' suffered long-lasting separation from siblings (Senate Community Affairs References Committee 2004a: 107). Many children were falsely told that their parents were deceased, or did not love them, despite failed attempts by parents to visit their children (105–106). Physical deprivation, hunger and inadequate dental care were common (111). Some children were the subjects of medical testing (117). Others were the victims of sustained brutality, including solitary confinement, cruel beatings and humiliation (137). A large number of children experienced sexual abuse (197). Children generally did not receive an adequate education and, instead, were forced to work on farms or in laundries (110). Many had their names and identities changed by institutional staff (94).

Such evidence extended the pivotal, earlier findings of Peter Read beyond the experiences of Aboriginal and Torres Strait Islander children to include that of the working and poverty classes in Australia. The subsequent Senate report *Forgotten Australians* stressed the need for an associated public narrative and specifically recommended that the National Museum of Australia create a permanent exhibition, with a capacity to tour, that dealt with the history and experiences of children in institutional care (Senate Community Affairs References Committee 2004a: 326). However, incidental conversations amongst staff at the National Museum about this recommendation surmised that Aboriginal children, unlike their non-Indigenous institutionalised peers, suffered loss of their culture and therefore it was their narratives that were more deserving of exhibited representation. It is interesting to note that when it comes to contemplating the exhibition of non-Indigenous Australian historical figures from the dominant culture, the Museum does not assess their significance through a similar constructed competition of suffering. Captain James Cook and his explorations of the Pacific and Australian of the Year Awards, are two separate examples of displays in the Museum that have been part of a consensus history without a need for discussion of the subjects' worth within a hierarchy of victimhood. This raises the questions as to why the Forgotten Australians are not afforded this same privileged profile too.

The answer may lie within the field of the history of violence and trauma. Martschukat and Niedermeier (2013) as well as Arnold-de Simine (2013) observe that, through the historical accounts within this specific topic, some lives are deemed more grievable than others. The National Museum of Australia did not create an exhibition about Forgotten Australians until the push came in 2009 from an Australian Labor government with targeted funding. The support of the Labor government may be viewed as an attempt to bring class identification to a consensus history of the institutionalisation of children in Australia. This may exemplify one of the characteristics of the unhelpful museum – a reluctance to support social change in the absence of government approval and extra funding.

Trauma-informed practice

The *Inside* exhibition comprised both objects and associated testimonies of survivors of institutionalised 'care'. The sourcing of this material required extensive consultations with survivors, scaffolded by trust-building. Many survivors live with post-traumatic stress disorder

and may endure social isolation. Also, the childhood experiences that they reported to museum staff were emotionally confronting.

This denoted an additional challenge to the pre-existing need to validate the worth of this history. Whilst the National Museum of Australia had extensive commitment and experience in liaising with Aboriginal and Torres Strait Islander stakeholders in relation to cultural heritage, subsequently demonstrated in their guidelines for engagement with Indigenous stakeholders (National Museum of Australia 2015), there appeared to be little ease in responding to trauma survivors, specifically. Perhaps this is not surprising given that the role of the traditional museum has been to maintain and display object collections and not to attend to the emotional issues that may arise when sourcing narratives that concern traumatic events in history. As Stephen Weil observes:

> Museum workers are fundamentally technicians. They have developed and passed along to their successors systematic ways in which to deal with the objects (and the information about those objects) that their museums collect and make accessible to the public. Through training and experience they have developed a high level of expertise as to how those objects ought properly be collected, preserved, restored, classified, catalogued, studies, displayed, interpreted, stored, transported, and safeguarded.
>
> *(Weil 2007: 36)*

The *Inside* exhibition provided an opportunity to educate museum visitors about the painful narratives of Forgotten Australians and the associated systemic failure to nurture

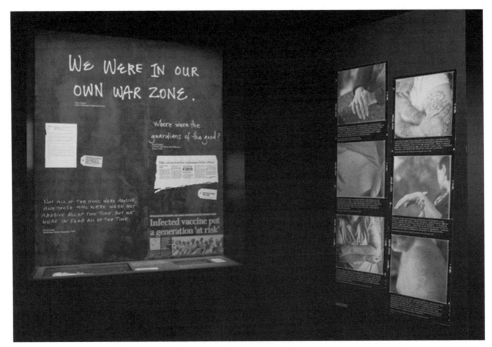

FIGURE 12.1 Detail from exhibition *Inside: Life in Children's Homes and Institutions.*
Photo: Jason McCarthy, National Museum of Australia.

vulnerable children. However, senior staff were quick to prescribe what I perceived to be a form of dilution and containment of the anguish of this living history. In meetings, the curatorial team were instructed to include 'the good stories'. Later in private, we irreverently joked amongst ourselves that, similarly, our curatorial colleagues at the Australian War Memorial were probably not expected to represent the merits of trench warfare! Whilst we certainty represented, in the *Inside* exhibition, humorous anecdotes and examples of profound positive acts of nurturing by some institutional staff, it seemed absurd to redeem, in an exhibition, the heinous consequences of the systemic institutionalisation of children. As Joanna Penglase, former President of the Care Leavers of Australasia Network, asserted, 'If we had cared about children we would not have put them into warehouses and storage dumps for inmates' (Senate Community Affairs References Committee 2004b: 42).

At the beginning of my museum contract, I conducted a series of follow-up telephone conversations with survivors whom we had met at Parliament House, in Canberra, on the day of the National Apology to Forgotten Australians and Former Child Migrants. Through these conversations, I was building trust and collecting narratives and sourcing objects for the exhibition. However, not long into this process, I was assigned a mobile telephone and told to conduct these conversations outside the Museum building because the associated subject matter was upsetting my fellow curators on the office floor. I persevered throughout my curatorial banishment, spending hours seated on a bench outside without access to the usual office resources, taking extensive notes in an exercise book balanced on my lap.

As word-of-mouth spread amongst survivors about the pending *Inside* exhibition as well as their assessment that I was 'trustworthy', Care Leavers who lived locally and in isolation began to use the National Museum as their self-appointed drop-in centre. I supported these spontaneous visits with conversation and cups of tea. One survivor was homeless and endured several health problems. On one occasion, an ambulance was required and on another, I needed to seek emergency accommodation. A senior staff member responded to this by taking me aside and telling me that he would have preferred it if I had 'kept my distance' and reminded me of the importance of seeing a counsellor (Chynoweth 2014). This prescription existed in stark contrast to a parallel, public discourse throughout the museum sector of the need to engage visitors and embrace diversity (for example, Black 2005; Museums Australia Victoria 2013). How can the National Museum of Australia, or any other museum for that matter, expect to engage visitors and embrace diversity while its management, in the confines of private offices, instructs its curators to keep their distance from those stakeholders who are trauma survivors? The expectation of detachment seems more akin to the traditional methodology of academic research than to the work of a contemporary, inclusive museum.

I was also advised, 'You can't fix these people'. I acknowledge the dysfunctional drama that may result when identifying with the role of 'rescuer' in response to another who is cast in the role of 'victim' as discussed by transactional analyst Stephen Karpman (1968). However, that is different from a museum employee fulfilling a duty of care to the public and responding professionally to the safety needs of a visitor. There also exist societal inequities that do indeed deserve attention and museums should not shy away from contributing to this work. It is unrealistic and inauthentic for key museum staff, on one hand, to espouse their quest for museums as inclusive and accessible spaces while expecting that this pursuit can possibly be fulfilled within a culture of maintaining the status quo. The 'keep your distance' directive

exemplifies Bernadette Lynch's analysis of the way in which the traditional museum maintains inequitable power relations:

> the museum institution continues to maintain order and control, not through violence and political or even economic coercion, but ideologically, through a hegemonic culture in which the values of the institution become the "commonsense" values of all (and participants … become acculturated and complicit).
>
> *(Lynch 2016: 91)*

The need to contain and manage emotions in relation to the *Inside* exhibition was also evident in the extensive staff meetings, prior to the opening of *Inside*, concerning how best to respond to any visitors who might display signs of distress at the exhibition content. Whilst this was both a thoughtful and professional consideration, it was also symptomatic of an overall emphasis within the Museum on the negative feelings associated with this history and not on the narratives as a potential impetus towards social justice. Trauma survivors devote their time and extreme emotional labour to share their personal and deeply distressing experiences with museum staff and do so in good faith, often in the hope of personal and/or social benefit. Therefore, museums have a moral obligation, in response, to support the quest for these positive advances. Julia Rose notes:

> History workers who interpret difficult histories accept the responsibility to develop ethical representations with enough confidence and courage to believe that their work to commemorate the difficult histories will make a positive difference. Courage as a toll encourages history workers to take the risks of facing the difficult histories, of facing the resistances from learners. Courage is also needed by visitors who need to remain committed to learning about the difficult history despite the pain or anxiety the histories cause the visitors.
>
> *(Rose 2016: 125)*

The lack of focus on the exhibition's potential to support social justice for survivors was also demonstrated by the decision by the Museum to stop public contributions to the *Inside* online blog on the day that the exhibition opened. The blog had been created in addition to the *Inside* exhibition as a safe, moderated forum for Forgotten Australians and Former Child Migrants to share their experiences. The blog had been live for two years during the lead-up to the exhibition opening and had become highly valued and trusted by survivors as a means for publishing personal testimonies and artwork. Survivors also used the website to notify other survivors of campaigning initiatives, protests, meetings and reunions. Some survivors had successfully used the site to reconnect with lost family members. Curators of *Inside* had planned for the blog, which had been live since December 2009, to remain active after the opening of the exhibition so that visitor responses could be published. The decision was made to close the blog on the day that the *Inside* exhibition opened, even though external government funding had been offered to maintain it. The Museum had also offered to extend my contract but I declined. I could not, with a clear conscience, face the very stakeholders who so generously contributed to the exhibition and inform them that the blog that they so valued had been closed. I was to learn that, while my formal museum employment had concluded, my work was not yet over.

An exhibition is only the beginning

At the opening of the *Inside* exhibition in the Museum's entrance hall, my final day on the job, I faced my next challenge.

'Are you going to help us get justice?' came the plea from a woman who had been sent to an adult psychiatric facility as a child. The sister of the woman sitting next to her had also been sent to that same institution – Wolston Park Hospital, formerly known as Goodna Asylum. These women when, they were children, did not have a mental illness. This practice was the result of the policy of the Queensland government, specifically the Committee on Youth Problems, formed in 1959 and chaired by the government's police minister. The Committee recommended a medical response to so-called 'juvenile delinquents' and agreed to the establishment of 'Child Guidance Clinics' led by a psychiatrist, with police given powers to direct children to a court for committing 'anti-social acts'. Therefore, children were admitted to psychiatric facilities without either being diagnosed with a mental illness or having committed a crime. Most of the women who were admitted had run away from out-of-home care – either from an abusive foster family or an institution for children.

As I learned from my research for the *Inside* exhibition, former child inmates of Wolston Park reported to me that they were denied an education, locked up in wards with criminally insane adults, sent to solitary confinement, forced to take anti-psychotic medication, given shock treatment and were raped and tortured by male warders. Now as adults, these survivors live with complex post-traumatic stress disorder and other health problems from injuries that were inflicted on them when they were children. As adults, many have survived periods of homelessness and substance abuse.

Courageous attempts by these survivors to seek justice had been thwarted. One test case was put forward, in 1997, in the Supreme Court of Brisbane, but the State of Queensland used the statute of limitations in its defence, and successfully argued that too much time had passed between the alleged abuse at Wolston Park and the start of legal proceedings ('Erin' 2016). The women were also denied the opportunity to present their testimonies as part of the 1998 Commission of Inquiry into the Abuse of Children in Queensland Institutions known as the 'Forde Inquiry'. This refusal of their witness statements was informed by the terms of reference of the Inquiry, which only focused on institutions for children and Wolston Park was an institution for adults. The Queensland government did, however, make a formal apology in 2010 to former children under state care who were placed in adult mental health facilities, but the government did not, as promised, proceed with reconciliation talks with these survivors (Queensland Government 2017: 3).

So these women at the time of the exhibition opening at the National Museum of Australia were still seeking justice.

'Are you going to help us get justice?'

A manager of a traditional museum could easily compile a long list of reasons why a curator on the last day of her job should ignore this behest. I did not. I assured her that I would do all that I could to assist.

And so, in my personal capacity, having left the Museum, I liaised with those former child inmates of Wolston Park Hospital whom I had met as part of my preparation of the *Inside* exhibition. The priority was to draw public attention to the need for the Queensland government to continue with their promised resolution with these women. This was attempted through a media release, written in consultation with the women, which a newspaper journalist used as a basis,

in addition to a series of interviews, for her national coverage of the issue. However, there was no subsequent response from the Queensland government to these articles. The quest for justice was not going to be easy. It took my travelling to Brisbane to meet more of these survivors and archival research to gain a more comprehensive understanding of how and why the Queensland government enabled such a heinous policy. The aim was to use this research to support the women's testimonies and to leverage the government to provide a just response.

Then, in 2013, the Royal Commission into Institutional Responses to Child Sexual Abuse was established. The Australian government amended the Royal Commission Act 1902 in order to enable private hearings in addition to a series of case studies selected for public hearings. I was formally requested to participate, with these women survivors, in a private meeting of the Royal Commission. There, I spoke to my research. I never predicted, when starting my work at the National Museum, that my curatorial work would be extended by tabling my research at a legal inquiry.[2] On went the push for visibility and justice. The women wanted to be part of a Royal Commission public case study. Despite, or because of, extensive lobbying for this outcome, their request was not fulfilled. It was not until a senior bureaucrat read an opinion piece on this matter (Chynoweth 2016) that the Queensland government, itself, initiated a series of meetings with the women. In February 2017, the Queensland government announced a reconciliation process for those who as children were in the care of the state and inappropriately placed in Queensland adult mental health facilities. Later, in March of that year, the Queensland health minister stated publicly that financial payments would be part of this process. In October 2017, the Queensland government announced generous ex-gratia payments for the women who chose to participate in the reconciliation process. It had been more than five years since two women at the National Museum of Australia asked me if I was going to help them 'get justice' and we had won.

Towards an authentic alliance

How might this experience be applied to the work of museums in supporting social justice when working with vulnerable people? First and foremost, museums have a unique opportunity to authentically represent history amidst a plethora of narratives in a mediatised culture that are often exploited for entertainment and profit. Museums, then, should find the courage to exhibit difficult stories without the need to construct 'balance' or to represent a superficial resolution. When it comes to vulnerable groups, it is important for museum professionals to be conscious of making moral judgements as to who is the most 'grief worthy' and how this may lead to decisions concerning who might be most deserving of representation in exhibitions and whose narratives are to be ignored. This is not to say that museum curators should not use editorial expertise, nor should museums succumb to pressure and surrender to reactionary groups that perpetuate inequity. However, curatorial decisions should be informed by rigorous research and not by the construction of suffering competitions or by trends in identity politics. As sociologist Jacqueline Z. Wilson states:

> Every society identifies itself and its essential qualities by recourse to what are deemed its generative historical narratives. Those narratives are the products of manifold processes of inheritance, mythmaking, remembering, forgetting and choice. As a nation-state still working through those processes, still making those choices, Australia is a society in transition, with individual citizens each conducting their own searches, whether diligently or sporadically or entirely subconsciously, for their sense

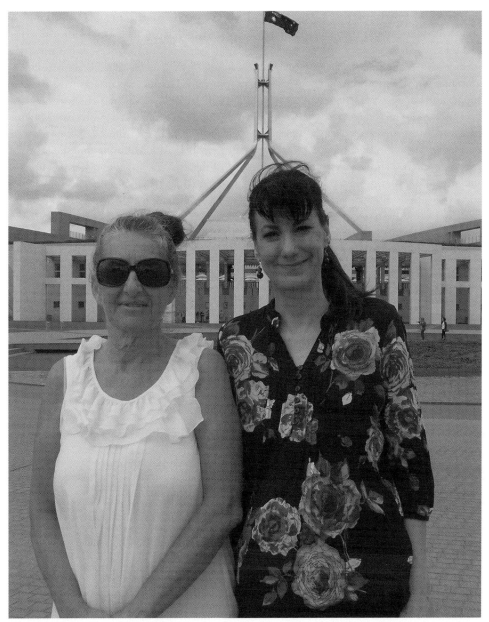

FIGURE 12.2 The author (right) with survivor/campaigner Christine, at Parliament House, Canberra, Australia.
Photo: 'Erin', 2018.

of personal identity in relation to the nation. We are, in one way or another, engaged in the quest for a collective intelligibility. I contend that for that intelligibility to be any more than ephemeral, an illusion of coherence, it must arise from an *inclusive* spectrum of narratives.

(Wilson 2008: 211)

Further, museums should not shy away from direct, ethical, personal engagement and consultation with survivors. Museum professionals cannot rely solely on secondary source material and mediatised narratives to draw conclusions about survivors' experiences. Just as museums include staff with expertise in research and handling objects, additional skills are required in engaging with victims of trauma. As part of this imperative, museum managers have a role in supporting curators who undertake this work by understanding that their curators may also be battling certain 'hangovers' from traditional museum structures and protocols. Museum managers need to acknowledge that museums are in transition and those curators who are dealing with exhibition content concerning human rights violations, trauma and social justice are, more often than not, working at the coalface of this transition. These curators will need support in forging this new path. This is not to say that curators will not benefit from advice and expectations of process and standards but it may also be helpful for managers to demonstrate openness in supporting this evolution by asking open questions – for example, 'What is it that you need to fulfil this work?', 'How can I support you?' or 'Is there anything that we could be doing differently to make this work easier?'

Museum managers may also assist by understanding that not all museum staff will feel comfortable with a project that involves liaison with vulnerable stakeholders, even if they are not involved in that project directly. Curators directly involved in these projects should not bear the brunt, alone, of educating their colleagues. Managers should also be mindful that museum staff that are either unsympathetic or feel distressed, may isolate the curator who is working with survivors and narratives of trauma.

Museums should also resist the temptation to end their work with an exhibition or a single event in museum programming. The end point should be social justice and the exhibition should be viewed as a means to this end, not an end in itself. This is no simple quest but it may be supported by attention to 'recognition gaps', which sociologist Michèle Lamont defines as 'disparities in worth and cultural membership between groups in a society'. Recognition not only affects well-being but also impacts social policy (Lamont 2018: 421–422). The Senate Report *Forgotten Australians* (2004) concluded that non-Indigenous, domestic Australian survivors of the institutionalised 'care' system had been overlooked by both social services and the public history sectors. The Australian government identified the National Museum of Australia as a key component in its national policy to destigmatise this cohort. The Museum's haste in blocking ongoing contributions to the exhibition blog and in only affording short-lived programming to an associated exhibited history, could be interpreted as, at best, a tokenist response to a government imperative. Forgotten Australians or Care Leavers mainly stem from families of blue-collar workers or the poverty class who do not fit the contemporary scripts of the neoliberal virtues of the affluent. The Stolen Generations, on the other hand, are the subject of museum admiration and their narratives are a valued extension of a vast Aboriginal and Torres Strait Islander collection, which includes priceless artworks.[3] There is a challenge here for museums to pay attention to those marginalised groups that may not be perceived as possessing any 'culture', let alone one that produces worthy and valuable aesthetics. How should museums respond to those marginalised groups whom they do not like? Specifically how might the Australian museum sector fill the Care Leaver recognition gap?

It is important to target resources to maintain an ongoing relationship with survivors and/ or partnerships with associated advocacy organisations. When such support groups do not exist, museums should think about how to initiate advocacy and campaigning. Just as museums

conserve objects beyond their display in an exhibition, so too should museums commit to the maintenance and support of those survivors who donated their emotional labour in providing their personal histories to the museum, if survivors wish it.

Museum staff can support social justice by identifying ways, in consultation with survivors, in which survivors can benefit from curatorial research and representation in exhibitions. As part of this process, it is important not to imply that a survivor should be grateful for such curatorial attention or that museum recognition should be regarded by survivors as an honour or a privilege. If museums are serious about inclusion, then such work should be perceived as a standard part of the job. Further, any expectations of gratitude may, even inadvertently, reinforce dominant power relations for vulnerable people. For example, in relation to Care Leavers, the punitive nature of the welfare system in the twentieth century was exemplified by some institutional staff expecting children to be grateful for the out-of-home care that they received (Corby *et al.* 2001). It is important that museum staff do not repeat or reinforce historical power dynamics.

In fact, it is museum staff who need to demonstrate gratitude for those external stakeholders who re-traumatise themselves when they donate their personal violent experiences to an exhibition. The testimony of the trauma survivor is the currency for those museums that wish to demonstrate their capacity to be inclusive. The competency in exhibiting painful testimonies may be reported by museums in their annual reports, espoused by curators at conferences and analysed in academic publications. The donated narrative of the trauma survivor secures academic and museum funding, wins grant applications and paves careers. The sourcing of these difficult testimonies comprises the plum in the Christmas pie that the privileged museum professional, like the character Little Jack Horner in the traditional English verse, extracts with 'his' thumb while boasting, 'What a good boy am I!'[4]

Just as museums conserve objects in collections well beyond their exhibited years, so, too, do museums have an obligation to support those who provide the object that is the narrative. Museums must not allow historical injustices to be compartmentalised in the past. Instead, museums can let visitors know what concrete actions they can take to support the path to justice. We must encourage museum staff and visitors to politically engage in the present and to ensure that those whose rights have been violated are not cast off by museums once an exhibition has been created. Exhibiting the story is not enough. In fact, it is profoundly unethical for museums to take the narratives of the vulnerable and do nothing, in return, for these generous donors. One might argue that the level of stakeholder engagement required to support social change is more easily supported by small, specialised museums as demonstrated by the work of the Danish Welfare Museum, for example. However, such reasoning may fuel a sectoral divide, enabling 'mainstream' national, public museums to evade their responsibilities in also addressing inequality and marginalisation. In the words of Susana Meden, project director of the International Museum of Democracy, Argentina, 'We believe that all museums, whatever their typology, are potential human rights museums' (2018).

In 2016, two of the women survivors who, as children, had endured incarceration in Wolston Park Hospital, met with a minister in the Queensland government. One concluded the meeting by reading the words from the private speech that she had prepared to describe her childhood experience in solitary confinement – the rape, the torture, the neglect and punitive medical treatment. Her words resound as a cry for all, including museums, to not perpetuate an inequitable status quo but instead, to work committedly and practically for social change:

You have inherited righting the wrongs of the past that both sides of Government knew about and were complicit in.

It is cruel what happened to us but it is also cruel what is being done to us now by making us fight for so long.

It is time to finish it.

('Erin' 2017)

Notes

1 See McCarthy 2004.
2 I had previously been employed as a union organiser and facilitated successful campaigns. Therefore, I had a working knowledge of how to apply research and advocate in solidarity in the interests of policy change. My unexpected, externally prompted application of this experience to my post-curatorial work also echoes Adele Patrick's observation in her contribution to this book. Here, she notes the employment of support and development workers at the Glasgow Women's Library. These case studies, then, may well suggest a rethink of the skills that are emphasised as part of museum staff recruitment.
3 The National Museum of Australia includes in its 'Collection Highlights' the Martumili Ngurra canvas (2009), the Mornington Island headdress, the Balarinji art and design collection, the Papunya collection, Sugu Mawa artwork, Tasmanian Aboriginal shell necklaces, Warakurna history paintings and Yawkyawk sculptures (National Museum of Australia, no date, b).
4 From the English verse:

> Little Jack Horner
> Sat in the corner,
> Eating a Christmas pie;
> He put in his thumb,
> And pulled out a plum,
> And said, 'What a good boy am I!'
> (Anon. 1750?)

Bibliography

Anon. (1750?), *The History of Jack Horner: Containing, the Witty Pranks He Play'd, from his Youth to his Riper Years, Being Pleasant for Winter Evenings,* London: Printed and sold in Aldermary Church Yard, Bow Lane.

Arnold-de Simine, S. (2013), *Mediating Memory in the Museum: Trauma, Empathy, Nostalgia,* Basingstoke: Palgrave Macmillan.

Black, G. (2005), *The Engaging Museum: Developing Museums for Visitor Involvement,* London and New York: Routledge.

Chynoweth, A. (2016), 'Who is Protected by the Royal Commission's Private Hearings? The Case of Wolston Park Hospital Survivors' in *On Line Opinion,* viewed 27 October 2017, http://onlineopinion.com.au/view.asp?article=18116.

Chynoweth, A. (2014), '*Your* Rhonda is Downstairs! The Need for a Whole-of-Museum Approach to Survivors of Trauma', *Museum Worlds: Advances in Research,* 2: 152–155.

Commission of Inquiry into Abuse of Children in Queensland Institutions (1999), *Report of the Commission of Inquiry into Abuse of Children in Queensland Institutions,* Brisbane: Queensland Government.

Corby, B., Dolg, A. and Roberts, V. (2001), *Public Inquiries into Abuse of Children in Residential Care,* London and Philadelphia: Jessica Kingsley.

'Erin' (2017), Email correspondence with author, 18 June.

'Erin' (2016), Telephone interview with author, 29 March.

Karpman, S. (1968), 'Fairy Tales and Script Drama Analysis', *Transactional Analysis Bulletin*, 7 (26), 39–43.

Lamont, M. (2018), 'Addressing Recognition Gaps: Destigmatization and the Reduction of Inequality', *American Sociological Review*, 83 (3), 419–444.

Lynch, B. (2016), 'Challenging Ourselves: Uncomfortable Histories and Current Museum Practices', in J. Kidd, S. Cairns, A. Drago, A. Ryall and M. Stearn, *Challenging History in the Museum: International Perspectives*, London and New York: Routledge, 87–98.

Martschukat, J. and Niedermeier, S. (eds) (2013), *Violence and Visibility in Modern History*, Basingstoke: Palgrave Macmillan.

McCarthy, G. (2004), 'The "New" Cultural Wars: "Constructing" the National Museum of Australia', Australasian Political Studies Association Conference, 29 September – 1 October, Adelaide, Australia, viewed 5 June 2013, http://citeseerx.ist.psu.edu/viewdoc/download?doi=10.1.1.549.8999&rep=rep1&type=pdf.

Meden, S. (2018), 'Education on Human Rights in Latin American Museums', Federation of International Human Rights Museums Conference, 25–28 September, Canadian Museum for Human Rights, Winnipeg, Canada.

Museums Australia Victoria (2013), *Developing Diverse Audiences*, seminar, National Gallery Victoria, 22 October.

National Museum of Australia (2015), *Indigenous Cultural Rights and Engagement Principles*, Canberra: National Museum of Australia.

National Museum of Australia (no date, a), 'History of Our Museum', viewed 1 February 2019, www.nma.gov.au/about/history.

National Museum of Australia (no date, b), 'Collection Highlights', viewed 1 February 2019, www.nma.gov.au/explore/collection/highlights.

Queensland Government (2017), *Reconciliation Plan: For Children who as Wards of the State were Placed in Adult Mental Health Facilities*, Brisbane: Queensland Government.

Read, P. (1981), *The Stolen Generations: The Removal of Aboriginal Children in New South Wales 1883 to 1969*, Sydney: NSW Department of Aboriginal Affairs.

Rose, J. (2016), *Interpreting Difficult History at Museums and Historic Sites*, Lanham, MD: Rowman & Littlefield.

Senate Community Affairs References Committee (2004a), *Forgotten Australians: A Report on Australians who Experienced Institutional or Out-of-Home Care as Children*, Canberra: Commonwealth of Australia.

Senate Community Affairs References Committee (2004b), *Official Committee Hansard (Reference: Children in Institutional Care – Wednesday 4 February 2004)*, Canberra: Commonwealth of Australia.

Weil, S. (2007), 'The Museum and the Public', in S. Watson (ed.), *Museums and Their Communities,* London and New York: Routledge, 32–46.

Wilson, J. Z. (2008), *Prison: Cultural Memory and Dark Tourism*, New York: Peter Lang.

INDEX